D1498982

PHOTOGRAPHY
IN THE MODERN ERA

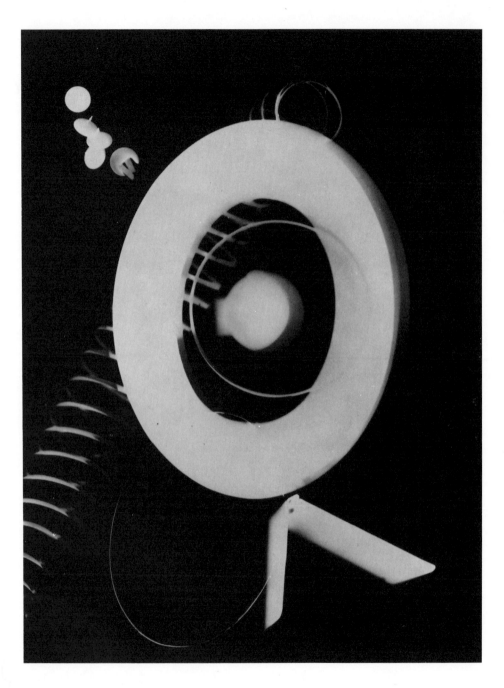

MAN RAY, Rayograph, 1922

PHOTOGRAPHY IN THE MODERN ERA

EUROPEAN DOCUMENTS
AND CRITICAL WRITINGS, 1913–1940

EDITED AND WITH AN INTRODUCTION BY
CHRISTOPHER PHILLIPS

THE METROPOLITAN MUSEUM OF ART / APERTURE

NEW YORK

This book is published on the occasion of the exhibition
The New Vision: Photography Between the World Wars,
Ford Motor Company Collection at The Metropolitan Museum of Art,
held at The Metropolitan Museum of Art September 23–December 31, 1989.

Published by The Metropolitan Museum of Art and Aperture

John P. O'Neill, Editor in Chief
Barbara Burn, Executive Editor
Ruth Kozodoy, Editor
Robin Fox, Designer

Typeset by U.S. Lithograph Inc., New York City
Printed and bound in the United States of America by
Arcata Graphics, New York City

Library of Congress Cataloging-in-Publication Data

Photography in the modern era.

 Includes bibliographical references.
 1. Photography. I. Phillips, Christopher.
TR185.P5 1989 770 89–12790
ISBN 0–87099–562–6
ISBN 0–87099–563–4 (pbk.)
ISBN 0–89381–406–7 (Aperture)
ISBN 0–89381–407–5 (Aperture: pbk.)

JACKET/COVER FRONT:
László Moholy-Nagy or Lucia Moholy, *László Moholy-Nagy*, 1925–26

JACKET/COVER BACK:
André Kertész, *Fork*, 1928

CONTENTS

INTRODUCTION

The history of photography is more than a succession of images and names. As the historian Alan Trachtenberg has pointed out, it also encompasses the changing ideas which have shaped and reshaped our understanding of the medium and its potentials. The essays in this collection have been brought together to shed retrospective light on the multiple, frequently conflicting understandings of photography that arose in a setting of unprecedented visual innovation: the 1920s and 1930s in Europe. This was the era of the "new photography" practiced by László Moholy-Nagy, Alexander Rodchenko, and Man Ray, among many others, and characterized by the exploration of techniques like photomontage, the photogram, and the purposely disorienting vantage point. Simultaneously, the questions raised by these new approaches to photography attracted the attention of some of the most imaginative writers and critics of the day, who sought to comprehend the rapidly changing forms and uses of photography in a period of social and cultural upheaval.

The impulse for undertaking the present volume of translations of documents and critical writings came directly from my own teaching experience. Attempting to introduce graduate and undergraduate students to the range of European photography of the 1920s and 1930s, I was repeatedly struck by the fact that only a handful of the key writings from this period were available in English. Therefore, over the course of several years, while carrying out research into the role played by photography within the various European avant-garde movements, I made a systematic effort to locate the writings that seemed to represent best the main currents of those movements. I sought in particular documents that would convey the flavor of the debates that swirled around the phenomenon then variously called the new photography, modern photography, avant-garde photography, or the new vision. The issues investigated in these writings were often rooted in the discussions that took place within constructivist, futurist, or surrealist circles. For this reason they explored questions generally quite distinct from those that preoccupied such well-known American photographers

as Alfred Stieglitz, Paul Strand, Edward Weston, and Walker Evans during the same years.

This book has been prepared in conjunction with The Metropolitan Museum of Art's exhibition *The New Vision: Photography Between the World Wars, Ford Motor Company Collection at The Metropolitan Museum of Art.* The generosity of the Ford Motor Company and the efforts of Maria Morris Hambourg, curator of photography at the Museum, have made this exhibit and its accompanying publications possible. The present volume serves in an obvious sense as a companion to the catalogue of the exhibition, offering a collection of historical materials that provide important insights into the works and artists presented there. But it also provides the most comprehensive overview to date of the volatile mixture of attitudes and practices that informed the photography of this period, and thus goes far, I hope, toward filling the long-standing need for documentary source material felt not only by myself but by many teachers, scholars, and critics. I will be gratified if this volume proves of value in the attempt to know better this fascinating and complex era, and in the effort to understand the past—and ultimately the present—of the photographic medium.

The period that produced these essays occupies a central place in what might be called the intellectual history of photography. Although it was a century old, photography was repeatedly described during this time as having only recently been truly discovered—which is to say, having only recently revealed its social and creative consequences. Accordingly, these writings represent a moment of excited and sustained reflection on the nature of the medium, its historical development, and the scope of its actual and potential uses.

During the 1920s, especially, many observers recognized that photography constituted an important link between the artistic avant-garde and an emerging mass, technological culture. It was a medium which, in the hands of El Lissitzky, Man Ray, or Moholy-Nagy, could be used to explore in arresting ways the formal issues which preoccupied the most advanced painting and architecture: visual transparency, interpenetration, rhythmic patterning, and unaccustomed perspectives. But photography was understood as something other than an artistic medium in the usual sense. Indeed, at a time when the traditional notions of both the artist and the artwork were being fundamentally revised, in the wake of such movements as futurism, dadaism, constructivism, and surrealism, the question which had seemed so

pressing to nineteenth-century commentators on photography—could the medium be ranked with the fine arts?—was rapidly replaced by others. Suddenly revealed in the light of the newly discovered beauty of the machine, photography was seen to share in the precision and economy of machine processes; Vilém Santholzer's 1925 essay in this collection vividly demonstrates the exuberant embrace of photography as a product of technological culture. At the same time, photography was grasped as a medium whose images could be multiplied thousands of times by high-speed printing presses, and could, by way of illustrated books, newspapers, and magazines, reach a vast and increasingly image-hungry public.

As the essays by Moholy-Nagy and Jan Tschichold most clearly illustrate, the prospect of harnessing adventurous photography to the new means of mass dissemination provided a recurrent theme for avant-garde artists. Their goal was to bring about a total transformation of visual and mental habits. What Moholy called the "new vision" was actually part of a much wider, utopian project that aimed to teach men and women to contend with the unprecedented demands of an increasingly urban, mechanical age. The same desire to break with the perceptual habits and the pictorial customs of the past took on a tone that was even more urgent, and distinctly political, in the writings of Alexander Rodchenko, working in the still-revolutionary culture of the Soviet Union of the late 1920s.

Moholy, Man Ray, and Rodchenko all saw photography as a medium ripe for experimental exploration, and for the ceaseless production of optical provocations ranging from wholly abstract to ultra-objective imagery. But even within the avant-garde there were alternative proposals for developing photography as a modern visual medium. Indeed, as these essays clearly demonstrate, by the end of the 1920s there arose a vocal opposition to experimental photography which in Germany found its champion in the photographer Albert Renger-Patzsch. Defining photography as a medium of absolute realism, one whose mission was to reveal the essence of the visible world, Renger-Patzsch viewed with suspicion the work of experimentalists like Moholy. For Renger-Patzsch, the revelation of visible form—whether organic, architectural, or machine—could be accomplished only by those few photographers who devoted themselves to the mastery of pure photographic technique and who practiced utter faithfulness to the medium's own traditions. In his view, work such as Moholy's was much too

closely engaged with the forms and concepts of contemporary abstract painting; in this respect it represented to Renger-Patzsch no more than a modern version of earlier, so-called pictorial photography, which had mimicked the visual idioms of Impressionist and symbolist painting. As the writings of Ernö Kallai, in particular, illustrate, the idea of establishing an absolute distinction between the mediums of painting and photography had persuasive advocates within avant-garde circles.

Photography as objective realism or photography as an experimental medium? This was the crux of the debate that took place in the late 1920s and early 1930s in Germany, in the Soviet Union, and in France, where surrealism had placed its own special stamp on avant-garde photography. The 1929 *Film und Foto* exhibition in Stuttgart, which brought together the leading exponents of the new photography from Germany, the Soviet Union, the United States, France, and the Netherlands, undoubtedly marked the high point of the experimental movement. But it also became the occasion for increasingly vocal criticisms that avant-garde photography was growing academic and formulaic. As a direct consequence of this debate, which took place against a background of sharpening political and economic crisis, documentary and reportage photography began to win the loyalty of many former avant-gardists; this development is traced in Karel Teige's 1931 essay "The Tasks of Modern Photography." It is well known that in the United States the 1930s witnessed the triumph of documentary and reportage photography; in a roughly parallel development, Europe saw the experimental wing of avant-garde photography ultimately displaced by advocates of a more direct engagement with the social world. Even so, the legacy of earlier avant-garde concepts is often evident; as, for example, in the French essayist Pierre Mac Orlan's argument that reportage photography provides startling visual access to the "social fantastic"—the everyday surrealism—of the modern world.

While the extensive literature on photography during this period sprang from a widespread interest in the medium, it also depended directly on the flourishing of avant-garde journals and reviews throughout Europe. Many of the selections included in the present book had their origin in such publications. Often ephemeral, sometimes numbering no more than a dozen pages in length, reviews like *De Stijl*, *G*, *Merz*, *Blok*, *MA*, *Lef* and *Novyi lef*, *La Révolution surréaliste*, *ReD*,

Documents, Bifur, L'Esprit nouveau, i10, Zenit, Punkt, and *Les feuilles libres* were aimed not at a general audience but at a tiny circle of initiates drawn from the international literary and artistic avant-garde. These publications seldom placed great value on the tradition of the well-made essay; instead, articles were likely to be highly polemical, and frequently couched in a densely theoretical or technical language. They occasionally reflected, too, the literary experiments of futurism, dada, and surrealism. Aside from their challenging, sometimes willfully difficult style of exposition and argument, these essays are likely to present problems to today's readers because of topical allusions that, six decades later, have become all but indecipherable. To clarify for readers of this book those references that might otherwise prove baffling, editorial notes have been provided wherever possible identifying names, places, concepts, and titles of works.

A few words should be said regarding the principle of selection and the scope of this volume. Given the extensive quantity of untranslated writing on European photography, I have tried in general not to duplicate the material already available in English in such collections as David Mellor's *Germany: The New Photography, 1927–33*, Vicky Goldberg's *Photography in Print*, Alan Trachtenberg's *Classic Essays on Photography*, and Beaumont Newhall's *Photography: Essays and Images*. For the same reason the frequently reprinted essays of Walter Benjamin, "A Short History of Photography" and "The Work of Art in the Age of Mechanical Reproduction," have been omitted. It has seemed worthwhile to present selections in their entirety without editorial excisions, since it is seldom possible to judge what readers of the future will deem significant. While a few selections, like those of Jan Tschichold and Ernst Jünger, are excerpted from lengthier books or essays, I have generally avoided extracting fragmentary passages that form an integral part of a larger work. For this reason the great many passing remarks on photography scattered throughout dada and surrealist writings have been omitted here. However, the bibliography that concludes this volume, while by no means exhaustive, includes a wide range of additional publications which will enable the interested reader to pursue this subject in considerable depth.

It should be stated at the outset that the selection presented here makes no attempt to represent the entire panorama of photographic activity of the 1920s and 1930s. Instead, these essays focus on one

relatively small yet nonetheless significant area, the "new photography." This means that several other interesting and important aspects of photographic work during these years can receive only passing attention. While the rise of modern documentary and reportage photography is mentioned in many of the texts included here, fully dealing with this subject would require a volume of translations far larger than the present one. Similarly partial is the treatment here of photography's potential as a medium of political communication. The widespread discussion that took place around this issue is represented here primarily in essays which reflect the direct political engagement of photographers, artists, and critics of the avant-garde: in the debate over photography in the Soviet Union, for example, and in those essays which explore the political uses of photomontage. Also outside the scope of this collection is the extensive specialized literature concerning photography as a modern means of advertising or fashion illustration.

The selections have been organized according to country of origin, and within those groupings, chronologically. This period is marked by an extraordinary international exchange of images and ideas in the visual arts; nonetheless, a clear sense of the development of critical positions is best obtained by following the debates that unfolded within national boundaries. Then it quickly becomes apparent that in different contexts, different focal points emerged. In Germany, for example, the critical examination of photography was set within a wider intellectual debate about the ways that technology was transforming every aspect of modern life. French responses to photography, on the other hand, were far more concerned with the contribution of the individual creator, and the discovery, and literary appreciation, of lyrical values in the individual photographic image. The essays from the Soviet Union turn ultimately on a practical question: what should be the attitude of revolutionary artists to the visual culture of the past?

Even within the framework it sets for itself, this collection inevitably contains gaps and imbalances. They reflect more than anything the current state of historical research. Soviet avant-garde photography, Italian futurist photography, and Central European photography have only recently become the objects of systematic scholarship, and forthcoming studies will undoubtedly bring to light valuable material that is currently unavailable. Finally, two important essays by Siegfried Kracauer and Walter Benjamin, noted in the bibliography, were

regrettably unavailable for inclusion in this volume; they will, however, appear elsewhere in forthcoming translations.

Three individuals deserve thanks for their help in the initial stages of this project. Rosalind Krauss's early encouragement, and the continuing stimulation offered by her own writings, were crucial. John C. Waddell provided sustained support, a reflection of his deep interest in the photography of this period. And without the energetic involvement of Maria Morris Hambourg, this book would never have come so rapidly to fruition.

For their advice and encouragement during various phases of this project I am grateful to Richard Bolton, Marta Braun, Ulrich Keller, Nan Rosenthal, and Abigail Solomon-Godeau.

For their willingness to share their own specialized knowledge of this period I wish to thank Jaroslav Andel, Peter Nisbet, and Rosalinde Sartorti. John Bowlt deserves special thanks for generously sharing his extensive store of Russian biographical and historical knowledge, which considerably enriched the editorial notes to the selections from the Soviet Union.

An undertaking like this would be impossible without the cooperation of many specialized library collections. Particular thanks are in order to the staffs of the library of the Museum of Modern Art; the library of the Department of Photography of the Museum of Modern Art; the New York Public Library; the Library of Congress; the Bibliothèque Nationale, Paris; the Staatsbibliothek, Berlin; the library of the Folkwang Museum, Essen; and the Institüt für Zeitungsforschung, Dortmund.

This book has benefited greatly from the careful attention of the editorial department of The Metropolitan Museum of Art. Barbara Burn played an important role in shepherding the book through its early stages, and in organizing the process of translation. Erik La Prade worked diligently to obtain the necessary permissions agreements. Above all, Ruth Kozodoy deserves special recognition for her untiring efforts to attain maximum clarity in the translations and the accompanying editorial notes.

JEAN COCTEAU

AN OPEN LETTER TO M. MAN RAY,
AMERICAN PHOTOGRAPHER

Poet, playwright, and filmmaker, Jean Cocteau (1889–1963) was already a well-established literary figure in 1922 when he published this high-spirited tribute to the photograms (cameraless photographs) of Man Ray. Quotations from the letter were published in the November 1922 issue of the American magazine *Vanity Fair* accompanying reproductions of four of Man Ray's "meaningless masterpieces," and helped bring the photographer to international attention.

In his open letter, Cocteau points out that Man Ray has accomplished an ironic reversal of the avant-garde axiom according to which photography has freed painters from the task of realistic representation, thus enabling them to pursue abstraction. One of the lessons of Man Ray's semiabstract photograms, or rayographs, according to Cocteau, is that now painters may again, in good conscience, pursue realism.

Original publication: Jean Cocteau, "Lettre ouverte à M. Man Ray, photographe américain," *Les Feuilles libres* (Paris), no. 26 (April/May 1922), pp. 134–35.

My dear Man Ray,

You know my strong distaste for the modern, a loathing shared by our friend Tzara, who represents, for so many naive souls, *the* modern poet, or in other words, the latest fashion. This distaste for the "modern," for "progress," does not imply love for the eternal, something which to me, alas, seems difficult to understand. I love a work which seduces me right off, intrigues me, removes the blindfold from my eyes. The eighty photographic prints, a true album of *Caprices*, that you did me the honor of bringing me one morning, have this advantage, that their seduction works on everyone worthy of feeling. I feared, after Picasso, being left without any spectacles to enjoy. I owe one to you. I would call it exquisite joy, if the public knew the terrible meaning of that term used by the neurologists to express the fact that a pain—"exquisite pain"—has reached a previously unknown limit, escaping from their control.

I refuse to believe in imbecilic formulas like: The better is the enemy of the good. A French formula par excellence. Translation: If I invest my four francs in order to have five, I risk losing them. That old saw heightens the prestige for us of the unfinished sketch.[1] I have been ill recently. I was treated with X-rays. X-rays are the devil's own work. How often I heard: "If I were you, I would limit myself to two treatments. Since you are getting results, why risk overdoing it?"

I return to your prints and I muse, despite their perfection, over the prospect they hold out if one looks to tomorrow, and over the dark room[2] you have just opened up on treasures, cinematographic among others.

Since Picasso I have followed with curiosity, and regret as well, the experiments which, denying painting, continued to make use of painting. I am already enchanted by Max Ernst's prints.[3] But Max Ernst cheats, he cuts out and pastes together with taste. His work still depends on the play of the mind. Your prints, however, are the very objects themselves, not photographed through a lens but by your poet's hand directly interposed between the light and the sensitive paper.

The placement, the surprise of the objects, the strength of the lights and other contrivances, everything leads to a metamorphosis of the motif, and the result is a meaningless masterpiece in which ultimately there appear the most voluptuous velvets of the etcher. Who else has ever been able to obtain such a range of blacks which disappear into each other, those penumbral half-shadows and more than half-shadows so curious to observe on days of eclipse?

On the day of an eclipse I saw a chicken fall asleep at the first signs of the false night. She had a wealth of superb plumage. She cast three shadows. A normal shadow, within which was inscribed a sort of projected shadow, and another, this one vast, which stretched across the farmyard and ran up the wall.

No doubt, my dear Man Ray, people more attentive to symbols than I will see in your prints (so precious because there exists only one of each) phantasmagorical images and landscapes. You come from the country of Edgar Poe. I find in them only a joy that calls for no excuse. The most beautiful of all.

In the past, Daguerre and then Nadar[4] liberated painting. Thanks to them the copyists could hazard nobler undertakings.

You have liberated painting once again. But backwards. Your

mysterious groupings surpass all the still lifes that try so hard to conquer the flat canvas and the marvelous ooze of paint.

Our time moves swiftly. I will give it a year before your disciples are hiding their prints from you, and that is why, though ill and ever so tardy, I am hastening to register your patent as inventor.

The painter will be able once again, without regrets, to study the human face in detail, and you, my dear Man Ray, will nourish our minds with those dangerous games it craves and thanks to which a Picasso, a Georges Braque, will one day, without doubt, rejoin Raphael.[5]

Translated by Robert Erich Wolf

1. Nineteenth-century French romantics prized the rapidly executed sketch, in which the traces of artistic inspiration were thought to be more clearly discernible than in the more painstakingly executed oil painting.

2. The French *chambre noire*, derived from the Latin *camera obscura*, signifies both a darkened room and a photographic camera.

3. Max Ernst (1891–1976), the German-born painter, sculptor, and collagist, in 1921 exhibited in Paris a number of collages employing photographic fragments as well as illustrations clipped from catalogues and periodicals.

4. Louis Jacques Mandé Daguerre (1789–1851) invented the daguerreotype process, which was made public in 1839. Nadar was the pseudonym of Gaspard-Félix Tournachon (1820–1910), a caricaturist and portrait photographer who was one of the most celebrated French photographers of the nineteenth century.

5. Cocteau was a vocal proponent of the "return to order" in postwar modern painting, noticeable around 1920 in the new attention paid to classical themes by such artists as Picasso, Gino Severini, and André Derain.

TRISTAN TZARA

PHOTOGRAPHY UPSIDE DOWN

Tristan Tzara (1896–1963), a Romanian-born poet, was one of the founders of the Zurich dada movement in 1916, along with Hans Arp, Hugo Ball, and Richard Huelsenbeck. By early 1920 Tzara had moved to Paris; there, with Francis Picabia and André Breton, he helped spark a new round of dada activities.

Tzara was one of the first to see the photograms made in Paris by Man Ray during the winter of 1921–22. Tzara characterized the works as "pure dada." This was no doubt due to Man Ray's accidental discovery of the photogram process in his darkroom, to the seemingly unpredictable nature of the technique, and to the resulting transfiguration of common household objects (such as a comb, a key, a table knife, and an egg) into images of beauty and delight. In August 1922 Tzara composed the text presented here. It served as the introduction to Man Ray's portfolio of photograms (or rayographs) called *Les Champs délicieux*, which was published in December of that year. Pitting photography against painting, Tzara proceeds by way of dada non sequiturs and elliptical allusions to suggest the sense of surprise that the rayographs produced in their first viewers.

Original publication: Tristan Tzara, Preface, in Man Ray, *Les Champs délicieux* (Paris: Société générale d'imprimerie et d'éditions, 1922). The text also appeared in *Les Feuilles libres*, December 1922/January 1923.

No longer does an object, by crossing the trajectories of its outer edges within the iris, project a badly inverted image on the surface. The photographer has invented a new method: he presents to space an image that exceeds it, and the air, with its clenched fists and superior intelligence, seizes it and holds it next to its heart.

An ellipse turns around the partridge; is it a cigarette box? The photographer turns the spit of his thoughts to the sputtering of a poorly greased moon.

Light varies according to how stunned the pupil is by the coldness of paper, according to the weight of the light and the shock that it causes. A wisp of delicate tree conjures up metal-bearing beds of

earth, or bursting plumes of water. It lights the hallway of the heart with a lace of snow. And what interests us is without reason and without motive, like a cloud dropping its load of rain.

But let's speak of art for a moment. Yes, art. I know a gentleman who makes excellent portraits. This gentleman is a camera. But, you say, there is no color, no trembling of the brush. At first this uncertain quiver was a weakness that justified itself by calling itself sensitivity. Apparently the virtues of human imperfection are to be taken more seriously than the virtues of a machine's precision. And still lifes? I would like to know if hors-d'oeuvres, desserts, and baskets of game are not more attractive to the breath of our appetite. I listen to a snake whirring in a mine of petroleum; a torpedo twisting its mouth; dishes breaking during domestic quarrels. Why don't they make portraits of this? Because what this concerns is a medium that conveys a special commotion to those who approach it, but that uses up neither eyes nor colors.

The painters saw this, they gathered in a circle, they argued for a long time, and they came up with some laws of decomposition. And laws of construction. And of convolution. And laws of intelligence and comprehension, of sales, of reproduction, of dignity and preservation in museums. Others came along afterward with cries of enlightenment to say that what the first ones had done was nothing but cheap bird excrement. In its place they proposed their own merchandise, an Impressionist diagram reduced to a vulgar though charming symbol. For a moment I believed in their cries, the cries of idiots scoured by fountains of snow, but I very quickly perceived that they were only tormented by a fruitless jealousy. They all ended up confecting English postcards. Having known Nietzsche and sworn on their mistresses, having extracted the enamel from their friends' corpses, they declared that beautiful children deserved good paintings in oil, and the best of these was the one that returned the highest price. Paintings with tailcoats and curled hair, in gilded frames. To them this is marble; to us, our chambermaid's urine.

When everything we call art had become thoroughly arthritic, a photographer lit up the thousand candles of his lamp, and the sensitized paper absorbed bit by bit the black outlines of some everyday objects. With a fresh and delicate flash of light, he invented a force that surpassed in importance all the constellations intended for our visual pleasure. The mechanical, exact, unique, and correct distor-

tion is fixed, smooth, and filtered like a mane of hair through a comb of light.

Is it a spiral of water or the tragic gleam of a revolver, an egg, a glistening arc or the floodgate of reason, a keen ear attuned to a mineral hiss, or a turbine of algebraic formulas? As a mirror throws back an image without effort, as an echo throws back a voice without asking why, the beauty of matter belongs to no one: from now on it is a product of physics and chemistry.

After the grand inventions and the tempests, pockets of magic wind sweep away all the little swindles worked by sensitivity, knowledge, and intelligence. The dealer in light values accepts the bet proposed by the stableboys. The measure of oats they give to the horses of modern art each morning and evening will not disrupt the thrilling course of his game of chess with the sun.

ROBERT DESNOS

THE WORK OF MAN RAY

The French poet Robert Desnos (1900–1945) was one of the central members of André Breton's surrealist group of the mid-1920s. In this appreciation of Man Ray's rayographs Desnos proposes that they represent a new term in art—neither wholly abstract nor wholly realistic. In fact, he suggests, it may be more fruitful to think of photograms as belonging to the realm of poetry than to the visual arts. In the rayographs' pure spontaneity, in their overturning of conventions, and in the "bouquet of vertigo" which surrounds them, Desnos discovers a new and unexpected beauty.

Original publication: Robert Desnos, "Man Ray," *Le Journal* (Paris), December 14, 1923. This translation first appeared in *Transition* (Paris), no. 15 (February 1929).

Our only exploration of the Universe has been with the aid of senses corrupted by prejudice. Our vision of the world when reduced to its minimum is the same as that of the most primitive missing link: doubtless the blind fish in the depths of the ocean constructs his mythology among the aromatic seaweed in spite of the entire collection of gods which man strives to force from matter. With the awakening of our senses, we decreed that chaos had been dispersed. But there are other forms of chaos surrounding us and we have no way of dividing these into water, air, earth, or fire. There is an infinity of senses which we lack. The conquest of just one of them would revolutionize the world more than the invention of a religion or the sudden arrival of a new geological era.

As a matter of fact, we have not complete mastery of our five delicate receptors, despite the experience of many thousands of years. Dreams, for instance, which depend essentially on sight and what we call optical illusions, because the camera does not capture them, are entirely outside that control which man pretends to exercise over all that surrounds him.

A famous captain ordered his soldiers to strike the enemy on the navel: another on the hair and another the left wrist. But the poet

knows well that there are no premature corpses (all deaths are anonymous).

It would be, in my opinion, renaturing the significance of the Universe that Man Ray suggests to me, were I to dwell on the figuration of dazzling elements in his work; for he reveals a land that is as tangible and, for the same reasons, as indisputably material as light, heat, or electricity.

A painter, Man Ray gives greater thought to the chess game of the spirit than to that of painting. He speculates on the slightest move of the obelisk or on Marcel Duchamp's throat. The spirals twine in and out like supple brains, but not a single point obeys the attempt to straighten out their straight-line curves in order to designate an illusory winner in the lottery or, more illusory still, an hour. He arrives between two shocks of an earthquake, stops creation on the peak of a plunge, immediately before the return to the normal position. He catches faces at that fugitive moment between two expressions. Life is not present in his pictures and still there is nothing dead about them. There is a pause, a stop, only: Man Ray is the painter of the syncope.

A sculptor, he demands that the most ironbound laws take a direction outside the realm of chisels. He abandons marble and granite to gravestones and clay to shoe soles; for him other plastic materials are necessary in order to realize, in space, constructions that are independent of their resistance to human forces. The mysterious physical knows little difference between the fragility of paper and the solidity of porphyry. If it were pleased to do so, it would endow the former with vigor and the latter with a mobility that fears liquids. Weight, at its solicitation, would transform a lampshade into a sort of spiral more sensitive than a seismograph or a weather vane condemned by some whimsical meteorologist to confinement in space under a muted crystal bell.

A photographer, Man Ray derives neither from artistic deformation, nor from the servile reproduction of "nature." Your planes and humps will reveal to you a person you do not know, and whom you have never dared glimpse in your dreams. A new "you" will spring from the delicate hands of the chemist in the red glow of the laboratory. It will bat its eyes out in the open air, the way night birds do.

There does not yet exist a word for the designation of Man Ray's invention, these abstract photographs in which he makes the solar specter participate in adventurous constructions. As children we used

to cut out our hands imprinted on citrate paper[1] exposed to the sun. Proceeding from this naive process, he thus succeeded in creating landscapes which are foreign to our planet, revealing a chaos that is more stupefying than that foreseen by any Bible: here the miracle allows itself to be captured without resistance and something else, besides, leaves its anguishing thumbprint on the revelatory paper.

That sentimentality which dishonors nearly everything man touches is barred. An attentive chloroform will communicate to you the metaphysical anguish without which there is no dignity on earth. If you are able to abandon terrestrial conceptions, you will penetrate into a world having neither longitude nor latitude, into a bit of that infinite which, open to a few, is the most moving excuse that the modern epoch could give for its productive aptitude.

Like the famous monk who, far from the Eucharistic boons, established the presence of thunder in a mixture of sulfur and saltpeter, Man Ray does not calculate or predict the result of his manipulations. In his wake we will go down these toboggans of flesh and light, these vertiginous slopes, and we will hunt the keys of partly glimpsed cellars. A clown in his paper veinstone heavier than lead makes far-off signals. But we hold the miraculous between the sides of this sheet of paper, just as we hold it everywhere we want it to be; great imaginary maelstrom that hollows itself and offers us its bouquet of vertigo.

But we dare not lose ourselves bag and baggage therein, despite the reiterated calls of our likeness in the depths of the water. Tomorrow you will read in the newspapers a fully detailed account of the crime, with proofs to back it up: fingerprints and anthropometric photographs. You may nevertheless be sure that we will not agree as to the significance of this black or colored type: these letters and these pictures.

It is of little importance to me whether the conception of Man Ray is superior or inferior to his realization. Beginning with the moment when I agree to consider it, I have the same rights over his work that he has. Except when my door is tightly closed, those I am fond of know how to get it open. The exegesis has yet to irritate many creators. Seeing their work get away from them, they can't restrain a sentiment of property, that master of mediocre souls. If the reasons given by a spectator for the justification of a work are superior to those of the author, the spectator becomes the legitimate possessor of the work he is discussing. But the attitude of Man Ray lets us understand no such conflict. It guarantees for him supremacy in his own province. Behind

his persistent silence it pleases me to see the partial beatitude of those who have received a revelation. Whatever his initiation may have been, Man Ray derives from poetry, and it is in this capacity that I have lived today on his domain, which is as wide open as Eternity.

Translated by Maria McD. Jolas

1. Citrate paper, also called "printing-out paper," slowly darkens when exposed to light and does not require chemical development.

MAN RAY

DECEIVING APPEARANCES

Born in Philadelphia, Man Ray (1890–1976) began his career as a painter, and first took up the camera in 1915 to make photographic copies of his paintings. A frequent visitor to Alfred Stieglitz's "291" gallery in New York, he participated with Marcel Duchamp in the activities of the New York dada group in the years 1915–20, and at Duchamp's urging moved to Paris in 1921. There he became one of the best-known members of the surrealist group and a frequent contributor to surrealist reviews like *La Révolution surréaliste*, as well as a successful portrait and fashion photographer.

In the 1926 essay "Deceiving Appearances" Man Ray makes clear his own preference for photography that opens up new domains of visual experience. For this reason he recommends that photographic invention be based on poetry and inspiration, rather than on a slavish adherence to visual convention. He argues, indeed, that photography retains its value precisely to the degree that it is not artistic in the usual sense—that is, not bound by aesthetic laws and limitations of any sort.

Original publication: Man Ray in *Paris Soir*, March 23, 1926.

I am not one of those who say: "that watering can is blue, that house is pink," or those who say: "nothing is beautiful but truth, only truth is pleasant." There are better things to do in life than copy. I admire those painters who make the mistake of imitating the famous master-pieces of nature. Isn't it this perpetual mania of imitation that prevents man from being a god? This one imitates in oil, the next in Alexandrines, another in clay!

Imitation is merely artistic laws and limitations. I prefer the poet. He creates, and every time man is raised in the moral order, he is a creator, whether of a machine, a poem, or a moral attitude.

As far as painting goes, isn't it amazing that some painters still persist, a century after the invention of photography, in doing what a Kodak can do faster and better?

Bonnat's work[1] was useful as long as photography was insufficient. It is folly to make with oil on canvas images that one obtains better on photographic paper.

I maintain that photography is not artistic! Grievance for some, praise for others. A form of expression is only capable of evolution and transformation to the degree that it is not artistic.

I am a painter myself, and I have been brought to make use of photographic plates for material reproduction. And I feel that poetry does not lose out in the process. Artists have never set great examples: artists, the primitives? Victor Hugo, an artist? Seurat, an artist? Rimbaud? No, no, no! They never went through a period of apprenticeship. Art is the negation of inspiration, without which a work is without spirit. Besides, photography is not limited to the role of copyist. It is a marvelous explorer of those aspects that our retina never records, and that, every day, inflict such cruel contradictions on the adorers of familiar visions that are so few, whose turn was over before a bold navigator could go around the world.

I have tried to capture those visions that twilight, or too much light, or their own fleetingness, or the slowness of our ocular apparatus rob our senses of. I have always been surprised, often charmed, sometimes literally "enraptured."

Photography, and its brother, the cinema, join painting as it is perceived by any spirit conscious of the moral needs of the modern world.

1. Léon-Joseph-Florentin Bonnat (1883–1922) was a French painter of historical and biblical scenes and of portraits noted for their photographic verisimilitude.

FLORENT FELS

PREFACE to *MÉTAL* by GERMAINE KRULL

Florent Fels (1893–1977) was the editor of *L'Art vivant*, an influential maga-
zine which during the 1920s set out to explore the manifestations of modern
culture in the arts and in everyday life. The author of numerous monographs
on contemporary artists, Fels became increasingly interested in the work of
modern photographers in the late 1920s. Germaine Krull (1897–1985) was
among the best known of the industrial, portrait, and fashion photographers
working in Paris during the 1920s. The photographs in her book *Métal*, all
devoted to industrial subjects, comprise some of her strongest work. In his
lyrical preface to *Métal*, Fels makes it clear that he finds Krull's photographs
of power stations, factory machines, the Rotterdam transporter bridge, and
the Eiffel Tower compelling, not only because of their striking graphic quality
and unusual perspectives, but also for their discovery of a "modern sublime"
in the emerging industrial landscape.

Original publication: Florent Fels, Preface, in Germaine Krull, *Métal* (Paris:
Librairie des arts décoratifs, 1927).

The industrial activity of our time presents us with sights to which we
are still unaccustomed.

Their newness grips and frightens us as the great phenomena of
nature do. In their turn they generate a state of mind to which paint-
ers and poets sometimes pay tribute.

The great cities of Europe strike us as dilapidated and anachronistic.
Provincial towns with their avenues to promenade in, their pleasant
fountains, a bandstand, suddenly take on an antiquated look. Mean-
while the lyricism of our time puts its name down in streams of
cement, in cathedrals of steel. We are witnessing something paradoxi-
cal: great enterprises are serving all the works of progress except
for those that would help improve the human dwelling. Save for a
privileged few, our contemporaries' homes are much like those of our
ancestors in the time of Richelieu and Cromwell. City dwellers are
crushed under the growth of commercial projects. What we want are
houses with windows looking out on gardens. For modern people, mod-
ern homes, with plenty of sunlight and fresh air. Cement and steel are

essential for this, and so, ten years after the war, steel will finally serve a noble cause and perhaps regain its good name.

Steel is transforming our landscapes. Forests of pylons replace age-old trees. Blast furnaces supplant hills.

Of this new look of the world, here are a few elements caught in fine photographs, specimens of a new romanticism.

Germaine Krull is the Desbordes-Valmore[1] of this lyricism; her photographs are sonnets with sharp and luminous rhymes. What an orchid, this Farcot engine, and what disturbing insects those regulator mechanisms!

Double exposure gives a fantastic look to the most precise mechanisms. Confronted with a milling machine covered with oil sludge, lifeless debris, and streaming water, one thinks of Dostoyevsky.

In the halo surrounding them the powerful dynamos, silent and tranquil in their action, seem to send forth luminous vibrations; and what trumpet calls are shot into the air by the smokestacks, these new god-herms that rise along our roads! Mechanical bridges burrow into space. Trains with their clattery uproar shatter the horizon line. They leave the earth and, in the inexorable advance of progress, glide on the ether, transporting marveling living creatures toward astral railway stations.

The deep, gentle movement of hammers softens ingots like leaden elephants.

And now behold the [Eiffel] Tower, steeple of sound waves.[2] At first its incongruous monstrosity surprised and irritated us. Now, at a thousand feet above the ground, lovers rendezvous there with the birds. And the poets, from the Douanier Rousseau[3] to Jean Cocteau, would have us believe that, on fine spring evenings, fairies ride toboggans down its wing sheaths.

What that giantess lacked was a crown of starry hair: she has been given one. Industry inscribes its luminous progress at full length along the Tower's nighttime spine.

The airplane, the elevator, the wheel, which sweep some few human beings up to the kingdom of the birds, have suddenly changed even our natural element.

The Tower remains the supreme symbol of modern times. Leaving behind New York and its smoke-crowned palaces, it was the Eiffel

Tower, beacon in the high air, that Lindbergh kept in his sights so as to hit the mark of Paris, in the sentimental heart of the world.

Translated by Robert Erich Wolf

1. Marceline Desbordes-Valmore (1786–1859) was a French actress and poet.

2. A radio transmitter was located atop the Eiffel Tower.

3. See p. 17, n. 3.

ROBERT DESNOS

SPECTACLES OF THE STREET—EUGÈNE ATGET

In this belated notice of the death of Eugène Atget (1856–1927), Robert
Desnos (see p. 7) pays tribute to a photographer who had become known to the
surrealists only a few years before, when Atget's neighbor Man Ray published
several of his photographs of Paris in *La Révolution surréaliste*. Atget, who
had systematically photographed the old *quartiers* of Paris since the late 1890s,
became in the mid-1920s a model for younger photographers working in a
lyrical documentary vein. Among surrealists like Desnos, Atget was hailed as
a visionary primitive: a wanderer with a camera in a fabulous, labyrinthine
city.

Original publication: Robert Desnos, "Spectacles de la rue. Eugène Atget,"
Le Soir (Paris), September 11, 1928.

There is a modern Olympus where, in the midst of scientific instru-
ments, certain modern sorcerers sit gravely—Niepce, for example, and
Daguerre, Nadar, Ader, Sauvage, and others, whom Jules Verne, Santos-
Dumont, Voisin, and the two Lumières will join.[1] However, it is not
there that I see Eugène Atget, in the relative immortality of the ency-
clopedias. Eugène Atget died at the beginning of the year. I know
little of his life, except that after being an actor, he came when past
forty to live in Rue Campagne-Première, in a curious studio where I
had the chance of meeting him but once. He was an old man with the
face of a tired actor. He worked in the midst of a fabulous quantity of
documents, plates, proofs, albums, books. But what documents! For
thirty years, Atget has photographed all of Paris with the marvelous
objective of creating a dream and a surprise. These are not the albums
of an artist left to the libraries, but the visions of a poet, bequeathed to
poets. Without ever sacrificing to the picturesque or to the merely
anecdotal, Eugène Atget has focused life. His work is composed of
many series comprising tens of thousands of photographs: bourgeois
homes, homes of workingmen, homes of luxury including that of Mlle.
Sorel,[2] the booths of street fairs, grocery store windows, barbershops,
stairs, stocks of street merchants, etc. He has seen all with an eye
which well deserves the terms sensitive and modern. His mind was of

the same race as that of Rousseau, the customs agent,[3] and his view-point of the world, determined by an apparently mechanical medium, is also the vision of his soul.

I should like to see an edition of *Fantomâs*[4] brought out (and some-day someone must decide to publish again this epic of contemporary life), and it should be illustrated by Atget's photographs. It behooves one merely to know that since the time of Nadar, and with still more importance, it is the work which has most revolutionized photography.

Atget is now no more. His ghost, I was going to say "negative," must haunt the innumerable poetic places of the capital, and upon opening his photograph albums now in the possession of Berenice Abbott,[5] herself a great photographer, I continually expected to see him arise. But Atget has never made a photograph of himself, a dis-tinction reserved for Berenice Abbott.

The city dies. Its ashes are scattered. But the dream capital, created by Atget, raises its unconquerable ramparts under a gelatine sky. The maze of streets pursues its course like a river. And the crossroads serve always for pathetic rendezvous.

Translated by Berenice Abbott

1. Joseph Nicéphore Niepce (1765–1833) was an early French experimenter in photography. Clément Ader (1841–1926) was a French engineer and inventor; Al-berto Santos-Dumont (1873–1932) and Gabriel Voisin (1880–1973) were pioneers of aviation. Auguste Lumière (1862–1954) and his brother Louis Lumière (1864–1948), inventors of early cinema technology, made some of the first motion pictures in the 1890s.

2. Cécile Sorel (1875–1966) was an actress long associated with the Comédie Française; photographs of her antique-filled apartment often appeared in French magazines in the period before World War I.

3. Henri Rousseau (1844–1910), a French naive painter acclaimed by the painters of the avant-garde, was called Le Douanier because of his job as a customs officer.

4. Fantomâs was the mysterious hero of a pulp book serial by Pierre Souvestre and Marcel Allain which was popular in France before World War I. His adventures, set in contemporary Paris, formed the basis for the film director Louis Feuillade's serial films of 1913–14. Both the written and the filmed exploits of Fantomâs were extrav-agantly praised by the surrealists.

5. Berenice Abbott (b. 1898), an American, worked as Man Ray's assistant in Paris before establishing herself there as a portrait photographer. It was thanks to her efforts that a large collection of Atget's prints and negatives came to the U.S. in 1929.

ALBERT VALENTIN

EUGÈNE ATGET

Albert Valentin (1908–68) was a Belgian novelist active in the French surrealist movement between 1928 and 1931. He was expelled from the group in December 1931 for working as assistant director on a film which the surrealists judged "counterrevolutionary": René Clair's *À nous la liberté*.

The following essay appeared in *Variétés*, a review published in Brussels and edited by P.-G. van Hecke, which was responsible for popularizing surrealist ideas and for introducing its readers to images by the best modern photographers. (Photomontages by Valentin were published in *Variétés* in 1928–29.) Valentin's consideration of Atget reveals a debt to André Breton and Louis Aragon in its oblique, seemingly impromptu observations—the author artfully contrives to stumble onto his real subject as if by accident, after a good deal of preliminary speculation on subjects that were then under discussion in surrealist circles. Valentin celebrates the lyrical vision of the contemporary world that he finds in Atget's work, and its recognition of a modernity emerging in everyday life. This is an Atget who reinvented Paris as a "cerebral landscape" partaking equally of fact and dream, and with his photographic images teaches the viewer to see the mysteries of the present in a more penetrating way.

Original publication: Albert Valentin, "Eugène Atget (1856–1927)," *Variétés* (Brussels, December 1928), pp. 403–7.

> And I have seen at times what men have thought they saw.
> **RIMBAUD**

It is not entirely impossible that the general in question really did cry: "And now forward, men, into the Hundred Years War!" For my part, I don't count myself among the scoffers. Because it is in just that sort of grandiloquent pronouncement, which is in equal parts facetiousness, prophetic quality, and surrender to fatality, that it is given to certain men to perceive the least definable elements: I mean the air they breathe, the climate in which they move, the instant of time in which their life runs its course, and the trajectory it assumes. An age is

valued first by the part of it that originates from temporary things; it is most unfortunate if it does not have some distinct characteristics of its own that are best assimilated as early as possible. All the rest—its points of contact with the time that preceded it, its subjection to the general rule—can be learned without lengthy investigation; and compulsory schooling exists, which simplifies matters. It is not just today that the divorce between the two currents arising out of that distinction has become noticeable, but it is only today that it has picked up such speed; and this may be perhaps because of the introduction, into one camp and the other, of imposters and popularizers. Among whom, to argue from extreme examples, one really has to count Paul Valéry[1] and Jean Cocteau. For the former the whole affair comes down to invoking tradition, and for the latter to persuading us it is he who has the immediate advantage. Still, they are the finest cronies in the world, but not the sort to turn to for counsel. As for the others, those who perhaps unwittingly establish a harmony between their personal inspiration and momentary realities, there is a temptation to claim that they reveal nothing, and that instead the universe conforms to the description they give of it—that the model little by little takes on the colors of the portrait. But this hardly matters, and we won't entangle ourselves in that kind of prejudgment: however you may approach them, the poet and the painter always turn out to have right on their side and to take the credit for it. As for the contemporary authors who delight me through their familiarity with all those particular modes and manners of the age I live in, I am willing for them to be mistaken about the origin, the nature, and the meaning of the phenomena their works inform me of, but I'm not worried if, when I consider them on my own, those phenomena appear to me in the light of some particular phrase. Now supposing that those authors are deceiving neither themselves nor me, that they are "getting warmer," as children say playing hide and seek, I will grant that their interpretation holds only in a narrow ambit, that the translation they offer me of current happenings covers only a tiny part of those events, and that an immense field is left for other views. I am even willing for them to be aided, in their discovery of the modern and in its transposition into sentiments and feelings, by the fictions of a few forerunners: Rimbaud, Lautréamont, Gérard de Nerval,[2] to cite only those to whom the most astonishing forms of present-day lyricism are indebted.

But if it is a matter of merit to make oneself the defender and

illustrator of the few immediate and perishable truths one discerns, there is no less merit in recognizing that they were already expressed by a number of precursors. It may be that the fate of those writers we named was to be "accursed," and that, by submission to the aim they espoused, they condemned themselves to holding popular approval in contempt, and to winning their due audience and reward only from an uncertain posterity. Of all the ways of making a necessary sacrifice, the one they chose was the only one worth anything, and circumstances have borne this out. Still, the means to which they resorted in order to communicate with us—the words, the appeal to the imaginary, the intervention of the arbitrary—were, however freely they treated them, no less time-tested and inherited. With painting, the same could be said of the Douanier Rousseau. Conscious or unconscious, those rebels were revolutionary only in relation to a prior state of things. Now at the same time or close to it, unknown to them and ignorant of them, a man was collaborating on the same task as theirs, opening the way to that extraordinary cerebral landscape which has compelled our attention and which maintains an equilibrium between fact and dream. This was Eugène Atget, and what is paradoxical is not only that this primitive should have been a visionary gifted with such foreknowledge, but in addition that to manifest it he should have used an instrument with no past, untested by experience. We know little about this prodigious photographer except that he was once an actor of no repute in touring companies and then tried his hand at painting before dedicating himself, with a rudimentary camera in hand, to interminable perambulations throughout Paris and its outskirts. Needless to say, this métier earned him nothing but misery. We are told that Victorien Sardou[3] used to accompany him on those excursions and would respectfully point out to him the "picturesque spots." We have no reason to doubt this information, although the picturesque, in the sense generally used, is what is most lacking in the sights Atget chose to reproduce. But on closer inspection, those dead-end streets in the outlying neighborhoods, those peripheral districts that his lens recorded, constituted the natural theater for violent death, for melodrama; and they were so inseparable from such matters that French filmmakers, Louis Feuillade[4] and his disciples—at a time when studio expenses were what was skimped on—employed them as settings for their serials. Atget himself did not see that far ahead, he merely obeyed his own infallible instinct, which led him into decidedly strange places where

there appeared to be nothing of the slightest interest. The unspeaking inhabitants that he has restored to us stir us by some strange and quirky twist not due to premeditation or surprise. We experience a certain malaise in contemplating the world we discover in the ten thousand plates Atget printed, although it is every inch our own. Our footsteps resound on the tiled floor of an enormous waxworks museum, and that personage asleep on a bench, is he a visitor or one of the exhibits? Everything has an air of taking place somewhere else, somewhere beyond. Beyond that hotel room; beyond that furnished room turned topsy-turvy by love or crime or both at once; beyond that street-fair merry-go-round at a dead standstill; beyond that orthopedist's shop window; beyond the tailor's and the barber's wax models; beyond that door to a brothel crowned by an outsized street number; beyond that vendor's tray of toilet articles; beyond that inside courtyard not even the organ grinder's racket can awaken; beyond those abandoned work sites; beyond that secondhand stuff spread out on show; beyond that sloping street where a laughable whore is on the watch. Her client must be heading this way because, in the shadow, we can make out her pimp, a woman shopkeeper, and various walk-on characters of minor importance. But on Atget's photosensitive paper there are only a few miserable buildings, and at the door of one of them a street girl with no hope in her eyes. All the rest is somewhere else, beyond, I tell you; in the margin, in the filigree-work, in the mind, at the door of the least perspicacious: it is enough to look, and if you really have to find some justification for Atget, Rimbaud is there with his well-known tirade: "I used to love idiotic paintings, overdoor pictures, stage décors, carnival tumblers' backdrops, signboards, popular prints, old-fashioned literature, pornographic books with bad spelling, novels of our grand-mothers' day, fairy tales, tiny books for tiny tots, old operas, silly refrains, naive rhythms."[5] So much the worse for those who do not confess to a taste like that; so much the worse for those who turn their backs on the fantastic and perfect mirror Atget holds out to them: should they wish to smash it and to scatter its debris, they will only multiply the view which is reflected there and which will pursue, will haunt them. Better to give in to the reality he teaches us and which everywhere envelops us. On the sidewalks of Moscow one encounters strange women peddlers in the blast of the wind, in the thick of the snow: to passing women and young girl students they hold out, dangling from their arms, brassieres which no one stops to buy. I remember

that, hallucinating before this tawdry display, I regretted that Eugène Atget was not there to turn his camera on it. But Atget had been dead ten months by then; it was ten years since an insurrection had roused the Russian people; for fifty centuries the earth had been turning round and in its revolutions plunging a hemisphere of images, turn by turn, into light and into shadow, until they disappeared, until they were reborn. Happily, individuals possessed of a mental eye more penetrating than the other catch those images in flight, and transport them into a book, a drawing, a song. And now here is their group that grows larger with the latest arrivals, whom I salute, and who themselves, armed with a glass eye, need no more than a chemical-coated plate or a spool of revolving film to renew the legendary miracle—because he stops the sun who arrests and makes fast the forms it illuminates.

Translated by Robert Erich Wolf

1. Paul Valéry (1871–1945), the French symbolist poet, was also a prolific critic and essayist.

2. Arthur Rimbaud (1854–91), the Comte de Lautréamont (the pseudonym of Isidore Ducasse, 1846–70), and Gérard de Nerval (the pseudonym of Gérard Labrunie, 1808–55) were French nineteenth-century poets whom the surrealists claimed as their ancestors.

3. Victorien Sardou (1831–1908) was a successful French playwright.

4. The French film director Louis Feuillade (1876–1925), in the years before World War I, created a series of motion pictures dealing with real-life subjects which were shot on location in Paris. He also directed the *Fantomâs* series (see p. 17, n. 4).

5. The lines paraphrased are from Rimbaud's "Alchémie du verbe."

FLORENT FELS

THE FIRST

SALON INDÉPENDANT DE LA PHOTOGRAPHIE

In 1927, in the pages of his magazine *L'Art vivant*, Florent Fels (see p. 13) expressed his dissatisfaction with the retrogressive pictorial photography displayed in the annual Salon of Photography. Subsequently he and several collaborators organized one of the first important exhibitions of modern photography in Paris. This "independent salon" was held in May and June of 1928 in the stairway gallery of the Théâtre des Champs-Élysées, and has become known as the *Salon de l'Escalier*. The exhibition, described in this brief essay, included works by a varied group of young photographers including Man Ray, André Kertész, Paul Outerbridge, Berenice Abbott, and Germaine Krull, and also featured a historical section displaying the work of Atget and Nadar. The exhibition attracted wide attention and proved to be a landmark event that spurred the recognition of modern photography in France.

Original publication: Florent Fels, "Le Premier Salon Indépendant de la Photographie," *L'Art vivant* (Paris), June 1, 1928, p. 445.

A committee made up of Lucien Vogel, René Clair, Jean Prévost, Charensol,[1] and the writer of these lines has taken steps to create an Independent Salon of Photography whose first showing will take place at the Salon de l'Escalier, in premises placed at their disposal by the administration of the Comédie des Champs-Élysées.

It was decided to include in this presentation the photographers Nadar, d'Ora, Kertész, Berenice Abbott, Huene, Albin Guillot, Germaine Krull, and Man Ray,[2] and to organize on this occasion a retrospective of the works of Atget.

The arbitrary association of these few names is evidence enough of the aim that inspires the exhibition's organizers. We are much less concerned with showing the public a panorama of contemporary photography than with focusing their attention on a few works, by precursors and by others now in full possession of their craft, all of whom are responsive to a particular frame of mind. Above all we wished to avoid "artistic" photography, photography inspired by painting, engraving, or

drawing. Certain English practitioners have a mania for treating their subjects in lights and shadows, and labor to give their works the look of Rembrandt . . . or Carrière.[3] Some French commercial photographers go to great effort to make their subjects resemble so many Helleus or Brisgands.[4] Others go back to the technique of the Impressionist painters and adopt it for photography, and so we get sunsets on the banks of the Seine, sunlight through the branches of a bosky grove, all that aesthetic that finds its proper outlet in painting but has nothing to do with the strict laws of photography dedicated to two tones, white and black.

The limited space in the rooms made available to the organizers forced them to omit excellent photographers. Actually, this year's exhibition is something of a preamble, and for next year we hope to request the collaboration of masters like Gerschel, Lorelle, Hürliman, Streichel, Sheeler,[5] and others in assembling a series of "sensational reportages" of past times.

From the outset, two names struck the organizers as essential: those of Nadar and Atget.

Nadar, the friend of Baudelaire, Gautier, and Dumas (whom he resembles body and soul); Nadar whose name, transposed, became Jules Verne's Michel Ardan, an invented character who differs little from the original; Nadar the journalist, collaborator on *Charivari*, *Le Journal pour Rire*, *Le Corsaire*, founder of the *Revue comique*, author of *La Robe de Déjanire*, the *Histoire de Murger et de la vraie bohème*, and *Baudelaire le poète vierge*; Nadar who ensured postal service by balloon during the siege of Paris; Nadar who created that panorama of nineteenth-century celebrities, the *Panthéon Nadar*;[6] mind of a thousand resources and multiple ventures, fantastic and brilliant, he whose name would come in the final hour to the lips of the dying Baudelaire: "Nadar. . . Manet . . ."

Nadar had conceived photography as a universal art destined for widespread dissemination. He sought the truth of his subject less in attributes than by reproducing the particular character of each of his models. It will be seen in this exhibition how much his portraits resemble the finest close-ups in the contemporary cinema. There is a "Nadar style," which the son of the creator of the "gallery of famous men" realized in his turn in the portraits of Stéphane Mallarmé, Dierx, and Goncourt.

Atget's name is little known to the general public. There were only a few of us, writers and painters, familiar with his works and with the strange dwelling of this surprising man who sold, at a hundred sous the print, the most beautiful still lifes and the most hallucinating views of Paris. A former actor, a friend of Frédéric Lemaître, he belonged to that now vanished world which knew the Boulevard du Crime, the Quinze-Vingts, the Paris Revolution, the cheap bath houses, the Funambules, and Tortoni's.[7] While showing one the marvels in his library he would declaim the most Romantic grand speeches of the dramatic repertory, a repertory that included *La Tour de Nesle* and *Lazare le Pâtre*, *Marie-Jeanne la femme du peuple* and *Ruy Blas*. It is perhaps this Romanticism that we rediscover and love in his work, work of pure poetry through which we can glimpse the smile of the divine Gérard de Nerval, that other lover of the mysterious beauties of Paris.[8]

What Man Ray brought to photography was the ability to give a plastic feeling to inanimate things and to create dramatic portraits with faces entirely devoid of lyrical expression, using nothing but judiciously employed lighting. Moreover it was Man Ray who rehabilitated amateur photography and who, using a modest portable camera like a standard Kodak, found a way to recreate moments of intense life.

Germaine Krull is a kind of Valkyrie of photographic film. She has reporting in her blood. When she sets out to conquer the instantaneous, nothing can resist her. That is how it happened that, when in Saint-Malo recently for the blessing of the flotilla of fishing boats, in her rush to embark she almost toppled the Archbishop of Rennes into the sea. In that instant when His Eminence might have plunged into the waves, Germaine Krull would have found the time to take a sensational news photo; still, she did manage to get the most beautiful smile from the prelate in return for His Grace's escaping the peril that had almost opened beneath his feet.

Kertész is a marvelous creator of poems, and his metaphors are humble objects, the skies, trees, and roofs of Paris. Along with these will be seen remarkable portrait photographers—d'Ora, Berenice Abbott, Huene, Albin Guillot—who give us precious and living documents of elegant style and of the most beautiful faces in the world.

All of them take pains to be exact, clear, precise. All of them shun the blurring that can only be justified in the cinema. They play

no tricks with either the model or a métier which, to qualify as art, must have laws of its own.

A good photograph is, above all, a good document.

Translated by Robert Erich Wolf

1. Lucien Vogel (1886–1954) was the publisher of the magazines *Jardin des modes* and *Vu*. The French filmmaker René Clair was apparently not involved in the exhibition, according to recent research by Maria Morris Hambourg. Jean Prévost (1901–44) was a novelist and journalist. Georges Charensol (b. 1899), a critic, was an editor of *Les nouvelles littéraires*.

2. The exhibition included photographs by both Félix Nadar and his son Paul Nadar (1856–1939), who directed the Nadar portrait studio in Paris after his father. Madame d'Ora was the pseudonym of Dora Kallmuss (1881–1963), an Austrian portrait photographer who established a studio in Paris in 1925 and became well known for celebrity and society portraits. The Hungarian-born photographer André Kertész (1894–1985) was active in Paris in the 1920s and 1930s. For Berenice Abbott, see p. 17, n. 5. George Hoynigen-Heune (1900–68), a Russian-born photographer, was a leading fashion photographer in Paris during the 1920s. Laure Albin-Guillot (d. 1962) was one of the most active French portraitists and photographic illustrators of the 1920s and 1930s. For Germaine Krull, see p. 13.

3. The painter Eugène Carrière (1849–1906) was noted for his atmospheric portraits.

4. The reference is probably to Paul-César Helleu (1859–1927), a French painter and engraver whose portraits enjoyed wide popularity just after World War I, and the French painter Gustave Brisgand (d. ca. 1950), who was known in the 1920s for his expressive portraits.

5. Lucien Lorelle (1894–1968), a French photographer, from 1927 to 1934 directed the Studio Lorelle, which specialized in portrait and advertising photography. Martin Hürlimann (b. 1897), a German photographer, was the editor of *Atlantis* magazine. "Streichel" is perhaps the American photographer Edward Steichen (1889–1973). Charles Sheeler (1883–1965) was the American painter and photographer. Gerschel has not been identified.

6. The journals named were mainly satirical or political. Two of the books deal largely with bohemian life; the third is a memoir about Nadar's friend Charles Baudelaire. The *Panthéon Nadar*, which was published as a large-format lithograph in 1854, depicted in caricature leading poets, novelists, historians, and journalists of the day.

7. Boulevard du Crime: the Paris district whose theaters offered the goriest of murder plays; the Quinze-Vingts: the hospital for the blind; the Paris Revolution: the Paris Commune of 1871; the Funambules: a Paris theater specializing in acrobatic acts; Tortoni's: a chic café famous for its ices.

8. For Gérard de Nerval, see p. 22, n. 2.

PIERRE MAC ORLAN

THE LITERARY ART OF IMAGINATION
AND PHOTOGRAPHY

Novelist, journalist, poet, and essayist, Pierre Mac Orlan (1882-1970) was responsible for some of the most provocative criticism of photography written in France during the late 1920s. His fiction was often set in picturesque Parisian districts like Montmartre, and focused on marginal characters whose codes of conduct, inherited from earlier epochs, brought them into conflict with the modern world. Mac Orlan found in photography a perfect vehicle for exploring what he called the "social fantastic"—that realm created when deeply rooted ways of life were jarringly displaced by an emerging machine civilization.

In this essay Mac Orlan surveys contemporary photography and divides it into two currents, artistic and documentary. He proposes, however, that documentary photographs are themselves unconsciously artistic, although in a way that pertains more to literary than to visual art. By virtue of their capacity to freeze moments of time, emphasize subtle details overlooked by the eye, and thereby force us to respond to objects and events in unaccustomed ways, photographs work to retore an essential mystery to our understanding of the world.

Original publication: Pierre Mac Orlan, "L'Art littéraire d'imagination et la photographie," *Les nouvelles littéraires* (Paris), September 22, 1928.

Now that we have begun to realize that a photographic image is no more true than the interpretation of the same sight in a drawing or a painting, we become even more sure about the evidence, which is among the most moving of our time. It is difficult to obtain from a painting or a drawing a degree of emotion capable of dominating us in the way that writing and composing can, if the writer is not devoid of sensitivity. Painting is sufficient unto itself, and so is drawing, for reasons that escape critics. These two arts don't go well with literature, particularly drawing, which, in the form of illustrations, collaborates very closely in the fabrication of books. The true illustrators are writers. They think, they compose; only the means of expression change. They are also subjected to the emotional forces that permitted the

writer to compose his book, and it is extremely rarely that they them-
selves are creators of literary energy. Creative energy in literature feeds
on powerful but incomplete causes—we should not generalize—in
the case of many writers. It is precisely the incomplete side of these
inspiring forces that can seduce a man whose thoughts are always
seeking to cross any and all boundaries. The literature of imagination
begins beyond all frontiers, whether they surround a human figure, an
ocean horizon, a feeling, a prejudice, or any act precisely defined by
law. An illustrator and an imaginative writer think and are stimulated
in the same way. They can seek their inspiration in the same scraps
or in the same cerebral and plastic riches. A painter is a painter just
as a rose smells like a rose. It is a phenomenon of nature without any
chemistry of the library or of the cerebral laboratory. Painters, writers,
and illustrators thus live on good terms with one another, but without
lending one another anything.

Yet it is enough to look at any daguerreotype to experience the
creative force of which literature is an incomparable conductor. Pho-
tography is at the very birth of its glory. Do we decipher better or with
less prejudice the things that we can use? Possibly. Phonograph, pho-
tograph, all the graphs, after being thrown far from delicate, sensitive
existences, are reinstated in the lives of those who marvel at seeing
and hearing. They take a unique revenge in restoring to the things
whose limits they mechanically reproduce the presence of that univer-
sal mystery of which everything possesses a part that confers on it both
its personality and its interest in the world. The photographic art, at
the point where it is now, can be divided into two classes that are more
or less the poles of all human artistic creation. There is plastic photog-
raphy and documentary photography. This second category is literary
without knowing it, because it is no more than a document of contem-
porary life captured at the right moment by an author capable of grasp-
ing that moment. The artist sometimes has to search for six hours to
find the unique second when life, in some way, is "caught in the act."

That reminds me of an evening I spent in London in the Chinese
quarter, Pennyfields. A thick fog conferred a dignity and a horror
worthy of a wax museum on the drunken girls in front of the doors of
their brick houses. My presence, at five in the afternoon, in that wide,
short street, seemed to have immobilized life. The sight of those wax
figures lost in the fog could cause certain ideas to be born. I hurried to
take several snapshots, rapidly, haphazardly. Then I had them devel-

oped. They were bad and they gave me marvelous prints. In one of them, in the foreground, there was a door with a broken window. In the place of one of the windowpanes someone had put up a placard in Chinese characters. The street was shown in its entirety. You could see all the front doors on the right side of the street. And in the frame of each door appeared a woman's skirt . . . only a skirt, because all the wax girls had drawn back when they saw me with my camera. In the foreground there were a very pretty leg and the bottom of a dress, along with the Chinese poster. The mystery began with that leg. The photograph had fixed an essential detail there, whose importance in that moment I can't even explain, and that the direct sight of that street where I was strolling couldn't reveal to me.

For those who look for the often subtle details of modern society, photography is an incomparable revelation. People like Man Ray, Kertész, Berenice Abbott, and others, in their portraits, give a totally new meaning to the interpretation of the lens. At this moment, photography is the most accomplished art, capable of realizing the fantastic and all that is curiously inhuman in the atmosphere that surrounds us, and even in man's very personality. Man Ray searches for the abstract lines of a fantastic plasticity such as one finds in the paintings of De Chirico, for example. In Kertész's works, the fantastic restlessness of the street, most in keeping with the tastes of central Europe, interprets the secret elements of shadow and light, deriving a romantic flavor from them. If our age leaves on the literary history of our time the very clear impression of a new school dedicated to European Romanticism and social fantasy, and produces lasting works, we will have to add to the names of writers the names of draftsman-writers like George Grosz and Masereel,[1] and those of photographer-poets like Man Ray and Kertész, the newcomer.

In the most beautiful compositions by these artists one finds traces of the sentimental activity of speed, light, and woman, which are the three most appropriate elements to express our anxiety over the end of Europe, and perhaps of the world. The taste for catastrophic hypotheses is one of the most characteristic parts of the passive element of humanity (as opposed to active forces, whose mode of expression it is difficult to foresee). There are terrifying photographs that show humanity, after several centuries of readings, inventions, and sacred patter, just as it is. We must see humanity in photojournalism, i.e., in the head of a Chinese decapitated by the blow of a calm, obese execution-

er's saber; in the portrait of a young woman in a short skirt and silk stockings sitting in the electric chair; in the corpses of Russians, Romanians, Bulgarians, etc., etc. . . . ; in the bodies that are excoriated, cut up, and tortured according to the human laws of 1928. We must contemplate these documents of social activity of our time and stretch our thoughts to their extreme limits, so that we can search the thousand faces that make up a crowd, captured by a lens, for the traces of our own end, that is, our own anguish.

1. George Grosz (1893–1959), the German painter and graphic artist, produced work in the years after World War I savagely caricaturing German society. Franz Masereel (1889–1972), a Belgian artist living in France, was known during the 1920s for his expressionist-style woodcuts and drawings on big-city themes.

PIERRE MAC ORLAN

ELEMENTS OF A SOCIAL FANTASTIC

In this essay Mac Orlan expands his notion of the social fantastic, pondering the photograph's ability to condense into an evocative image the atmosphere of a moment or an epoch. In a fantastic age age such as the present, he suggests, the photographer's goal is to be a "perfectly organized witness." Particularly interesting are Mac Orlan's ideas about the correspondence between photography and death, a theme that has figured in speculation about the medium from its earliest days. The essay was illustrated with two images of murder scenes: Daumier's lithograph *La Rue Transnonain*, and an anonymous police photo of a blood-soaked bedroom.

Original publication: Pierre Mac Orlan, "Éléments de fantastique social," *Le Crapouillet* (Paris), March 1929.

The mystery that emanates from certain sights, certain people, and certain objects does not spring just from the power of revelation that a human brain can possess, however skillful an artist or writer may be in making use of that force.

One feels entirely incapable of deciphering the actual causes of such an imprecise state of mind as anxiety.[1] Anxiety is not so much a disposition of the temper of some individuals as an almost always indefinable embellishment of the atmosphere and of the picturesque elements that act on us as on a barometer. Anxiety was born with the presence of the first man on earth. People have always sought to give it a meaning that conforms to the preoccupations of their time. It hovers like a low-lying cloud around a few words that seem to foretell both public and personal calamities. Those words possess a strange force, and have no need of a new qualifying adjective to rejuvenate their power of creation. Words like war, blood, plague, gold, are richer words than any motion picture we have been able to see. They unreel all on their own in endless strips whose secret images are more powerful than any words one can add to those essential words. The word "blood," for example, belongs to literature. Strictly speaking the images it gives rise to can just as well belong to the art of literature, but

however skillful the writer may be in seizing and utilizing the plastic interpretations it calls forth, the anxiety that the word blood arouses, when one subjects it to the productive analysis of the art whose traditions continue to dominate us, remains decidedly difficult to define under the triple aspect of sight, smell, and touch.

It is true that on certain faces death sometimes reveals an expression unknown to those daily acquainted with those faces. What is utterly mysterious for man is, unarguably, death. To be able to create the death of things and creatures, if only for a second, is a force of revelation which, without explanation (which is useless), fixes the essential character of what must constitute a fine anxiety, one rich in forms, fragrances, repugnances, and, naturally, the association of ideas. It is thanks to this incomparable power to create death for a second that photography will become a great art, one not comparable with the plastic arts, yet one which allies itself with singular power with everything that goes to make up the cerebral aspect of things—the only aspect that counts, because it is what commands our sympathy or our antipathy.

If, to illustrate these few reflections on a subject dear to me, the social fantastic of our time, I choose an anonymous photograph, it is in order to leave its emotive value intact, without appending the afterthought of an anecdote already utilized by literature. Here we have a hotel room, in a hotel whose four dimensions would please Francis Carco.[2] The actors in the drama are no longer here. What remains is only the blood, and the variations it inspires in our thoughts, from moral and physical revulsion to the detailed invention of appalling acts—ending up in this simple image, all but indescribable but heavy with fear, heavy with greasy, steamy smells, and, if one takes the trouble to think about it, heavy with anxiety.

What we have here is not some artist's interpretation of a fact, nor an image that offers the equivalent of reality. It is simply reality, as revealed by the provisional death of that same force that gave life to this scene of carnage. That death, that same momentary immobility, reveals and makes it possible to isolate the disquieting element that gives this unspeakable and vulgar image an emotional power—a power which acts on the imagination much more profoundly, and much more clearly, than the real sight of the room without the camera eye as intermediary.

This power of revelation inherent in photography is just now be-

ginning to be utilized. The camera eye aims for a close association with the personality of a human mind. Photography is an art of instinct. The decisive act can scarcely be expected to submit to laws of composition and rhythm comparable to those governing most of the plastic arts.

It is easy to estimate how important the photographer's art will become for the analysis of an epoch which lets itself rely on the extraordinary sensitivity of its first-hand witnesses. We will all one day go whistle for the funereal ferryman who waits at the inevitable quays of the River Styx. True, but our baggage will be terribly more cumbersome than that of the voyagers who preceded us. Ours is laden with eyewitness reports and with the instruments to obtain them. To be a perfectly organized eyewitness is the ideal of most people in these times.

The discoveries of humanity that touch most on our everyday existence tend to facilitate that task. The phonograph is an apparatus that bears witness, and the photographic lens likewise. The latter has only recently penetrated the fantastic domain of shadow. Light, for it, is no more than a means to explore shadow, to reveal its cerebral appearances, its dangers, the specters that people it and that are the residues and poisons given off by our intellectual combustion.

Already a few men and a few women one could call visionaries of the lens[3] have penetrated the still unknown reaches of what must be described as a social fantastic. It is with those creators that I wish to concern myself in this almost sentimental column,[4] now entrusted to me.

Translated by Robert Erich Wolf

1. The French word *inquiétude* has been rendered throughout as "anxiety."

2. Francis Carco (1886–1958), a French writer and bohemian figure, was the author of novels set in Pigalle and Montmartre.

3. The French *visionnaires de l'objectif* skillfully plays off the double meaning of *objectif*, which can be rendered either as "lens" or as "objective."

4. Apparently a series of essays was envisioned, but never carried out.

SALVADOR DALI

PHOTOGRAPHIC TESTIMONY

Much of the photographic work associated with surrealism in the 1920s and 1930s attempted to suggest a dream logic through the use of experimental techniques like solarization, multiple exposure, or photomontage. But surrealists like André Breton and Salvador Dali saw even the seemingly prosaic photographic document as a potential surrealist object. Convinced of the fundamental instability of reality itself, they sought to demonstrate that the unexpected details captured in a straightforward photograph could trigger a kind of psychic shock in the viewer that would ultimately lead to the discovery of new relations between imagination and reality.

In this text, written in the year Dali (1904–89) moved from his native Spain to Paris and became active in the surrealist movement, one can already find evidence of his soon-to-be-proclaimed intention "to systematize confusion and thus help discredit absolutely the world of reality." Dali proposes that virtually any photographic image be considered an aesthetic object, since "the mere fact of transposing something seen to a photograph already implies a total invention." His implication that the medium itself harbors an inherent power to estrange parallels ideas advanced during the same period in Germany by László Moholy-Nagy.

Original publication: Salvador Dali, "Le Témoignage photographique," *La Gaceta literaria* (Barcelona), no. 6 (February 1929), pp. 40–42.

We shall never tire of repeating the lamentable consequences brought on by the intervention, in one way or another, of the artist who draws. He automatically destroys everything that comes under his hand, be it illustration, poster, documentary, etc.

When will we give up on the inadequate, nonexistent draftsman and replace him with the living emotion of photographic testimony?

This is not the moment to sing again the praises of photography which we have repeated endlessly and with fervor; only to call for its use in all the sectors where very bad drawings still persist.

The use of photographic evidence is in any case being extended every day to new disciplines, and its very new and powerful possibilities touch on the most diverse activities, hitherto verifiable only with an approximation we could almost describe as emotional.

In everything from strictly scientific works—natural history, geography, etc.—to novels (as recently in André Breton's *Nadja*), photographic testimony has taken a part in the same way as it has in publicity or the pure poem.

Photography can put together the most complete, scrupulous, and emotionally stirring catalogue mankind has ever been able to imagine. From the subtlety of aquariums to the swiftest and most fleeting motions of wild beasts, photography offers us a thousand fragmentary images that come together in a dramatized cognitive whole. A capital in a cathedral, situated thirty feet up in perpetual obscurity, is revealed to us by photography with all the fineness of detail that only skillful *photogénie*[1] at last permits us to know. Beyond the implacable rigor to which photographic testimony subjects our mind, its evidence is always and ESSENTIALLY THE SUREST VEHICLE OF POETRY, and the most agile process by which to perceive the most delicate osmoses that take place between reality and surreality.

The mere fact of transposing something seen to a photograph already implies a total invention: the recording of an UNPRECEDENTED REALITY. Nothing has proved the rightness of surrealism more than photography. Uncommon powers of surprise, those of the Zeiss lens!

We have repeated many a time that photography can replace and preserve much longer, and with more real effect than direct vision, a large number of the archaeological objects menaced by a precarious survival, or which are the occasion of serious conflicts with our comfort and the development of our cities. We think that archaeological sites would profit from being judged as they were originally, and not corroded by time, lamentable and cadaverous, with all the symptoms of putrefaction on which sentimental snobbism bestows its unreserved enthusiasm. We think that humanity would have much more reason to rejoice if it had a collection of photos and a complete film of the Parthenon just after its completion, rather than possessing only the heritage of its miserable remains. (We know that for artists it's the remains that they appreciate most.)

Between ourselves, I should like to call to your attention the efforts of Joan Subias, the historian of Catalan art, who adds to his great erudition the primordial conditions of mind (generally so rare among

those who devote themselves to archaeological research) which permit him to contemplate a work by Max Ernst as well as a Romanesque sculpture. Joan Subias has obtained, for example, the head of the Christ of Vilabertran, which is tantamount to inventing it whole cloth. That photo, the end product of a long process of thought and experimentation, acquaints us with the first authentic detail of the Cross of Vilabertran, a work as invisible[2] as it is renowned.

In reality the head is 2½ inches high and 2¼ inches wide, and it is entirely impossible, because natural lighting is always unreliable, to appreciate it in even approximately the way it is now revealed to us by photographic testimony—testimony that is cold, anti-artistic, and therefore underrated.

Translated by Robert Erich Wolf

1. The term *photogénie* was widely employed in discussions about French film during the 1920s, particularly by René Clair, Jean Epstein, and Louis Delluc. *Photogénie* signified the mysterious transformation that occurs when everyday objects are revealed, as if anew, in a photograph or on the motion picture screen.

2. "Inexistent" is the word employed, but its meaning here is "invisible."

CARLO RIM

ON THE SNAPSHOT

In this witty little essay, the caricaturist, novelist, and editor Carlo Rim (the pseudonym of Jean Marius Richard, b. 1905) attempts to fathom the peculiar fascination of contemplating a photograph, and to assess photography's place in the increasingly visual culture of the twentieth century. Rim describes the powerful transformation that photography has wrought in our relation to time and to the past. The modern era, he contends, truly began with the appearance of photography.

Original publication: Carlo Rim, "De l'instantané," *L'Art vivant*, no. 137 (September 1, 1930).

A lady, sporting a bird's nest on her chignon and a small cushion on her posterior, lifts up her heavy skirt to cross a totally deserted Place de la Concorde. A gentleman with a gendarme's moustache follows her with light and airy footstep. He wears a coachman's stiff hat, a stiff white celluloid collar, a vast topcoat with narrow lapels set quite high, and the long, pointy, flexible half-boots of Little Tich...[1] This old snapshot dates from twenty-five years ago. That is quite an age for a photograph. What has become of the gentleman and the lady? Did the gentleman accost the lady? Did the lady not rebuff the gentleman? Did they fall in love? Did they have children? I would pay a handsome price for a snapshot of the couple, now in their fifties, whose first meeting was once caught by a random street photographer. I hear what you are murmuring. No, I am no more of a busybody than anyone else. Don't get the idea that the private affairs of your contemporaries are any special concern of mine, nor that I enjoy gossiping about other people's doings. What I should like, however, is to be able to extend my friendship or my love to people I do not know, will never know, do not wish to know. Their name, age, tastes don't matter to me. Try to understand me. For me, they cannot just be human creatures like others.

There is the photograph between us.

If some day on a deserted shore, among the wreckage cast up there, or perhaps at the bottom of an old chest, someone were to find a roll of film preserved by miracle from the damage of water and time, a roll with twelve snapshots taken down the course of the ages and at particular moments, then a legend at one and the same time more precise and more fantastic would take the place of another legend, and the realm of love and dream would not only be preserved safe and sound but would once more become the lion's share. Should that day come, the bronze doors of the bone-chilling Pantheons and the museums would be shut for good and all, and the Caesar on Place Vendôme,[2] restored to his fellowmen, would slide down the length of his greased amusement park pole and take his place among us once again.

The advent of modern times dates from the moment the first daguerreotype appeared on the scene. The camera lens, capturing the appearances of fleeting instants, has marked out the past with a succession of presents. The day photography was born humanity won a precious victory over time, its most redoubtable enemy. To be able to perpetuate for even a relative eternity humankind's most ephemeral aspects, was this not a way of stopping time, a little at least, in its dread course? The first snapshot made that victory decisive. In the posed photograph time still held its own, because its benevolent collaboration was asked for. But the snapshot flies in the face of time, violates it.

Photography has given a material guise and body to time, which otherwise eludes our human grasp. It has given them to time the better to take them back again. And so it has destroyed the confused and eminently literary notion we have of the past. Thanks to the photograph, yesterday is no more than an endless today. And like the cable that ties a balloon down to earth, our sensitive and precise photographic apparatus lets us survey the most difficult terrain, creating a kind of vertigo very much its own.

Our culture has become visual. Which means that photography (in its two forms: static and dynamic) arrived at the right moment, in a world neither too old nor too young to understand and cherish it. Our five

senses, which took off all together from the starting line at a pistol shot, soon went their separate ways. Touch, a hefty lout of a jockey, has already shown his bum to the field; smell rears back at the hurdles; taste slows down to browse the field and saunters through a leisurely race; hearing, after an admirable takeoff, runs out of wind, staggers, and loses ground. While sight itself, fresh as a daisy's eye, makes it to the winning post "in an armchair," as racing fans say.

Photography alone, at once objective and typical, will express for the tender-hearted mechanics we are the neo-romanticism of our day, the saraband of ciphers made flesh in zero's own moonlight.

There is the posed photo and the snapshot, just as there is sculpture and the footrace. The snapshot has invaded that ultimate refuge of the pose: the family album. Twenty million Kodaks have clicked this summer on all the beaches of the world. The family albums from now on will be peopled by silly grimaces and human hams. The plaster-of-Paris rock, the green park monochrome backdrop, the cable release, and Gerschel's black cloth are all being relegated to the museum.

The snapshot is something complete in itself.
 A film is a succession of snapshots more or less *posed*, and it only very rarely gives us the illusion of the unexpected and rare. Ninety films out of a hundred are merely interminable poses. One doesn't premeditate a photograph like a murder or a work of art.

Photography is rather like those huge American department stores where you find everything you want: old master paintings, locomotives, playing cards, tempests, gardens, opera glasses, pretty girls. But steer clear at all costs of the floorwalkers. They are terrible chatterbox bores who have no idea what they are saying.

A photographer for the *Daily Mirror* said to me: "The most beautiful photos I've ever taken were on a day I had forgotten my film."
 That photographer is a poet perhaps, but quite certainly an imbecile.

The photographer's personality?

Obviously each of them blows his nose in his own fashion.

But the most successful photographs are not those that required the most trouble.

That would be just too easy.

Translated by Robert Erich Wolf

1. Little Tich was a popular English clown.

2. The "Caesar" is the statue of Napoleon atop the Vendôme column in Paris.

PIERRE MAC ORLAN

PREFACE to *ATGET PHOTOGRAPHE DE PARIS*

Following Eugène Atget's death in 1927, the bulk of his remaining photographs and negatives were acquired by Berenice Abbott, then a well-known portrait photographer in Paris. When she permanently returned to New York in 1929 Abbott brought with her this Atget collection, and in the following years she worked tirelessly to introduce Atget's photographs to an American audience. Prints from Abbott's collection of photographs made by Atget during four decades formed the basis of *Atget photographe de Paris*, the first monograph devoted to the photographer. It was brought out in 1930 in American, French, and German editions, and won wide attention for Atget's lyrical photographs of Paris.

This essay by Pierre Mac Orlan (see p. 27) introduced the volume. In it Mac Orlan recapitulates a number of his previously published ideas regarding photography's relation to the "social fantastic" of the modern world. His portrait of Atget as the lyric poet of the humble Parisian *quartiers* has little to do with the earlier surrealist understanding of Atget as an unconscious "primitive." Instead Mac Orlan presents Atget as a knowledgeable, self-effacing man of the people, a hard-working tradesman similar to those he photographed, an "artisan poet of the crossroads of Paris."

Original publication: Pierre Mac Orlan, Preface, in *Atget photographe de Paris* (New York: E. Weyhe, 1930).

The world has been subject, since the European war, to the great joys and the no less considerable disappointments of curiosity. That desire for knowledge is able to utilize the new elements that man brings into play, which are merely plastic ways to attain curiosity's ends. A few years back, books achieved that result. But today our imagination, after nourishing itself on texts for centuries, is borrowing the principal elements of its creations from images instead.

The image, as popularized by photography and the cinema, is a great provider of sentimental knowledge. It presents itself with guarantees, often specious, of being an independent witness. It brings to life, in the fruitful solitude of a studio, imaginary sights born out of a common truth which appears to each of us without intermediary, that

is, without being distorted by talented interpreters. Photography is by its nature relative, but such as it is it strikes us as utterly unenhanced, utterly pure, like a truth that can serve as point of departure for our own interpretations of nature and of social life.

The art of photography is a literary art. More exactly, the camera, particularly when it renders life without motion, is one of those new mechanisms which, if not providing a renewal of human feeling, can at least let us know what is happening around us. A camera lens and the turntable of a talking machine are the two greatest intermediaries between life and all the lyrical or simply literary interpretations that can be extracted from it. The importance of the phonograph and the camera is already recognized by everyone who, because of his interests or profession, is obliged to experience the often bitter fruits of his curiosity. Those instruments are the secret elements of the laboratories where the lyricism of our universe can be captured like a luminous force, for the benefit of the little private light bulbs that illuminate the life of each of us.

To know? Everyone—and even the most insensitive people have a place in the world—strives toward that goal, at once both fragile and unyielding. To know what? It's difficult to say. It may be that, in the approximate knowledge of what he can perceive, a man seeks knowledge of his own personality.

One of the most picturesque forms of knowledge assumes the name "adventure" when it seeks to take into consideration all the appearances of anxiety that are adventure's guardians.

Adventure, which leads humanity toward its nearly unforeseeable end, reveals itself to us only in immobility.

And so a photographic view of certain details of the world shows at once the presence of adventure in a landscape which had kept it carefully concealed from human eyes. The photograph of a street, of a crossroads, a highway, or a riverbank—these are so many outward semblances full of secrets that the observer is free to interpret in his own way. Color, which throws into confusion all speculations about the mystery, does not intervene to divert attention toward the painting. Painting intermingles with life itself. A painted landscape, however, owing to the presence of a human interpretation, reveals nothing that can withstand the proof of a photograph. [1]

Adventure writes itself in black and white. Black and white are purely cerebral colors. They are good conductors of all the secret forces that govern the universe for the sole and definitive benefit of lyrical invention, which alone bears within itself its own explanation: an explanation based on the seductive mysteries of the five senses.

Mysteries! Daily that word recharges batteries of which some are already out of fashion. In principle there is no more mystery than there is adventure. Each of us carries inside a certain capacity for mysterious creations which rapidly open paths toward a goal that is never reached. Still, it is the hope of attaining that goal that we call adventure. All literature, even that which glories in being drab and sterile, draws the power of its action from that word. It is enough to get hold of the equipment which can enable one to make the point. The photographic lens is a priceless tool for the motionless adventures which alone are the masters of action. Through the lens nature vastly enriches the thoughts of those who study her, but *only* through the lens. Under natural sunlight, nature shows herself without mystery. Black and white, colors of night and principles of the photographic image, illuminate it with a fire as inhuman as it is intelligent. A photographic knowledge of the world is cruel.

This is because the power of photography consists in creating sudden death, and in lending to objects and beings the traditional mystery that gives death its romantic force.

The camera's click suspends life in an act that the developed film reveals as the very essence. A photograph of a street almost always discloses some detail which will lend that street a literary character.

The photographic vision adroitly associates itself with the secret mores of things. It exaggerates their tragic and fantastic aspect, making relatively easy all the sentimental investigations in the domain of shadow.

A face fixed forever by the camera lens can be judged to its depths. It lets itself be seen. It is the most powerful document one can possibly encounter at the start of a book.

Certain effects of photographs representing human faces go beyond all the professional frontiers of the imagination. A man's thought and the strength of observation that gives rise to that thought cannot themselves penetrate more deeply into something seen. A lens's inexorable

gaze lifts away all the veils that are no more than the result of a few social conventions whose very existence renders our human eyes insensitive.

Photography, to my mind, is the expressionist art of our time. I am not speaking of the photography which is associated with drawing in montage compositions of striking effect.

Whether involved in advertising, which is an art just being born, or appearing in the margins of sometimes hermetic literary works, photography contributes a distinctly contemporary element which perfectly reproduces the intellectual spectacle of an age dominated by speed. For that reason, just as what reveals light is shadow, what reveals movement is stillness.

Machinery, which it seems to me constitutes the picturesque aspect of movement, is essentially photogenic. On the photosensitive plate polished steel finds a still sleeker interpretation of its shining richness. That anecdote in which the machine plays the principal role is beginning to become common. Like all stories worth being spread about, it loses the force that quickened it at the start, and becomes a commonplace that has not yet faded into oblivion.

It should not be forgotten that the machine, however powerful its forms and its purpose, is merely a very minor detail in the hands of man, who remains, forever, master of mystery.

Since the time of Nadar, Atget, and a few others who already around 1900 had managed to interest artists and writers in what they were doing, others have learned to obey, if not the whims, at least the exigencies (purely professional, in any case) of the precious lens that captures whatever we wish.

Those who were won over by the camera and had already studied nature as painters could not help trying this method to carry out investigations entirely free of both storytelling and social documentation. Those experiments are in certain respects related to painting. Essentially, they impose a human personality which almost always diverts them from their initial significance, toward partial studies of volumes and of the relations between shadow and light. Cézanne's influence can be sensed in certain photographs which are of unquestioned value for those interested in the reactions imposed by laboratories of poetic physics.

We know the experiments of Man Ray, Kertész, Berenice Abbott, Tabard, Germaine Krull, and Moholy-Nagy; and others whose names I forget have sometimes worked in that manner.

Yet the photographic art is an art of submission. *Life* prescribes its projects, and sometimes its hypotheses as well. The lens takes its own revenge by revealing, by uncovering, what even the most skillful and sensitive observer does not always see, precisely because of his own two eyes.

Therefore I think that imposing commercial considerations on artists has permitted them to reach the very summit of an art which is new only because of the ceaseless change in the scenery of our lives.

Those changes in setting, which have been extraordinarily rapid since 1900, to choose one date, result in a kind of highly contagious romantic perversity whose symptoms have ended up amounting to a cause: the social fantastic.

Every age is familiar with its own social fantastic. The study of shadow is enriched by all the refuse of the day. The social fantastic inhabits the nighttime of our cities. It is wonderstruck by relative degrees of light, and to old religious principles it gives a popular character whose seductions are innumerable and legendary.

Paris, like all the world's cities from the greatest to the smallest, possesses a socially fantastic character all its own that gives it a more intimate meaning. There is the great international fraternity of historic monuments. They may help give an official personality to the big cities, but they leave no mark on a city's thousands of faces. Cities' personalities do not differ because of their official architecture, but by that indefinable appearance of the ordinary streets which are really the small songs of a very delicate patriotism.

One can't hope to catch the strains of that familiar song by looking at a great city's celebrated monuments. One must know what it is like to live there, close to the very nature of the street, which is nothing but an assemblage of shops, dwellings, cafés, bars, big stores peopled with human creatures of various expressions. It is not the grand international hotels, the ministries and banks, the churches and temples that give a city its personality, but on the contrary one's intelligent recollections of those popular quarters where bars loom into view out of the fog, which artlessly present a string of sights whose origins defy

counting and which may end up out in Frascati's *guinguettes*[2] and in the corrugated iron lean-tos in the outskirts where ragpickers live, passing by all the dance halls around the Bastille, the Temple, and the rue des Gravilliers.

Paris, if you really want to understand it, is still the Paris of François Villon. It is also the Paris of Atget.

There are numerous albums of art photographs of Paris. They make no distinction between an avenue in Paris and a sunset over the Adriatic. It is difficult to form an impression of this deeply moving city by contemplating attractions like the church of the Madeleine, the Bourse, the Gare de l'Est and the Trocadéro. Still, I had better explain that that remark is not meant to be deprecating. All those monuments possess indisputable sentimental value: to understand them you need only know how to find the cliché that defines them. Around the Madeleine there is a flower market. A few years back, a one-legged prostitute who plied her trade there excited no end of curiosity. Other things go on, just as idiosyncratic—depending on the time of day— around the Madeleine. A good photographic image should not ignore such details. A good souvenir of the Madeleine or the Bourse or the Gare de l'Est is made of just such insignificant detail, sometimes vulgar but always vivid. It's at this point that the photograph takes an honorable place on the scale of literary and sentimental values.

All the works churned out to introduce people to Paris and to create nostalgic memories can be criticized for being conceived in one way or another on the classic plan: Paris in Twenty Lessons.

One good lesson is enough to know a city. A single photograph chosen out of hundreds can stand for Paris, Berlin, London, Moscow.

Outside of Atget's Paris, of which this book gives the essentials, there isn't much. It takes several generations before one can honestly enjoy the charm, finally revealed, of a vulgar and naturally anonymous postcard. A human presence is still necessary to lend a melancholy fascination to those views that have become classic as tombs.

Thus, in the magnificent collection of old photos owned by my friend, the painter Dignimont,[3] I happened on a view of the grand boulevards near the Porte Saint-Martin. That photograph was taken perhaps around 1865. It is powerful, in the sense that it sets all the wheels of the imagination spinning. That power depends on a single

detail: the presence of a squad of soldiers of the guard, preceded by their band. It is an everyday image of street life and of the picturesque aspect of social life in 1865. Nothing in that banal spectacle, enlivened by photography with a certain divine spark, could have been invented. That one print outdoes what all the memoirs and commentaries of the era can resurrect in an imagination, however nostalgic, if it no longer has the faintest notion of the social value of a squad of riflemen.

Photographic views of Paris offer two different worlds: that of the day and that of the night.

It is easier to exploit the night if you want to stir the public's curiosity. The elements of night are the great stage directors of a social fantastic which is rather naive and always easy to understand.

When François Villon glimpsed a crack of orange light under a door on a street of cabarets and bathhouses, he went home to his uncle's house and thought: the Lights of Paris.

Nothing is changed, despite the luminous apotheoses of the Pigalle quarter. That fairyland of lights, like the humble oil lamp in the university quarter, still leads toward this image: a poet dreams in a little room and writes, "The Lights of Paris..."

The lights of this Paris, our contemporary, may be more numerous and more brilliant; but the shadow—the secret intelligence of light—is still inhabited.

The limits of knowledge are always rather hypothetical. Photography makes use of light to study shadow. It reveals the people of the shadow. It is a solar art at the service of night.

Photographs taken in a street during the day make it easy to foresee what that street will become when night takes over the watch.

The sentimental past of Paris goes along very nicely with everything that a simple old man, an old street peddler such as Atget became, can possess in the way of literary subtlety.

Paris is not a city that right away surrenders herself to the first desire of a photographer, no matter how lyrical. It takes time for the houses to adopt a passerby who isn't from the neighborhood. Belonging to a certain quarter doesn't always mean that the neighboring arrondissement welcomes us with open arms. The streets of Paris are hospitable, but in the French manner, which is flighty and all too superficial.

You need the particular gift of sympathy to be able to acquire in a few days that freedom of the city that lets you contemplate a photograph of the Place du Tertre with a spontaneous smile of friendly and knowing complicity.

A photographic vision of Paris is so much more complicated because the city boasts a very picturesque internationalism. But this crossroads of Europe instinctively conceals its familiar faces. Atget, who had an admirable acquaintance with the streets of Paris, was certainly one of the purest poets of that anthill of small independent lives.

The photographic elements of Paris, those that give this collection of images assembled by Berenice Abbott its force, are what our fathers called *le petit commerce*, the small-shop trade. The small-time shopkeeper of Paris, the worker on the public streets, have a place of key importance in it. Here we meet up with the elite of the people, those who give the street its history, its anguishes, and its triumphs. What we need is for a man like Atget, a conscientious individual almost entirely free of vanity, to come into the world in each of the globe's great cities, to leave us an exact image of them, because only the visions inspired by the collective emotions ring humanly true.

Atget did not search out the complications of the night and of the early hours so full of delightful surprises; he never spoiled his shots on the chance of breaking out beyond the territory where he was master. His work is above all loyal. It constitutes reportage of exceptional quality and is often a source of purely plastic wonder. No one knew Paris better than he, from the Fort-Monjol now long disappeared[4] to the pleasant lawns of a children's playground. He knew how to recognize in every thing the nuance that gave that thing its value.

Atget died very old and perhaps deeply discouraged. Yet I do not think so. I met the ancient Atget once, by chance. At that point he was selling photographs of shops and of loose women to serve as documents for painters. That one-time man of the theater was impenetrable. In the first place, because no one tried to understand him and to understand the profound value of his work. Atget was a man of the street, an artisan Poet of the crossroads of Paris. He did not advertise his occupation by an appropriate street cry, but one could not fail to note his tall figure, a little stoop-shouldered, carrying a camera on a

tripod past the market woman hawking her fruit and vegetables, the mender of chair bottoms, and the goatherd with his panpipe.

The models always had a friendly welcome for him. He worked and loved the sights of his work with a tenderness that could be compared with the Douanier Rousseau's, keeping in mind however that Atget was a cultivated man and thus perfectly informed about the resources of the tools and the technique that he employed.

The old poet of the streets died not so long ago, and it is thanks to Berenice Abbott that his name has not foundered in the dispersion of his work into innumerable anonymous prints. The young American artist-photographer was able to gather the best of what constitutes Atget's personality. Those who purchase this book will come to know that personality in their own manner. They will be able to look for a long time at these deeply moving images. One must look at them for a long time, patiently, if one is to understand the secret of those stones and those trees. The power of a photographic print lies in the fact that it can be looked at longer than is usual for a painting or drawing.

For many among us Atget's Paris is now no more than a memory whose delicacy is already mysterious. It is worth all the books written on the subject, and without doubt will inspire others.

Translated by Robert Erich Wolf

1. A play on words: *ne révèle rien à l'épreuve de la photographie* also refers to the development of a photographic print.

2. *Guinguettes*: suburban dancing and drinking spots.

3. André Dignimont (1891–1965), a French painter and illustrator of books by Mac Orlan and Francis Carco, specialized in seedy night-life scenes of bars and prostitutes.

4. The Fort-Monjol is very likely the tiny rue Monjol in the 19th arrondissement. For over a quarter century this notorious neighborhood was dominated by Parisian street gangs. They were cleared out by the police in 1925.

PHILIPPE SOUPAULT

THE PRESENT STATE OF PHOTOGRAPHY

The poet and novelist Philippe Soupault (b. 1897) founded the avant-garde literary review *Littérature* with André Breton and Louis Aragon in 1919. In that same year he and Breton carried out a famous experiment in automatic writing which was published as *Les Champs magnétiques*. Active in Paris dada and the early surrealist movement, Soupault was expelled from the surrealist group by Breton in 1926. His subsequent novels carried him progressively farther from surrealism toward a lyrical realism.

This short essay appeared as the introduction to the second *Photographie* annual published by the magazine *Arts et métiers graphiques*. The annual served as a yearly showcase for the work of the most highly regarded international photographers. In his essay Soupault describes a widespread turn away from photographic experimentation that took place at the end of the 1920s, accompanied by new interest in photography as a medium of realistic imagery. He belittles the notion of photography's kinship to art and stresses the value of its contribution as a visual document, advising photographers to attend to subject matter and craft and to set aside "artistic pretensions."

The photographs Soupault cites at the end of the essay are ten strikingly different portraits of the same female model made by ten photographers (including André Kertész, Germaine Krull, Man Ray, Maurice Tabard, and George Hoynigen-Heune), which were published in *Photographie*.

Original publication: Philippe Soupault, "État de la photographie," *Photographie* (Paris, 1931).

After being scorned, neglected, and slandered, around 1923 photography suddenly began to enjoy a vogue still difficult to characterize. As always when any sort of new fashion is involved, all sense of proportion was quickly lost. The craze knew no bounds. Photography simply had to be considered an art, at whatever cost. What was really serious was that the photographers began to believe themselves artists, and everyone rushed to confirm them in that conviction.

Let's not exaggerate. But when all is said and done, that claim to high status would really not have mattered very much if the photographers, on the pretext of "making art," had not suddenly and deliber-

ately neglected the very experiences they ought to have been pursuing further. With a very few exceptions, the sort of exceptions that prove the rule, photographers tried to turn out paintings; that is, with very different materials they set out to follow in the wake of the painters. As a consequence their attitude became totally distorted and their point of view outright dangerous.

If instead of praising to the skies the photographers' efforts and the results they were obtaining (some of which, I hasten to say, were truly remarkable) people had taken the trouble to give careful study to the technique of photography, perhaps we might have been spared those uncolored paintings which bore one so quickly. What needs especially to be stressed is that a photograph is above all a *document*, and that it should from the start be considered as such. It can represent a subject to be exploited in painting or even literature; but conversely, it should never be detached from its subject or even from its *usefulness*.

What photographers ought to do now is forget art and orient their activity in a direction likely to prove infinitely more fruitful. If they persevere along the path they have chosen, continuing in that essentially artistic domain, they risk seeing their efforts end in miserable failure. It is obvious that the beauty of a photograph is totally different from the beauty of a painting; one could even say it is at the farthest extreme. Those who believe in photography and have faith in its future are beginning to understand the danger. Coming years will see the most solidly established reputations sink into oblivion, and only those who are willing to give serious thought to their métier and rid themselves of all their artistic pretensions will be able to carry their effort forward to any useful purpose.

It is clear that the experiment attempted by *Arts et métiers graphiques*, this comparison of ten photographs of the same face, gives convincing evidence that, for photographers not afraid of renouncing their misplaced ambitions, a passionately interesting adventure lies ahead.

This album obliges us to believe that all hope is not lost, since the collaborators in this special number of *Arts et métiers graphiques* have the courage to face up to the most urgent problems.

Translated by Robert Erich Wolf

MAN RAY

THE AGE OF LIGHT

In this essay, written at a time when experimental approaches to photography had been increasingly eclipsed by documentary and reportage photography, Man Ray (see p. 11) defends his own amalgam of dada and surrealist attitudes toward the practice of photography. The photographic image can only find its audience, he asserts, if it encourages the awakening of desire and aims at its lyric expression. To achieve this end the photographer must give free rein to the subconscious and must search for the limits of outrage. Dismissing the increasing professionalism of photographers during the 1930s, Man Ray insists, in true dada fashion, that "a certain amount of contempt for the material employed to express an idea" is necessary for its purest realization.

Original publication: Man Ray, "The Age of Light," in *Man Ray: 104 Photographs 1920–1934* (Paris/Hartford, Conn.: James Thrall Soby, 1934).

In this age, like all ages when the problem of the perpetuation of a race or class and the destruction of its enemies is the all-absorbing motive of civilized society, it seems irrelevant and wasteful still to create works whose only inspirations are individual human emotion and desire. The attitude seems to be that one may be permitted a return to the idyllic occupations only after meriting this return by solving the more vital problems of existence. Still, we know that the incapacity of race or class to improve itself is as great as its incapacity to learn from previous errors in history. All progress results from an intense individual desire to improve the immediate present, from an all-conscious sense of material insufficiency. In this exalted state, material action imposes itself and takes the form of revolution in one form or another. Race and class, like styles, then become irrelevant, while the emotion of the human individual becomes universal. For what can be more binding among beings than the discovery of a common desire? And what can be more inspiring to action than the confidence aroused by a lyric expression of this desire? From the first gesture of a child pointing to an object and simply naming it, but with a world of intended meaning, to the developed mind that creates an image whose

strangeness and reality stirs our subconscious to its inmost depths, the awakening of desire is the first step to participation and experience.

It is in the spirit of an experience and not of experiment that the following autobiographical images are presented. Seized in moments of visual detachment during periods of emotional contact, these images are oxidized residues, fixed by light and chemical elements, of living organisms. No plastic expression can ever be more than a residue of an experience. The recognition of an image that has tragically survived an experience, recalling the event more or less clearly, like the undisturbed ashes of an object consumed by flames—the recognition of this object so little representative and so fragile, and its simple identification on the part of the spectator with a similar personal experience, precludes all psychoanalytical classification or assimilation into an arbitrary decorative system. Questions of merit and of execution can always be taken care of by those who hold themselves aloof from even the frontiers of such experiences. For, whether a painter, emphasizing the importance of the idea he wishes to convey, introduces bits of ready-made chromos alongside his handiwork, or whether another, working directly with light and chemistry, so deforms the subject as almost to hide the identity of the original, and creates a new form, the ensuing violation of the medium employed is the most perfect assurance of the author's convictions. A certain amount of contempt for the material employed to express an idea is indispensable to the purest realization of this idea.

Each one of us, in his timidity, has a limit beyond which he is outraged. It is inevitable that he who by concentrated application has extended this limit for himself should arouse the resentment of those who have accepted conventions which, since accepted by all, require no initiative of application. And this resentment generally takes the form of meaningless laughter or of criticism, if not of persecution. But this apparent violation is preferable to the monstrous habits condoned by etiquette and aestheticism.

An effort impelled by desire must also have an automatic or subconscious energy to aid its realization. The reserves of this energy within us are limitless if we will draw on them without a sense of shame or of propriety. Like the scientist who is merely a prestidigitator manipulating the abundant phenomena of nature and profiting by every so-called hazard or law, the creator dealing in human values allows the subconscious forces to filter through him, colored by his own selectivity,

which is universal human desire, and exposes to the light motives and instincts long repressed, which should form the basis of a confident fraternity. The intensity of this message can be disturbing only in proportion to the freedom that has been given to automatism or the subconscious self. The removal of inculcated modes of presentation, resulting in apparent artificiality or strangeness, is a confirmation of the free functioning of this automatism and is to be welcomed.

Open confidences are being made every day, and it remains for the eye to train itself to see them without prejudice or restraint.

TRISTAN TZARA

WHEN OBJECTS DREAM

In this essay, written twelve years after his preface to Man Ray's portfolio *Les Champs délicieux*, Tristan Tzara (see p. 4) returns to the subject of the rayograph. Beginning in the mid-1920s French surrealists had shown an increasing interest in the actual materialization of the products of dreams and the imagination, most clearly evident in the attention they paid to the surrealist object. In 1933 an exhibition of surrealist objects was held in Paris at the Galerie Pierre Colle, and an elaborate classificatory system was established to distinguish among different varieties of works by artists like Max Ernst, Meret Oppenheim, and Man Ray. They included fabricated objects, mathematical objects, found objects, irrational objects, mobile objects, dreamt objects, and so on. Here Tzara suggests, in typically oblique fashion, yet another turn of the spiral: that one might see Man Ray's rayographs as the dreams of objects themselves—as the "projections . . . of objects that dream and that talk in their sleep."

Original publication: Tristan Tzara, "When Objects Dream," *Man Ray: 104 Photographs 1920–1934* (Paris/Hartford, Conn.: James Thrall Soby, 1934).

Along this promenade that joins the ends of days to the ends of nights, untiringly present, whose length cannot be measured in spite of the conjecture of the limits barely presented to our spirit, along that promenade where the ends of days bound to the ends of nights fall out of step to miserably drag adrift of the tunnels, from wreck to wreck, shipwrecked with blindness, we perceive the times of life, the times of joys and grandeurs, of despair and of servitudes, at the touch of our lost glances, at the touch of compact, thin masses, infinitely sweet to the doubt that runs along us, the objects. So goes the caress of the sea to the mountain that in the end rends like a wave; it is the secret of the certainty that inhabits it henceforward. The view of that rend is insensibly profound, for it calls forth sorrow, its constant companion, but it is not around it, in the waving circles that a stone causes in the clear weather of water and the moon—or the eddies of a train hurled at full speed into the sky—that life is no longer searching for its insoluble "why" and is resigned to its combustion without shadows or aftertaste.

It is not so much the reality of the material, and its problematic

solidity, as its significance as a landmark to designate space, to sensitize us to time and our own existence, that attaches the object to the representative forms of our mental life. Submarine views, pebbles of clouds, flights of sharks through waves of applause, retinas of sails, dawns of crustaceans in glass, orientation tables, watches of lightning, crumpled papers that disturb the stars and the thousand pens of resentment, everything that elicits tenderness in the absence of all reason, unstable flames, sisters of love (the same indifference that we show them is the proof of a vast peace, certainty); from infancy to death, you are caught in that ocean with only your sovereign silence for company, a sensitivity that you choose according to the indestructible appearances and the infinitely variable forms of the laws of nature. Objects to touch, to eat, to devour, to place on the eyes, on the skin, to squeeze, to lick, to smash, to crush, objects to belie, to flee, to honor, cold or warm objects, feminine or masculine, day objects or night objects that you absorb through your pores the greater part of your life, which expresses itself unperceived, that counts because it wasn't known and that dispenses itself without counting the thousand magnets poised on the edge of the unanimous route; your slumbers fixed in the butterfly box have cut the diamond beneath all the faces of the earth, in our infancies lost inside us and ineffably charged with dreams like the geological layers that we use for bed sheets. Open flight in a division of flesh beyond the unusual delight of the embraces of midnight: it is experience that is consumed by its unacknowledged impotence. Thirst eternally reabsorbs itself and the contours of the passage of flesh derive from an always limpid vigilance and from hills whose vegetation is grouped in marine clumps in the form of sponges and from microscopic navigations of blood and alcohol.

Thus was established, on the road of the universe, inscribed cruelly in the psychic life of each one of us, the contradiction of the man who wants, on the endless stairway, each journey to be a familiar utensil, beloved or indifferent, while the continuity of life is not hampered by the materiality of facts, for it is no more than waves and imperceptible passages of rounded angles. And that continuity possesses its own particular world that fills the land with radiating shadows, with the most beautiful memories of caresses, with deaths and emotions that can no longer be silenced on earth. They are the projections, caught in transparency, by the light of tenderness, of objects that dream and that talk in their sleep.

MAN RAY

ON PHOTOGRAPHIC REALISM

The French title of this essay, *Sur le réalisme photographique*, is a word play that suggests the contending forces of realism and surrealism in photography. Published during the period of the French Popular Front, when artists and writers were repeatedly encouraged to place their talents at the service of a politically engaged social realism, Man Ray's text echoes the stubbornly independent attitude that had been voiced by surrealists like André Breton regarding the subordination of art to political demands. Man Ray defends the prerogatives of the artistic imagination, derides attempts to harness art to social or commercial tasks, and finally offers a ringing defense of surrealism as the only art able to express the true nature of an era of turmoil.

Original publication: Man Ray, "Sur le réalisme photographique," *Cahiers d'art*, no. 5–6 (1935).

What painter, however emancipated, however revolutionary and sure of himself—what painter face to face with a photograph has not had an instant of misgiving or intimidation, feeling that he himself is outside reality? That photograph, itself less substantial than the paper it is printed on, can evince a force, an authority, which, like certain words, goes well beyond the force and the authority of any material work. I understand that force as the immediate necessity for social contact, on which the photograph depends. As do words, it demands dissemination and attention from the masses without delay.

Painting can wait—even in neglect and incomprehension—certain that some day it will be discovered, recognized; whereas photography, if it does not take its place as an immediate fact, loses its force forever. Nothing is sadder than an old photograph, nothing arouses so much pity as a soiled old print. They have tried to revive old films, admirable old films, films that had been made with great effort, and at great sacrifice; but it became clear that those films belong to a past beyond our grasp, a past impossible to bring forward into the present. And so we have to admit that a photograph, by its dependence on the social situation, is made for its own immediate age, and in the face of that

obligation the photographer's personality takes second place. The intensity of his vision of the age can heighten the force of the message, but one shouldn't confuse that message with the photographer's personality, which can't have the same freedom as the poet's or painter's.

During the fifteen years I've been making photographs I have used only one of my eyes to capture the documents of our time; with the other (which I saved for personal, uncorrupted needs), I passionately observe the ineptness or adroitness of those who have tried to use photography for their own ends. The impartiality with which—sometimes grudgingly—I have always placed that eye at the service of all social or personal strengths and weaknesses has come not from a lack of conviction, but from the hope that, since photography cannot shut itself off in isolation like painting, some day I would find the collaboration which would spark a great enlightenment. I must confess that my patience has really been put to the test. Even when I was my own collaborator, I lapsed into pointless exercises that had a bad effect on me. For example, two or three tries quickly convinced me that vertical architecture (churches, skyscrapers) *is not photogenic*. An apple, a nude, offer more possibilities, because their social value is infinitely greater. Those who had the most selfish reasons to take advantage of photography—the publications acting from obscurely mercenary motives which tried to bend me to their own needs, the searchers after clever gimmicks who showed up in the hope of profiting from my technical discoveries and found nothing new that could be converted into what they were looking for—all of them wasted their efforts with me. If one didn't have complete confidence in the automatism of this eye and the way it functions with a social consciousness imposed by its own physiology, its power was frittered away in feeble attempts. But when no fetters were imposed on the camera, the results, with very few exceptions, fully justified the confidence placed in it.

Surrealism has so far been the only force capable of bringing luminous, impressive, true forms out of the darkroom. It has never been afraid of going too far, it has never betrayed our authentic impulses, it has never acted with tact or circumspection. We know to what lies an entirely aesthetic preoccupation can lead "beauty" and "morality," to the point where the length of the beard is taken as an index of intellectual strength and virility.

Only complete contempt for all formulas, aesthetic or timorous,

joined to a total familiarity with the craft, can serve a new social condition and show its worth.

Perhaps someday photography—if we allow it to—will show us what painting has already shown us, our true portrait, and will give to the spirit of revolt that exists in every truly living, sensitive being a plastic and enduring voice of its own.

Translated by Robert Erich Wolf

LOUIS ARAGON

JOHN HEARTFIELD AND REVOLUTIONARY BEAUTY

A poet, novelist, and essayist, Louis Aragon (1897–1983) was a founder of the avant-garde review *Littérature* (1919) with André Breton and Philippe Soupault. He was one of the animating spirits of the Paris dada movement and an important member of the surrealist group throughout the 1920s; his novels *Anicet* (1920) and *Le Paysan de Paris* (1926) were influential experimental works. By the early 1930s Aragon had moved away from surrealism to become an active member of the French Communist Party. With several other ex-surrealists he founded the Association of Revolutionary Writers and Artists (AEAR) in 1932, and served as editor of its journal *Commune*. From the mid-1930s onward Aragon was a relentless advocate of socialist realism in literature and the visual arts.

In April and May of 1935 an exhibition organized by the AEAR showed 150 of John Heartfield's anti-Nazi photomontages. It was the first time Heartfield's work had been shown in Paris. Aragon prepared the following essay as his contribution to a public forum on the exhibition. In it he makes clear his allegiance to an art of revolutionary realism, and portrays Heartfield as the model of a politically engaged artist.

Original publication: Louis Aragon, "John Heartfield et la beauté révolutionnaire," *Commune*, no. 20 (April 1935), pp. 985–91.

To paint. In the streets of Paris, 1935, there are thousands of paintings mounted on panels, as if they were election posters: little cats, flowerpots, landscapes—but no one stops in front of these; then suddenly, a crowd: the nude figures of women. They remind me, for obvious reasons, of pin-ups in the covered trenches . . . and next to them, on a folding chair, the painter. Of course, this is hardly the place to pursue the history of painting, not here amid these canvases destined to hang in dubious and undistinguished bachelors' quarters, in dining rooms, or in the back rooms of drab shops. This is hardly the place where the game is being played—this game of the human spirit whose players are known as da Vinci, Poussin, Ingres, Seurat, Cézanne. Even so, all things considered, what is the difference between the problems of these sad sidewalk beggar-artisans and those problems

resolved by the vast majority of painters who have been placed on the pedestals of critical acclaim and glory, is it not merely a matter of degree?

The anguish common to all artists, that which Mallarmé has called *the white solicitude of our canvas*, hardly makes martyrs of today's painters.

And few of them could even hear what Picasso told me one day several years ago: "The important thing is the space between the painting and the frame." No, most among them do not question the decadence of their thought as to where the painting ends, this scandal of fluff and filler, the confusion of the painter who views the subject from the periphery. But how many who have felt this "drama of the frame" have understood its true significance? Having escaped its creator, the painting is inserted into a frame—a practice which doesn't usually concern the painter—and yet... And yet he isn't indifferent as to where the completed painting ends up and what surroundings extend or complete it. An artist is not indifferent as to whether his work is seen on a public square or in a boudoir, in a cellar or in the light, in a museum or at the flea market. And whether we like it or not, a painting has its canvas borders and its social borders. Your young female models, Marie Laurencin, were born in a world where the cannon thunders; your nymphs caught at the edge of a wood, Paul Chabas,[1] shiver while unemployed; your fruit bowls, Georges Braque, illustrate the dance in front of the buffet; and I could similarly address myself to everyone from van Dongen, painter of the Lido, to Dali, painter of the oedipal William Tell, to Lucien Simon[2] with his little Breton girls, to Marc Chagall with his curly-headed rabbis.

Like poetic anguish, pictorial anguish has assumed changing forms through the generations and has translated itself in a thousand ways —from the religious preoccupations of the Pre-Raphaelites to the surrealists' haunting of the unconscious, from the mystery within reality of the Dutch painters to the disquieting pasted-on objects of the cubists. The problem of expression was not the same for the young David that it was for the young Monet, but the extraordinary thing is that, beyond the means of expression, we have never seriously examined the wish for expression and *the thing to be expressed*.

This disregard, in itself a strange defense—this refusal to lay even the groundwork of a debate—took form at the beginning of the twentieth century via a sort of logic which is provoked by the aggrava-

tion of social contradictions; it attained its culminating point, so to speak, at the time when the war of 1914 inaugurated a new era of humanity. I say its "culminating point" because since then, even in the extreme manifestations of painting, such as dada and surrealism, violent signs of a reaction have appeared against this extreme point in art to which cubism is advancing. A negation of dada, an attempt to synthesize the dadaist negation and the poetic heritage of humanity in surrealism—art under the Treaty of Versailles has the disordered appearances of madness. It is not the result of a small group's will, it is the maddened product of a society in which irreconcilable opposing forces are clashing.

Because of this, the lessons of a man moved by events to one of the points of conflict among these rival forces, where a minimum of play was given to the artist and the individual, are all the more precious today. I am speaking of John Heartfield, for whom the entire destiny of art was brought into serious question by the German revolution in the aftermath of the war and whose entire *oeuvre* was destroyed by Hitlerian fascism in 1933.

John Heartfield was one of those who expressed the strongest doubts about painting, especially its technical aspects. He is one of those who recognized the historical evanescence of that kind of oil painting which has only been in existence for a few centuries and seems to us to be painting *per se*, but which can abdicate at any time to a new technique more consistent with contemporary life, with mankind today. As we know, cubism was a reaction on the part of painters to the invention of photography. Photography and cinema made struggling for exact *likeness* childish. Artists drew forth from these new mechanical accomplishments a conception of art which led some to attack naturalism and others to attempt a new definition of reality. With Léger, this led to decorative art; with Mondrian, to abstraction; with Picabia, to the organization of *soirées* on the Riviera.

But near the end of the war, several artists in Germany (Grosz, Heartfield, Ernst), in a spirit very different from the cubists who pasted a newspaper or a matchbox in the middle of a painting in order to give themselves a foothold in reality, came to use in their critique of painting this same photography which had challenged painting to new poetic ends—but relieved of its mimetic function and used for its own expressionistic purpose. Thus was born the *collage*, which was different from the *pasted papers* of cubism, where the thing pasted some-

times mingled with what was painted or drawn, and where the pasted piece could be a photograph as well as a drawing or a figure from a catalogue—in short, a *plastic snapshot* of some sort.

In the face of the decomposition of appearances in modern art, a new and living taste for reality was being reborn under the guise of a simple game. What provided the strength and attraction of the new collage was this sort of verisimilitude borrowed from the figuration of real objects, including even their photographs. The artist was playing with reality's fire. He was becoming once more the master of those appearances in which the technique of oil had little by little lost and drowned him. He was creating modern monsters; he paraded them at will in a bedroom, on Swiss mountains, at the bottom of seas. The dizziness spoken of by Rimbaud overtook him,[3] and the *salon at the bottom of a lake* of *A Season in Hell* was becoming the prevailing climate of painting.

Beyond this point of expression, beyond this freedom taken by the painter with the real world, what is there? "This happened," said Rimbaud: "Today I know how to salute beauty."[4] What did he mean by that? We can still speak about it at length. The men whom we speak of have met different fates. Max Ernst still prides himself today on not having left that lakeside setting where, with all the imagination one could want, he still endlessly combines the elements of a poetry which is an end in itself. We know what happened to George Grosz. Today we will concentrate more specifically on the fate of John Heartfield, whose show presented by the AEAR at the Maison de la Culture gives us something to dream of and to clench our fists about.

John Heartfield *today knows how to salute beauty.* While he was playing with the fire of appearances, reality blazed around him. In our benighted country, few know that there have been soviets in Germany. Too few know what a magnificent and splendid upheaval of reality were those days of November 1918, when the German people—not the French armies—put an end to the war in Hamburg, in Dresden, in Munich, in Berlin. Ah, if only it had been but a matter of some feeble miracle of a salon at the bottom of a lake when, on their machine-gun cars, the tall blond sailors of the North and Baltic seas were going through the streets with their red flags. Then the men in suits from Paris and Potsdam got together; Clemenceau gave back to the social democrat Noske the machine guns which later armed the groups of future Hitlerians. Karl and Rosa fell.[5] The generals rewaxed their mus-

taches. The social peace bloomed black, red, and gold on the gaping charnel houses of the working class.

John Heartfield wasn't playing anymore. The pieces of photos he had arranged in the past for amazement and pleasure, now under his fingers began to *signify*. The social *forbidden* was quickly substituted for the poetic *forbidden*; or, more exactly, under the pressure of events and in the course of the struggle in which the artist found himself, these two forbiddens merged: there was poetry, but *there was no more poetry that was not also Revolution*. Burning years during which the Revolution—defeated here, triumphant there—rose in the same fashion from the extreme point of art: Mayakovsky[6] in Russia and Heartfield in Germany. And these two poets—one under the dictatorship of the Proletariat and the other under the dictatorship of Capital, beginning from what is most incomprehensible in poetry and from the last form of art-for-the-few, turned out to be the creators of the most striking contemporary examples of what art for the masses, that magnificent and incomprehensibly decried thing, can be.

Like Mayakovsky declaiming his poems through loudspeakers for tens of thousands, like Mayakovsky whose voice rolls from the Pacific Ocean to the Black Sea, from the forest of Karelia to the deserts of Central Asia, the thought and art of John Heartfield have known this glory and grandeur to be the knife that penetrates all hearts. It is a known fact that it was from a poster depicting a clenched fist which Heartfield did for the French Communist Party that the German proletariat took the gesture of the "Red Front." It was this same fist with which the dockworkers of Norway saluted the passage of the *Chelyuskin*, with which Paris accompanied those who died on 9 February,[7] and with which only yesterday at the movies I saw a huge crowd of Mexican strikers frame the swastika-emblazoned image of Hitler. It is one of John Heartfield's constant concerns that the originals of his photomontages be exhibited adjacent to the pages of *A-I-Z*, the illustrated German magazine where they are reproduced, because, he says, it must be shown how these photomontages penetrate the masses.

That is why during the existence of the German "democracy" under the Weimar constitution the German bourgeoisie prosecuted John Heartfield in the courts. And not just once. For a poster, a book cover, for lack of respect to the iron cross or to Emil Ludwig[8] . . . When it liquidated "democracy," its fascism did more than just prosecute: twenty years of John Heartfield's work was destroyed by the Nazis.

In exile in Prague, they continued to hunt him down. At the request of the German embassy the Czechoslovakian police closed down the same show which is presently on the walls of the Maison de la Culture and which constitutes everything done by the artist after Hitler's coming to power—this show in which we can recognize classic images like that admirable series of the Leipzig trial which future history books will never be able to do without when retelling the epic of Dimitrov.[9] (Speaking to Soviet writers, Dimitrov was astonished recently to find that literature has neither studied nor used "this formidable capital of revolutionary thought and practice" that is the Leipzig trial.) Among painters, Heartfield is at least one man whom this reproach does not touch and who is the prototype of the anti-fascist artist. Not since *Les Châtiments* and *Napoléon le Petit*[10] has a single poet reached these heights where we find Heartfield, face to face with Hitler. For, in painting as well as in drawing, precedents are lacking—Goya, Wirtz, and Daumier notwithstanding.

John Heartfield *today knows how to salute beauty.* He knows how to create those images which are the very beauty of our age, for they represent the cry of the masses—the people's struggle against the brown hangman whose trachea is crammed with gold coins. He knows how to create realistic images of our life and struggle which are poignant and moving for millions of people who themselves are a part of this life and struggle. His art is art in Lenin's sense, because it is a weapon in the revolutionary struggle of the Proletariat.

John Heartfield *today knows how to salute beauty.* Because he speaks for the countless oppressed people throughout the world without lowering for a moment the magnificent tone of his voice, without debasing the majestic poetry of his colossal imagination. *Without diminishing the quality of his work.* Master of a technique of his own invention—a technique which uses for its palette the whole range of impressions from the world of actuality—never imposing a rein on his spirit, blending appearances at will, he has no guide other than dialectical materialism, none but the reality of the historical process which he translates into black and white with the rage of combat.

John Heartfield *today knows how to salute beauty.* And if the visitor who goes through the show of the Maison de la Culture finds the ancient shadow of dada in these photomontages of the last few years—in this Schacht[11] with a gigantic collar, in this cow which is cutting itself up with a knife, in this anti-Semitic dialogue of two birds—let him

stop at this dove stuck on a bayonet in front of the Palace of the League of Nations, or at this Nazi Christmas tree whose branches are distorted to form swastikas; he will find not only the heritage of dada but also that of centuries of painting. There are still lifes by Heartfield, such as this scale tipped by the weight of a revolver, or von Papen's wallet,[12] and this scaffolding of Hitlerian cards, which inevitably make me think of Chardin. Here, with only scissors and paste, the artist has surpassed the best endeavors of modern art, with the cubists, who are on that lost pathway of quotidian mystery. Simple objects, like apples for Cézanne in earlier days, and the guitar for Picasso. But here there is also *meaning*, and meaning hasn't disfigured beauty.

John Heartfield today knows how to salute beauty.

Translated by Fabrice Ziolkowski

1. Marie Laurencin (1885–1956) painted decorative, lyrical portraits; Paul Chabas (1869–1937) was an academic painter of portraits and nudes.

2. Lucien Simon (1861–1945) was an academic French painter and illustrator known for his portraits and genre scenes.

3. In the 1870s the poet Rimbaud advocated hallucination and the systematic derangement of the senses as methods for achieving the renewal of poetic imagery.

4. The reference is to a line from Rimbaud's "Une Saison en enfer" (1873).

5. Gustav Noske (1868–1946) was the German Minister of the Interior responsible for the bloody suppression of the 1919 Spartacist uprising in Berlin. Karl Liebknecht and Rosa Luxemburg, leaders of the revolutionary Spartacist group, were summarily executed after their arrest during that insurrection.

6. Vladimir Mayakovsky (1893–1930) was a Russian poet and a leading figure of the Soviet avant-garde.

7. On February 6, 1934, right-wing groups rioted in the heart of Paris, and on February 9 and 12 large counter-rallies were staged by the parties of the left. The events galvanized and unified the left, eventually leading to the formation of the Popular Front.

8. Emil Ludwig (1881–1948) was a prolific German author of popular biographies of great men such as Napoleon, Bismarck, and Kaiser Wilhelm II.

9. Georgi Dimitrov (1882–1949), a Bulgarian Communist, was among those ac-
cused of responsibility for the Berlin Reichstag fire of 1933. He was put on trial in
Leipzig in the fall of that year. His spirited defense of himself and his fellow defendants
against the charges brought by Nazi leaders like Goebbels and Göring attracted
international attention.

10. In December 1851, following Louis Napoleon's coup d'état, the French poet
Victor Hugo went into political exile in Brussels. In 1852 he published *Napoléon le
Petit*, a pamphlet excoriating the would-be emperor. In 1853 he brought out a collection
of biting, sarcastic poems, *Châtiments*, in response to Louis Napoleon's proclamation
of the Second Empire.

11. Hjalmar Schacht (1877–1970), a German financier, was president of the
Reichsbank under Hitler, 1933–39.

12. Franz von Papen (1879–1969), a German diplomat and conservative political
figure, was chancellor of Germany in the year before Hitler's appointment to that
office in 1933.

LOUIS ARAGON

Untitled contribution to *THE QUARREL OVER REALISM*

In the spring of 1936 Louis Aragon and the Association of Revolutionary Writers and Artists organized a public debate around the question of realism in contemporary literature and the arts. Their aim in sponsoring the event was clearly to win support for the doctrine of socialist realism. Nevertheless a wide range of opinions was aired, including those of the painter Fernand Léger and the architect Le Corbusier. The talks were subsequently published in the book *La Querelle du réalisme*.

In his own contribution to this debate Aragon offers a short history of the relation between painting and photography. He argues that in the years following the First World War a number of photographers, such as Man Ray, pulled abreast of and joined the leading movements in painting. This new photography, however, could be understood only by the tiny audience already attuned to avant-garde visual art, and therefore it was doomed to sterility. The medium's future, Aragon asserts, belongs to photographers engaged in social and political struggles.

Original publication: Louis Aragon, untitled essay in *La Querelle du réalisme* (Paris: Collection Commune, Éditions sociales internationales, 1936), pp. 55–68.

It is always at those moments when social equilibrium is at the breaking point, when the dominant class no longer has anything but the trappings of authority and the real strength lies in a class in the ascendant which the masters of society strive to disguise, that the realist tendency in the art and literature of class societies makes its appearance. This is a fact which memories of the period prior to 1789 and of Diderot's campaign on behalf of realism, as well as those years just before the Commune when Manet, Flaubert, Zola, and Courbet represented art, renders clear, patent, and unquestionable to the majority of us. Bearing in mind that these thrusts of realism correspond to the historic rise of the bourgeois class in the first instance and of the proletariat in the second, the fact is that, whether one likes it or not, in art and in literature, the cardinal problem—the open wound—that which stirs the tempest on all sides; in short, the only issue over

which, in these days of the Popular Front,[1] one can bring the artists of the period ardently to grips, as this evening, is, in the case of both writers and painters, the question of realism. I want to see in this fact the symbol, the prophecy, the herald of the victory of those social forces which combined against the "two hundred families."[2] Perhaps I displease you by drawing on the news of the day for my figures of speech, but it can't be helped.

Where, today, do we see the antithesis of realism more clearly than in the expression of Charles Maurras,[3] who dubs that handful of troublemakers who are linked with the merchants of munitions the "real country." The great triumph of the National Front organized on Joan of Arc's day—that was an unreal stage set, an attempt to hide the real forces of the country behind the trick of a parade. Who are those who fear realism in the cinema? Who placed a ban on *La Vie est à nous*[4] and *La Révolte des pécheurs?* Who arranged to have views of the lily-of-the-valley vendors shown on the screen to symbolize May Day in Paris? I could be carried away by examples: I must limit myself to a discussion of painting. Yes, it is true that at the present time the masters of this art, which has been the pride and honor of our country for centuries and especially during the last hundred years—men whose ideas, no doubt, were formed in a different period —are on the whole hostile to realism, in fact they do not even want to hear it discussed. This is so true that André Derain, who had, at first, promised to be present here, declined at the last moment to participate in our debate, which he considered futile and even "sinister." Yet, in his own painting, from his *Chevalier X* which is in the Museum of Western Art in Moscow down to the portraits which he paints today, what steps have been taken in the direction of realism? From what, then—not only with Derain but with the best of our painters—does this distrust of realism derive, this flight from reality which modern exhibitions so strikingly illustrate? We must go back some distance in our consideration of the matter.

In my brochure *La Peinture au défi* which appeared six years ago—today all of it does not seem to me of equal worth, but in the main it is still in keeping with my present opinion—I attempted to show that painting, during a certain epoch, found itself confronted with a challenge, the challenge of photography. It goes without saying that this was more apparent than real and that no battle ever took place between these two allegorical monsters, the one armed with a

palette and the other with its head hooded in a black cloth. Beneath this challenge we should look for the economic forces at work, we should bind this challenge to history. Yet, it is certain that the initial argument which induced painters to abandon the imitation of nature —the primary form of realism—lay in the uselessness of attempting to rival the camera. My statement is perhaps too broad, for it is equally true that the beginnings of photography did, at the outset, stimulate the realism of such a man as Courbet, for example. Then came a period when the naturalistic painter wanted to paint more realistically than the photographer, by painting that which eluded draftsmanship and the art of black and white. Impressionism is the last stage of this rivalry. Suddenly, the painters grow desperate, break off short right there and seek their road in quite another direction. With Braque and Picasso they even reached the point of wishing no longer to imitate nature but rather to compete with it. We have the frequently quoted *mot* of Georges Braque, who wondered whether or not one of his still lifes "would hold its own" if set down in a field of wheat.

However, in studying this metamorphosis of modern painting, it seems to me that in general the despair caused painters by photography has been too often taken lightly. In fact, I think that in order to study what is taking place in the field of painting it would be necessary to glance over the evolution of photography, and then the whole question would be clarified. There still appears, only too frequently, the tendency to believe that the intrinsic elements of painting are explicable by themselves, and by themselves alone, and that painting constitutes a world that is closed and even unintelligible to him who is not a painter. This particularism, which is opposed to the research of general laws applicable to all the arts, is found with all its obscure resistances among the inhabitants of the Republic of San Marino who assert that there is a San Marino situation which has nothing in common with the rest of humanity and who, if we had invited them to a debate this evening on "Realism and San Marino," would have been of the opinion, no doubt, that such activities are useless, even "sinister." For my part, I am unable to believe that painting can have an evolution contradictory to that of other creative activities of men, and, for example, that instead of contributing to the widening of human knowledge it tends to return purely and simply to magical conjurations. I will speak, therefore, of photography.

In its infancy, photography, with its technical imperfections, had

at first regarded painting as an ideal far beyond it, which it sought to approach. It imitated the picture to such an extent that the camera portrait was often made in a frame, as may be seen in the Dallamagne photographs from the Nadar collection, reproduced in a recent book (*La Photographie en France au XIX^e Siècle* by Gisèle Freund),[5] a book which is of considerable importance because of its contributions to the history of art and on which I shall, this evening, rely for testimony on more points than one.

During this period the pose is too long and difficult, the apparatus heavy and cumbersome. The photograph is essentially a studio photograph. All these factors, particularly in the case of the portrait, condition the stiff, studied, academic attitudes imitated from paintings. The first photographs play an important role in discrediting the pictorial clichés which up to that time were accorded a certain respect. The contempt in which the photo is held by the artists leads them to react against that which is hackneyed in their own arrangements. Later on they seek to substitute for the attitudes of romantic figures simple, everyday attitudes. Hence it is not the photograph which points the way to realism, but painting itself. The "snapshot" which we came to know later was, at that time, not feasible. It did not precede, it followed pictures like the celebrated *Bonjour, Monsieur Courbet!*[6]

Painting, fleeing from photographic competition, also led the way out of the studio, into the open air with the Impressionists. Romantic art had been the accomplishment of men who had meditated on the paintings of their predecessors. Delacroix, contemptuous of photography, was in reality "photographing" pictorial subjects taken, not from nature, but from the painters of the Renaissance. The curves of his figures are most frequently the mental copies of a Michelangelo or a Benozzo Gozzoli.[7] The *realists* of the Second Empire break with this painting which draws its deepest inspiration from painting and not from life. And in this way they point out the road to the photographers. One might say that the entire history of photography is that of its technical advances. But these advances, since the day of the daguerreotype, have resulted, on the photographer's part, in a series of conceptions of his art culminating, as it seems to me, in the very important work published in 1934 by the American photographer, Man Ray. This represents the work of fourteen years. From 1920 to 1934, from photos which might be simple magazine illustrations to these black and white

rayographs taken by direct impression on the plate without a camera, Man Ray embodies to perfection the classical in photography. It is now no longer in the pose or composition of photography that he imitates the picture or painting: Man Ray is not a contemporary of Ingres, but of Picasso. His photograph, with striking virtuosity, succeeds in reproducing the very *manner* of modern painters, that element in them which, more than any other, it seems, should challenge the objective and mechanical. Even the impasto—even the very touch of the painter—we find it all here. And all the painters as well: Manet, Seurat, the extreme point of *pointillisme*, Picasso. Here the camera goes so far as to lean on them, not only for material but for pattern also. With Man Ray the photograph thus becomes a sort of new criticism of painting which stops at nothing, not even surrealism. But at the same time its researches are tainted with the same sterility which had formerly affected painting; this photograph is detached from life, its subject matter is the art which preceded it. Someone completely unfamiliar with the painters alluded to would not be able to appraise fully these results. More than ever, photography, in the case of Man Ray, its master in the postwar period, is a studio art, with all the term implies: the eminently static character of the photograph. An art which corresponds fully to the social balance of the period when the Treaty of Versailles was not yet entirely shattered, and when "prosperity" allowed the experimenter a relative tranquility, reflected in beautiful human faces that are without defect and without misery.

However, in photography there had existed for a long while another current. At the beginning of the century, family albums were full of snapshots which were generally scorned, or scarcely taken seriously, and in fact regarded as much further from art than the posed photograph. The taste of our middle class tended toward more elaborate photographs, and one should read Mlle. Gisèle Freund apropos the "retouched" photograph, which she discusses in the book I have already mentioned. For the retouched photograph, which makes for uniform prettiness and idealizes everything, is the class characteristic of the type of photography demanded by the reigning bourgeoisie. In this special domain it constitutes the mystification, the weapon against realism. "How awful," said our aunts or cousins, when they saw a snapshot which had caught them just as they were. And undoubtedly they were right. Horrors were there which they would have preferred no one should disclose.

But before a real knowledge of what the snapshot was revealing, from the human and social standpoint, could achieve a wide contemporary recognition, the advent of the moving picture was necessary. The cinema seizes millions of fleeting, impermanent aspects of the world around us. It has taught us more about man in a few years than centuries of painting have taught: fugitive expressions, attitudes scarcely credible yet real, charm and hideousness. What revelations concerning our own movements, for example, do we not owe to the slow-motion picture? What did we understand of human exertion before the slow-motion picture, what of the expressions resultant from abominable suffering? And so on.

How much of all that is to be found in classical photography up to and including Man Ray? Exactly nothing. We must look to the most recent times to find, finally, among the younger photographers, a sort of renewal of their art, which was certainly based on the development of new types of cameras. In the last few years, the manufacture of cameras such as those of the newspaper photographers, the principle of which is very similar to that of cinema cameras, has brought about an absolutely new school of photography, which has nothing concerted about it, but of which certain features may be found in the work of numerous artists. It has so happened that, thanks to the technical perfection of the camera, photography in its turn has abandoned the studio and lost its static, academic character—its fixity. It has mixed into life; it has gone everywhere taking life by surprise: and once again it has become more revealing and more denunciatory than painting. It no longer shows us human beings posing, but men in movement. It arrests moments of their movements that no one would have ventured to imagine or presumed to see. For a long while, through a desire for simplicity, the painter had reached the point where he allowed his model only the most common, elementary, natural gestures. He would have recoiled before the too infrequent excesses of this or that human attitude. The photograph, on the other hand, today stops at nothing. It is discovering the world anew.

Here I am led into a parenthesis. The strange part of this rediscovery is that, suddenly, when timid painting has long since renounced daring compositional arrangements, photography reproduces at random, in the streets or anywhere, the earliest audacities of painters. We are in a period analogous to that in which painters, for the first time, after abandoning the art of the icon which was the earliest stage

of our painting tradition, the Byzantine style carried on through Cimabue, dared to set on canvas or in fresco human heaps in which arms, masked faces and pikes cut haphazard across the picture without any regard for the individual form. Today the crowds are returning to art through the photograph—with the excited gestures of children at play, with the attitudes of a man surprised in his sleep, with the unconscious habit gestures of the idler, with the heteroclite diversities of human beings as they follow one another along the streets of our modern cities. And here I have especially in mind the photographs of my friend Cartier.[8] It is not merely by chance, either, that some of his most interesting pictures were made in Mexico and Spain.

I mean that this art, which is opposed to that of the relatively peaceful postwar period, truly belongs to this period of wars and revolutions we are in now, by the fact of its accelerated rhythm. I find it extremely symptomatic that the photographic anthology of Man Ray bears the date of 1934. It would lose its significance had it been extended beyond the sixth of February[9] of that year. The advances in photographic technique are parallel to the social events which condition them and render them necessary. It is the camera which the reporter took up during those February days, which he had to make use of for days like that, that teaches a lesson about the contemporary world that ought to open the eyes of all, and why not the eyes of the painter?

Painters have had various attitudes toward photography. At first scorn, then emulation, then panic. They have seen in the photographic apparatus a rival—they have looked at it as the laborer of the nineteenth century looked at the machine. They have held it responsible for all their misfortunes. They have tried not to do what it does. That was their great idea. This misunderstanding of a human acquisition, of a device for broadening the field of knowledge, was bound, quite naturally, to force them in the direction of a denial of knowledge. In other words, towards a reactionary attitude. In proportion to their talent, even the greatest of the painters became absolute ignoramuses. They sought to make their paintings represent and signify less and less. They drowned themselves in the delectation of mannerism and material, they lost themselves in abstraction. Nothing human remained on their canvases and they were content to become the demonstrators of the technical problems of painting. They ceased painting for men, and no longer painted for anyone but painters. Add to this, and here I speak of the best, that the easy financial circumstances resulting from

the speculations of the period we were in, by furnishing a relatively comfortable livelihood for the masters of painting, swept them each day further along in this direction. They lost sight of life because, like grown-up children, they lived on their rich parents, the picture dealers. The awakening has been rude.

The social conditions which had permitted this curious evolution, this flight from reality toward magic ceremonies and all that game of echoes from the past history of art which goes by the name of the Paris School—the conditions no longer exist today. Yet the painters, among whom an uneasiness is evident, are nevertheless very slow to revise their ideas—ideas they have held all their lives. They are not far, if I may insist on speaking of photography, from repeating that photography is their enemy, and from demanding that Kodaks be smashed as vulgar mechanisms. They have not understood that the photographic experience is a human experience which they cannot neglect, and that the new realism which will come, whether they wish it or not, will see in photography not an enemy, but an auxiliary of painting. It is just this which men like Max Ernst and John Heartfield, in the pictorial avantgarde, sensed vaguely when they tried, in various ways, to incorporate the photograph into the picture. But this was only a transitional phase. The photograph teaches us to see—it sees what the eye fails to discern. In the future it will not be the model for the painter in the old sense of academic models, but his documentary aid in the same sense in which, in our day, files of daily newspapers are indispensable to the novelist. And would anyone say that the newspaper, or reporting, for example, is in competition with the novel? This is the sort of nonsense which is put forward when photography and painting are contrasted. I will assert that the painting of tomorrow will use the photographic eye as it has used the human eye.

I should like to announce here a *new* realism in painting. That is to say, I do not in any way imagine a return to an old realism. Painting cannot have passed unaffected through the experiences of the last seventy years. From these experiences it will certainly retain the essentials. It is not for me, but for the painters, to determine what these essentials are. What I can tell them, however, is that it will turn the arms which they have forged to uses which the painters never dreamed of at the time. In 1930 I wrote in *Peinture au défi*, "One can imagine a time when the problems of painting and, for example, those which have made for the success of Cézannism, will seem as antiquated as the prosodic worries of the poets of other days seem now."

This time has not come for everyone, but already there are plenty of painters for whom in six years that point has been reached. Recently Goerg[10] said to me that it was astonishing to think that one could line up the works of a painter produced during the last few years, and not find a difference among those which preceded and those which followed the 6th of February, 1934. Coming from Goerg, to whom it does credit, this declaration is worth dwelling upon, and for myself I consider it exemplary. It clarifies what this new realism can be, what it may be.

The realists of the Second Empire were vulgar realists, but still there were among them great painters, such as Courbet. Their realism is only naturalism. Nature is their master. It is the goal that art attempts to achieve. The role of art is to copy nature. The realists of the days of the Popular Front would not know how to be naturalists. Nature is not by any means the supreme good for them, nor the supreme beauty. They are men of a period in which men have undertaken to transform nature. That is to say that nature only furnishes them the elements of their art, but they paint in order that these elements may become profitable to man, for the harmonious evolution of man, the master of nature. For the naturistic illusion, that source of naturalism which derives from Rousseau, of Geneva, they will substitute reality. Human expression in painting will no longer be dictated, for these painters, by the forces of nature—it will be the product of human forces, it will interpret consciously, and not by the circumlocutions of former times, men who are no longer mere details of the landscape, nor exist independently one of the other, but whose positions are determined through the social relationship of one with the other. This realism will cease to be a realism dominated by nature—a naturalism —and become a realism which is a conscious expression of social realities, an integral element in the combat which will eventually alter these realities. In a word, it will either be a socialistic realism or painting will cease to exist, that is, will cease to exist on a level of dignity. It is a great role, gentlemen, which falls to you, and I have only one fear: that there may be among you some very considerable artists whom the fear of taking up a contrary attitude to that to which they have held, and the dread of being left unworthy of such a high destiny, is sweeping to a failure to recognize what would truly make for future greatness.

No more than the writers can you painters remain mere entertain-

ers; no more than they will merely humor the ear in the future, will you flatter the eye. Believe me, the moment has come for you to speak out like men. You will no longer decorate the palaces of the mighty with anodyne arabesques. You will be working with other men as their equals in the world which is coming, do not forget it. They are looking to you for inventions that are as fine as the wireless. If, as a celebrated saying has it, it is the role of the writers to be the *engineers of the soul*, do you believe that your destiny ought to be less? You painters are going to build the new world. That certainly is worth a revision of your ideas.

Translated by James Johnson Sweeney

1. The *Front national*, the French Popular Front, was a political union launched on July 14, 1935 by the Communist, Socialist, and Radical parties to counter the rise of extreme right-wing political groups in France.

2. During the Popular Front period the French left repeatedly criticized the concentration of economic and political power in the hands of the two hundred wealthiest French families.

3. Charles Maurras (1868–1952) was the leader of the right-wing nationalist organization Action Française.

4. *La Vie est à nous*, a 1936 film directed by Jean Renoir for the French Communist Party, aimed at dramatizing the ideals of the Popular Front.

5. Gisèle Freund's book *La Photographie en France au 19e siècle. Essai de sociologie et d'esthétique* (Paris: La Maison des amis du livre, 1936) was one of the first major attempts to chart a social history of photography. Like Aragon, the German critic Walter Benjamin, then living in Paris exile, derived many of his ideas about the social function of photography from Freund's book.

6. *Bonjour, Monsieur Courbet!* or *The Meeting* (1854) was one of the best-known realist paintings of Gustave Courbet (1819–77). It presents, with studied artlessness, a scene in which the artist is greeted on a country road by his patron, Alfred Bruyas.

7. Benozzo Gozzoli (1420–97) was a Florentine painter of the early Renaissance.

8. The French photographer Henri Cartier-Bresson (b. 1908) frequently published his work under the name Henri Cartier during the Popular Front period.

9. See preceding selection, n. 7.

10. The reference is probably to Edouard Goerg (1893–1968), a French painter, engraver, and illustrator.

LÁSZLÓ MOHOLY-NAGY

PRODUCTION-REPRODUCTION

The Hungarian-born constructivist artist László Moholy-Nagy (1895–1946) was the central figure in the development of avant-garde ("new vision")[1] photography in Germany during the 1920s. In his many writings on photography and his teaching at the Bauhaus,[2] as well as with his own photograms, photomontages, and camera photographs, Moholy sought to demonstrate that the visual issues raised by modern painting could be explored just as effectively through photography. His much-discussed book *Painting Photography Film*, published in 1925, predicted the birth of a modern "culture of light" which promised to transform both visual perception and visual communication.

Even before he and his wife Lucia Moholy began to experiment with the photogram technique in late 1922, Moholy-Nagy had already written about the potential experimental uses of technological mediums. In the following essay, which appeared in the summer of 1922 in the Dutch avant-garde review *De Stijl*, Moholy spells out the theoretical position which was the starting point for his subsequent work in photography and film. He proposes that mediums like film, photography, and sound recording—which previously had been used primarily to reproduce sights and sounds with precision and fidelity—might be systematically broken down into their elementary technical processes, then experimentally extended in new directions. Thus, for Moholy, "reproduction" signified imitative or representational art; his own real interest lay in "production," the creation of entirely new forms suited to a technological age. His photograms, which dispensed with the camera's lens to create abstract images directly from the play of light on photographic paper, are a striking embodiment of the ideas first set forth in this essay.

Original publication: László Moholy-Nagy, "Produktion-Reproduktion," *De Stijl* (Leiden) 5, no. 7 (July 1922).

If we are to gain an adequate understanding of the expressive and formal means of art and other related areas of creative activity, as a basis for further development, then we have to investigate the relevant factors: man himself, and the mediums he uses in his creative endeavors.

Man is a synthesis of all his sensory faculties, i.e., at any given stage he is most perfect when his constituent faculties are developed to

the limit of their potential—the cells just as much as the most compli-
cated organs.

Art is instrumental in this development—and this is one of the
most important roles art has to play, since functioning as a human
totality depends on developing the senses to their fullest extent—for
art attempts to create new relationships between familiar and as yet
unfamiliar data, optical, acoustic or whatever, and forces us to take it
all in through our sensory equipment. It is in the nature of human
existence that the senses are insatiable, that they reach out for more
new experience every time they take something in. This is the reason
for the perpetual need for new modes of creativity. *From this point of
view creative endeavors are only valid if they produce new, as yet unfa-
miliar relationships*. By this I mean that, from the creative point of
view, the most we can say of reproduction (the reiteration of relation-
ships that already exist) is that it is a question of virtuosity.

Since it is above all production (productive creativity) which has
a role to play in human development, we must turn to media which
have up to now been used only for reproductive purposes, and try to
open them up to productive ends. This calls for a close analysis along
the lines suggested by the following questions:

What is this equipment/medium for?

What is the essence of its function?

Is it possible, and worthwhile, to open it up so it can serve pro-
ductive ends as well?

We can apply these questions to particular instances: gramophone;
photography: the individual (static) image; film.

Gramophone. As yet the function of the gramophone has always
been to reproduce existing acoustic phenomena. The sound modula-
tions to be reproduced are scratched into a wax plate with a needle
and then translated back into sound again with the aid of a microphone.

The equipment could be opened up to productive ends by by-
passing the mechanical recording process. One could incise the grooves
in the wax plate oneself. The kind of sound effects played back would,
in terms of composition and of the concept of music, imply a funda-
mental renewal of the means of producing sounds (new, as yet nonex-
istent sounds and sound relationships) without new instruments and
without an orchestra.

The basic premise of such work is experimental in the laboratory
sense: close examination of the different characteristics produced in

the groove by different sounds (length, breadth, depth, etc.); investigation of one's own independently produced grooves; and finally, work on mechanical processes to perfect the manually developed language of the groove. (Possibly mechanical reduction of larger hand-engraved plates.)

Photography. The camera captures light effects by means of a silver-bromide plate at the back. As yet we've only made use of this function of the camera in a secondary sense: to capture (reproduce) particular objects as they reflect or absorb the light. If we are to bring our reassessment to bear on this, we shall have to use the light-sensitivity of the silver-bromide plate to capture and fix light effects (moments in the play of light) produced by manipulating mirrors or lenses, etc.

A great deal of experimentation is needed here. Astronomical photography using telescopic equipment and X-ray photography were interesting precedents.

Film. Motion relationships in light projection. These are brought about through a linear arrangement of frozen partial movements. Film practice to date has concentrated mainly on the reproduction of dramatic action. There has no doubt been much important work in film, in part of a scientific nature (the dynamics of various kinds of movement: human, animal, urban, etc; observations of various kinds: of how things function, of chemical action, etc; film newsreels, etc.). There has also been some extension of the reproductive function in a constructive direction, but the main challenge is to work with *motion as such*. It goes without saying that in order to do this one has to create a play of forms to carry the motion.

Animation work (advertising) can be seen as a naive attempt in this direction. More sophisticated examples can be found in the work of Rutmann[3] and in Thomas Wilfrid's Clavilux,* but there the motion appears as an abstract drama (abstraction or stylization of erotic or natural events), though it does involve the attempt to include colored imagery. The most sophisticated work to date is that of Eggeling and Richter,[4] where in place of dramatic action we find a specially created play of forms, though to the detriment of motion as a creative element. For motion here is not created pure; the overemphasis on the develop-

* The name refers to a kind of color-organ, but the concern here is with light projection on a surface, not in space.

ment of formal elements absorbs nearly all the impetus of motion. The way forward from here is to create movement in space without recourse to the development of formal elements in their own right.

Translated by Caroline Fawkes

1. The term "new vision" does not refer to any organized photographic movement. *The New Vision* was the title of the 1930 American translation of Moholy-Nagy's book, *Von Material zu Architektur* (1929), which summarized Moholy's famous Bauhaus preliminary course. In the United States, "new vision" has generally come to designate the kind of experimental photography that Moholy and other avant-garde photographers advocated.

2. The Bauhaus, established in Weimar in 1919 by Walter Gropius, encouraged its students to seek a new union of art, design, and technology. Moholy-Nagy, who taught the year long preliminary course and directed the metal workshop in the years 1923–28, was by far the most outspoken advocate of photography and film among the Bauhaus faculty. It was thanks to his example that a number of Bauhaus students took up photography in the mid-1920s. In 1926 the Bauhaus was moved to Dessau, and in 1932 to Berlin.

3. Walter Ruttman (1887–1941) was a German filmmaker known in the early 1920s for his abstract films. He received wide acclaim for his experimental urban documentary, *Berlin, Symphony of a City* (1927).

4. Viking Eggeling (1880–1925), a Swedish-born experimental filmmaker active in Germany in the early 1920s, was best known for his *Diagonal Symphony* (1924). Hans Richter (1888–1976) was a German filmmaker whose experimental *Rhythmus 21* (1921) attracted considerable attention. Richter was one of the editors of the avant-garde Berlin review *G*, and in 1929 organized the film section of the Stuttgart *Film und Foto* exhibition.

LÁSZLÓ MOHOLY-NAGY

UNPRECEDENTED PHOTOGRAPHY

In 1927 the first volume of the photographic annual *Das Deutsche Lichtbild* featured two short statements by László Moholy-Nagy and Albert Renger-Patzsch on the nature of photography and the paths it might take. Their opinions, which may be read here and in a later selection (see p. 104), contrasted sharply. The unmistakable division between Moholy's experimental attitude and Renger-Patzsch's commitment to photographic realism prepared the ground for the ensuing debates in Germany about avant-garde photography.

In "Unprecedented Photography" Moholy-Nagy presents photography as a modernist visual medium. He argues that it represents a historic mutation in the visual arts, reflecting the fact that "this century belongs to light." The immediate task of the photographer consists in developing a true "language of photography" entirely from within its own range of optical and chemical possibilities. Emphasizing the need to move beyond traditional forms of representation, Moholy points out some of the new experimental techniques which photographers might begin to explore.

Original publication: László Moholy-Nagy, "Die beispiellos Fotografie," in *Das Deutsche Lichtbild* (Berlin, 1927), pp. x–xi; also published in *i10* (Amsterdam) 1, no. 1 (1927), pp. 114–17.

Until now, all the essays and commentaries about the paths and aims of photography have been following a false trail. Again and again, the question singled out from all the various possible approaches as the most essential has been that of the relationship between art and photography.

But the *fact* of photography does not grow or diminish in value according to whether it is classified as a method of recording reality or as a medium of scientific investigation or as a way of preserving vanished events, or as a basis for the process of reproduction, or as "art."

The photographic process has no precedent among the previously known visual media. And when photography relies on its own possibilities, its results, too, are without precedent. Just one of its features— the range of infinitely subtle gradations of light and dark that capture the phenomenon of light in what seems to be an almost immaterial

radiance—would suffice to establish a new kind of seeing, a new kind of visual power.

But the subject of photography involves infinitely more. In today's photographic work, the first and foremost issue is to develop an integrally photographic approach that is derived purely from the means of photography itself; only after a more or less exact photographic language has been developed will a truly gifted photographer be able to elevate it to an "artistic" level. The prerequisite for this is: no dependence on traditional forms of representation! Photography has no need for that. No ancient or contemporary painting can match the singular effectiveness available to photography. Why the "painterly" comparisons? Why Rembrandt—or Picasso—imitations?

One can say without utopian extravagance that the near future will bring a great transvaluation in the goals photography sets itself. The investigation is already under way, although frequently along separate paths:

Conscious use of light-dark relationships. Activity of brightness, passivity of darkness. Inversions of the relationships between positive and negative values.

Introduction of greater contrasts.

Use of the texture and structure (facture)[1] of various materials.

Unknown forms of representation.

The areas that have yet to be examined can be established in line with the new elements of photographic practice, as follows:

1. Unfamiliar views made by positioning the camera obliquely, or pointing it up or down.

2. Experiments with various lens systems, changing the relationships familiar to normal vision, occasionally distorting them to the point of unrecognizability. (Concave and convex mirrors, funhouse mirror shots, etc., were the first steps.) This gives rise to a paradox: the mechanical imagination.

3. Encircling the object (a further development of stereo photography on *one* plate).

4. New kinds of camera construction. Avoidance of the foreshortening effect of perspective.

5. Adapting experiences with X-ray—aperspectivity and penetration—to the uses of photography.

6. Cameraless photographs, made by casting light on the sensitive surface.

7. True color sensitivity.

Only a work that combines all possible interrelationships, the synthesis of these elements, will be recognized as true photography.

The development of photography is receiving a powerful impetus from the new culture of light, which is already highly cultivated in many places.

This century belongs to light. Photography is the first means of giving tangible shape to light, though in a transposed and—perhaps just for that reason—almost abstract form.

Film goes even further—generally one might say that photography culminates in film. The development of a new dimension in optical experience is achieved to a still greater degree by film.

But the spadework accomplished by still photography is indispensable for a developed cinema. A peculiar interrelationship: the master taking instruction from the apprentice. A reciprocal laboratory: photography as an investigatory field for film, and film as a stimulus for photography.

The issues raised by cinema provide lessons that serve as guiding principles for the practice of photography and can enrich the photographic results themselves: changing light intensities and light tempos, variations in spatial motion engendered by light, the extinguishing and flashing forth of the whole organism of motion, the triggering of latent functional charges in us, in our brain. Chiaroscuro. Light-palpability, light-movement. Light-distance and light-proximity. Penetrating and cumulative light rays. —The strongest visual experiences that can be granted to man.

Translated by Joel Agee

1. "Facture" was the term used by many constructivist artists and critics to refer to the specific visual characteristics of a material's surface texture.

LÁSZLÓ MOHOLY-NAGY

PHOTOGRAPHY IN ADVERTISING

Moholy-Nagy did not regard photography primarily as an art form, but rather as one of the most effective means, along with film and graphic design, to transform the visual culture of the modern world. In this article, written in 1927, he attempted to demonstrate that his experimental approach to photography had potential applications in the field of advertising. Like many avant-gardists of the 1920s, Moholy held a benign view of advertising's place in modern life. He saw in it not a powerful means of manipulation, but an imaginative new form of visual communication—one attuned to the speed and intensity of urban existence. The seriousness of Moholy's interest in putting his visual experiments to practical use was confirmed when, in 1928, he left the Bauhaus to work as an independent graphic designer in Berlin.

Original publication: László Moholy-Nagy, "Die Photographie in der Reklame," *Photographische Korrespondenz* (Vienna), no. 9 (September 1927), pp. 257–60.

Photography: Terra Incognita

Photography in advertising is not an alien concept. Supposedly "good" commercial artists have frequently used "good" photographs as models for their posters, often unscrupulously translating them into the language of painting or drawing, but never allowing the photographic model to appear as such. Thus the true appeal of the original technique could never be seen.

A technical process can only attain its fullest development when its sources, its various appearances and possibilities are understood, and it is then explored on the basis of that understanding. And yet, despite photography's widespread uses and already visible potential, surprisingly little work has been done in this field.

However finished and complete photography may seem, what we are in fact experiencing today are the first groping efforts to take possession of both the apparatus and its expressive potential. That is one reason for the great impact of the new experiments. With their new results, they demonstrate more and more conclusively what possibilities

are offered by the new technology. But they have not yielded a systematic overview of photographic work. Besides, until now the products of photographic experimentation have always had their individual colorations, and therefore present little that is authoritative and from which one might deduce objective laws of work.

After a century of photographic practice it is much more important to lay a theoretical foundation, following the new viewpoint of a person who has not yet been prejudiced by art, for whom no inalterable facts of the beautiful and correct exist, and who can thus attend and respond to the laws of the material and to his own innermost being.

Photography and Advertising

The appeal of what is new and still unused is one of the most effective factors in *advertising*; therefore it is appropriate, even from the most superficial point of view, to include *photography* in advertising.

A modern engineer, if his goal and the functional purpose of his work are clear, can without any great effort make a product that is formally adequate and perfect in its economic construction. But the photographic advertisements of our time are not so easy to define. They don't come with "user's instructions." Research into the physiological and psychological laws of visual effectiveness is still far behind the times, compared to the study of physical laws.

A beginning exists: there are numerous books about advertising, there are institutes dedicated purely to the psychology of advertising, there are first-rate advertisements—but we do not yet have a clear notion of how advertising in general should adapt to the constantly changing times, how a revolution takes place in the visual and simultaneously in the intellectual sphere without first making itself felt among the masses. One should be able to detect the slightest stirrings in this area. But we are far from that in every field. Even emerging new technologies that might prove useful are frequently rejected with vague arguments, although the right questions would in most cases clear the way for their safe and productive use.

Even more easily misunderstood are the prospects opened up by the new avenues of visual expression, from manual and relatively crude techniques to the more exact, technical ones like photography and projection. They are kept relatively up-to-date only by secondary and tertiary application—in fashion and advertising.

These "secondary and tertiary applications" mainly exploit the impression of truth conveyed by photography, as opposed to the imaginative product of the painter.

But it is obvious that for any kind of work to be effective, it must be carried out in a creative manner. Creative design is founded on knowledge of fundamental biological laws and mastery of the corresponding technology. We know today that advertising, too, has need of creative powers, just like other forms of design. This insight, in turn, is the basis for conceiving of advertising photography as *visual design*.

The Nature of Visual Design

In my book, *Painting Photography Film* (Bauhausbücher 8, Verlag Albert Langen, Munich), I tried thoroughly to clarify the problems of visual design. On the one hand, representation and imitation of objective forms; on the other, primary visual facts (light-dark, color) as the medium of creative design.

With our optical apparatus, our eyes, we register primary visual data: the appearance of light and dark, or colors. These appear in various forms, positions, and directions, depending on their function and the economy of their relationships. Their sheer existence exerts a biologically determined effect on any person equipped with healthy visual organs, even when they are not copies of persons, objects, or actions.

The old paintings were effective, firstly, because of their descriptive nature (that is, the painters of past centuries provided an illiterate world with a large part of the information service that is, in our day, the function of the newspaper, book, photograph, film, and radio); and secondly, because they harmonized relationships among primary visual data. (That is, the pictures simultaneously revealed the visual laws that are grounded in the physical structure of man and are therefore universally valid. Goethe called this the "sensual-ethical" domain.) In the course of time we have often allowed our receptiveness toward the "sensual-ethical" effects of color to be blunted. Today we are faced with the task of clearing away a slag heap of false opinions about the primacy of visual values and the meaning of pictures. The painters of the last hundred years did a good part of the spadework. More and

more, their paintings became experiments in liberating color for immediate sensory experience—and all the more powerfully as our urban, technologized existence was progressively drained of color. Even the technical aspects of painting were purified, and from the interaction of idea and technology there emerged a freer, more objective approach to the use of technical methods. Here technology not only led to a purification of the recording process, but also to a purification of the intellectual attitude. As a result, future visual designers will no longer reject out of hand scientific knowledge that has long been exploited by technology and industry: light polarization, interference phenomena, subtractive and additive color mixtures, etc. Knowledge of primary visual relationships will therefore be aided by a purified technique that will replace the primitive instruments of the past (brushes, canvas) with the most precise physical implements (spray guns, projectors, reflectors, exact surfaces of artificial material). Serious contemporary photography is—in the technical sense—the pioneer of this instrumentation. In the biological sense, it still lags behind painting.

On the Autonomy of Photographic Means

There are infinite worlds hidden from our view in photographic matter. It is necessary to extract from the inherent laws of the medium a corresponding result: an exact language of photography.

Thus an effort is currently being made to assemble everything that is relevant to photography or associated with it, in order to accelerate its process of crystallization and deduce from that various working methods. The path to crystallization takes us initially through the most primitive applications: pure representation of the world of objects, an optical recording of appearances, simply to take note of their existence. Photography does not want to simulate anything, it records, but this recording method—we must emphasize this again and again— has its own, still unfathomed laws with respect to technique and design. Contrary to the usual idea that photography reaches its highest point in imitation, we must emphasize that the ability to capture the appearances of light and make them seem virtually tangible belongs to no other medium. An effort to explore this capacity is now being made. Foremost among these experiments is *cameraless photography:* the fix-

ing of spatial rays in black-white-gray, in their immaterial, non-pigmentary effect. Where photography is used without a camera, as in a photogram, the relationships of contrast between deepest black and brightest white, with the intermediation of the subtlest gray tones, are sufficient to create a language of light that is devoid of representational meaning yet capable of eliciting an immediate visual experience. If this kind of pictogram is compared with good photographs taken with a camera, the surprising conclusion will be that the elements conducive to the picture's effectiveness are the same in both cases.

Intimation of a Program

Countless photographic experiments are under way. They often take separate paths; nevertheless, their differences are simply facets of one and the same phenomenon. All that is happening is that from time to time people yield to the tremendous expansion in photographic technology. The boundaries of this expansion are incalculable. Everything is still so new in this area that the very act of searching leads to creative results.

Technology is the obvious pioneer in this process. The illiteracy of the future will be ignorance of photography. All the desires of today's photographic epicures will then be an unremarkable if not automatic accomplishment.

But before that, several branches of photography will have to be fully developed:[1]

1. Conscious use of light-dark relationships (quantity-quality):
 (a) The activity of brightness, passivity of darkness;
 (b) Inversions of the relationships between positive and negative values:
2. Introduction of the greatest contrasts.
3. Use of the texture and structure (facture) of various materials. Not according to illusionist points of view, but according to light-dark—direction—form.
4. Unknown forms of representation:
 (a) Unfamiliar views made by positioning the camera obliquely, or pointing it up or down:
 (b) Experiments with various lens systems, changing the relationships familiar to normal vision, occasionally distorting them to the point of "unrecognizability." (Concave and convex mirrors, funhouse mirror shots, etc., were the first steps.) This gives

rise to a paradox: the *mechanical imagination*. "Photoplastic":[2] superimpositions, retouchings:

(c) Encircling the object; a further development of stereo photography on *one* plate;

(d) New kinds of camera construction; avoidance of the foreshortening effect of perspective;

(e) Adapting experiences with X-ray—aperspectivity and penetration—to the use of photography.

5. Cameraless photographs made by casting light directly on the sensitive surface.

6. Use of new emulsions on all sorts of materials.

7. Accurate and supremely flexible color sensitivity.

8. Full development of the various methods of projection and reflection: film, sky projection, plays of light.

9. Photographic typesetting and printing machines; wireless photography; optophonetics.[3]

Whether the exploration of these points comes to serve science or the news service, literature or advertising, is of no fundamental importance. Advertising can use anything that increases its effectiveness. A good advertisement must take all the possible reactions and subtle feelings of the public into account. A dangerous idea in the hands of people without culture, but useful for all who live with their time and recognize its challenges.

Today everything is concentrated, more powerfully than ever before, on the visual. Another reason for taking possession of all available means of visual expression.

The Photogram in Advertising

As an experiment I have used photograms on book covers, magazines, and posters for optical companies. The visual medium itself produced effective possibilities. It is easy to predict that our eyes, trained to adapt to the increasing refinement of visual language, will soon encounter similar works yielding even richer and more stimulating pleasures. That is true for the use of *X-ray pictures*.

An X-ray photograph is also a photogram, a picture produced without a camera (in this case, a reproduction of an object). It permits us to look into the inside of an object, penetrating it, and at the same time revealing its outer form and its construction. Used in advertising, X-rays will be important and profitable in the near future.

"Photoplastic"

The dadaists tried to combine pieces of different photographs into a new whole that would affect the viewer by its confusion of colors and forms. Illustrated magazines are trying to produce a realistic representation of "nonsensical" subjects by cleverly retouching parts of the picture or introducing elements that do not belong in it (April Fool's jokes).[4] These photomontages were the precursors of new and future "photoplastics."

My goal is to produce photoplastics which—although composed of many photographs (copied, pasted, retouched)—create the controlled and coherent effect of a single picture equivalent to a photograph (with camera obscura). This method allows us to depict a seemingly organic super-reality. Its possible uses are infinite. Photosculpture can be especially effective in advertising. By developing and mechanizing this technique, photoplastic, together with direct photography, will in all probability eliminate all the different types of manual-imitative painting. Hardly anyone has the courage, as yet, to see the perfect and overwhelming interconnectedness, the creative powers that are involved in the making of a work of visual imagery with mechanical means. Nevertheless, the development of photoplastic, of super-photography, is inevitable.

Photoplastic in Advertising

As in so many other vital areas of modern life, the Americans, thanks to their freedom from traditional constraints, are ahead of Europe in the use of photographs for advertising. Their healthy instinct, their uninhibited feeling for life in the present, their material, tactile-haptic disposition (their preference for "tangible" facts),[5] long ago led them to use photographs of merchandise in their advertisements. They quickly left the primitiveness of their beginnings behind. They have worked out a brilliantly clean way of clarifying the picture even to its smallest details (setting aside their use of typography, which is, for the most part, inferior).

Naturally, photoplastic posters and ads must work their effects not merely by means of their associative potential, but also through a clear visual organization of light and dark tones.

These and similar experiments have to be tried and pursued again

and again, for we will advance beyond the standards of the past only if we recognize and cultivate the autonomy and self-sufficiency of the medium.

And if the same demands we are making of black-and-white photography are applied to color photography, the most revolutionary visual developments will occur.

Translated by Joel Agee

1. In the passage that follows Moholy-Nagy repeats a number of points made earlier in "Unprecedented Photography" (see preceding selection).

2. "Photoplastic" was the term Moholy-Nagy introduced as a substitute for "photomontage," in order to emphasize the compositional pliability of the technique. The new name never found wide use, and Moholy himself eventually dropped it.

3. Optophonetics was a proposed method of electronically translating light waves of differing lengths, which are visible as variations in color, into corresponding sound variations. Both Raoul Hausmann and Moholy-Nagy (in his book *Painting Photography Film*) looked forward to the development of optophonetic techniques that would make possible abstract "musical films" combining optical and acoustic tracks.

4. Here Moholy undoubtedly refers to the *Aprilscherzen* made famous by the *Berliner Illustrirte Zeitung*, Germany's largest illustrated weekly. Each April 1 *BIZ* presented its readers with an elaborately doctored photograph showing some unlikely sight: for example, elephants wandering the main streets of Berlin.

5. Moholy draws here on terminology popularized by the art historian Alois Riegl in his book *Die spätrömische Kunstindustrie* (1901). In Riegl's view, the history of art involved the slow shift of human perception from a haptic (or tactile) dominance to an ever more purely optical relation to the world. Moholy relied on this notion to justify his belief in the supercession of painting by photography. The tactile values of a painted canvas, he asserted, were anachronistic in comparison to the photograph's manipulation of pure light values.

ERNÖ KALLAI

With responses from
Willi Baumeister, Adolf Behne, László Moholy-Nagy

PAINTING AND PHOTOGRAPHY
(Excerpts)

In 1927 the Amsterdam avant-garde review *i10* published this essay by Ernö Kallai; it proved controversial enough to draw replies from critics, including Adolf Behne, and artists, such as Willi Baumeister and László Moholy-Nagy. Kallai (1890–1954), who settled in Germany after leaving his native Hungary in 1920, contributed art criticism to a number of German magazines and was an editor of the *Socialistischen Monatshefte*. Although he was among the early advocates of constructivist art, from the mid-1920s Kallai grew ever more pessimistic about the results produced when art and machine technology were combined. Kallai's views became very evident in 1928 when he was named editor of *bauhaus* magazine: in its pages he questioned many of the fundamental ideas of recently departed Bauhaus figures like Walter Gropius and Moholy-Nagy.

In "Painting and Photography" Kallai attempts to define the different expressive possibilities open to the two mediums. To do so he employs a critical term that had been frequently used in discussions of constructivist art: facture, or the visual texture of a material surface. For Kallai, painting is inevitably a more aesthetically satisfying medium than photography. The variable physical qualities of paint pigment, he argues, encourage the viewer to recognize and respond to the complex relation between a painting's material reality and its aesthetic, nonmaterial aspiration. The surface of the glossy photographic print, on the other hand, offers no such textural play, only an "optical neutrality" that Kallai finds deadening. Kallai continued to explore these questions in his 1928 essay "Pictorial Photography," also included in this volume.

While the responses of the painter and graphic designer Willi Baumeister (1889–1955) and the Berlin art and architectural critic Adolf Behne (1885–1948) take issue with Kallai's arguments, probably the most dramatic contribution to the exchange is Moholy-Nagy's. He accuses Kallai of a veiled attempt to rescue the craft of painting, which Moholy regards as obsolete in a machine age. Moholy insists that facture remains an important part of the photographic image, too—no longer in the form of "coarse-grained pigment," but as an increasingly sophisticated manipulation of light and shade, a true "facture of light."

Original publication: Ernst (Ernö) Kallai, "Malerei und Fotografie," *i10*, 1, no. 4 (1927), pp. 148–57; responses in *i10*, 1, no. 6 (1927), pp. 227–40.

The return of painting to objective representation is frequently criticized as an imitation of nature that can be achieved considerably more easily and more completely by photography. Even so convinced a theoretician of the New Objectivity as Franz Roh[1] warns postexpressionist art against falling into the external imitation of objects, because it "could thereby shrink in importance, and all of painting could be overrun by those splendid machines (photography and film) that in terms of imitation garner us such a harvest of unsurpassable things." According to this view, the imitation of nature is of interest for painting merely as raw material or as the subordinate part of real pictorial creation. . . .

If, however, the vital creative impulse in painting today can still lie precisely in this, that one brings a sense of devout admiration to even the most modest expressions of nature, then it is impossible to consider imitation and creation as irreconcilable opposites. And it is not a question of limiting the former exclusively to the field of photography while assigning the latter only to painting. All the less so inasmuch as photography, in its own special way, can be just as representational and at the same time just as creative as painting. It needs only to find its master.

We know photographic depictions, portraits, and landscapes that owe their beauty to such ingenious and delicate operations in the mechanics and chemistry of their birth that they must be judged craftsmanly creations of high artistic culture. This is the case with the photograms of such artists as Man Ray, Moholy-Nagy, and Spaemann-Straub,[2] which have become free of restriction to subject matter to the point of complete nonobjectivity, and appear as ghostly emanations of light.

The difference between painting and photography, therefore, has nothing to do with the false alternatives "imitation or creation." On both sides are to be found creatively animated, that is, creatively formed, reproductions of nature, as well as creations that stand outside of any objective connection. Even the question, "handicraft or mechanical work?" is not decisive. The painter is given the possibility of bringing the lawful production of form in his domain right up to the edge of a

disposition that is based simply on calculation, and he may endow his facture with a polished evenness or the glossiness of enamel. There are a number of pictures of this kind (by Mondrian, Malevitch, Moholy-Nagy, Lissitzky, and Buchheister,[3] among others) that—despite mechanical gestures and the theoretical attacks of their own creators against this art—are paintings, indeed, excellent paintings. On the other hand, the many craftsmanly possibilities available to the photographer have already been indicated. . . .

Photography is incapable of this impressive degree of materiality and palpability. To be sure, it produces marvelously clear and distinct reproductions of reality. But the material substrate of this rich illusion is exceedingly poor and insubstantial. It is limited to the dull coating of the light-sensitive layer of the negative plate or film, and to the sheen or tint of the printing paper. Both the negative and the positive lack facture—lack a visually perceptible tension between the image and the picture material. From its modest solidity, the visage of nature is sublimated as a *light* picture. It makes no difference if the photograph's present black-and-white translation of light is eventually extended to color. Color photography, too, can only be a materially neutral "light-image" of nature. It may attain an appearance of reality as forceful as that of painting; it may even surpass it. But the plastic invigoration of the image, its orchestration, so to speak, through facture, is lost to photography.

The intrusion of facture in all the effects produced by painting has very fundamental consequences for the particular nature of the creation of images in this art and for the law governing this creation. The finest compositional techniques are absolutely demanded by the tactile values of its facture—by the material, quantity, plastic structure, and surface of its physical covering. This is why the simple substitution of these tactile values by paper texture and photomechanical printing is so detrimental to the quality even of those reproductions that, in other respects, do an excellent job of approximating the original. . . .

Through this property of the facture even the most soaring, spiritually oriented pictorial visions are connected directly into the current of our perceptions of material efficacy; they are, so to speak, incorporated into our existence. Thus arises the great, exhilarating tension between the sometimes coarse palpability of the means of creation and the spiritual intention they embody. And in this tension lies the special creative force, the real beauty of all painting. By contrast,

the lack of facture removes even the clearest photographic representation of nature from our sense of material reality. It may simulate the appearance of reality ever so convincingly, yet this appearance remains incorporeal, without weight, like reflections in a mirror or in water. Here is a decisive opposition: painting can join the coarsest materiality of means with the most delicate spirituality of vision; photography can display the ultimate material refinements of the means of creation yet nevertheless provoke representations of the coarsest realism. . . .

There are photographers who would like to give their picture area a flat structure. They constrict the natural view, work with interlaced diagonals that hit against the image boundaries, or with parallel lines extended across the image field that run into the perpendicular or horizontal boundary lines of the image. However, the more they take pains to build up their composition in layers and to bring it into a structural relationship with the picture plane, the more evident it becomes that all these efforts are in vain, since photographs have no facture in which such multilayered connections can be physically realized. The gelatine of the light-sensitive layer and the paper texture offer no resistance against which there could be generated an accord and a tension within the image's grain. The plane in which the photographic image forms is a pure, transparent mirror surface where all forms and tones can come into view without resistance, though it is precisely on account of this lack of resistance that they unavoidably lose any fixed relationship to the picture plane. Their combination, effected through the action of the photographic material, is one of complete optical neutrality, and as a result even the most immediate foreground shot seems to reach back into an indefinite depth behind the picture plane. Between the most extreme photographic foreground and the picture plane there always lies the incomprehensible appearance, dull or shiny, of an air-filled interval. No photographic figure can take shape in the picture plane itself. An optical union with this plane is possible only at the price of the complete effacement and dissolution of form. The photographic picture plane has just one use, to be a resistance-less vista onto spatial emanations of light. For insuperable physical reasons its own optical appearance is without consistency or tension. Consequently all attempts to give this appearance the look of a tension-filled picture, with the kind of compression of the image found in painting, are empty and vain. They go against the creative possibilities of their material and are thus inimical to style.

Certainly photography, excluding cinematography, is motionless, like painting. But this motionlessness cannot be stiffened and expressively emphasized by a structure of mutually opposed tensions. Once again, this results from lack of facture. Like all other tensions in the picture, these static tensions, too, receive their load-carrying capacity in the last analysis from the material combination and hardening made possible by facture. The material saturation that occurs through facture endows even a completely naturalistic representation with special weight and force of inertia in the optical equilibrium of its world of illusion. Compared with such naturalistic representations in painting, all photographic compositions come across as passive tarrying in space, without any tension, no matter how richly endowed their forms may be with indications of static interlacings and combinations. A baroque painted ceiling or a suspended construction painted by Lissitzky or Moholy-Nagy will always endure in the realm of movement and countermovement governed by the force of gravity, whereas in a photographic landscape the optical equilibrium signifies no tension-filled meeting of opposites, no struggle, but rather an already anticipated state. This is due simply to a lack of facture, of real material arrangement and weighting down of forms.

Just how far the range of effects can be extended through facture has recently been demonstrated in cubism and related artistic manifestations. Picasso, Braque, Willi Baumeister, and others devoted the greatest care to making their facture a composition of the most varied tactile values (rough, smooth, dense, porous; elevated, sunken) and, what is more, a texture of the most varied materials (oil, paper, graphite, plaster, etc.). This division within the facture serves the purpose of emphasizing even further the tectonic relationships within the partial surfaces, surfaces that are determined through color and form and out of which in turn the layers of the overall texture of the picture are built up. The Russians Tatlin, Pevsner, Rozanova, and Altmann,[4] among others, turn facture almost into an end in itself. They strive to give the picture's material composition its most intense development and to subordinate all other effects produced by the picture to this realism of facture. This results in the creation of works that, despite their uniformity and limitation to a single color, are animated in the highest degree. Effects are produced that photography, with its lack of facture, can never hope to match.

To be sure, attempts have been made to give photography the materially more vivid appearance of facture by the use of textured paper and refined printing techniques, in particular to liken this appearance to the painting of Rembrandt or the Impressionists. But such deceptions always betray the emptiness behind the dummy. A more felicitous course has been found by those artists who construct photographic compositions by pasting together various cutouts (Heartfield, Grosz, Hausmann, Moholy-Nagy, Hannah Höch, Citroen, among others).[5] This procedure has yielded its most truly powerful effects within the context of futurist and dadaist aims. These mounted photographs indisputably possess a high level of tension in their surfaces and in their static relationships. Yet even here a certain degree of contradiction persists between the photographically determined insubstantiality of the individual surfaces and the total effect, which is achieved through the presence of a true material plane that serves to hold together the montaged pieces. Such photomontages are hybrids between painting and photography. . . .

The limits that are drawn by facture signify, however, certain restrictions even for painting. . . . The constructivists, in their efforts to pursue painting as the expression of a purely technical spirituality, reasonable and exulting in movement, have in this way made many experimental strides beyond the materially determined limits of their art. The attempt to achieve the greatest possible material relaxation of tension, and thus the greatest relaxation in terms of surface and static relationships, leads into the realm of photography. Such freely floating immateriality can be attained only by light emanations, in particular the nonobjective light formations of photography. And these formations point quite clearly toward the transition to movement. They strip the vision of things of its materiality, but with this loss in creative life they acquire in turn the wonderful, vibrant asset of movement and arrive at the moving photograph, that is, film. These possibilities contain the seeds of photography's greatest threat to painting. Painting or film?—that is the fateful question of visual creation in our time. This alternative is an expression of the historical turning point in our mental existence. We stand at the frontier between a static culture that has become socially ineffectual and a new, kinetic reformulation of our world picture that is already penetrating the sensibility of a mass audience to an unheard-of degree.

Response by Willi Baumeister

Rousseau painted a landscape in which telephone poles with white insulators are visible. No previous painter had considered such things of any use. But he was without sentimentality, concrete and more enamored of the truth than all his fellow landscape painters. His pictures even resembled photographs, and yet at the same time they were more abstract.

The quantity of his naturalism was great, the quantity of his abstraction small, but it was qualitatively intense. The painters of the synthetic tendency have meanwhile turned toward abstraction. They sought the complete negation of the imitation of nature, and that is how they attained the truth of creation in itself, that is, of means and material. Photography, as a creative means and a kind of neo-naturalism, would like to display relationships similar to those found in Rousseau, whereby, along with a large quantity of naturalism, a small but intense quantity of abstraction produces the work. And photography has succeeded in this endeavor. The so-called "Sachlichkeit" does not display these propitious relationships. The results of "Sachlichkeit" remain vague creations. Their literary, sociopolitical value, on the other hand, is recognized.

Response by Adolf Behne

Kallai compares a landscape by Courbet[6] with an ordinary landscape photograph and finds, rightly, a difference. He defines it thus: the landscape by Courbet has facture, the photograph does not; and he generalizes this (in itself debatable) assertion to a thesis: painting and photography are fundamentally and truly different because of the presence of facture in the one case and its absence in the other. He thus comes to the conclusion that constructivist painting, which places but little value on facture (which, moreover, is scarcely true), threatens to turn into photography, a reproach that earlier has been addressed rather to the crass naturalists.

Kallai proceeds according to the wrong method. Courbet's landscape has not only facture but a frame as well; that is to say, it is also—and this is decisive—an ordering of a given surface. The ordinary landscape photograph is not. (When it does contain the beginnings of an order, these come from the same source as Courbet's order

and therefore have nothing to do with photography as such.) If Kallai wants to put a Courbet on one side (craftsmanly facture plus order), then on the other side he must put a work that represents mechanical facture plus order. (For, in fact, photography also has facture—only it is a technical rather than a craftsmanly one, just as, say, a machine-made cup also has a facture, although not an individual craftsmanly one.) As a first step toward "mechanical facture plus order" Kallai himself mentions the photomontage, and here he has to agree that only "a remnant of contradiction persists." (That such a remainder is still there seems quite understandable, since photography is still fighting for its own special law of creating order.) If Kallai wishes to exclude the element of order from photography, then he must do the same with painting; otherwise, the comparison cannot yield useful results. He would then have to formulate the comparison in this way: on the one hand, the facture of the brush, and, on the other, that of light. Perhaps he would then arrive at other results.

The characteristic thrust of Kallai's work is its enthusiasm for the individual, craftsmanly work of the brush. An enthusiasm that leads him to turn facture into an independent entity unto itself.

The one-sided overestimation of facture would have to lead Kallai to the following conclusion: a photograph after a painting by Mondrian belongs with an amateur photograph from Wannsee Beach, for both are without facture; while Mondrian's painting belongs with a retouched photograph from the Arthur Fischer Studio, Berlin, Passage . . . , since both possess facture.

Response by Lázsló Moholy-Nagy

The way in which something has been produced shows itself in the finished product. How it shows itself is what we call facture. It would be a mistake to call facture only that which appears as palpable surface simply because most of the earlier manual techniques at the same time display a tactile value.

But precisely because, for me, facture is not the same thing as tactile value, I find Ernst Kallai's formulation of the problem unfounded. I see in it, rather, a veiled attempt to rescue craftsmanly, representational painting.

There is nothing to object to in representation. It is a form of communication that concerns millions of people. Today it is possible

to obtain visual representation of unprecedented accuracy by photography and film. Manual procedures cannot match these techniques. Not even, indeed least of all, through the qualities of facture. For when facture becomes an end in itself, it simply turns into ornament.

Likewise with photography. It too should be employed—and for the moment this is a mere wish—in its primary truth. The fanatical zeal with which photography is pursued in all circles today indicates that those with no knowledge of it will be the illiterates of the future. In the coming age photography will be a basic subject like reading and arithmetic. All the wishes of the photographic gourmet will then become second nature, if not achieved automatically.

Beyond this—and despite all the prejudices on the subject—photography is justified not merely as a reproductive technique, for it has already accomplished significant things in the productive realm. It teaches us how to refine our use of the medium by revealing possibilities inherent in the interplay of light and shadow. Through a chemical process, the finest tonal gradations form in a homogeneous layer. The coarse-grained pigment disappears, and a facture of light emerges. Very good results have been obtained with this black-and-white effect of the photographic layer—even without representation (in the photogram). Similar things are bound to happen in the domain of color. The achievements of the color chemists as well as the discoveries of the physicists, allowing us to work with polarization, interference phenomena, and subtractive mixtures of light, will supersede our medieval pictorial methods.

This does not mean that the activity of painting in the manual fashion is doomed, either today or in the future. What "inspired" earlier times can also be a pedagogical instrument for developing a deeper, more intense understanding. But the recognition or rediscovery of an expression that develops on the basis of biological factors and is therefore self-evident ought not to be set forth as a special accomplishment. The personal evolution of an individual who gradually rediscovers through his own effort all previous forms of optical activity cannot become a constraint on those who are more highly developed, on everyone.

The "fateful question," in my opinion, is not "painting or film," but rather the advance of optical creation into all the places where it may legitimately go. Today that means photography and film, as well as abstract painting and play with colored lights.

The new generation, which does not have as much sentiment and tradition to shed as we do, will profit from the problem's being posed in this way.

Translated by Harvey L. Mendelsohn

1. The *Neue Sachlichkeit*, or New Objectivity, was a major current in German realist painting of the 1920s. In his 1925 book *Nachexpressionismus* (Postexpressionism), the art historian Franz Roh (see p. 160) examined the emergence of the *Neue Sachlichkeit* movement.

2. Heinrich Spaemann and Karl Straub were German photographers active in the 1920s whose photograms appeared in the review *i10*.

3. Carl Buchheister (1890–1964) was a painter of geometric abstractions during the 1920s.

4. Vladimir Evgrafovich Tatlin (1885–1953), Antoine Pevsner (1886–1969), Olga Vladimirovna Rozanova (1886–1918), and Natan Isaevich Altmann (1889–1970) were key figures in the development of Russian constructivism.

5. Hannah Höch (1889–1978) was a German painter and dada photomonteur. Paul Citroen (b. 1896), a Dutch painter and photographer, worked in Berlin and Amsterdam during the 1920s.

6. Actually, Kallai makes no reference to Courbet in his essay. Behne uses the work of Courbet, known for its thickly painted surfaces, to represent the epitome of painterly facture.

ALBERT RENGER-PATZSCH

AIMS

After serving in the German army during the First World War, Albert Renger-Patzsch (1897–1966) studied chemistry at the Dresden Technische Hochschule, and in 1920 opened his own photography studio in Bad Harzburg. His meticulous photographs emphasizing the formal aspects of plants, architecture, and machines quickly attracted attention. Thanks to the success of his 1928 picture book *The World Is Beautiful*, Renger-Patzsch was by the end of the decade one of the most influential and widely exhibited photographers in Germany.

Renger-Patzsch championed a style of precise, ultra-objective photography that in some ways ran parallel to the *Neue Sachlichkeit* (New Objectivity) movement in German painting of the twenties. Although he believed, like Moholy-Nagy, that photography must develop its own, specific means of expression, Renger-Patzsch was convinced that "the secret of a good photograph resides in its realism." Thus he found little value in the work of either old-style pictorial photographers or contemporary experimentalists like Moholy-Nagy. When in 1927 *Das Deutsche Lichtbild* published short statements by Renger-Patzsch (reproduced below) and Moholy-Nagy (see p. 83), the stage was set for a much wider discussion of modern photography which other voices were quick to join.

Original publication: Albert Renger-Patzsch, "Ziele," *Das Deutsche Lichtbild*, 1927, p. xviii.

Photography has only recently come of age. Emulating the visual arts through the medium of photography is still the endeavor of many gifted photographers, and, today no less than in the years of photography's infancy, success in this vein is still the criterion of artistic style in photography.

Art is at a turning point. Since the turn of the century, there has been a prevailing effort to avoid worn paths in order to discover *new laws*.

Artistic expression played a significant role, though not the most important one, in the art of earlier epochs. Historical, religious, literary impulses predominated, although the emphasis shifted at various

times. Always lagging behind these trends was: photography. Photography has its *own* technique and its *own* means. Trying to use these means to achieve painterly effects brings the photographer into conflict with the truthfulness and unequivocalness of his medium, his material, his technique. And whatever similarity to works of pictorial art can be attained is, at best, purely superficial.

The secret of a good photograph, which can possess artistic qualities just as a work of visual art can, resides in its realism. For rendering our impressions of nature, of plants, animals, the works of architects and sculptors, and the creations of engineers, photography offers us a most reliable tool. We still don't sufficiently appreciate the opportunity to capture the magic of material things. The structure of wood, stone, and metal can be shown with a perfection beyond the means of painting. As photographers, we can express the concepts of height and depth with wonderful precision, and in the analysis and rendering of the fastest motion, photography is the undisputed master.

To do justice to modern technology's rigid linear structure, to the lofty gridwork of cranes and bridges, to the dynamism of machines operating at one thousand horsepower—only photography is capable of that. What those who are attached to the "painterly" style regard as photography's defect—the *mechanical* reproduction of form—is just what makes it superior to all other means of expression. The absolutely correct rendering of form, the subtlety of tonal gradation from the brightest highlight to the darkest shadow, impart to a technically expert photograph the magic of experience.

Let us therefore leave art to the artists, and let us try to use the medium of photography to create photographs that can endure because of their *photographic* qualities—without borrowing from art.

Translated by Joel Agee

AUGUST SANDER

REMARKS ON MY EXHIBITION AT THE
COLOGNE ART UNION

August Sander (1876–1954) was among the most significant portrait pho-
tographers working in Germany during the 1920s and 1930s. In the early
1920s he abandoned his earlier atmospheric, pictorialist style in favor of an
objective, matter-of-fact approach to his subjects. In 1924 Sander embarked
on an ambitious long-term project, making portraits of Germans from all
classes and occupations. His work on the project ended only with the Nazi
accession to power in 1933.

Sander exhibited a number of his portraits in 1927 at the Cologne Art
Union. At this time he prepared the following statement of his aims, which
was displayed as a wall panel adjacent to the exhibition. Reaction to the
exhibition was highly favorable—Sander was hailed as a "Balzac of the
lens"—and helped pave the way for the publication of sixty of his portraits
in the book *Antlitz der Zeit* (Face of the time) in 1929.

Original publication: August Sander, "Erläuterung zu meiner Austellung im
Kölnischen Kunstverein," exhibition statement, November 1927; reprinted
in *Vom Dadamax zum Grüngürtel. Köln in der zwanziger Jahre* (Cologne:
Kölnisch Kunstverein, 1975), p. 148.

People of the 20th Century
A Cultural History in Photographs

divided into 7 groups, arranged by cities, comprising about
45 portfolios

I am often asked what gave me the idea of creating this work:

Seeing, Observing, and Thinking

and the question is answered.

Nothing seems better suited than photography to give an abso-
lutely faithful historical picture of our time.

We find illustrated writings and books from every period of his-

tory, but photography has given us new possibilities and tasks that are different from those of painting. It can render things with magnificent beauty but also with terrifying truthfulness; and it can also be extraordinarily deceptive.

We must be able to bear the sight of the truth, but above all, we must transmit it to our fellow human beings and to posterity, regardless of whether this truth is favorable to us or not.

Now if I, as a healthy human being, am so immodest as to see things as they are and not as they should or might be, I hope I will be forgiven, but I can do no other.

I have been a photographer for thirty years and have taken photography very seriously; I have followed good and bad paths and have recognized my mistakes.

The exhibition in the Cologne Art Union is the result of my search, and I hope to be on the right path. There is nothing I hate more than sugar-glazed photography with gimmicks, poses, and fancy effects.

Therefore let me honestly tell the truth about our age and

people.

Translated by Joel Agee

ALBERT RENGER-PATZSCH

JOY BEFORE THE OBJECT

In the following essay, which appeared in the Berlin art journal *Das Kunstblatt*, Albert Renger-Patzsch (see p. 104) develops his idea of photographic realism as the only legitimate path for serious photographers. At this time his sharpest criticism was still directed at the pictorial photographers, who remained quite active in Germany. Renger-Patzsch's call for photographers to "look at things anew" did not, however, signal an approval of experimental photographic techniques. Before long his main attack would shift its target to avant-gardists like Moholy-Nagy, who in his opinion relied too heavily on visual devices developed by abstract painting.

Original publication: Albert Renger-Patzsch, "Die Freude am Gegenstand," *Das Kunstblatt* (Berlin), no. 1 (1928), p. 19.

Photography has been in existence for nearly a hundred years. The country-fair magicians have become a group of serious professionals.

Through films and illustrated magazines, photography exerts a tremendous influence on the masses. The photographic industry is developing at an American tempo and we are in possession of a splendid tool.

It strikes us as all the more peculiar, then, that so-called "artistic photography" still lies aslumber like Sleeping Beauty, and that pictures in the style of an 1890 *Gartenlaube*[1] are still accorded the highest recognition at the great international exhibitions.

Due to its mechanical processes, photography is without doubt the most refractory artistic medium; and at a time when photography was technically still very unfinished, the most obvious course of action was to engage in a race with painting and to produce photos in which one tried to feign "art," ruining one's own technique with an alien method.

To a photographer who remains within the limits prescribed for photographic technique, the mechanical procedure of his medium, the swiftness of its execution, the objectivity of its representations, and the possibility of arresting static moments of fast and even the

fastest movements—these represent the greatest and most obvious advantages over every other medium of expression.

The rigid adherence of "artist-photographers" to the model provided by painting has always been damaging to photographic achievement. There is an urgent need to examine old opinions and look at things from a new viewpoint. There must be an increase in the joy one takes in an object, and the photographer should become fully conscious of the splendid fidelity of reproduction made possible by his technique.

Nature, after all, is not so poor that she requires constant improvement. There is still room within that rectangle of shining bromide paper for new spatial and planar effects; many things still await the one who will recognize their beauty. The unretouched photos reproduced here are efforts in this direction.

Translated by Joel Agee

1. *Die Gartenlaube* was a popular magazine aimed at a middle-class audience, and known for its sentimental illustrations.

HUGO SIEKER

ABSOLUTE REALISM:

ON THE PHOTOGRAPHS OF ALBERT RENGER-PATZSCH

Hugo Sieker (b. 1903), a writer about whom little is known, offers in the following essay both an eloquent appreciation of the photographs of Albert Renger-Patzsch and a strong argument for photography as a medium of "absolute realism." On this point Sieker takes open issue with László Moholy-Nagy, especially with Moholy's idea that photography should be used not only in a "reproductive" (that is, representational) manner, but also in experimental ways to create utterly new types of images. Sieker insists that what sets photography decisively apart from other visual mediums is its unrivaled capacity as a faithful recording instrument, one able to reveal the very essence of the object before the lens. In Renger-Patzsch's photographs of nature Sieker finds evidence of an unsuspected "prodigality of existence," and a power that is not only aesthetic, but spiritual.

Original publication: Hugo Sieker, "Absolute Realistik. Zu Photographien von Albert Renger-Patzsch," *Der Kreis* (Hamburg), March 1928, pp. 144–48.

I

Photography, which spent eighty of the hundred years of its existence in ignorance of itself, dedicated to the ideal of resembling painting as closely as possible, has only recently grown conscious of its own laws and thereby become an independent domain of visual art.

Thanks to two (opposite) essential characteristics, photography has conquered extensive new realms of visual expression:

—It is the medium of *absolute realism*, a goal which manual art has never completely achieved and has approximated only at the expense of its more fundamental powers. Is it a coincidence that naturalism in painting became a questionable ideal at the moment when the medium of absolute naturalism had been obtained?

—It provides the means for a super-realism and for the capturing

of other dimensions (the miracle of slow motion in film, of *time sequence* in general).

As the most reliable realistic method of apperception it stands primarily in the service of science: as X-ray, in astronomical and microscopic photography, as geological, zoological, and aerial reporter, in close-ups and enlargements of motifs from the plant world (Prof. K. Blossfeldt),[1] etc., it brings things to light that would otherwise remain mysterious and obscure.

Photography's propensities for illusion and irrealism have mainly been cultivated with artistic intentions: in the many cinematic tricks, in the superimposition of different objects (simultaneity), in photocollage[2]—which an artist like Max Ernst has used to remarkable effect (a method, incidentally, that was used by Strindberg as early as 1890, just as in an inspired mood he anticipated reflective photography by directly recording moonlight, for instance, on a bromide silver plate);[3] also in photomontage (Russia) and typophoto;[4] but mainly in the *nonrepresentational light projections,* so-called photograms, magical games with and without a camera, whose inventors and masters are Moholy-Nagy (Dessau) and Man Ray (Paris).

The photogram developed out of opposition to the use of photography as a faithful recording instrument. In his interesting "Apology for Photography,"[5] Moholy-Nagy demands that photographic techniques that are used exclusively for "reproductive purposes" be put to productive use, and he recommends the employment of mirrors, lenses, crystals, and liquids to fix *consciously controlled light phenomena* on the plate. Man Ray has, in a similar way, accomplished veritable feats of magic by using light effects or double exposures to transform pipe bowls, teaspoons, eggs, and the like into ghostly apparitions of some other dimension. A cubist of photography, he plays with physical and chemical laws and can summon an astral phenomenon from any trouser button.

II

Moholy-Nagy is mistaken when he deprecates representation as "reproduction." This argument is very popular among proponents of the various directions of abstract art, but it is surely inadequate. For an object translated into pictorial terms has not only its value as a thing,

but also an "abstract" value created by the structure, the weight distri-
bution, and the rhythmical tensions of the picture plane. For this rea-
son the "New Objectivity" should be regarded not so much as a reaction
against non-representational art as its synthetic revision. What was
termed "abstract" by one school was put to use by the other, though
not for its own sake.

How empty this controversy becomes in the light of a Russian
film, this extraordinary realization of every point in Marinetti's futur-
ist manifesto and of all the naturalist tendencies from Hauptmann to
Dix![6] Many an approach that, in painting, had been inflated into an
independent idea, shrinks back into a subordinate *means* in the ser-
vice of a new totality—in the service of the dramatic idea, the stage
direction, which will use a cruel close-up as readily as the purely
expressive element of movement.

What matters, ultimately, is whether the means (be they realistic
or *x*-istic) serve to establish a higher order in which they themselves
—become insignificant!

It is at this point that I will begin to speak about the art of Albert
Renger-Patzsch, whose method is absolute realism, the most precise
and objective record of thoroughly familiar things.

III

This photographer dispenses completely with phototechnical juggling
acts, concerned as he is with achieving the sharpest and most precise
depiction of his subjects. Why the outcome is not an expression of
scientific exactitude but of an unquestionably *artistic order* remains
inexplicable. It is for virtues other than his perfect technical mastery,
acquired through many years of experience as technical director of the
photographic department of the Folkwang publishing house[7] as a press
photographer, that he deserves to be called an artist.

What makes him an artist is his pursuit of the charm of earthly
things, his ability to force even the most accidental and transient phe-
nomena into pictures that are superbly organized, balanced, and struc-
tured. It is also his enormous, patient sacrifice, his ceaseless
observation, keeping watch, waiting. He can take an accidental con-
figuration of clouds at the end of a day at the beach and bind it in a
picture, as if by a spell, with such marvelous balance that the result
is a supremely calculated composition, a magnificent flower that seems

cast of some precious liquid element. This capturing and shaping of the most secret life, done with a searching mind and a highly developed taste—that is the hallmark of a totally artistic creativity.

IV

It is true that the forms of this art were made by another creator, and that the human achievement consists "merely" of the manner in which these forms are depicted.

It is a venerable tradition nonetheless. Some very great painters, like Leonardo and Dürer, strove for this ideal, which the camera achieves more purely than they could: to exclude as completely as possible any human element, in the service and emulation of natural form. (The fact that photography would make an achievement like Dürer's patch of grass *meaningless* today, or that Leonardo's sketchbooks would be *unnecessary* in the age of the camera, casts a sharp and rather painful light on a situation in which the machine has annexed entire provinces from the ancient kingdom of art.)

But the decisive criterion of genuine creativity will always be whether the realistic artist succeeds in raising the familiar world to a level where it is not only uncommon but profoundly stirring. And in this perspective, it does not lessen but enhances their artistic merit that in the pictures of Renger-Patzsch, it is mainly the works of the *demiurge* that elicit our admiration. *That* we admire them (to the point of awe) proves that this photography reveals nature more intensely than nature reveals herself—precisely because it offers a concentrated selection of what nature withholds by her very abundance.

It is significant that in writing about these photographs it is impossible not to touch on the mystery of life: for their essential quality is that they awaken in the viewer, quite forcefully at times, this extremely rare *amazement* at the *miraculousness of physical reality.* With a strange immediacy, they set in motion religious vibrations; their effect is greater than that of mere aesthetic appeal.

V

We see the familiar earthly things—parts of them, as a rule (such sharp objectivity always calls for *detail*)—yet they seem strange and miraculous!

The eerie eye of an adder, surrounded by the body's armor, a wondrously crafted coat of lancet scales; the improbably graceful gesture of a potter's hands as he shapes the clay on the wheel; an orchid's fearsome, gaping calyx, like the jaws of a beast, the shameless display of its demonic sexuality; withered grasses in the snow, an exquisite play of forms, like a Japanese woodcut; the stump of a mooring post covered with small oysters, silt, and lichen as with precious jewelry; the architectural grandeur of an agave (what a temple in the flower pot); the trumpet of a rolled philodendron leaf piercing the dewy freshness of dawn; hoar frost crystals among delicate stalks, like flowers dropped by angels; elfin ice formations by a waterfall, gloriously opalescent pillars of the palace of winter.—These are the kinds of things we are shown, so precisely (without significant enlargement) that even the smallest pore of a leaf becomes a sucking funnel, and the tiniest hair a revelation of some essential vital function. Gazing into the eyes of animals, we see the very enigma of creatureliness; peering into a fortified citadel of cacti—what fearsome defences are these, and against what overwhelming assault? Or a seed at the moment of unfolding its labyrinthine interior, like an antediluvian monster bursting from the jaws of hell. . . . And more poignantly than ever before, we recognize the fact that all of Creation is a single living being, a monstrous hydra whose every hunger entails an enjoyment and several murders and measures of defense—and every love a beauty and an enticement, but also many cruelties.

Rarely does one experience so intensely the prodigality of existence.

These photographs place us on the outermost edge of realism, where we feel closer to the mysterious than on the peaks of more properly "human" art. Gazing into these vertiginous depths of wonder, we come to understand the core of truth in the Talmudic saying:

If thou wilt know the Invisible,
Look closely upon the visible!

VI

Every work of art leads a life of its own in the viewer, independent of its maker. Here, all that was arduous in the making becomes a pleasure; the viewer is intoxicated by the very thing that cost the creator

much sweat and bitterness. But all good art is well-fermented—and one does not imbibe a choice wine with a view to writing a critique about it. What joy when the writer reaches the point where he no longer needs to adduce examples, when he comes to the end of all his examining and interpreting and can give free vent to his enthusiasm!

In doing so he may inadvertently fail to attend to this or that sober responsibility—a critical comment, for instance, concerning the lack of color, which of course in these photographs is virtually replaced by an unbelievably subtle gradation of black and white; or a biographical introduction of the man who offered him the intoxicating potion—but this we shall make good with a single sentence: Albert Renger-Patzsch was born in 1897 and lives in Harzburg.

If there is justice in comparing good art to a feast, to a noble wine, it would be quite inappropriate to speak of it as if from behind a lectern. This, oh friend of art, is advice for the viewing of art as well. Forgive the stammering tongue, therefore, if it did not speak dryly enough.

Translated by Joel Agee

1. Karl Blossfeldt (1865–1932) used his own photographs of plant forms in teaching classes on ornamental design in Berlin. His enormously popular photographic book *Urformen der Kunst* (Primordial forms of art) was published in 1928.

2. The term used is *Phototypie*, but photo-collage appears to be what is meant.

3. In the 1890s the Swedish playwright August Strindberg (1849–1912) devoted himself to an obsessive series of experiments in chemistry, botany, and optics.

4. "Typophoto" was Moholy-Nagy's term for the combination of photography and typography in graphic design.

5. The 1925 edition of Moholy-Nagy's *Malerei Photographie Film* carried a short introduction under the title "Apologie der Photographie."

6. Gerhardt Hauptmann (1862–1946), a German dramatist, essayist, and poet, was one of the leaders of the naturalist movement in German literature in the late nineteenth century; Otto Dix (1891–1969) was an important German painter associated with the realist style of the 1920s.
 By the late 1920s Russian films such as those of Sergei Eisenstein had won a wide following in Germany.

7. From 1921 to 1924 Renger-Patzsch was the head of the photography department of the Folkwang Archive in Hagen.

ERNÖ KALLAI

PICTORIAL PHOTOGRAPHY

In this essay Ernö Kallai continues to maintain, as he had the previous year in "Painting and Photography" (see p. 94), that the possibilities of photography as a visual medium are considerably more limited than those of painting. Comparing a well-known still life photograph by André Kertész, *Mondrian's Eyeglasses and Pipe* (1926), to a similarly composed painting by Lajos Tihanyi, Kallai finds the photograph's lack of surface texture, or facture, a fatal visual weakness. After similarly dismissing what he sees as the limited artistic possibilities of the photogram and the photomontage, Kallai offers a surprisingly warm endorsement of Albert Renger-Patzsch's sharp-focus, realist photography. His defense of the revelatory power of the objective camera image provides a preview of an argument that was increasingly heard in Germany during the late 1920s, when the enthusiasm for experimental photographic techniques began to wane.

Original publication: Ernst (Ernö) Kallai, "Bildhafte Fotografie," *Das Neue Frankfurt* (Frankfurt), no. 3 (1928), pp. 42–49.

Painting and photography are usually compared according to this formula: a painting is always, even at its most structurally severe, a personal and psychological encapsulation of form, while photographs are bound to objectivity because they are the outcome of a mechanical and chemical process.

The formula is no doubt correct, but the concept of photographic objectivity shouldn't be taken too rigidly. The recent history of photography shows several stylistic changes that were only possible because the technical side of photography too is accessible to the influence of a spiritually and intellectually oriented artistry. At present, of course, photography has its own "New Objectivity," which claims that the atmospherically veiled moods of the Impressionist photographs were artificially concocted for the sake of a painterly effect, and that those works were thus not truly photographic at all.[1] Remarkably enough, we find among these critics of Impressionist photography artists who experiment with cameraless photograms and photographic collages. The

manipulations by which Bruguiere, Man Ray, Moholy-Nagy, Spaemann-Straub[2] try to direct the chemical-mechanical processes that generate their photographic fantasies in light and dark are of an extremely personal and subjective, if not playful, character. In a photomontage like Moholy-Nagy's "Jealousy," photographic and painterly elements have been fused into a highly arbitrary synthesis.

But there is no need to go so far. There are photographers who record the three-dimensional, figural elements of their subject with the utmost objectivity and clarity, and nevertheless evince very distinct personal qualities in their work. Portraits by Erfurth, Peterhans, or Umbehr,[3] for example, or Renger-Patzsch's pictures of landscapes, animals, and plants, convey the most subtle refinements of psychological and formal observation, of framing, lighting, and exposure, of artistic sensitivity and technical mastery. If nothing more were involved than the emotional neutrality of a technical procedure, the concept of photographic objectivity would be adequately exemplified by a good passport photograph or a successful photo-report, and everything going beyond this kind of sober documentation would have to be regarded as an artistic deformation of photography.

An interesting example is a perfectly self-enclosed and balanced photographic still life by Andor Kertész, where absorption in figurative presence has hardened into the most naked puritanical severity. We are reproducing this picture next to a painting by Lajos Tihanyi.[4] The similarity of motifs and structures in these two works enables us to point out an essential difference between the pictorial effects of painting and photography. Both the painter and the photographer have chosen a view from above. The painter has used a straight-down angle of vision so that the top of the table and its cloth are a vertical plane that coincides with the plane of the canvas. The application of color gave him a further opportunity to create a highly tactile, material surface and to build up firmly the four sides of the picture to provide some visual resistance. All the parts of the composition have been immovably built into this visual front wall of the picture plane. The wall is in tension with the dimension of depth. Static interlocking and spatial tension result from the material anchoring and definition provided by the illusion of the picture plane.

In the photographic still life, the perspective conditions that might create this kind of planar illusion are just as present as they are in the painting. Nevertheless, the photographic picture plane permits the

eye to penetrate deeply, offering it no resistance. The light-facture[5] reflects like a mirror, it can produce illusions of flatness as well as depth, but the lack of tangible surface application offers the eye no point of reference to integrate this illusion into a stable picture plane.

This limit to the pictorial effects available to photography is especially evident in the cameraless photograph. Since the exposure of a sensitive surface can be modulated at will, an artist may consciously compose a photogram with a view toward producing a planar effect. Spaemann-Straub in particular have made some very interesting experiments in this connection. However, in a photogram even the best composition cannot effectively establish signs indicating overlapping planes and static interlocking; the forms remain decorative. The light-engendered nature of the photogram cannot be captured under such tectonic conditions. Its chiaroscuro shines forth right before our eyes, but this immaterial, enigmatic beauty is as impalpable as the Milky Way in a clear night sky. By contrast, even the most spiritualized painting still remains tangibly earthbound. A handicap, but not necessarily a disadvantage: on the contrary, it supplies a most powerful impetus. The special intensity of painting resides precisely in the penetration and mastery of resistant matter, in the gradually growing material realization of the painter's vision.

Because of the immateriality of its light-facture, the photogram is an inadequate medium for many essential realms of artistic experience. The possibilities of photomontage are also very limited. This method, with its representational photo fragments, does possess a tangible physicality. Furthermore, it permits the arrangement of its pasted elements, which will produce a static tension between them, as in painting—especially if this impression is reinforced by the addition of drawing or painting. A further appeal of photomontage is the element of surprise. Fragments of different photographic structures are surgically removed from their original, tonally coherent chiaroscuro enclosures, and suddenly appear in a thoroughly alien pictorial whole that is no longer composed of luminous space, but of pasted or painted planes. This varied, nonphotographic juxtaposition of photo fragments is employed by Moholy-Nagy ("Jealousy") in a manner that one might call surrealistic, a manner that could be adapted cinematically. But however surprising and witty photomontage may be, its most idiosyncratic quality also implies an essential failing. It is not an organic composition but a tricky, mechanistic, pieced-together product.

In the end, photography can attain its most enduring and profound effects only through the pursuit of reality, especially natural reality. Nature offers countless constellations of a vast variety of forms, each the product of innermost necessity, each with its own uniquely powerful expressiveness and order, and all of them able to be understood in spatial-pictorial terms. The camera can give sensory immediacy to the most hidden germ cells as well as the most monumental phenomena in this abundance of organic life; it satisfies our sensibilities with the subtlest stimuli and the most vehement sensations. But the most marvelous thing about this photographic illusionism is this: its light-facture combines the most dense, material, realistic rendering of appearance with the most radical dematerialization of the means of representation. This retreat of the picture into an intangible chiaroscuro infuses just those most severely objective, meticulously exact nature photographs of our time with the power of a magical abstraction in black and white. There is a "magical realism" of the camera that strikes me as more impressive, and worthier of our age, than the school of painting that goes by that name.[6] Photographic realism captures nature without problematic obscurity, without petit bourgeois sentimentality; simply with the clear and knowingly serene eyes of modern intelligence. And yet we experience its pictures as miracles of an absolutely unrestricted, mysteriously silent, and blindingly precise revelation of the real.

The most impressive results of photography are not due to aesthetic speculations, but to the photographer's joy in his subject—the most important *leitmotif* of modern photography, according to no less a master than Renger-Patzsch himself. How can the capricious imagination of even the most original photomontage compare with the fantastic reality of a straightforward camera negative? The most sophisticated photogram cannot match the wondrous chiaroscuro structures of a simple X-ray. And camera photography is drawing a wider and wider circle of practitioners. It has become an essential component of advertising and reporting, of scientific and literary illustration. Its technical possibilities are far from exhausted, and have yet to be perfected (color photography, television, etc.).

Insuperable difficulties arise only in the case of certain snapshots. The abrupt disjunction of the moving figures from the order of the nonmoving parts of the picture can only be resolved cinematically. Only in film can the full range of tensions in photographic imag-

ery, conditioned by the light-facture and not susceptible to static representation, be creatively explored. Photography flees the bonds of stasis, in order to accomodate itself to the rhythmic law of organized motion.

Translated by Joel Agee

1. Kallai refers to the style of turn-of-the-century art photographers, who sought by means of soft-focus lenses, textured printing papers, and hand-manipulated print processes to suggest the look of Impressionist prints and paintings.

2. Francis Bruguiere (1879–1945) was an American photographer whose "light abstractions" were exhibited in Berlin in 1927. Photograms by the German photographers Heinrich Spaemann and Karl Straub were reproduced as illustrations to Kallai's essay.

3. Hugo Erfurth (1874–1948), a portrait photographer from Dresden, taught at the Leipzig Academy for Graphic Arts and Book Design in the late 1920s. Walter Peterhans (see p. 170) headed the photography department at the Bauhaus in the late 1920s. Otto Umbehr (1902–80), better known as Umbo, was a versatile photographer and photo-journalist who taught at Johannes Itten's Berlin art school in the late 1920s.

4. Lajos Tihanyi (1885–1938), a Hungarian painter and a friend of Moholy-Nagy, worked in Berlin in the early 1920s. In 1923 he moved to Paris and there became a friend of the photographer André (in Hungarian, Andor) Kertész.

5. For facture see p. 85, n.1.

6. In his 1925 book *Nachexpressionismus*, the art historian Franz Roh (see p. 160) used the term "magical realism" to describe German realist painting of the 1920s that derived from the work of Giorgio De Chirico.

JAN TSCHICHOLD

PHOTOGRAPHY AND TYPOGRAPHY

During the 1920s, avant-gardists such as El Lissitzky and László Moholy-Nagy believed that the combination of modern photography and typography on the printed page promised to open an entirely new era of graphic communication. Jan Tschichold (1902–74), one of the most inventive German typographers of the 1920s, began in 1925 to publish influential articles calling for the use of modern sans serif typefaces in graphic design. In 1926 Tschichold was invited to teach at the Master School of German Book Printers in Munich, and in 1927 he helped to establish the Circle of New Advertising Designers with Kurt Schwitters, Raoul Hausmann, and others. Keenly interested in the new photography of the 1920s, Tschichold was a member of the advisory committee that helped to organize the Stuttgart *Film und Foto* exhibition in 1929. Tschichold summed up his thinking on typography and graphic design in his 1928 book *Die neue Typografie* (The new typography). The following text, which was published in the German Werkbund's journal *Die Form*, comprised a chapter of that book.

Original publication: Jan Tschichold, "Fotografie und Typografie," *Die Form* (Berlin), no. 7 (1928), pp. 221–27; and *Die neue Typographie* (Berlin: Bildungsverband der deutscher Buchdrucker, 1928), pp. 89–98.

The artistic value of photography has been disputed throughout its history. The first attack came from the painters, who eventually realized that photography could not offer them serious competition. Today art historians are still quarreling about certain problems raised by photography. Book designers still deny photography the right to be part of the design of a "beautiful book." They contend that type, with its purely graphic, strongly physical, material form, is aesthetically incompatible with the photomechanical halftone, which, though seemingly "plastic" as a rule, is more planar in its material makeup. Focusing on the external appearance of both kinds of printing, they find the principal fault in the halftone's "plasticity," which is supposed to be inappropriate for a book. The objection amounts to very little indeed; after all, the halftone resolves itself into many tiny, opaque, individual points which are quite obviously related to type.

But none of these theories has been able to prevent photography's victorious career in book design, especially in the postwar years. The great, purely practical value of photography resides in the relative ease with which this mechanical process can furnish a faithful copy of an object, compared with the more laborious manual methods. The photograph has become such a characteristic sign of the times that our lives would be unthinkable without it. Modern man's hunger for images is mainly satisfied by photographically illustrated newspapers and magazines. Advertising pages (especially in America) and, occasionally, advertising posters are more and more frequently using photographs. The great demand for good photographs has had an extremely encouraging effect on the craft and art of photography: there are fashion and advertising photographers in France and America who are qualitatively superior to many painters (Paris: Paul Outerbridge, O'Neill, Hoynigen-Huene, Scaioni, Luigi Diaz; America: Sheeler, Baron de Meyer, Ralph Steiner, Ellis, etc.).[1] Exceptional work is also being done by the usually anonymous photo-reporters, whose pictures are often more captivating, not least for their purely photographic quality, than the supposedly artistic gum-prints of the would-be portrait photographers and amateurs.

Today it would be quite impossible to meet the enormous demand for printed pictures with drawings or paintings. There would neither be enough artists of quality nor the time required to create and reproduce the works. There are many current events about which we could not be informed if photography didn't exist. Such extraordinary consumption can only be met through mechanical means. This consumption—which has its roots in the greatly increased number of consumers, in the growing dissemination of European urban culture and the perfecting of all the media of communication—calls for an up-to-date medium. The medieval woodcut, the book designers' ideal, is neither up-to-date nor rational from the point of view of production. Purely technical factors forbid its widespread use in modern printing techniques, and it cannot satisfy our need for clarity and precision.

The peculiar appeal of photography lies precisely in its great, often supernatural clarity and perfect objectivity. Due to the purity of its appearance and the mechanical nature of its production, photography has thus become the foremost pictorial medium of our time. To call photography in and of itself an art is no doubt questionable. But in all the many uses of photography, is art the point? The kind of

photography needed for reportage or documentation may be very simple, may even be altogether inartistic. For such pictures aspire to nothing more than communication by way of images—there is no formal intent. Where there is a higher demand, the natural course of development will always produce the needed supply. But although in itself photography is not an art, it definitely contains the germ of an art, which of course will inevitably be very different from the other arts. On the border of art, we find the so-called "posed" photograph. With the proper lighting, arrangement, and framing, effects can often be achieved that bear a remarkable resemblance to works of art.

Photography may become an art in two forms in particular: as photomontage and as photogram. The word "photomontage" signifies a picture that is entirely a pasted composite of individual photos (photo-paste-picture), or that uses the photograph as one pictorial element among others (photo-drawing, photo-plastic). The boundaries between these genres are fluid. In photomontage individual photos are used to construct a new pictorial unity, which, being a conscious creation and not a product of chance, has an intrinsic right to be called a work of art. Of course not every photomontage is a work of art; not every oil painting is, either. But what Heartfield (who invented photomontage), Baumeister, Burchartz, Max Ernst, Lissitzky, Moholy-Nagy, Vordemberge-Gildewart[2] have accomplished in this field deserves the name, without any doubt. These are no longer arbitrary arrangements, but logically and harmonically constructed images. The initially accidental form of the individual photo (gray tones, structural effect, line movements) acquires artistic meaning through the composition of the whole. What makes photomontage different from the art of the past is the absence of an external model. It is not, like the old art, an act of continuity, but the material expression of a free imagination, in other words a truly free, human creation that is independent of nature. The "logic" of such a creation is the irrational logic of art. But a quite supernatural effect is created when a photomontage consciously exploits the contrast between the plasticity of the photograph and the inanimate white or colored surface. This extraordinary impression is beyond the reach of drawing or painting. The possibilities of strongly contrasting sizes and shapes, of contrasts between near and distant objects, of planar or more nearly three-dimensional forms, combine to make this an extremely variable art form.

Photomontage also offers the widest opportunities for the utilitar-

ian purposes of advertising. Here it is naturally not possible, except in rare cases, to balance all the parts in such a way as to produce the free equilibrium of a "work of art," since the obligation to maintain logical coherence, logical dimensions, a given text, and so forth, can be very limiting. The task of an advertising artist is, in any case, not the creation of free works of art, but of better advertisements. The two may, but need not, coincide. Some of the finest uses of photomontage in advertising can be seen in John Heartfield's book covers for Malik[3] and Max Burchartz's industrial advertisements.

We present a characteristic example: the cover picture for a portfolio of advertisement by Burchartz.[4] Unfortunately, the reproduction gives only a faint impression of the intensity and richness of the original.

Photograms are photographs that are produced without a camera, using only sensitized paper. This simple method is not really new: photograms were made long ago by placing flowers on photographic paper.

The inventor of the artistic photogram is an American living in Paris, Man Ray. Around 1922 he published his first creations of this kind in the American magazine *Broom*.[5] They show an unreal, supernatural world that is a pure product of photography, and that bears the same relation to the usual journalistic and documentary photographs that poetry does to everyday conversation. It would be naive to regard these creations as products of chance or as clever arrangements: any expert can affirm that they are nothing of the sort. Here the possibilities of autonomous (cameraless) photography were worked out for the first time; from the use of modern material there developed the photogram as a modern poetry of form.

The photogram can be used in advertising as well. The first one to do this was El Lissitzky in 1924. An absolutely excellent work by him is the photogram for Pelikan Ink. Even the writing was produced by a mechanical-photographic method. The techniques for making photograms are very simple, but too various to be described in a few words. Anyone who wishes to undertake the experiment will find ways of his own to achieve the effects he desires. Since all one needs is sensitized paper and at most a darkroom, anyone can try his hand at making photograms. In this connection, special mention should be made of the book *Painting Photography Film* by Moholy-Nagy, which includes a thorough and very instructive discussion of these matters.

Now, a typographer faced with the task of inserting photographic

images into the copy has to ask himself, above all, what kind of type-face he should choose. The prewar generation of artists, opposed as they were to photography, attempted a solution to the problem but were unable to find it, since from the start they considered any combination of type and photography to be a compromise.

Our generation has recognized the photograph as an essential modern typographical medium. We feel enriched by its addition to the earlier book printing media; indeed we regard photography as the mark that distinguishes our typography from all its predecessors. Exclusively planar typography is a thing of the past. By adding the photograph we gain access to space and its dynamism. The strong effect of contemporary typography comes precisely from the contrast between the seemingly three-dimensional structures in photographs and the planar forms of the type.

The main question—which typeface to use in combination with the photograph—in the past met with attempted solutions of the strangest sorts: employing type that appeared to be or actually was gray, using strongly individualized or very fine types, and similar measures. As in all other areas, here too the goal was superficially to coordinate the constituent parts, and thus reduce them to a common level. The result was at best a unified gray, which could not really hide, however, the obvious compromise.

Today's unabashedly up-to-date typography has solved the problem with a single blow. In striving to create an artistic unity out of new primary forms, it simply does not recognize a problem of type (the choice of sans serif was dictated by necessity), and preferably uses the photograph itself as a primary medium, thus arriving at the synthesis: photography + sans serif! At first sight it seems that the hardness of these clear, unambiguous black letters is not compatible with the often very soft gray tones of the photograph. Naturally, their combination doesn't result in a uniform gray, for their harmony lies precisely in their contrasting forms and colors. But what both have in common is objectivity and impersonal form, the distinguishing traits of a truly modern medium. Their harmony is therefore not merely the external and formal blending that was the misguided ideal of the earlier designers, nor is it arbitrary; for there exists only one objective type—sans serif— and only one objective method of recording our environment—photography. Thus the individualistic graphic form, script/drawing, has been replaced by the collective form: typophoto.[6]

By typophoto we mean any synthesis of typography and photography. Today we can express many things better and faster with the help of photographs than by the laborious routes of speech or writing. The halftone thus joins the letters and lines in the type case as an equally up-to-date, but more differentiated, typographical element. It is their equal in a fundamental, purely material sense, at least and quite obviously in book printing, where the surface is resolved into (quasi-typographical) raised points at the same level as the letters. In the case of photogravure and offset printing, this criterion can no longer be applied; here the assertion of material inequality of type and photograph would no longer find any support.[7] The integration of the photograph into the rest of the set is subject to the laws of meaningful typography and of a harmoniously designed face. Now that we moderns no longer know the aversion of book designers to photographs, and now that the luxurious concept of the "beautiful book" has become a thing of the past, the contemporary book designer regards the photograph as one of the many equally valid components of a beautiful book.

An excellent example of typophoto in advertising is our reproduction of Piet Zwart's advertisement.[8] Here we also encounter an applied advertising photogram (paper-insulated high-voltage cable). The capital *H* begins the word "high," the lower-case *l* the word "low." The different kinds of type and the black and red shapes are very well balanced; the whole design is enchantingly beautiful. The two red lines of type show how powerfully color can intensify the effect of a photograph. The smooth red plane of the fat *l* contrasts effectively with the delicate three-dimensional forms of the photogram. The typographical forms correspond in size with the forms in the photograph: the central line of NKF, with the center of the cross section of the cable; the line beneath the red lettering, with the cable's outermost point. One might say that typophoto is one of the most significant graphic media in contemporary typography and advertising. It will not be long before the popular varieties of typophoto (especially illustrated magazines and part of the advertising industry) free themselves from the influence of supposed "tradition" and attain the cultural level of our times by a conscious and radical application of modern design principles.

The great possibilities of photography itself have hardly been recognized yet, except by a narrow circle of specialists, and are certainly far from exhausted. But there is no doubt that the graphic cul-

ture of the future will make much more extensive use of photography than is done at present. Photography will be as symptomatic of our age as the woodcut was for the Gothic period. This imposes today, on all the graphic professions, the obligation creatively to develop the techniques of photography and reproduction, so as to ready them for the increased demands of a near future.

Translated by Joel Agee

1. Paul Outerbridge (1896–1959), George Hoynigen-Huene (1900–1968), Egidio Scaioni (1894–1966), and Luigi Diaz were photographers active in Paris in the late 1920s. Fashion and advertising photographs by Charles Sheeler (1893–1965), Baron Adolph de Meyer (1868–1946), Ralph Steiner (1899–1986), and William Shewell Ellis appeared frequently in American magazines of the late 1920s.

2. Max Burchartz (1887–1961) and Friedrich Vordemberge-Gildewart (1899–1962) were, like all the others named in the text, practitioners of photomontage during the 1920s.

3. On John Heartfield and Malik Verlag, see p. 128.

4. Accompanying the original article was a Burchartz photomontage for the Bochum Verein, a manufacturer of industrial equipment.

5. Man Ray's rayographs appeared in *Broom*, a review edited by the Americans Harold Loeb and Matthew Josephson, in early 1922.

6. Moholy-Nagy devoted a chapter of his 1925 book *Painting Photography Film* to a discussion of "typophoto," or the combination of modern photography and typography in graphic design.

7. Both photogravure and offset printing dispense with the tiny dot structure that characterizes the halftone reproduction. Tschichold's argument is particularly abstruse in this passage.

8. The article included a reproduction of a Zwart advertisement for the paper-insulated high-tension cables manufactured by NKF (Nederlandsche Kabel-Fabrik) of Delft.

FRANZ HÖLLERING

PHOTOMONTAGE

In Germany—as in the Soviet Union—the late 1920s witnessed a continuing debate over the political uses of photography and photomontage. The following essay appeared at a time when photomontage techniques, first popularized by the Berlin dada group around 1920, had begun to appear more and more frequently in magazine illustration and advertising design. The author, Franz Höllering, was a frequent contributor to *Der Arbeiter-Fotograf* (The worker-photographer), a journal which sought to encourage amateur working-class photographers to depict their world with a politicized "worker's eye." Höllering all but dismisses the value of photomontage for worker-photographers: rather than emulating artists, he advises, they should seek to become effective photographic observers of everyday reality.

The sole photomonteur singled out for praise is John Heartfield (the pseudonym of Helmut Herzfelde, 1891–1968), whom Höllering presents as a special case. Heartfield, who had been one of Berlin dada's key figures, worked throughout the 1920s as a designer of book jackets for his brother Wieland Herzfelde's radical publishing house, Malik Verlag. It was only after this essay appeared that Heartfield began contributing to the weekly *Arbeiter Illustrierte Zeitung* (Workers' illustrated)—which Höllering had edited from 1925 to 1927—the ferociously satirical political photomontages that won him international acclaim.

Original publication: Franz Höllering, "Photomontage," *Der Arbeiter-Fotograf* (Berlin), no. 10 (1928).

Photomontage, photo-assemblage . . . the name describes it well: several photos are put together, assembled, into a single picture. The individual pictures used in a photomontage lose their independent purpose and value, they become the means for the production of a new picture, its constituent elements, just as (in a purely material sense) a painting is made of colors and lines. And, in photomontage as in painting, a conceptual element, which is the essential thing, enters in: the temperament, the ability, the worldview of the person creating the painting or photomontage—of the artist. For anyone who tries to form a new whole out of separate, individual parts has to be an artist.

The history of photomontage is very short. Noteworthy photo-combinations of this kind have only been in existence for ten years. The most famous and probably the best are the works of John Heartfield, who was the first to use photomontage for the production of effective book covers (Malik Verlag), arriving at a form which one might call highly artistic; and in saying this we are not indulging in the currently popular overestimation of photomontage. It is characteristic that this leading photomonteur is an artist, a painter. Presented with the new task of producing effective book covers, he created for this purpose a new medium, the combination of several photos. He usually arranges them on a colored ground, often in perfect fusion with the lettering necessary for the book title, etc. His montages provide an apt encapsulation of the book's contents. The photos are selected to support and reinforce each other so as to give an immediate impression of the book's atmosphere, its political tendency, and its concrete factual content.

For John Heartfield, therefore, photomontage is a means to a particular practical end; he only uses it where it is objectively needed, where it is the only or the best method for achieving the desired effect, where a drawing or a single photo would be insufficient. And only there. And thus, always keeping in mind the "what for" and "where," he has also become an artist of photomontage, comparable to the stonemasons of the medieval churches, who created works of art for a concrete purpose, without any aesthetic theory, profoundly rooted in the ideas and emotions of their time. The proletarian artist Heartfield, understanding the meaning and movement of his time, has put the modern technical medium of photography at the service of his artistic will—quite unlike the many imitators who seized upon a "new form" without knowing its content and now, in a vacuum, are filling their meaningless time with meaningless aesthetic games.

It may indeed be fun, pasting little pictures together. Little children have always enjoyed it. When it's done by adults without artistic pretension, it remains a private amusement and is none of our business, even if in our opinion it's a deplorable waste of time. But photomontage has become a fad. Some people seem to use it as a substitute for crossword puzzles. A dilettantism of the worst sort is in full bloom, and what we have seen of the results is truly horrifying. To the proletarian photographer, the only advice we can offer is: stay away from this, don't allow yourself to be deflected from your great mission of

photographing the truth, don't let yourself be seduced by a trivial game that's being puffed up and made to sound important by phony claims about its supposed artistry. You are a worker. Be proud of it. You have nothing in common with the latest fashionable bourgeois pastime. In your hands, a camera has meaning only if you use it as a weapon. With its aid you must make a record of your reality, which is strong and hard and agitating enough, stronger than any little picture and paste job. Learn to see the simple great facts, photograph them plainly and clearly, so that they can't be explained away. That is your task. Photomontage also contains the additional danger that several intrinsically good, true pictures could be combined into a single false, bad picture—precisely the opposite of what you want. Beware.

This does not mean that a proletarian photographer should not occasionally make a photomontage out of his pictures for a particular purpose, one really suitable for this kind of treatment. That may be useful and necessary at times, and also beautiful. Our illustration shows an example of this kind of work, and of how well it can be done.[1] But proletarian photographers will have to resist this horrible epidemic called photomontage. If permitted to spread unchecked, it could succeed in reducing the fighting unit of proletarian photographers to an ineffectual dilettantes' club with ridiculous artistic ambitions.

Less is often more. Just as an apple, an egg, a piece of bread is healthier and purer than all the delicacies that are concocted to tickle the palate of an unnatural and overfed society, a small clear photo is more than some pasted mishmash of a hundred photos. The proletarian photographer should create documents of his time, not worthless trivia. If that were his goal everything would be simpler, he would throw away his camera, buy himself a fretsaw, and build all sorts of dust-collecting kitsch and decorative junk.

If the movement of proletarian photographers is to have any value, its members must learn to distinguish clearly between the essential and the trivial aspects of a photograph. The single and only essential thing is the meaning a photograph has in the context of the great idea of socialism. (However—pictures of misery alone are often worthless, and a "beautiful" picture can be effective in our sense—provided it clearly captures a moment from which we can draw strength, understanding, and insight.) What will always remain trivial is whimsy, hobby-work, shop talk. Photomontage seduces with these. Therefore be warned!

Simple, clear, beautiful pictures of your world—that is your goal. No dilettantish artiness. You want to report what the world really looks like. For the others report what suits the business of capitalism. Only by earnest, down-to-earth work, not by play, can so great and high a task be carried out.

Translated by Joel Agee

1. Accompanying the article was a striking photomontage of factory equipment and machine parts by "H. H., Breslau."

LÁSZLÓ MOHOLY-NAGY

SHARP OR UNSHARP?
A Reply to HANS WINDISCH

This exchange between László Moholy-Nagy (see p. 79) and the writer and photographer Hans Windisch took place in the Dutch avant-garde review *i10*, to which Moholy-Nagy was a frequent contributor. It demonstrates how greatly Moholy's own understanding of "objective photography" differed from that of Albert Renger-Patzsch. Moholy expresses his astonishment that Windisch (the editor of the annual *Das Deutsche Lichtbild*), who previously had been sympathetic to avant-garde photography, had more recently voiced his fear that photographic objectivity was going too far.

Seeing in modern photography's extraordinary resolution of detail a falsification of human vision, Windisch proposes that by using lenses of lesser acuity the photographer can come closer to suggesting what the eye actually sees. (Similar ideas had been advanced by the nineteenth-century British photographer P. H. Emerson and by the German critic Willi Warstatt.) Moholy-Nagy replies by warning against a revival of the "Impressionism" of earlier pictorial photography. The camera, he contends, should not be subordinated to the defects of the eye, but should instead be used to correct old habits of seeing and to open altogether new paths of optical expression. "Objective photography," he concludes, "must help us see."

Original publication: László Moholy-Nagy, "Scharf oder unscharf?" *i10*, 2, no. 20 (1929), pp. 163–67.

I

A photo shop in Munich (Schaja, Maximilianstrasse 32) publishes an excellent periodical under the title *Schaja-Mitteilungen*.

One of its editors is Hans Windisch (editor of the volume *Das Deutsche Lichtbild*, Verlag Bruno Schultz, Berlin W 9), who reports regularly on technical and general photographic questions under the name "Professor Schaja."

The following paper by Professor Schaja appeared in *Schaja Foto-*

Mitteilungen 5, nos. 9 and 11:*

If you keep your eyes open you must have noticed that certain photographs in some respect differ from your own photographs—in "accentuation," contour, "presentation."

Your photo is like the ones in a "wanted" notice or a passport, rendering with appalling exactness the geography of the face: every single hair, every pore, and every freckle can be seen in sharp focus. This is certainly the gentleman or lady in question, but you would never have thought that he or she is so perfectly suited for a "wanted" notice.

There are instances where the implacability of the photographic lens produces pictures which have the character of optical vivisection.

So, must a portrait be as blurred as possible, or do we even have to cheat a bit? No—but *photography must not become microscopy.* Our impression of a face is actually a composite of that person's hundred faces superimposed in our imagination, whereas *the photographic lens records* but one of these hundred in a diligent, dull, and witless way, though it does so *with an exactness our eye is absolutely unable to achieve.*

In its fanatic exactitude it reproduces everything that is alive as something rigid and hopelessly unchangeable. It is certainly an incorruptible witness; a witness, however, who is prevented by the details from comprehending the whole. The photographic lens seizes upon every freckle and every scar of a razor cut, but the comprehensive total impression, which can often only be intuited, remains a matter of indifference for photographic optics. Some portraits are such staggering "likenesses" and so one-sidedly exact that we would rather not look at them.

It is said that "the camera does not lie," and this is true in the objective sense (the word *Objektiv* says it),[1] but it does lie constantly in the subjective sense, because it cannot separate what is important from what is quite unimportant.

Our eye sees in another way from that of the lens.

We do not speak here only of portrait photography; there are

* In order to make it more readily intelligible, I have abbreviated the text already published in *Schaja-Mitteilungen.* The italics are mine. If desired, the original text is available. —M-N

innumerable photographic undertakings which suffer from the rather dilettantish exactness of the modern, excessively corrected lens, and even fail because of it.

We realize one day that *we have to simplify*, extract the essence—but how?

This is possible, in an exact optical way, without retouching and without manipulating the negative in any way.

However, not every category of snapshot suits the planar, summarizing mode of representation achieved by the modern lens in such highly precise and clear-cut pictures of, for instance, insects, flowers, or mosses—here, the results are magical, and we welcome the utmost sharpness. *But it would be less expedient if I were to make an equally sharp photograph of you, recording among other things the rather visible signs of your unshavenness today. I think you would have to be treated quite differently from a dozen june bugs. With a different lens, I mean. Excessive exactness is always disturbing when the general impression is the main point. It is like looking at a mosaic too meticulously from too near.*

So if we care to protest against the quasi-scientific rationalism of the anastigmatic[2] picture, and if we enjoy much more a picture emphasizing only what is essential, this is because— quite aside from artistic values—it resembles more closely what our eye sees.

The photograph often seems "emotionless" and "dead" because there is an essential physical difference between the eye and the lens. In addition to the physiological reasons leading to this rejection of what is too photographic, there is, however, yet another and perhaps even more important consideration, the psychic one. When looking at pictures, landscapes, portraits, etc., we prefer to be able to take a spiritual excursion between and behind the objects therein. We want to carry further and to interpret what the picture has merely suggested. But whatever is fixed and final is registered, nothing more.

This is why there has always been a search for lenses that can approximate the eye's ability to take a "view of the whole." Many slightly (spherically and chromatically) undercorrected lenses have been developed in recent decades, all of them based on the model of the first and simplest of all lenses, the monocular lens.

Our present eyeglasses offer us a photo-optics that is freed

of the worst defect of the old monocular lens, distortion. The monocular lens has every possible optical defect, in particular coma [light-blur], chromatic and spherical aberration, and astigmatism.

But we can turn to account these very defects.

What we want is:

1) *Suppression*, or at least a toning down, *of what is overly photographical*, excessively detailed, in the picture.

2) Close gradation of tonal effects, the soft blending of contours, but without the photograph being fuzzy.

Anyone working at a more profound level with such a primitive lens will realize how very similar are its operations to those of the human eye: a summarizing, "poster-like" effect, with a considerable depth of focus. The sharp center of the picture is surrounded by weaker and less distinct images; thus, in spite of the center's sharp contours, we do not get the inexorable exactness of the anastigmatic picture. Furthermore, light that emanates from very bright surfaces endows the picture with a luminous, unfixed and oscillating character, and indeed this is the special charm of this mode of optical operation. The anastigmat gives the effect of lighting; what the spherically and chromatically uncorrected lens provides is light.

My reply to Professor Schaja in no. 11 of the *Schaja-Mitteilungen* was as follows:

In the matter of "objective" photography versus "photography reduced to essentials," my opinion differs from yours, and I feel compelled to declare this publicly, since what you refer to seems to me of vital importance for the present state of photography.

(Besides, your views might tempt some optical factories to install in amateur cameras those lenses that produce soft contours instead of highly corrected lenses, since they might now presume this to be financially advantageous.)

Partly due to the present tempo of life, partly also because of laziness, we are unfortunately too much accustomed to let the individual passerby glide past us in a schematically simplified form, instead of looking him straight in the face. Too often we perceive only social gestures.

We must remind ourselves that there is a biological way of look-
ing at man, where every pore, every wrinkle, and every freckle is of
importance.

The objectivity of the lens (*Objektiv*) and the proper use of light
have a thousand times more to say about man than the lens which with
soft outlines attempts to capture the "total impression" of different
positions in life.

The desirable way of activating the observer does not consist in
his "carrying further what the picture suggests," but rather in urging
him to an intuitively exact interpretation of real correlations as given
in the representation of the signs of life as objective primary material.
This is why I protest against easily misunderstood recommendations
in an Impressionist vein, especially since today we possess the basic
technical prerequisites to combine objective exactness with the most
wonderful light effects and—given the right person behind the cam-
era—to create out of these elements the visual representation of the
world.

In fact, I even presume to say that—for pedagogical reasons—
I would a thousand times rather have exaggeration of objectivity, of
sharpness, outlines, and details, than a mode of presentation that
combines the planes, no matter how skillfully, but omits the details.
Objective photography must teach us to see. We do not want to subor-
dinate the lens to the insufficiencies of our faculty of seeing and per-
ceiving: it must help us to open our eyes.

The reply by Professor Schaja appeared in the same issue:

> You will certainly believe that I too am protesting against photo-
> graphic nebulousness. On the other hand I am convinced that
> so-called objective photography may very well be a falsification. I
> am ready to take a most exact photograph of your wife, and to
> disfigure her photographically to such an extent that it would
> never enter your mind that it represented your wife. And then I
> would take another photograph of her, in which you would recog-
> nize her at least as a distant acquaintance. That is to say: I will
> neither practice photographic psychiatry on your wife, nor catch
> her in a random state of mind, nor examine her skin under the
> microscope; I just want to express by means of a photograph

what I like about the architecture of her head and the composure of her nature.

But this has nothing to do with her freckles or any other side issue. I am certainly not going to undertake semi-psychiatric procedures with the insufficient (and deceptive) means of the lens.

The complementary ideas of our imagination are much more revolutionary [? M-N] than the most exact description of life. As far as portraiture is concerned, "objective" photography is grotesque, silly, appalling, and occasionally a plain falsification of the living being. There are certainly some sensational effects in "objective" photography, but *radicalism concerning instruments and technique is not good*. Thin or thick paintbrushes were never regarded as artistic criteria. Let us have no doubt on this score, the *Objektiv*, the anastigmatic lens of our day, is anything but an objectively operating instrument. In some cases its exactness may be fascinating, in others it is idiotic. There are cases where it falsifies by excessive zeal, and others where we may use it only with an eye-guard. *I personally prefer taking photographs in the same way that I see with my two eyes.* Your brain says "objective," i.e., "this is so." However, in your case there is no question of objectivity either, but merely of a different, a new, a refreshing playing with something we call optics.

All in all, I think that the attitude we hold toward the world and toward objects, and the instruments we use for approaching them, will and must always remain a matter of temperament.

Perhaps you think that photography is a cultural factor of outstanding importance? For whom? For those who manufacture moving pictures out of cellulose and explosive agents on the side?

II

I consider the question discussed here important enough to be taken out of the restricted professional sphere of *Schaja-Mitteilungen* and to be presented to a larger reading public. In the following lines I shall respond briefly to Professor Schaja's last answer.—M-N

It is staggering for me to see Windisch—whom I thought so far to be

my comrade-in-arms—using such antiquated arguments. How can he still be making the sentimental demand for subjective interpretability, refuted long ago? How can he locate in this idea the criterion of delight in art, of quality? Does he not know that art is something complete in itself, that can never be interpreted but only conceived—according to our frame of mind? He would leave all the doors wide open to our poor, misguided, shortsighted, self-indulgent contemporary, walled in with his habitual notions, instead of mobilizing him with what has never been seen, never noticed: exactness.

I do not want to insist on particular words. The word "objective" can certainly be misinterpreted. But in this case the main question is not "objective" and "subjective," but rather the possibilities of photographic procedures transcending ocular experience. It is entirely possible that our eye, as Windisch-Schaja says, does see the world only in an unsharp, summary way. *But why should the photographic camera conform to the human eye?*

Windisch quite disregards the fact that the main point in art always resides in those values which human intensity is able to summon from the material, from the instrument, for the purpose of expression.

If the camera is able to work more exactly—or, shall we say, in a different way—than our eyes, we ought to be glad! And if somebody believes the camera to be therefore unsuitable for portraiture, he should stay away from it. Photography was not created simply to accomplish the aims of manual painting. We should use the camera for performances not otherwise conceivable.

A mistaken view like that of Windisch caused a disastrous confusion thirty to forty years ago. In those days, mechanized work was supposed to "aspire to" the beauty of handmade articles.[3] That was a merry time indeed! But let us not mourn for it: we have it again, it seems, this time in photography.

There are many other details in Windisch's paper we could also touch upon. But especially in the case of innovations, any decision is determined not only by intellectual argument but also by sure intuition.

In spite of our habitual way of seeing and our own ophthalmic apparatus, we must do our best to search out possibilities that were previously unknown and that cannot be attempted with any other instrument, and to employ them for human expression.

Certainly, I also regard photography as a cultural "factor," even if irresponsible persons over and over again distort correct perceptions and great inventions.

Translated by Matyas Esterhazy

1. *Objectiv* is the German word for camera lens.

2. Anastigmatic lenses, which minimized earlier types of optical distortion and permitted edge-to-edge sharpness in the photographic print, were used increasingly after the 1890s.

3. Moholy-Nagy's friend, the architectural historian Sigfried Giedion, criticized nineteenth-century efforts to impart a handcrafted look to machine-made furniture and household items, calling them the results of a fatal misunderstanding of the new possibilities offered by industrial technology.

ERNÖ KALLAI

and ALBERT RENGER-PATZSCH

POSTSCRIPT TO PHOTO-INFLATION/

BOOM TIMES

A wave of German exhibitions and publications devoted to photography reached its crest in 1929 with the international *Film und Foto* exhibition in Stuttgart. Organized by the German Werkbund, an influential association of architects and designers, it presented about one thousand works vividly demonstrating the "new vision" in photography and graphic design. The exhibition coincided with the publication of two important books, *Foto-Auge* (Photo-eye) by Franz Roh and Jan Tschichold, and *Es kommt der neue Fotograf!* (Here comes the new photographer!) by Werner Gräff.

At just this moment opposition to the experimental wing of "new vision" photography was consolidating, however, as can clearly be seen from the following statements which appeared in *bauhaus* magazine in late 1929. Although unsigned, the opening remarks regarding "photo-inflation" are almost certainly the work of Ernö Kallai (see p. 94), who during 1928–29 was the editor of *bauhaus*. It was no doubt at Kallai's invitation that the photographer Albert Renger-Patzsch (see p. 104) contributed his acerbic commentary on the Stuttgart exhibition.

Original publication: *bauhaus* (Dessau) 3, no. 4 (October–December 1929), p. 20.

Postscript to Photo-inflation

That endless series of exhibitions and publications has moved abroad for a while. Let us quickly take advantage of the reprieve and come to our senses before it's too late.* It's time to say some things which no one wanted to hear at the peak of the commotion. You will perhaps argue that *bauhaus* too has brought out a photo issue. Correct. To be

* We have just received the terrifying news that the Werkbund's photo exhibition has suddenly reappeared, this time in Berlin, Kunstgewerbemuseum. Run! Flee while you can!

140

honest, by now we're almost regretting it. Although our publication did not amount to a jubilant transfiguration of photography as the only visual experience conducive to human happiness, as was claimed in other places—from highly serious design publications to gaily colored magazines. We tried to be judicious and critical. A resolve that, in view of the photo-inflation, cannot be carried out emphatically enough. Hence the following addenda.

Boom Times

still prevail in the world of photography, and everyone's in a hurry to bring in the harvest, even though the yield is scarce and of meager quality. These people display a remarkable haste and industry, and the only thing "modern" about this business is the method by which it is transacted.

For photography is already one hundred years old, and there is no need for haste. But the way exhibitions are managed today, with everyone worried that he'll miss the right moment and fail to profit from the boom before it's over—all this has an incomparably comical effect. But the general rush and haste has been accompanied by a confusion of ideas that gives one pause.

In the fashionable photograph—with a few exceptions—affectation and craving for originality are coupled with a lack of aesthetic standards and of craft. A blatant example: the Stuttgart exhibition, a selection of photographic ephemera in pretentious get-up. Not the kind of thing that should be shown in such an exhibition, namely, a cross section of international photography, measured by the best that can be found between the poles. Instead, it was a random heap of photos with only one common denominator: their mediocrity. In place of quality, quantity. Proof: the almost unanimous enthusiasm of the press. The recipe for success: shoot from above or below. Enormous enlargements or reductions, the trash can as the most satisfying motif. Send negative prints to the press, the monster eats everything. (Motive: new, interesting visual effects.) Take pictures at night, underexposure has the most interesting effects. And then: let chance work for you, it'll do the job. That's how modern photos are made, health food for magazines and conversational fodder for the culture-mongers, to the joy of their creators.

Translated by Joel Agee

ALBERT RENGER-PATZSCH

PHOTOGRAPHY AND ART

In this essay Albert Renger-Patzsch (see p. 104) expands upon ideas intro-
duced in his earlier writings. Beginning with the assertion that photography
has taken over the tasks of realistic representation that once belonged to
painting, he goes on to advise photographers not to follow modern painters
into the realm of abstract form, but instead to concentrate on the visual
means that belongs exclusively to photography—objective realism. For Renger-
Patzsch, the art of photography resides in the photographer's mastery of craft
and in his intensity of vision. He is contemptuous of those who would adul-
terate pure photographic methods with techniques borrowed from the other
arts.

Original publication: Albert Renger-Patzsch, "Photographie und Kunst," *Das
Deutsche Lichtbild*, 1929.

There was a time when one looked over one's shoulder with an ironical
smile at the photographer, and when photography as a profession seemed
almost invariably a target for ridicule. That time is now over. A num-
ber of people of cultivated taste, technical ability, and well-developed
formal talent have made photography into a matter of serious artistic
concern.

The question of whether photography *can be regarded as art or
not* has given rise to much verbal and written discussion. However, it
seems pointless to me to attempt to determine the question either way.
After all, one can prove everything: that it is art and that it is not, that
it assumes an intermediate position, that one must extend the concept
of art to take account of photography, and so on. Basically that is a
question which, for reasons of organization, might interest the editor
of an encyclopedia of conversation, but it has nothing to do with the
real issues. Therefore we shall refrain from any attempt at classification.

But photography *exists* and has for nearly a hundred years now. It
has acquired an immense significance for modern man, many thou-
sands of people live from it and through it. It exerts an immense
influence on wide sections of the population by means of film, it has

given rise to the illustrated press, it provides true-to-life illustrations in most works of a scientific nature. In short, modern life is no longer thinkable without photography.

There is not the slightest doubt that graphic art has been obliged to surrender to the camera much territory in which it was previously absolutely sovereign, and not only for reasons of economy, but because in many instances photography works faster and with greater precision and greater objectivity than the hand of the artist. While art used often to be concerned with representation—it was, after all, impossible to report by means of photographs—modern artists have drawn the right conclusions from the changes which have taken place, and have logically attempted to fashion art in abstract terms. Modern art can no longer pursue representational goals. Photography has clearly set off at a fine pace in the progress it has made; there is not the slightest doubt that the *photographic industry* has tackled all the difficulties with untiring energy, and that, hand in hand with science, it has performed a labor in the last thirty years which must fill us with admiration.

It cannot be denied that the practicing professional photographers and the photography enthusiast were not quite equal to the American pace at which this development took place. Photography was presented with opportunities, firstly because of the way in which photographic technique was perfected, and secondly because of the way in which graphic art, which seeks to solve abstract problems of form, color, and space, voluntarily retired from the field—and these opportunities have by no means been fully exploited as one might have expected.

Quite the reverse. Time and again people have been only too eager *to compete with art.* They perfect what they regard as high-quality printing processes, they improve negatives and positives, or rather they *make them worse by improving them,* in order to *turn a good photograph into a bad picture,* unaware of the fact that the very photographic materials and photographic techniques themselves permit one to achieve far greater variety.

Instead of studying these techniques in all their refinements, in order to attain the greatest achievements in the field of photography, they mix the techniques in an irresponsible way, and often one cannot tell from a production of this kind which part is due to photographic technique, and which to the drawing skills of its creator.

One of the oldest laws of art and craftsmanship is that one should maintain the unity of technique and materials. By using the paintbrush and the pencil in photography they interfere with this unity, and instead of coming closer to the work of art as intended, they come into conflict with one of the first laws of art. With great skill they will perhaps achieve a certain superficial resemblance to an artistic technique, but anyone who is familiar with such things will soon notice what they have attempted to do.

Without wishing to assign a particular status to photography, which, as pointed out above, seems to us unimportant, I should nevertheless like to assert that photography provides the most varied talents with *opportunities to express themselves in the most varied ways*, which may have nothing to do with the technique of the graphic artist but which nevertheless depend to the greatest possible extent on the taste, technical ability, and creative talent of the photographer.

Just as the graphic artist depends on the materials in which he is working, and, for example, an artist using etching materials to achieve the effects of lithography would become the object of scorn, so the photographer has to know his materials and their limitations, if, rather than achieving successes with the uninitiated, his aim is to reach the greatest heights in his field.

If we disregard color photography, which is not yet sufficiently technically advanced, then these limitations are as follows: *all shades of light from the brightest to the deepest shadow, line, plane, and space.*

In order to fashion these into vital form and shape he has the materials of light (natural or artificial), lens, plate, developer, printing paper, his eyes, and his photographic taste. These tools open up to him—within the limitations placed on photographic technique—a thousand creative forms. If he is a great master of the technique, then in a moment he can conjure up things which will call for days of effort from the artist, or may even be totally inaccessible to him, in realms which are the natural home of photography. Whether it be as the sovereign mistress of the fleeting moment, or in the analysis of individual phases of rapid movement; whether to create a permanent record of the transient beauty of flowers, or to reproduce the dynamism of modern technology.

Translated by Trevor Walmsley

KURT KARL EBERLEIN

ON THE QUESTION:

ORIGINAL OR FACSIMILE REPRODUCTION?

In May 1929 Alexander Dorner, the director of the Hanover Provincial Museum, organized a small exhibition that touched off a large controversy. Dorner displayed thirty-five original works on paper, mainly engravings and watercolors, side by side with high-quality photographic facsimiles of these works. The exhibition challenged viewers to distinguish the original from the copy, a task at which neither laymen nor professionals enjoyed much success. The exhibition sparked a series of wide-ranging discussions among German art historians, museum curators, and connoisseurs during the fall and winter of 1929–30. The debate constituted one of the first attempts to examine the new situation of what the critic Walter Benjamin later called "the work of art in the age of mechanical reproduction."

This selection and the one following are drawn from the "reproduction controversy." In this essay, Kurt Karl Eberlein (1890–ca. 1940s), a Berlin art historian and the former director of the Baden *Kunsthalle* in Karlsruhe, describes the spread of modern photo reproduction techniques as a part of the much wider challenge to traditional standards posed by the introduction of machine technology into every aspect of life. Eberlein expresses dismay at the growing use of facsimiles, contending that whatever leads away from the direct experience of authentic artworks presents a danger to art.

Original publication: Kurt Karl Eberlein, "Zur Frage: 'Original oder Faksimilereproduktion?'" *Der Kreis* 6, no. 11 (November 1929), pp. 650–53.

Although Max Sauerlandt's perceptive comments[1] in this magazine do not require any further discussion, we shall broach this timely (alas) subject once again, for the benefit of those who are still unpersuaded.

Consider how in the past a work of art, a painting for instance, was reproduced: there was only the artistic copy—which obeyed laws of its own—or the artistic reproduction. The reproduction was at first a more or less accurate translation of the painting's artistic values into other pictorial values, those of an engraving, a drawing, a contour drawing, a lithograph, or an etching. Not until the advent of technical

reproduction, which seemed to guarantee a new closeness to art (despite certain sources of error), was the mechanical eye, the lens, favored over the human eye as an artistic medium—even though man is still the assistant and agent behind the techniques of reproduction. Photography, heliogravure, color reproduction, collotype—methods of so-called facsimile reproduction—appear to have attained a near-miraculous fidelity; but actually they have produced false or falsifying surrogates.

When we are told that professors and museum curators can no longer distinguish between the original and the reproduction, we are reminded of those touching stories of antiquity about painted grapes and disappointed sparrows, a dog barking at its master's portrait, and similar artistic witness to a delighted verism. "Mutato nomine..."[2]—fables never die!

Speaking of the specialist, the able and frequently cited scholar of the arts, surely this much is beyond dispute: as long as his illustrative material consisted solely of artistic, approximate reproductions, he was much more dependent on experience and memory, a much surer instrument and organ. Given the inadequacy of means and the great distances that had to be traveled, it is simply astonishing how good the scholarly observations and results actually were. In our day, the memory and assurance of the eye—it's called "connoisseurship" now, and people write monologues about it!—are in sorry disproportion to the abundance of technically manufactured art reproductions. The organ of sight in both scholar and layman has without a doubt, on account of the general visual promiscuity, fallen behind technological development. "For seeing begotten, My sight my employ."[3]—in short, long live expertise!

Although the preeminence of photography has brought some advantages, its technical transposition and black-and-white falsification of color and form have taken bitter revenge on scholarship; and the visual aesthetics of an "educated" person in our time, "fundamental principles" and all, is nothing more than a photograph-aesthetics that fails wherever the artistic object reveals its uniqueness. That is why the teaching of art history at the universities, without the originals, can never amount to more than—at best—a history of artists.

But doesn't the famous facsimile reproduction serve scholarship as a useful aid, at least? In my opinion it contributes downright false information to the scholarly study of color and painting, although in

the hands of a knowledgeable person it may at times prove quite useful as a mnemonic aid.

However, the issue here is not scholarship but the general public, and the questions whether one can or should make a "foolproof" imitation of an art object, and whether there is a substantial difference between the epidermis of a living work of art and the artificial skin of a substitute. It is characteristic of our times, indeed something like a cultural disease, that nothing, absolutely nothing, is obvious, nothing indisputable. Time and again one finds oneself earnestly enjoined to discuss something that is beyond discussion, and one can hear perfectly mature human beings seriously debating whether a Mozart quartet played on the radio provides the same aesthetic experience that it does in the concert hall, whether a play is the same work of art on the film screen and on the stage, whether an offset print doesn't have the same artistic value as a watercolor, whether canned asparagus doesn't taste the same as fresh asparagus, and whether caviar and polished barley aren't equally good for the people's welfare. These impoverished spirits, who merely adopt the position of the technocrats, of a graphic arts enterprise, cannot and will not realize, once they have equated "l'homme" and "la machine," that the "deus" does not come "ex machina," and that machine-deus and art-deus are two different things.

But this is just what is so disgraceful and unbearable: that one has to set about explaining why a work of art is a work of art, why it belongs to a different order of production, why it can never be comprehended, represented, or reproduced by the machine and its techniques, why it is not a factory couch, a bicycle, or a toothbrush, and why the experience of art should not ultimately depend upon a well-meaning and commercially clever forgery! Since a poem by Goethe can be printed ten thousand times, and a quartet by Mozart too, why shouldn't one multiply a drawing, a watercolor, an oil painting by as great a number, especially since plaster casts...? etc. To put it very plainly: one is expected to dispute with illiterates the merits of not just a language, but an artistic language and an artistic notation; to explain that a text by Goethe or Mozart is, to begin with, a *score* that requires artistic re-production, and to explain that a plaster cast is an art substitute, a makeshift for seeing hands (!), but that the smallest substitution or erasure in a Goethe poem or in a Mozart quartet is as inadmissible and barbaric as it is in a drawing or a painting—in short, that they are trying to defend distorted, falsified, forged artistic scores!

Since falseness can only breed falseness, that hair-raising question about the vital and artistic value of fascimile reproduction never arises from contact with works of art, but only from the misuse of reproductions. The question of whether rotgut isn't wine does not insult pure wine but pure taste. All social, ethical, sophistic objections and excuses are irrelevant and ridiculous with regard to the work of art, no matter how noble one's motives, and only a brutal utilitarianism can enslave art to its purposes, making it a means to an end and thereby reducing it to "art for all." Schwind's[4] well-known comment, "Art is an aristocratic thing, it turns its back on the democratic gentlemen" is not meant politically but ethically, and it is true! *There is no universal right to the arts*! Whoever wants to possess life and art must "acquire" and earn them before they are his. The problem of art reproduction, as of art restoration, is, like everything else, a question of truth and authenticity. A picture, a drawing, cannot successfully be forged by facsimile reproduction, not once and not a thousand times, any more than a work of architecture can be duplicated, since it, too, is unique. A person who wants to forge the form, the body, and the skin of art should not expect us to discuss with him whether it is permissible to forge artificial skin, artificial patina, artificial antique value. *Forgeries are forgeries, even if they're only supposed to look like forgeries.* Every explanation of why the mysterious, magical, biological "aura" of a work of art cannot be forged—even though 99 percent of the viewers don't notice the difference—is an offense against the sovereignty of art. But let me give the enthusiastic and earnest friends of facsimile reproduction and so-called art prints a gift in parting, an example from my own experience, told briefly and straight to the point, "sine ira et studio":[5]

A long time ago, in a singular, well-known private gallery in Winterthur, I stood before the famous authentic painting by van Gogh that—how to put it?—immortalizes the garden of his hospital in Arles. After looking at it for a long time, I had the understandable desire to compare the picture with the facsimile print that was available for sale, which I did. But how great was my surprise when a careful comparison of the original and the art print revealed actual deviations of format, proportions, brush strokes, color tones, facture, and artistic

effect. It turned out, and others confirmed this, that the "facsimile print" which satisfies and deceives so many was actually—whatever the reason—not made after the original but after a recent copy, which, like all copies and forgeries, can never reproduce the incomparable signature of van Gogh's art, even though hard work and talent have done everything that is humanly possible. Of course I am not claiming that every chromolithograph is made after a copy, but this single case is quite enough for me. No one with a trained eye who has ever been able to compare a facsimile print with the original can be satisfied with the result; and if he is, it proves him a visual barbarian after all! This is what separates Marsyas from Apollo![6]

Finally, as a finishing touch—before we return to the real business of the day—let us forcefully and for all time nail the following twelve theses on the well-known board of the facsimile-men:

1. There is only one facsimile reproduction that can be tolerated: the one in the viewer standing before the original.

2. The farther a reproduction is from the original, the better it seems to be.

3. The farther the artist's hand is from the reproduction, the closer it seems to be.

4. It is an offense against the sovereignty of art and of the spirit to multiply one of its originals by the dozen, even if that were possible.

5. A work of art can only be copied in the same artistic technique as that of the work. A copy is either another work of art or a scientific copy, never a facsimile reproduction.

6. Aids to scholarship are not food for the masses.

7. The very manner in which a work of art is made determines its value. Precisely the same is true of a reproduction.

8. Everything that leads away from the work of art is harmful.

9. A drawing, a painting, a pictorial work, a dance work, a theater work can never be facsimiled, because each is a unique, intellectually shaped physical expression of art's essence.

10. A bird song is not a gramophone record. A facsimile reproduction is not a work of art.

11. A forgery is a forgery, even if 99 percent of all Ph.D.s, professors, and directors never did and never will see it.

12. Morality is always self-evident—even in the face of aesthetic forgeries!

Translated by Joel Agee

1. Max Sauerlandt, the director of the Hamburg Museum of Arts and Crafts, had opened the discussion of the facsimile question in the September 1929 issue of *Der Kreis*.

2. *Mutato nomine, de te / Fabula narratur*: "Change but the name, and the story's told about you" (Horace).

3. Eberlein here recalls a line from Goethe's *Faust*, part 2, act 5: "Zum Sehen geboren, Zum Schauen bestellt."

4. Moritz von Schwind (1804–71) was a German Romantic painter and a friend of Franz Schubert.

5. "Without bitterness or partiality" (Tacitus).

6. Marsyas was the Greek satyr who, having accidentally come into possession of Athena's flute, unwisely challenged Apollo to a musical competition.

ALEXANDER DORNER

ORIGINAL AND FACSIMILE

Alexander Dorner (1893–1957), an art historian and the director of the Han-
over Provincial Museum, was responsible for the exhibition that sparked the
German debate over facsimiles in 1929–30 (see previous selection).

Dorner was a friend of the Russian artist El Lissitzky and an admirer of the
ideas of the Bauhaus. He believed that modern photo-reproduction tech-
niques had fundamentally altered the situation of art, and in "Original and
Facsimile" he presents his case for the merits of art facsimiles. He argues
that the judicious use of high-quality reproductions can only increase the
effectiveness of museums as educational sites, and can convey the artistic
heritage to a wide audience. Making art copies available to everyone, Dorner
hopes, will rescue art from its increasing social isolation and help place it in
the mainstream of contemporary life.

Original publication: Alexander Dorner, "Original und Faksimile," *Der Kreis*
7, no. 3 (March 1930), pp. 156–58.

Nowadays when a facsimile is made of, say, a seventeenth-century
watercolor, it is without doubt, from the point of view of the artist and
his work, a violation. For this artist painted the watercolor as a unique
original. If he thought of reproduction at all, it would have been in the
form of a copper engraving or an etching; but that is something funda-
mentally different from a facsimile, for it does not try to duplicate the
original perfectly. It is a more or less willful translation of the compo-
sition into another milieu.

The making of facsimiles also violates our customary concept of
the original, whose uniqueness was, until now, an established fact.
With the facsimile print, reproductive technique has reached a level
of development that utterly changes the situation. *For the facsimile
actually tries to approximate the original, and therefore ultimately to
replace it.* Consequently, for living artists of those schools that still
stress the uniqueness of a work of art as part of its essence, and for
whom the original is a vastly complicated structure of very subtle
nuances, facsimile reproduction must be either tolerated because its

true character goes unnoticed, or battled against as an enemy of art.

Not until the emergence of the most modern schools of art, such as Mondrian's neoplasticism or Lissitzky's constructivism,* do we find a new, previously unthinkable state of affairs: artists welcoming the facsimile as a worthy ally of their art.[1] For these artists do not aim at giving a complex illusion of the surface appearance of bodies within a three-dimensional space; they show in the simplest way planes, lines, and colors themselves, in their real structure, liberated from illusory space. Consequently the facsimile does not represent a danger to their art, but rather, because of its exactness, an improvement. But only among these most recent artists has the tension between original and facsimile been resolved; in all other cases, it is necessarily present.

Is this a reason to oppose facsimile reproductions? Not at all! *For we need facsimiles of old works of art as well. We need them for reasons similar and related to the reasons for maintaining art museums.* When an altar is removed from a church, or a painting from a castle, and is placed in an environment that, generated by the interests and needs of the present, is incomprehensible apart from these interests and needs—that too is a violation of the original purpose of the work of art and the intentions of its creator. A movement calling for the elimination of museums and the return of all works of art to churches and castles would be essentially destructive (apart from the fact that it could not possibly succeed in practical terms). It would seek to diminish the use we make of the works of the past, by making them into islands lying isolated in the stream of contemporary life.

A similar case can be made for the facsimile reproduction of old works of art. A medium that evolved organically in response to the needs of our time, facsimile reproduction makes it possible to convey the riches of the art of the past to the greatest number of people. It goes one step further in the direction that was taken by founding museums. But this new step, too, unavoidably violates the original meaning of the works of art. How could it be otherwise, when pieces of an old world are translated into the terms of a new one and put to its uses?

* It is worth noting in this connection that recently even the French cubists, who stand at the border between the two camps of contemporary art, have set up a facsimile workshop in Sablons, whose products, in the director's own words, are "the original itself." The idea, evidently, is to dispense with the uniqueness of the original.

Since the tendencies of museum and facsimile run parallel to each other, it seems obvious that facsimiles belong in museums that are not able to give a complete overview of the development of art. A collection of facsimiles, which of course would have to be kept separate from the genuine works, could substitute for originals in all areas not covered in the museum's collection. The effect could only be to enhance the value of the museum, by increasing its effectiveness in one essential respect.

From the objective point of view of the artist and his work, the facsimile of an old work of art represents a disregard of that work's original purpose; while from the subjective point of view of our time it is a necessity. Thus it is understandable that no agreement can be reached in debates on the value of facsimile reproduction. For those who are more concerned with preserving the integrity of art works of the past than they are with adapting those works to the uses of our time, facsimiles will be anathema. As far as they are concerned, the ancient work of art can only be experienced at first hand, with a fingertip sense of the cracks in the surface. Indeed, for them the arduous pilgrimage to the work of art is part of the artistic experience; they want the old work of art to stand isolated from the stream of contemporary life.

For the others the ideal artistic experience is naturally obtained before the original, but at the same time it is essential that the art of the past have the greatest possible effect on the present. Now, since, practically speaking, the overwhelming majority of people cannot frequently come into contact with outstanding works of ancient art, and since, on the other hand, the facsimile—even according to its detractors—is able to convey up to 99 percent of the effect of the original, they are willing to sacrifice that one percent in the interests of the majority, and will advocate the production of facsimiles. They do so with a good conscience, because what distinguishes an ancient work of art from a historical relic—like Frederick the Great's sword—is the fact that the sword loses all its value if it is not the original, that is, if I cannot put my hand on the spot where Frederick the Great put his. But with a work of art, the purely historical experience is quite separable from apprehending the artist's ideas. The relation between the original and the ideal facsimile is comparable to the difference between the experi-

ence of hearing someone give a lecture (that would be the original) and that of reading the same speech (that would be the facsimile). The ideal facsimile can convey the full content of the original with a minimum of loss.

The enemies of facsimile think of the work of art only as a unique and sacred thing; the advocates consider, in addition, the artwork's uses for the present. To the former, what is important is the experience of a small number of individuals; to the latter, the further development of the people as a whole is equally important. No compromise is possible between the two.

Translated by Joel Agee

1. El Lissitzky's geometric "Proun" compositions had been effectively presented in a special issue of the Dutch avant-garde review *De Stijl* in 1922. By the late 1920s he had given up painting to work exclusively in graphic design.

WOLFGANG BORN

PHOTOGRAPHIC WELTANSCHAUUNG

Like his fellow art historians Franz Roh and Hans Hildebrandt, Wolfgang Born (1883–1949) saw in modern photography a culminating moment of the Western "history of seeing." In this essay Born attempts to summarize the importance of photography within the contemporary visual arts. Relating photography to the *Neue Sachlichkeit* (New Objectivity) movement in painting, Born sees them both as part of a wider swing away from Impressionism and toward a concern with structural form. Also evident in Born's remarks is a dawning disillusionment with the prospect held out by technology, a mood that will become even more pronounced in Paul Renner's 1930 essay "The Photograph" (see p. 164). For Born, photography commands present-day attention because it is one area where artists can lend human significance to an otherwise cold, mechanical process.

Original publication: Wolfgang Born, "Photographische Weltanschauung," *Photographische Rundschau* (Halle), 1929, pp. 141–42.

It is no accident: the topical significance of photography, its steadily growing role among the expressive means of our time, is not due to fad or fashion but to a necessity of intellectual history. Only an ideologue cut off from life would deny that our image of the world has undergone a change. Technology advances inexorably. True enough: this is the sorcerer's apprentice who, summoned by man, will never again leave him, even if he should desire it. We may confidently state that in mechanizing our existence and annihilating historical standards of beauty, technology has destroyed more possibilities of human happiness than it has brought about with its civilizing achievements. With the emerging recognition of this fact has come resistance. The eternal rights of humanity stand opposed to the rigid dictatorship of the machine. The crisis is here. The call for a new humanism is being sounded, noticeably, and already with fruitful results in many directions. There

is lost territory to be reclaimed. But the Romantic panacea of a "return" is a fiction. The creative personality will seek other paths. It will aim at spiritualizing matter, at shaping the brittle product of technology from the viewpoint of a living aesthetics; indeed, it will find a vantage from which things will begin to lose their hardness, a standpoint to which the brutal appearances will submit. Determined artistry will find a virgin territory of beauty, where the mind disposed to history encountered only chaos.

This discovery of reality is the mission of photography. It is not incidental that the very process of taking a photograph involves the use of technology. The nature of this medium is intrinsically adapted to the structure of the contemporary worldview; its objective way of registering facts corresponds to the thinking of a generation of engineers. Today the camera can unfold its finest virtue—truthfulness—without hindrance. For the task is to seize hold of the object, to draw it out of its labile involvement with other objects. True, one can experience a forest as a surging, flickering movement of color and light, of odors and sounds—and formally, one can do justice to this experience by means of Impressionism, as Wagner did in *Waldweben*, Liebermann[1] with his plein-air paintings, Peter Hille[2] with his lyrical mood poems. Other epochs experienced and expressed this phenomenon differently. When Dürer painted a forest the result was an assembly of individual trees, each one conceived as an independent organism. The interesting thing, for him, was the lawful arrangement of the branches, the silhouette and layering of the leaves—in short, not the transitory appearance of things but their actual structure. It was similar in 1800, when classicism was the dominant way of seeing, and to a certain degree it is like that now, when related tendencies hold sway in the arts (as the art historian Franz Roh has persuasively argued). This new realism, which finds satisfaction in extreme precision of detail, is the expression of a rational *zeitgeist*. But this does not mean that it has to be banal and devoid of artistry. For no one can be truly moved by reality without a certain secular religiosity, a spiritual way of seeing that intuits a hidden meaning behind the appearance of things. And it is this kind of emotion that is needed to produce a work of art; it is this that still distinguishes the artist from the engineer, who is merely concerned with the ultimate use of his work. Lawful order is at the core of the contemporary *Kunstwollen*.[3] Structure, not mood, is

the governing element in a picture. Crystalline severity, logic, balance, transparency—these are the qualities we expect in a work of art.

Should this not automatically incline us to reevaluate the photograph? What seemed regrettable to the Impressionist generation—that in photography, reality remains untransformed by the imagination—becomes an advantage to the spirit of the New Objectivity. The lens records its subject with impeccable accuracy, and it takes sophisticated trickery to make the contours blur, as was done in the attempt to imitate the interfusing spots of Impressionist paintings. But in order to raise a straightforward photograph above the documentary level to that of a work of art, a new mental attitude is needed, a very special relationship between the self and the object being photographed.

What is needed, to begin with, is the courage to tackle reality head-on. The eyes must be turned on the outer world without any inhibition, as if to forget all the sentiments that have attached themselves to the forms of life.

Take, for example, a construction site. Naked walls growing out of a patch of excavated earth surrounded by planks and wheelbarrows, bricks and cranes. A scaffolding of interlocking pipes, carrying, supporting, rising, higher and higher; and, ornamentally set off against this bright web of lines, the silhouettes of the workers.—Is this ugly? A mind attuned to the nature of things perceives an elegant play of wonderfully ordered forces, the lawful harmony of their equilibrium, the rhythm of the movements of working people that has so often been felt to be aesthetically fruitful. There is living beauty in this subject, the same beauty Dürer found in the morphology of his trees. But once this beauty has been clearly perceived, the picture grows out of the theme as a matter of course. Light and shadows supply the graphic power, the frame is determined by the proportions and points of intersection. Contrasts set off the essential from the accidental elements, the plane is examined once more to make sure that the balance of light and dark yields an ornamental effect. The camera will then record all of it, and the processes of developing and printing will complete the work and add nuances according to the author's intentions.

The world that surrounds us every day is full of such possibilities. The iron construction of a market hall, seen from below, displays the fan-

tastic boldness of its balanced tensions. The stairway, this eternally living element of architecture, allows us to experience the human stride in its corporeal significance and at the same time make a symbolic emblem of it. A picture of a person stepping onto a terrace, taken from below, will express a certain solemnity; a view from above of people going up and down the steps of a bank will suggest the breathless rise and fall of the stock market.

Above and below, near and far, must be understood as essential conditions of visual perception. The close-up leads to a revival of the still life, which can be an inexhaustible source of discovery. For this new way of seeing it will prove a particularly fortunate mode of expression, offering the richest diversity of possibilities. The material character of inanimate things comes energetically to the fore, and the more intensely the photographer engages the fundamental fact of their being, the more they appear, by the end of the process, to possess a soul. Indeed, they can even acquire a kind of uncanny life. Toys, for instance, have been photographed in a way that lends them all the vitality and imaginative energy they possessed for us when we were children. Lighting, framing, and composition can evoke that isolation that is the alpha and omega of a child's imagination.

From here, the way to abstraction also opens. The still life, simplified into an ornament, is dissolved into the optical substrata of its being. Shadow and light take on autonomous meaning, the refraction of light in crystals is put to pictorial use—and in the end, one obtains a kind of self-imprint of nature by its direct contact with photosensitive paper, without the intermediate operations of a camera.

This probing of reality for its ultimate expressive potential is an essential aid to the art of portraiture. The shadow, once an accidental side effect of sculpture, becomes autonomous. Its darknesses not only model the subject, they divide, underscore, conceal. Most photographers prefer artificial lighting: it permits a layering of the body in space that delimits and emphasizes as the photographer chooses. This conscious modeling of the form makes it possible to impart to it a psychological conception and meaning. Spiritualized realism arrives at a depiction of man for his own sake, undistracted by the Impressionist preoccupation with light or the decorative tendencies of Seccessionism,[4] which in recent decades (somewhat later than in painting) set the standard.

Finally, by way of conclusion, let me add that the achievements

of the individual disciplines will give modern photo reportage the power to explore complicated life processes in an artistic manner. If the impressionistic snapshot aspired to no more than to capture the fleetingness of an occurrence, the new photographer will try to set his scene dramatically, that is to say, with regard to its essence. Or he will create an emblem for some typical state of affairs, say, for the turmoil of modern urban traffic, by showing a concatenation of rolling wheels, pedestrians, and neon signs against the sky-high perspective of a department store facade.

In the photo reportage of the magazines we find, besides the banality of the average commercial picture, an increasing number of individual works which aspire to a methodical validity that transcends the incidental moment. The magic of an experience made visible immediately raises such prints high above the reams of pictures that leave one indifferent as one riffles through a magazine.

All this is evidence of what is meant by the title of this essay: "Photographic Weltanschauung." To grasp and evaluate the real, to feel and give expression to the nature of things, in the whole fullness of existence, by selection, camera angle, lighting, by that sensibility that is the mark of an artist—to give a soul to matter—that is the challenge, the urgent problem still awaiting a solution. With this program photography joins the productive currents of contemporary culture.

Translated by Joel Agee

1. Max Liebermann (1847–1935), a painter and graphic artist, was considered one of the leading German Impressionists.

2. Peter Hille (1854–1904) was a Berlin literary bohemian; after his death his poems attracted interest in expressionist circles.

3. *Kunstwollen* was an art-historical concept introduced by Alois Riegl in his 1901 book *Die spätrömische Kunstindustrie*. It signified the "will to form" characteristic of a given historical epoch and linked to that epoch's particular mode of spatial perception.

4. Born is referring to a photographic movement of the 1890s and early 1900s which was modeled on the Berlin Secession, an antinaturalistic, antiacademic artistic movement.

FRANZ ROH

THE VALUE OF PHOTOGRAPHY

Franz Roh (1890–1965) was a German art historian whose books included studies of Dutch painting and of twentieth-century art. His *Nachexpressionismus* (Postexpressionism) of 1925, an examination of postwar figurative painting in Germany, assessed the impact of photography on the visual arts; his subsequent acquaintance with László Moholy-Nagy confirmed his enthusiasm for "new vision" photography. In 1929 Roh coedited, with Jan Tschichold, the book *Foto-Auge* (Photo-eye). The following year he prepared short monographs on the photographs of Moholy-Nagy and Aenne Biermann. Roh was himself an active photographer and collagist.

In "The Value of Photography" Roh takes note of the battle that has broken out among avant-garde photographers over the question of realism vs. experimental creation. Like Moholy, Roh argues for an approach to the medium that embraces both of these poles. He insists, too, on the collective, democratizing potential of avant-garde photography, which he predicts will point the way to new forms of visual culture.

Original publication: Franz Roh, "Der Wert der Photographie," *Hand und Maschine. Mittelungsblatt der Pfälzischen Landesgewerbeanstalt* 1 (February 1930).

All vital and expressive activities can be divided into two classes: those that can be practiced only by very few people, and those that are basically accessible to everyone. Photography belongs to the latter category, and therein lies its far-reaching sociological importance. For a mechanical device to find such wide acceptance, three factors usually must be present: the apparatus has to be relatively inexpensive, it has to be technically easy to use, and the pleasure it offers (in this case, visual pleasure) must be in tune with the mood and direction of contemporary life. This collective aspect of photography produces groans among certain snobs and leading "soloists" in the field. These complaints are quite pointless. One should not complain about the steadily growing number of photo contests or the constant recurrence of certain camera viewpoints and themes. Only a narrow individualism takes offense at such developments, because even in the more

"aristocratic" field of art, a dominant style will eventually emerge, and that style will reveal itself in constantly recurring subjects, points of view, and spatial arrangements—particularly at times of high artistic flowering, when a certain uniformity always prevails. If modern photography expresses a certain unity, it proves, above all, that the times are again beginning to develop a continuity of attitude and style.

Of course, until now it was only a small avant-garde that abandoned worn-out tracks for the sake of new possibilities, but we may expect these pioneers to attract a following, in accord with the collective possibilities of photography.

Of the people who reject the Werkbund exhibition,[1] almost all are unused to today's tighter, more constructive vision, not only in photography but in painting, architecture, and sculpture. Daring camera angles are taken for "mannerisms" (the usual objection to anything new). Photography is put to its best purpose, however, when it does not show things as they have been perceived for generations, but instead presents new approaches that are bolder and not yet exhausted. For the old, familiar form, even if it was better (which was really not the case in photography around 1900), will blunt the sensibilities of viewers within a generation at the most, so that it takes a change of form to restore our capacity for vital experience. That is why we find new ways to isolate details: this allows us to experience the inner form of a thing, by removing the usual, and distracting, context that connects one thing to the "whole" or to other, adjoining things. But we also find large overviews (aerial shots) that put a piece of the world back into a more inclusive context than we can perceive in everyday life, and also views from the top down (from a chimney, for instance) that have the magical effect of showing the verticals at a slant, so that they take on the astronomical meaning of radia pointing to an imaginary center of the earth—which, in a higher sense, they actually are. Finally we capture the world of the microscope, not just for scientific reasons, but also with elemental amazement at the wondrous forms of the microcosm. Above all, of course, we record and preserve the movements of everyday life, whose comings and goings would otherwise rush past without our perceiving their intermediary phases. This is the source of photo reportage, a genre that represents the quintessence of photography: the capturing of unposed documents of life itself, of its positive as well as its abysmal sides.

Unfortunately a quarrel has erupted among the avant-garde pho-

tographers—most of whom are "amateurs" unaffected by the usual professional routines and therefore able to strike out on new paths —about the nature of photography. Should it be a medium of reportage or of artistic creation? This is a worthless pseudo-problem involving two opposing possibilities of one and the same technique. The photogram (copying certain objects directly on light-sensitive paper without a camera) and also the photomontage (the completely free combination of "fragments of reality") have great possibilities. On the other hand, a report of strictly real events, where one is less likely to get lost in subjectivity, also offers far-reaching opportunities. Genuine achievements are to be found in both fields. I tend to champion free creativity, since this approach has decisively expanded the range of possibilities of photography.

Since the same battle is being waged in the fields of painting and especially of poetry, the split among contemporary creative artists can be seen as an expression of the general bipolarity of our culture, and it is natural that this should be reflected in photography. In any case, neither these art forms nor photography should be limited to a precisely factual representation of the world. For there are two primordial delights of man, which, like breathing in and breathing out, should come together in every culture, if possible in every individual, and are as valid and pertinent here as anywhere. They are, on the one hand, the delight in realistic content, in the most exact recognition of a piece of reality; and on the other, the enjoyment of seeing that same familiar world become strange, alien, remote. In the first instance, the button precisely as a button. In the second, the button as a moon, as an utterly transformed entity. In this case the pleasure consists of discovering the shape and gleam of astronomical bodies in a bit of everyday banality, of sensing in something small and seemingly minor a much greater mystery of form.

All of the technical genres of photography (realistic photograph, photogram, photomontage, negative print, photo-typography) should therefore be cultivated. It is just this coexistence that lies at the root of today's productivity. Naturally, the essential ingredient is a human being with a clear instinct to stop at the right point, and to use framing, lighting, spatial tension, sharp or soft focus or a combination of both, and occasionally even expressive distortion. For the technical apparatus is merely a medium through which a human conception of the world seeks to realize itself. But "human" must not be understood

in the sense of philistine, average, or anthropomorphic: an "astronom-ical" understanding of the microcosmic world is perhaps the most human one, since the ability to experience such a concept is given to man alone.

Translated by Joel Agee

1. The Stuttgart *Film und Foto* exhibition, organized in 1929 by the German Werkbund, presented the most outstanding works of international "new vision" pho-tography.

PAUL RENNER

THE PHOTOGRAPH

One year after the German Werkbund's *Film und Foto* exhibition took place in Stuttgart (see p. 140), another vast exhibition of modern photography, *Das Lichtbild* (The photograph), was held in Munich. The talk delivered by Paul Renner at the opening of the exhibition is reproduced here. Renner (1878–1958) was a prominent member of the Werkbund and a well-known typographer and graphic designer; his sans serif Futura type design was one of the most widely used modern typefaces of the 1920s and 1930s. While he acknowledged the growing importance of technological forms like film and photography, in his book *Mechanisierte Grafik* (Mechanized graphics) of 1930 Renner expressed strong reservations about the theories advanced by Moholy-Nagy and other advocates of the "new vision," which he found too extreme and inflexible.

Renner's essay "The Photograph" reflects the growing feeling of many Werkbund members that their earlier, enthusiastic hopes for technology had been misplaced. Renner is explicit about the cultural losses that accompany an increasingly technological society, but shows a stoic determination to master the new machine environment. To achieve this end, he suggests, it is necessary both to understand photography and to instill it with human spirit and imagination.

Original publication: Paul Renner, "Das Lichtbild," *Die Form* (Berlin) 5, no. 14 (July 15, 1930), pp. 377–78.

Last year's Stuttgart Werkbund exhibition, *Film und Foto*—the most important elements of which are displayed on the north side of our hall—bore so little resemblance to all previous photography shows, its material was so completely different from what was shown just a year earlier at the Cologne *Pressa*[1] exhibition, that we may speak of a new photography as assuredly as we have been speaking for several years of a new architecture and a new typography. And if we examine what it is that makes this new photography—the subject of our *International Exhibition: The Photograph: Munich 1930*—so new and different, we will find qualities that we have already recognized in other fields as the special characteristics of the style of our age.

Photography is, to begin with, simply a graphic technique, a mechanical process of reproduction. That was true of printing, too, in its beginnings. But we have come to regard typography as an art—an art that loses rather than gains when it tries to deny the mechanical nature of its production and strives for effects that are only possible in handwitten script. The new photography, too, has given up trying to achieve artistic effects by mimicking chalk drawings, linoleum prints, or other manual forms of graphic art. Today, photography does not want to be anything but itself: it no longer worries whether or not it will be recognized as art.

It seems to me that this is the best path photography can take. A technique can only be intellectually mastered when its inherent laws are acknowledged and understood: that is, when we do not expect it to accomplish something for which it is not suited. But this implies—paradoxical though it may still sound—that all mechanical techniques will remain imitative methods of dubious value as long as we try to soften their inherently mechanical, unyielding, ruthlessly exact character. The new photography, the new architecture, the new household utensils, and the new typography have gained their specifically modern quality from this kind of imaginative response to the challenge of expressing their inherently mechanical quality.

And because this touches upon the particular concerns of the German Werkbund, which is represented in Bavaria by the Munich Bund, the initiator and co-organizer of this exhibition, I would like to clear up a misunderstanding that we often encounter in our work. Even the most intelligent observers overlook the fact that this profoundly imaginative embrace of mechanical techniques is precisely the arena where the most tenacious struggle for human autonomy is being waged. The usual assumption is that the reason man ventures so far into lifeless mechanical realms is that he is weary of his own humanity. No, we seek out the mechanical even though we are well aware of its demonic potential, just as a mountain climber will select a cliff as a kind of opponent against whom he will have to defend his life, step by step, with great tenacity and circumspection. We don't want to be mistaken for those defeatists who take a voluptuous pleasure in all man's losses as he struggles against the machine, and who are as happy as any progress-bedazzled philistine at the extent to which our lives are already infused with the glories of mechanization.

We of the Werkbund know what humanity has lost as a result of this mechanization. We know that an unbroken human being in the fullness of his life can only be found in a village that has hardly been touched by modern technology; that only there do people know what spring, summer, fall, and winter are; that only there can one experience the real taste of the humble foods supposedly available in the city, such as bread, milk, butter, and honey. Some of us would rather live in a village than in a big city, if we could afford such a luxury. But we did not create the cities and their living conditions; they were there before us and we cannot get rid of them. Nor did we create or encourage the growth of machine technology, which has long since become a part of every small commercial enterprise. We are not the sorcerer's apprentices people frequently take us for.

Neither, however, do we helplessly wring our hands as the old culture collapses before our eyes. We are not trying to flee into a romantic no-man's-land of arts and crafts. Nor are we building a Noah's ark in the hope of preserving single samples of the various species that can only live after the flood has dispersed. We are convinced that this flood will never disperse. And we are now doing the only thing that is left for us to do: we are familiarizing ourselves with the sinister element of the mechanical. We live in it—not like the fish in water, but like the seafarer on the ocean, who knows the treachery of the sea much better than does the summer vacationer at the seashore.

No, this flood will never disperse. The hand-lettered book, whose beauty we appreciate as much as anyone, has forever been replaced by the printed book, even though in Turgenev's lifetime the Russian czar would not read a book unless a calligrapher had first copied it out in a special decorative script. Perhaps a Russian czar might still be reading printed books and magazines today if his predecessors had started doing so a little earlier. We don't begrudge anyone the pleasure, if he can still afford it, of building his own house according to his personal taste, and of hiring the last artisans to build the interiors. But perhaps we are doing a service to our grandchildren and great-grandchildren, even more than to ourselves, when we devote, now, such earnest effort to the design of cheap factory products and mechanically produced household effects, to the floor plans of small apartments and the serial construction of houses. The older generation certainly didn't prevent the growth of mechanical mass production.

How could they have? It was inevitable. They paid it no heed, and left the problem of formal design to badly schooled building contractors and technical draftsmen.

No, we really don't love the mechanical any more than they did; but neither are we afraid of it. We look the facts—which are not of our making—in the eye, and we draw the conclusions that are forced upon anyone who feels responsible for the culture of our time. This commitment to the most important design problem of the day has lent special significance to all the exhibitions organized by the German Werkbund in recent years. And this dedication to the noblest task of our age is understood outside our borders: the current Werkbund exhibition organized by Walter Gropius in Paris has met with the greatest respect and recognition.

Now you will understand why we of the Werkbund are interested in an exhibition of photographs, and why we don't regard it as the exclusive concern of professional photographers. And now you will also understand why we don't worry that our action may conceivably hurt the sales of drawings, woodcuts, etchings, or lithographs. The damage is already quite old, and is in all probability irremediable. The family broadside illustrated with wood engravings has long been replaced by illustrated newspapers, filled with photographs from the first to the last page. The German people alone buy five million copies of these newspapers and spend one million reichsmarks on them each week. This is just one of the facts that demonstrate the importance of photography and its widespread use today. One may deplore this triumphal procession of mechanical graphics; but there is no way to stop it. What this means for us is: we have an obligation to show photography the way to its own domain. That would be a gain, not only for photography but also for the fine arts themselves, just as a clean separation between the domains of theater and film would benefit them both. Therefore our exhibition was not an attempt to provide a cross section of current photographic work, but was consciously limited to showing what might move us forward in this direction.

I don't wish to describe at great length the new photography's distinguishing characteristics. You can see them better with your own eyes. I wish to stress only one thing. The new photography seeks to preserve in the final print everything that is in the photographic negative; it refuses to sacrifice richness of tonal gradation to a cheap paint-

erly effect. It does not want to change or prettify anything, and therefore refrains from retouching any part of the picture, unless a fault in the plate requires it. It does not shrink from reproducing human skin with all its pores and hairs, all its charming irregularities and spots. It doesn't change the human face into an insipid sculpture made of wax or scented soap. It does not ask the subject to look into the lens and smile. It despises any form of coquetry between the photographer and an imaginary viewer of the photograph. It stalks its quarry like a hunter, it aims and shoots. It tries to catch life by surprise. It wants to be faithful to the facts. It seeks to document natural processes. It does not want the photograph to betray the presence of the photographer, nor does it want the photographed subject to appear to have held still for the photographer.

But the impersonality and objectivity that are so evidently the fitting expression of a mechanical process are not automatically guaranteed by the use of that process. Surprisingly, we are faced with the same kind of hierarchy that pertains to every art of the past. Truth in photography is by no means the automatic result of the mechanical technique, but is fundamentally an artistic truth. It is an intellectual achievement, the result of a spiritual attitude. It is therefore, as in all other arts, the distinguishing mark of the very best. Just one level below we see all the photographer's faults, just as a second-rate actor always betrays the true actor. With the complete bungler and the army of dilettantes, we see in photography, just as elsewhere—and despite the lens's precise graphic line—the false gesture, the inauthentic emotion, sentimentality, cute poses, a sickly sweet and dishonest attitude: in short, everything that makes kitsch so insufferable in all the other arts.

And this is perhaps the strongest impression you will take away from a careful look at so many photographs: that here, too, the technical aspect is completely overshadowed by the spiritual; that here, too, it is the human value alone that counts; that the art of photography consists of more than the mastery of a set of mechanical instruments. It, too, is a special way of looking at the world.

But we expect more of this exhibition than the aesthetic clarification of these problems. The Stuttgart exhibition has already exerted a very powerful effect on the profession and on the public. This considerably larger show will prove that the new approach, which brings us

back so close to the beginnings of photography, has by now claimed its victory, both in Germany and abroad. We hope that our exhibition will draw in all those who still hesitate and resist.

Photography represents, if not the most sublime, certainly the favorite pictorial medium of our time. We believe that, while maintaining the highest standards, we have put together a truly popular show. And so we hope that many people will come to look at these plywood boards with their thousands of photographs, as one might leaf through a large, instructive, entertaining picture book.

Translated by Joel Agee

1. The *Pressa* was an international exhibition of the modern press held in Cologne in 1928. Particularly noteworthy at the exhibition was El Lissitzky's use of giant photomurals in the Soviet pavilion.

WALTER PETERHANS

ON THE PRESENT STATE OF PHOTOGRAPHY

Despite László Moholy-Nagy's forceful advocacy of photography at the Bauhaus, it was only after his departure in 1928 that regular instruction in photography was offered there. From 1929 to 1932 the director of the Bauhaus photography department was Walter Peterhans (1897–1960), whose background included university study in mathematics, philosophy, and art history, as well as technical training at the Leipzig Academy of Graphic Arts and Book Design. The Bauhaus moved from Dessau to Berlin in 1932, and Peterhans continued to teach there until the school was closed by Nazi authorities the following year.

The following essay, which appeared as part of a special Bauhaus issue of the Prague avant-garde review *ReD*, makes it clear that Moholy's advocacy of unfettered photographic experiment did not long survive at the Bauhaus after his departure. While Moholy had previously called for the development of new visual means specific to photography, Peterhans gives this idea a much narrower, technical interpretation. Like Ernö Kallai he dismisses the abstract forms of the photogram as not truly photographic; and like Albert Renger-Patzsch he advises photographers to concentrate their attention on portraying objects in the world ever more precisely by means of pure photographic techniques, which he describes in considerable detail.

Original publication: Walter Peterhans, "Zum gegenwärtigen Stand der Fotographie," *ReD* (Prague) 3, no. 5 (1930), pp. 138–40.

The transformation in photographic methods and their effects that is taking place before our eyes is critical. What does it consist of?[1]

It is striking in the seeming unity and forcefulness of photographic working methods and results. But this unity does not really exist. The illusion of similarity[2] is based only on a common rejection of traditional techniques and pictorial methods, and on a common turning away from the psychological portrait and from the facile, and thus convincingly boring and accurate, likeness of Mr. X. It is based too on a shared avoidance of manual procedures that, after the fact, deny photography's technical principle—detailed, precise reduction of the image in the negative—and in its place substitute mechanical coloring. We fail to recognize the magic of photography's precision

and detailing, thus allowing what we already possessed to disappear —all in an attempt to make it the equal of the graphic arts, which rightly display other qualities arising from their different technical means. Hence we have not even noticed that photography is capable of giving us its own new vision of things and people, a vision of upsetting forcefulness, and that it gives this through its own characteristic selection from among the abundance of existing facts, a selection made possible by the decided individuality of its technique.

Consider a ball on a smooth plane. It presents us with various views according to the illumination and the play of shadows. It is a combination of individual properties that we join out of habit. The combination changes. It is always the ball on the given plane, though our eye does not experience the intense harmony to which it gives rise. This occurs, rather, through understanding, through the concept of the ball; in other words, the combination, for the eye, is fortuitous. With manual procedures it is possible to stress the rudiments of a picture and to allow what is not appropriate to disappear. Through exaggeration, deformation, suppression, and simplification, manual procedures effect the selection, the transition from object to picture. This is the process of combination from memories, from fixated portions of various views. The transplantation of this method into photography gives us the oil print and bromoil print.[3] But, whereas in the manual process the exploitation of the brush is the technique itself, in the pigment process it interrupts the work of the quantities of light that are active at every point and blurs the modes of operation proper to each of these two different technical methods.

We are capable, however, of renouncing the manual continuation of a process that is already completed by purely photographic means, if instead we simply form the object by photographic selection from among the individual facts. Through the establishment of the chiaroscuro, the spatial order, and the distribution of the depth of field, an image appears, an image that a precise technique derives by scrutinizing the object: the ball on the plane, touching it at only one point, forming itself in the same arc up to the opposite pole, in unstable equilibrium, in the atmosphere of the shadows, and built up in the delicacy and force of the silver gray tones. It is an image which makes these objects stand before us in their brilliance and unity; there is a vital harmony of the objects among themselves and outside of us. This method of working differs in principle from the manual processes.

Our free work with respect to the object precedes the technical photographic process, is guided by an exact knowledge of this process, its richness as well as its limits, and is entirely concluded with the introduction of the latter. Thus this process serves merely to actualize our visual conception.

Now we can return to our opening remark about the seeming unity of the different working methods and results. Photographic technique is a process of the precise detailing of the tonal gradations. To suppress this process means to rob the result of its specific photographic qualities. It is possible, nevertheless, to proceed differently, with great taste and artistry. For example: by setting the bright whiteness of a head amid the lustrous blacks of a high-contrast printing paper so as to achieve an extraordinary balance in size and structure relationships. But this effect is not specific only to photography, and to strive for it means to renounce photography's greatest possible quality (which can appear fleetingly in, for example, the gray tones of the lips that part like a wilting poppy leaf), in other words, to renounce what photography alone can show us. There are more than a few among the modern photographers who adopt these methods in making posters large and small, and produce graphic, rather than photographic, effect. Such methods are still new to us, and they can still be a useful weapon against the threat of lifeless sterility. And the sureness of taste that is often displayed is always welcome. But the black-and-white effect of these prints in which the silver is completely dissolved in the lights and completely reduced in the darks can also be obtained in the lithographic process, and if the gelatinization emphasizes the glossiness and purity of the tone, we are still left with only gelatinized lithographs, crudely photographed. Consider, by contrast, the small prints that Outerbridge[4] shows us: the subtle treatment of the darks, the sharp detailing of the brightest light tones, the broad and firm middle tones—the whole thing a set of variations of the tonal theme, yielding a delicate proximity and clarity of the material. Anyone who sees them will never forget these deeper, distinctive results obtained by the methodical development of technical properties specific to photography.

The situation is exactly the same with regard to the photogram, insofar as we are dealing with studies of light and dark based on the harmonies that emerge from combinations of the silver gray tones. Photograms school us for the transposition of the natural tones into the

silver gray scale, in that they free us from the at first bewildering fullness of tonal nuances occurring in the natural object. Yet what do photograms become when they are presented with the claim of being an end in themselves, along with X-rays of lilies, orchids, shellfish, and fish? How much more magical is the fact of their connection with the object outside of us, which is beautiful in itself.

Progress can come only from the further development of a technique that is still in its infancy and that, under the influence of manual procedures, we have completely neglected. It must come from the further development of the positive techniques that are used with developing papers. It is the characteristic curve[5] of silver chloride and silver bromide papers, with the "sudden drop-off" at its lower end, that accounts for those photographs in which the highlights do not stand out with the clarity of the middle tones. Ordinarily, either the highlights remain without detail (when we wish to emphasize their tonal purity), or else they appear muddy (when we wish to stress their detail). A purely technical problem thus arises from the demand for purer highlights and for the finest separation of the brightest middle tones; these lie ready in the negative, though they cannot be printed. The solution of this problem would allow us, for example, to picture snow not only as a bright spot next to the dark spots of the shadows and the earth, but in its material palpability, as a heap of crystals. Here it is a question of concrete problems of photographic technique, not of Moholyian false problems of photography with distorting lenses or without perspective.

It is well known that platinotype and pigment printing are characterized by a relative abruptness of tone, or lack of differentiation. I need not point out here the difficulties that arise with the use of these procedures. It is sufficient to recall that their formal effect goes completely against what we are striving for, because it is not based on silver particles that are embedded in the gelatine. Preliminarily, we arrive at the best results through fine-grained development of the negative, using amidol with excess sodium sulphate, of somewhat more delicate gradation than it should finally have. In this case the details of the lights are just hinted at and the darks are still differentiated. We can further employ a hot potassium bichromate bath and a second, final development to strengthen the brightest middle tones and saturate the darks, while preserving a complete looseness and lightness of the grain.

What is threatening to emerge in modern photography, as in every movement as it grows, is nothing other than a new academicism, nourished by dilettantism, when we have scarcely freed ourselves from the old one. It is possible, however, to intensify the pictorial character of our photographs more and more, using our knowledge of the effects of technical measures, and accomplishing the intensification before those technical methods are introduced. In other words, we can handle the technique flexibly, like a net that recovers treasure unharmed. In this way, even within the modern trends, we can separate dilettantism and academicism from the steady work on the real enrichment of our heritage.

Translated by Harvey L. Mendelsohn

1. This translation is reprinted from *Bauhaus Photography*, published by The MIT Press; brief omissions and the rearrangement of certain passages in the translation have been restored, following the original German, by Christopher Phillips.

2. That is, the illusion of similarity between the experimental and realist wings of the photographic avant-garde.

3. Oil printing, a nonsilver photographic process that could be used to obtain painterly effects, was favored by artistic amateurs. It was popularized around 1904 by G. E. Rawlins of Liverpool, who manufactured special gelatine papers for the process, and by the French photographers Constant Puyo and Robert Demachy. After 1911 it was increasingly displaced by the bromoil process.

4. Paul Outerbridge (1896–1959) was an American photographer noted for his meticulous still life images, a number of which were shown in the 1929 *Film und Foto* exhibit in Stuttgart.

5. The characteristic curve of a given photosensitive material may be graphed by plotting the changes in negative density that result from variations in its exposure and development. The systematic study of silver's idiosyncratic characteristic curve, introduced in 1890 by Ferdinand Hunter and Charles Driffield, enabled technically minded photographers like Peterhans (or Ansel Adams) to attain precise control over the placement of tonal values in their prints.

HANS WINDISCH

SEEING

A photographer and writer, Hans Windisch (b. 1891) was the editor of the annual *Das Deutsche Lichtbild* (German photography), which began appearing in 1927. In the early years of its publication Windisch showed himself to be clearly attracted to the work of avant-garde photographers, although his conception of the medium differed markedly from that of Lázló Moholy-Nagy; Windisch was primarily interested in the subjective, transformative power of the camera. During the same years Windisch was contributing to the radical journal *Der Arbeiter-Fotograf* (The worker-photographer), and in its pages calling for the use of the camera as a political weapon. In the essay that follows Windisch is concerned not so much with the politicized "worker's eye" emphasized by *Der Arbeiter-Fotograf* as with the idealized, revelatory vision of the avant-garde.

Original publication: Hans Windisch, "Sehen," *Das Kunstblatt*, 1929, pp. 129–34.

We no longer have any time, least of all for conscious seeing. We don't mind being presented with verbal and pictorial slogans, mentally and visually predigested: we are used to it. Ready-made products are delivered to our doors, and we are correspondingly lazy. A laziness that is a defense against the oppressive, irritating, all-too-much-ness.

Nor could it be otherwise: economizing on the brain, on the nerves; concentrating on the twelve square inches of ground on which we stand; keeping a balance, fixing our gaze on puny horizons; and not a moment without tension. Keep your eyes on the road, don't look to either side. Life is disenchanted—not demystified, but disenchanted. An age of prefabrication, including spiritual prefabrication. Psychiatrists concoct ready-made souls.

An amazing thought: there are people who produce things that are completely without purpose, people who stand off to one side of life, artists for example. How do they find the time, the concentration, the courage? It's another world. Enviable? Perhaps.

But where are the bridges? Bridges between them and a post office clerk, a church councilor, a stenographer? There must be a connection somewhere, a point of contact. And somehow, there must also be something that kind of justifies the existence of these outsiders. What do they play their games *for*?

For this: so that someone will hold still for a brief moment; will see; and will say: yes—that's how it is—strange—beautiful—.

He had seen it sometime or other, and not for the first time. Remnants of images close a circle. A small light flares. Gone.

An electric circuit has to close. That's what it's about. So it's something very simple. Fanatics of the eye, of the ears, of the manifold apparitions, are in search of Man (that is, themselves). Reflect a world back to him. But it takes refinement. Let that be their concern.

Some tubes of paint, a lump of clay, a typewriter, a camera—it makes no difference. They are building blocks.

These people have serious faces, programs, and magazines, but they play, they play God and say "creative" and always retain something of the child, enchanted and enchanting. They are the seeing ones. They enfold, they embrace with their eyes. Then—it doesn't matter how, by what means—the thing seen or envisioned takes shape. So it's hard to see why a photograph, for instance, is supposed to exist on a lower plane. Photography, of course, is discredited. But in the meantime it has been born, has gained autonomy, and a few people have managed to tow it away from the wake of painting, from the imitation of painting. Instead of all those pretty little pictures and pretty little feelings: purity, clarity, cool ascertainment. And yet not so cool. To discover something with a camera is to establish it simply as given, but the thing discovered—seen this way or that way or still another way—can be as new as the world on the first day.

The normal eye sees nothing, does not try to establish new relationships, make new acquaintances. No time, no need. But there are people running around with hungry eyes, including camera people. It's not true: it isn't the camera that discovers, uncovers, reveals new qualities. With the exception of a few sensational shots taken at $\frac{1}{1000}$ of a second and some of the triumphs of microphotography, it is the people behind the camera who are seeing with new eyes, asking: "Sentiments aside—what is going on?"

That is photography: to have a camera in the mind, to think photographically. At first glance, photography appears to be a method of more or less mechanical reproduction. But first of all, there is nothing "objective" about a camera lens,[1] it is as subjective as the physiological process of seeing requires. And secondly, you can cut all sorts of capers with a lens. Here, too, the medium of expression must be mastered perfectly to make it comply with the artist's intention. Mastery of photographic technique means having a good deal of science at your fingertips. The days of honest, plodding routine are over. New vision constantly raises new optical problems. Here, too, skill is indispensable.

The paths are slowly becoming clearer.

Synthesis: photomontage, superimposition of several photographs, objectless photography.

Analysis: Penetrating to the overlooked objects and events right next to us, virgin territory all around. Utterly simple things are suddenly very considerably there, have a self, live their own lives. What about US? We're there, too, and that's all.

One might say that the proboscis of a fly, enlarged a hundred times, is much more mysterious, that the sections of a cut crystal are much much more enigmatic, more pregnant with meaning, more fanatically affirmative, than the most clean-shaven privy councilor's face.

Translated by Joel Agee

1. The German word for lens is *Objektiv*.

RAOUL HAUSMANN

PHOTOMONTAGE

Trained as a painter, Raoul Hausmann (1886–1971) was one of the most active members of the Berlin dada group in the period 1918–20, and was a pioneer of the dada use of photomontage. He gave up painting entirely in 1923, and in the following years began to investigate the optical possibilities of the camera. In 1930–31 Hausmann was a frequent contributor to the Cologne review *a bis z* (a to z), writing on photography, photomontage, music, and painting.

In the following essay Hausmann offers a short assessment of photomontage's past and prospects. The text was first presented as a talk on the occasion of the 1931 Berlin exhibition *Fotomontage*, which was organized by the Dutch artist Cesar Domela Nieuwenhuis. The exhibition included work by Hausmann, Hannah Höch, László Moholy-Nagy, Jan Tschichold, and Karel Teige, as well as a section featuring montages and graphic work by Soviet artists like El Lissitzky, Gustav Klucis, and Alexander Rodchenko.

Original publication: Raoul Hausmann, "Fotomontage," *a bis z* (Cologne), May 1931, pp. 61–62.

In the battle of opinions, it is often claimed that photomontage is practicable in only two forms, political propaganda and commercial advertising. The first photomonteurs, the dadaists, began from a point of view incontestable for them: that the painting of the war period, post-futurist expressionism, had failed because it was nonrepresentational and it lacked convictions; and that not only painting, but all the arts and their techniques, required a revolutionary transformation in order to remain relevant to the life of their times. The members of the Club Dada,[1] who all held more or less left-wing political views, were naturally not interested in setting up new aesthetic rules for art-making. On the contrary, they at first had almost no interest in art, but were all the more concerned with giving materially new forms of expression to new contents. Dada, which was a kind of cultural criticism, stopped at nothing. It is a fact that many of the early photomontages attacked the political events of the day with biting sarcasm. But just as revolutionary as the content of photomontage was its form—photography and

printed texts combined and transformed into a kind of static film. The dadaists, who had "invented" the static, the simultaneous, and the purely phonetic poem,[2] applied these same principles to pictorial expression. They were the first to use the material of photography to combine heterogeneous, often contradictory structures, figurative and spatial, into a new whole that was in effect a mirror image wrenched from the chaos of war and revolution, as new to the eye as it was to the mind. And they knew that great propagandistic power inhered in their method, and that contemporary life was not courageous enough to develop and absorb it.

Things have changed a great deal since then. The current exhibition at the Art Library shows the importance of photomontage as a means of propaganda in Russia. And every movie program—be it *The Melody of the World*, Chaplin, Buster Keaton, *Mother Krausen's Journey to Happiness*, or *Africa Speaks*[3]—proves that the business world has largely recognized the value of this propagandistic effect. The advertisements for these films are unimaginable without photomontage, as though it were an unwritten law.

Today, however, some people argue that in our period of "new objectivity," photomontage is already outdated and unlikely to develop further. One could make the reply that photography is even older, and that nevertheless there are always new men who, through their photographic lenses, find new visual approaches to the world surrounding us. The number of modern photographers is large and growing daily, and no one would think of calling Renger-Patzsch's "objective" photography outdated because of Sander's "exact" photography, or of pronouncing the styles of Lerski[4] or Bernatzik more modern or less modern.

The realm of photography, silent film, and photomontage lends itself to as many possibilities as there are changes in the environment, its social structure, and resultant psychological superstructures; and the environment is changing every day. Photomontage has not reached the end of its development any more than silent film has. The formal means of both media need to be disciplined, and their respective realms of expression need sifting and reviewing.

If photomontage in its primitive form was an explosion of viewpoints and a whirling confusion of picture planes more radical in its complexity than futuristic painting, it has since then undergone an evolution one could call constructive. There has been a general recognition

of the great versatility of the optical element in pictorial expression. Photomontage in particular, with its opposing structures and dimensions (such as rough versus smooth, aerial view versus close-up, perspective versus flat plane), allows the greatest technical diversity or the clearest working out of the dialectical problems of form. Over time the technique of photomontage has undergone considerable simplification, forced upon it by the opportunities for application that spontaneously presented themselves. As I mentioned previously, these applications are primarily those of political or commercial propaganda. The necessity for clarity in political and commercial slogans will influence photomontage to abandon more and more its initial individualistic playfulness. The ability to weigh and balance the most violent oppositions—in short, the dialectical form-dynamics that are inherent in photomontage—will assure it a long survival and ample opportunities for development.

In the photomontage of the future, the exactness of the material, the clear particularity of objects, and the precision of plastic concepts will play the greatest role, despite or because of their mutual juxtaposition. A new form worth mentioning is statistical photomontage—apparently no one has thought of it yet. One might say that like photography and the silent film, photomontage can contribute a great deal to the education of our vision, to our knowledge of optical, psychological, and social structures; it can do so thanks to the clarity of its means, in which content and form, meaning and design, become one.

Translated by Joel Agee

1. Club Dada was the name of the informal Berlin dada group which Hausmann, Richard Huelsenback, and others organized in the summer of 1918.

2. These were introduced by the Zurich dada group at the Cabaret Voltaire in 1915–16. The static poem consisted of the silent juxtaposition of two or more unrelated objects on stage before the audience. The simultaneous poem involved simultaneous recitation by a number of performers gathered on stage. The phonetic poem dispensed with conventional language altogether and depended upon the rhythmic patterning of sounds for its effect.

3. The films mentioned range from musical entertainment *(Melodie der Welt)* to documentary *(Afrika spricht)* to a working-class domestic drama *(Mutter Krausens Fahrt ins Glück)*.

4. Helmer Lerski (1871–1956) was a German photographer known for his extreme close-ups of the human face.

DURUS (ALFRED KEMÉNY)

PHOTOMONTAGE, PHOTOGRAM

Alfred Kemény (1895–1945), like his fellow Hungarians László Moholy-Nagy and Ernö Kallai, left Hungary after the fall of its left-wing government in 1920. A member of the avant-garde group MA (Today) and a friend of Moholy's from student days in Budapest, Kemény was an advocate of constructivist art during the early 1920s, and traveled to Moscow to assess the movement at first hand. He joined the German Communist Party in 1923; under the pseudonym Durus he published art, theater, and literary criticism in the party weekly *Die Rote Fahne* (Red banner). In the late 1920s Kemény was one of the organizers of the Bund Revolutionär bildender Künstler Deutschlands (League of revolutionary German artists).

In this essay Kemény questions the suitability of avant-garde techniques like the photogram and the photomontage for political applications. Although he acknowledges the effectiveness of John Heartfield's photomontages, Kemény's skepticism about avant-garde photography is evident. His warning to working-class photographers to avoid the dangers of "aestheticsm" echoes that of Franz Höllering (see p. 128) three years earlier.

Original publication: Durus, "Fotomontage, Fotogramm," *Der Arbeiter-Fotograf* 5, no. 7, 1931, pp. 166–68.

There is no question that as means of agitation and propaganda, photography and film reach greater numbers of the working masses than can paintings, or even etchings and woodcuts. The masses' hunger for images is being satisfied to a large extent by photographs and films, and only to an infinitesimal degree by paintings. Magazines and newspapers are flooded with photographs, and soon books and brochures will not be able to do without photos. The photomontage has already conquered the book jacket, the book's outer skin. Revolutionary pamphlets using photographs, and the photographic design of Heartfield's book, *Deutschland, Deutschland über alles*,[1] have shown that books and pamphlets can be made much more lively and attractive by the inclusion of photographs in their design.

In the hundred years of its evolution, photography has had a decisive impact on human vision. Along with the development of trans-

portation in the last century, photography has made essential contributions to the conquest of time and space. Thanks to photography we can experience, in their reality, aspects of the five continents of the earth, simultaneously. Two adjacent photographs—let us say a picture from the United States and one from Somaliland—instantly shrink the distance between America and Africa to the briefest of intervals.

Like a great deal else, none of this surprises us any longer. We take it for granted. But a contemporary of Dürer and Holbein would surely have spoken of "wild imaginings" or "madness" if someone had suggested the possibility, in some faraway future, of making a person's likeness by purely physical-chemical means, with the help of a specially constructed apparatus. Different times, different time-bound techniques of illustration and pictorial design.

Today the technically up-to-date medium of photomontage is already in danger of becoming a mere vogue, the newest fad among the rich. A photomonteur, for example, presented a "cubist" dissection of his wife at the last photomontage exhibition in Berlin. This is degenerate "photomontage." Soon the fancier sort of Kurfürstendamm trollop will be expressing a desire to be cut into pieces by photomontage.

Today photomontages are being turned out by the hundreds for advertising purposes. The bourgeois advertising industry enables a bourgeois photomonteur to "work" as "pleasingly" and thoughtlessly as possible. A monkey-like cleverness known as routine is sufficient. Intellectual abilities would just get in the way. The purpose of advertising is, of course, to persuade people to serve the profit interests of the various capitalist enterprises. But this "harmless," seemingly apolitical appeal turns only too easily into outright propaganda for the capitalist system. In our illustration, the commercial photomontage with the caption: "Hamburg, Germany's gate to the world"—a slogan which the maker of the montage surely did not think through to the end —advertises not only Hamburg but Germany as a "great power," with its armored cruisers A and B and beyond them C, D, E, and F.

The concept "photomontage" signifies a "purely" technical procedure, the superficial coupling of details from different photographs. The recombined and newly related details are, in bourgeois photomontage as much as in proletarian-revolutionary photomontage, *parts of reality*. But while bourgeois photomontage uses photographed parts of reality to *falsify* social reality as a whole, disguising this falsification of the whole reality with the seeming *factualness* of the photo-

graphed details and thus giving the impresion of true reality (which is why the montaging of photos in bourgeois newspapers and magazines is so dangerous), revolutionary photomontage by an "artist" (technician) of Marxist orientation brings photographic details (part of reality) into a dialectical relationship, both formally and thematically: therefore it contains the actual relationships and contradictions of social reality.

Revolutionary photomontage, whose goal is ruthlessly to expose social reality, has paved the way for a completely new, previously unknown *Marxist method of artistic creation*; a method that does not start out from the pretense of the world's painterly or graphic "beauty," but from the need for political enlightenment based on the principles of historical materialism, founded on the revolutionary worldview of our age. As evidence of how a bold, cliché-free formal approach can help multiply the revolutionary import of an ideologically irreproachable photomontage, we present the excellent photomontage by Nilgreen:[2] "Imperialist Sharks Threaten the Soviet Union." *Our first concern is to hammer the truth into people's brains over and over again—the truth of exploitation, of the degrading capitalist system, of the conditions for the liberation of the proletariat—and thus to agitate and propagandize the masses as effectively as we possibly can.*

Completely new possibilities of work with pictures are opened up by *photography without a camera.* The first to experiment with this method was Man Ray, an American living in Paris. By casting light on a sensitive sheet or plate according to a preconceived plan, or by placing variously translucent objects on sensitive paper, it is possible to create novel visual effects that could not be achieved by taking normal photographs with a camera. The two cameraless photomontages by *Alice Lex*[3] reproduced here, *without precedent* in their pictorial approach and therefore extremely valuable, are well suited to reinvigorate revolutionary agitation and propaganda. These photo-graphics by Alice Lex evince the possibility of combining light and color treatment simultaneously. Original color relationships have been transformed into various degrees of brightness. The point of departure was the varying translucency of different colors. Figures cut out with a scissors and constructed from colored planes are placed on sensitive paper and then exposed to light, to produce a carefully planned propagandistic and graphic effect. Here is a truly contemporary combination of visual art and photography—something that cannot be said for the mingling of technically anachronistic etchings with photographic

elements.—*However, proletarian photographers should be warned, for the time being, against undertaking similar experiments. The result would be a passing fad of playful aestheticism, a distraction from the revolutionary class struggle and from the essential tasks of the proletarian photographer as a revolutionary reporter.*

Are the partial realities of the cameraless photos by Lex not "real" in the sense of normal photographs?! That is not the issue. The whole of social reality is contained in these pictures. The churches of the recently published photomontage postcard reproduced here—the dome, the Hedwigs-Church and the Kaiser-Wilhelm Memorial Church—are real Berlin churches. But the fact that the metropolitan city of Berlin is represented by churches alone—no matter how schematically—is proof that photomontage as a *falsification of social reality as a whole* has already become a weapon of cultural reactionism.

Translated by Joel Agee

1. John Heartfield's photomontages were used to illustrate Kurt Tucholsky's satirical book *Deutschland, Deutschland über alles* (1929).

2. Nilgreen was the pseudonym of the painter and graphic artist Oscar Nerlinger (1893–1969), the husband of Alice Lex-Nerlinger (see n. 3).

3. Alice Lex-Nerlinger (1893–1975), an artist and political activist, used photograms in political graphics.

RUDOLPH ARNHEIM

Excerpt from *FILM AS ART*

As a young art historian in Germany, Rudolf Arnheim (b. 1904) was attracted by the aesthetic questions raised by new technological media like cinema and radio. The following extract is from Arnheim's 1932 book *Film als Kunst* (Film as art), most of which later appeared, in Arnheim's own English translation, in *Film as Art* (1957). Several paragraphs omitted in that translation have been restored here.

Although Arnheim is addressing questions of film aesthetics, his remarks bear directly on topics of importance to still photography as well—for example, the issue of uncustomary camera vantage points that had so absorbed László Moholy-Nagy, Alexander Rodchenko, and others. Arnheim, already displaying a curiosity about the relation between perceptual experience and pictorial form that would later mark his classic *Art and Visual Perception* (1954), here attempts to explain the impact of unusual camera angles. Starting from the assumption that a photograph is a camera image projected upon a two-dimensional surface, he proceeds to analyze the pictorial changes that accompany every change in camera position—with results that can range from conventional views to puzzling distortions.

Original publication: Rudolf Arnheim, *Film als Kunst* (Berlin: Rowohlt, 1932), pp. 60–69.

In the Russian films—other people have copied the idea—the domineering forcefulness of a character is often expressed by taking the shot from the worm's-eye view. An iron captain of industry or a general—the camera looks up at him as at a mountain. Here again the fact that the actor has to be taken from some particular point of view is not handled perfunctorily but is consciously exploited: the perspective angle acquires meaning, a virtue is made of necessity.

A twofold effect can be produced by a clever position of the camera. If an artistic impression is to be achieved, this double effect is necessary; and must not only show the subject in characteristic fashion but must at the same time satisfy the spectator's sense of form. To photograph an autocrat from below not only points the effect which the figure is to have upon the audience, but, if cleverly executed, it also

results in an arresting play of form. It is unusual—or was until a few years ago—consciously to perceive such a distorted view of the human body. The hugeness of the body, the head—appearing very small because of the foreshortening—far away on top of the figure, the curious displacement of the facial structure (the way the tip of the nose with its two black caverns juts out over the mustache; the chin seen from below)—all this possesses a strong formal interest which need not imply anything with regard to the content. The strangeness and unexpectedness of this view have the effect of a clever *coup d'esprit* ("to get a fresh angle on a thing"), it brings out the unfamiliar in a familiar object. René Clair's film *Entr'acte*[1] contains a picture of a ballet girl dancing on a sheet of glass. The photograph has been taken from below through the glass. As the girl dances, her gauze skirts open and close like the petals of a flower and in the middle of this corolla comes the curious pantomime of the legs. The pleasure derived from so curious a shot is at first purely formal and is divorced from all meaning. It arises solely from the pictorial surprise. If in addition it had some significance, its value would be all the greater. The erotic element of the dance, for instance, might be brought into prominence at will by such a position of the camera.

Camera angles are often chosen solely on account of their formal interest and not for their meaning. A director has perhaps discovered some ingenious viewpoint which he insists on using even though it signifies nothing. In a good film every shot must be contributory to the action. Nevertheless, directors very often allow themselves to be led into violating this principle. They will show two people in conversation; they will take the picture from the level and then suddenly from the ceiling, looking down onto the heads, even though the shift in viewpoint brings out or proves or explains nothing. All that these directors have succeeded in accomplishing is the betrayal of their art.

In Carl Dreyer's beautiful film *The Passion of Joan of Arc*,[2] long discussions take place between priests and the Maid. This is an unfruitful theme for the camera. The real interest of these scenes lies in the spoken word. Visually there is little variety to be extracted from the endless confrontations of arguing speakers. The solution of the difficulty is surely to avoid putting scenes like this into a silent film. Carl Dreyer decided otherwise, and mistakenly. He tried to animate these cinematographically uninspiring episodes by variety in form. The camera was most active. It took the Maid's head obliquely from

above; then it was aimed diagonally across her chin. It looked up the ecclesiastical judge's nostrils, ran rapidly toward his forehead, took him from the front as he put one question, from the side as he put the next—in short, a bewildering array of magnificent portraits, but lacking in the slightest meaning. This byplay contributes nothing to the spectator's comprehension of the examination of the Maid; on the contrary, the spectator is irrelevantly entertained to prevent his being bored by what should be exciting. Form for form's sake—this is the rock on which many film artists, especially the French, are shipwrecked.

The curious camera angles to be found in many recent films —adopted either with artistic intent or merely for their own sake —were looked upon as malpractices in the early days of photography and film. In those days anyone would have been ashamed to present an audience with an oblique camera angle. What are the reasons for this change?

The fascination of the early films lay in the movement on the screen of objects which exactly resembled their originals in real life and behaved like them down to the minutest detail. This attitude toward film naturally determined the position from which shots were taken. Whatever was to be shown was taken from the angle which most clearly presented it and its movements. The task of the camera was in fact considered to be merely that of catching and registering life. The idea that the manner in which this was done might be of value in itself or do the job of recording information even more efficiently was not yet considered. People were not in those days dealing with film as an art but merely as a medium of recording. "Distortion" was obviously wrong since it was not yet intentional.

Only gradually, and at first probably without conscious intention, the possibility of utilizing the differences between film and real life for the purpose of making formally significant images was realized. What had formerly been ignored or simply accepted was now intelligently developed, displayed, and made into a tool to serve the desire for artistic creation. The object as such was no longer the first consideration. Its place in importance was taken by the pictorial representation of its properties, the making apparent of an inherent idea, and so forth.

Another aspect remains to be touched upon. An unusual camera angle (such as those mentioned above) has still another result, apart from characterizing the object in a particular sense and introducing an

attractive element of surprise by the unexpected shapes which a familiar object can assume. Pudovkin[3] has said that film strives to lead the spectator beyond the sphere of ordinary human conceptions. For the ordinary person in everyday life, sight is simply a means of finding his bearings in the natural world. Roughly speaking, he sees only so much of the objects surrounding him as is necessary for his purpose. If a man is standing at the counter of a haberdasher's shop, the salesman will presumably pay less attention to the customer's facial expression than to the kind of tie he is wearing (so as to guess his taste) and to the quality of his clothes (so as to know what his requirements are likely to be). But when the same man enters his office, his secretary will doubtless pay less attention to his tie than to his facial expression (so as to know what sort of temper he is in). It is a well-known fact that many married couples do not know the color of each other's eyes; that people are ignorant of the very pictures hanging on the walls of their dining rooms; that they do not know what the carpet on their floors is like; and that they have never noticed how their servants are dressed. It is indeed exceptional—apart from persons of aesthetic tastes and training—for anyone suddenly to lose himself in gratuitous contemplation, to watch his neighbor's hands, to examine the play of shadows on the pavement.

In order to understand a work of art, however, it is essential that the spectator's attention be guided to such qualities of form, that is, that he abandon himself to a mental attitude which is to some extent unnatural. For example, it is no longer merely a matter of realizing that "there stands a policeman"; but rather of realizing "how he is standing" and to what extent this picture is characteristic of policemen in general. Notice how well the man is selected; what a characteristic movement that one is in comparison with another, more obvious movement; and how the forcefulness of the figure is brought out by the shot being taken from below!

There are also certain artifices by which the spectator may be induced to assume such an attitude. If an ordinary picture of some men in a rowboat appears on the screen, the spectator will perhaps merely perceive that here is a boat, and nothing further. But if, for example, the camera is suspended high up, so that the spectator sees the boat and the men from above, the result is a view very seldom seen in real life. The interest is thereby diverted from the subject to the form. The spectator notices how strikingly spindle-shaped is the boat

and how curiously the bodies of the men swing to and fro. Things that previously remained unnoticed are the more striking because the object itself as a whole appears strange and unusual. The spectator is thus brought to see something familiar as something new. At this moment he becomes capable of true observation. For it is not only that he is now stimulated to notice whether the natural objects have been rendered characteristically or colorlessly, with originality or obviously; but by stimulating the interest through the unusualness of the aspect, the objects themselves become more vivid and therefore more capable of effect. In watching a good shot of a horse I shall have a much stronger feeling that "here is an actual horse—a big beast with a satiny skin, and with such and such a smell . . ." That is to say, therefore, not only form but also objective qualities will impose themselves more compellingly. It must, however, be mentioned that if this method is applied unskillfully it leads to the opposite result, and may produce a view of the object which makes it quite unrecognizable, or which shows it so much out of character that the effect is not strengthened but lost.

It may be convenient to summarize briefly here what has been said in the above paragraphs:

It is a property of photography that it must represent solids "one-sidedly" as plane pictures. This reduction of the three-dimensional to the two-dimensional is a necessity of which the artist makes a virtue. It is the means by which he achieves the following results:

1) By reproducing the object from an unusual and striking angle, the artist forces the spectator to take a keener interest, which goes beyond mere noticing or acceptance. The object thus photographed sometimes gains in reality and the impression it makes is livelier and more arresting.

2) The artist, however, does not direct the attention merely toward the object itself, but also to its formal qualities. Stimulated by the provocative unfamiliarity of the aspect, the spectator looks more closely and observes (a) how the new perspective shows up all sorts of unexpected shapes in the various parts of the object, and (b) how the solid which has been projected onto a plane surface now fills the space as a flat picture with a pleasing arrangement of outlines and shadow masses—thus making a good and harmonious effect. This design is achieved without any distortion or violation of the object, which appears simply as "itself." Hence the striking artistic effect.

3) Guiding the attention to the formal attributes of the object has the further result that the spectator now feels inclined to consider whether the object has been chosen characteristically and whether its behavior is characteristic; in other words, whether it is a representative example of its genus (for example, "a typical official"), and whether it moves and reacts in conformity with its species.

4) The novel camera angle, however, serves not only as an alarm and decoy. By showing the object from a particular point of view, it can interpret it, more or less profoundly ("The convict as a number"). Here too, there is a special charm in that to obtain this result the object has in no way been changed or touched up, but has been left exactly as it appears in real life.[4]

In conclusion, a practical example.

The above picture[5] represents a very familiar subject engaged in a very familiar occupation: a man is walking on the street. Of all the available angles, the one that suggests itself most readily would have involved the photographer's standing next to or in front of this man. But he shows the man from above, and this very emphatically underscores (instead of just taking for granted) the fact that in photography, every three-dimensional body has to be viewed from a particular vantage point. One does not see the man's face, but only his hat, and from above; of one leg, only the shoe; of the other, a piece of the calf. As a representation of the subject called "walking man," the picture couldn't be more inadequate. A viewer who had never seen a walking Central European would never derive from this picture an accurate notion of the typical appearance of such a person. But the photographer has a completely different intention. He presupposes a familiarity with the subject, and seeks to interest and possibly instruct the viewer by showing him this unusual sight of an extremely ordinary subject—just as any playwright, for instance, will presuppose that this audience is familiar with the stirrings of the human soul. For an artist never offers elementary education; he draws on the common experience and knowledge of mankind as material for his creative and interpretive work.

1) No one will look at this picture without some degree of attention. The uniqueness of the angle is "eye-catching," as the advertising people say. A picture of this unassuming walker taken from an ordinary camera position would probably not have invited more than a cursory glance, while this one makes you open your eyes wide. And

that brings the object more forcefully to the viewer's notice: Aha, someone's walking there, you can see his stride, you can see him swinging his arms; the forward-striving motion of the whole body is very vividly brought out. We have a stronger contact with this walking man.

2) We not only see a man walking, we also see the sort of picture he yields. a) Only the viewer who knows a walking man in his "standard view" can experience the appeal of this distortion: the way the round top view of the hat suddenly dominates the whole figure, the way the boot peeks out from under the rim of that hat, the way the left arm and the left leg appear to emerge from virtually the same place. One might say this is an ingenious variation on the theme of a walking man. Just as an artist using paper and pencil can give us the feeling that the living image of a familiar person is taking shape before us in simple black lines, the photographer reinterprets a long-known object by viewing it from such an uncommon angle. b) The "walking man's" body has become a planar image, and because this planar image is so unusual, it impresses itself on our consciousness. We notice the almost starfish-like figure whose blackness blends with the shadows on the ground; it is a kind of cross. The left leg and the boot of the right leg are aligned in a direction that forms a diagonal within the framework of the picture, for it leads roughly from the upper right to the lower left. The two arms, on the other hand, make an S-form which in its principal extent lies at a right angle to the direction of the legs. Roughly at the center of this cross is the round hat. In contrast to a), where we took note of the rearrangement of familiar forms, in b) we are looking at the subject purely as a black-and-white plane and observing the way it fits into a quadrangular frame, what sort of outlines it has, and what kind of planes it results in.

3) Our picture is not a typical example for point 3, for nothing in the choice of the subject is allowed to claim special attention. This is a perfectly ordinary man; we cannot say that he is well or badly selected.

4) This point applies more clearly to our picture: the camera angle brings out a particular meaning. We are shown, more incisively than we would be by a picture taken at a normal angle, how the arms perform a rowing motion to direct the body forwards, and the stride of the forward- and backward-stretching legs looks very active; the hat's function is clearly brought out by the way it shields the whole figure like a roof.

1. *Entr'acte* was a short film produced by René Clair in 1924 to be shown during the intermission of Francis Picabia's dada ballet *Relâche*.

2. Carl Theodor Dreyer's *The Passion of Joan of Arc* (1928) was noted for its use of expressive camera angles and close-ups.

3. Vsevelod Pudovkin (1893–1953) won a following in Europe with films such as *The End of St. Petersburg* (1927) and *Storm over Asia* (1928).

4. The text from this point to the end of the selection was translated by Joel Agee.

5. The photograph that accompanied the essay had previously appeared on the cover of Werner Gräff's *Here Comes the New Photographer!* (1929). It shows a walking man seen from directly overhead, so that only his hat, swinging arms, and striding legs are recognizable.

RAOUL HAUSMANN and WERNER GRÄFF

HOW DOES THE PHOTOGRAPHER SEE?

In the early 1920s, Raoul Hausmann (see page 178) proclaimed the new urban environment, together with cinema and photography, to be ushering in an epoch of unprecedented visual culture. At that time Hausmann looked forward to the birth of a "new man" whose senses and consciousness would be radically transformed. In "How Does the Photographer See?" published eleven years later, Hausmann is still calling for a living, dynamic vision. He regards the photograph as a training ground for expanded perception, and he now relies, like Rudolf Arnheim (see previous selection), on a more complex analysis of the relation between the physiology of perception and picture construction.

Hausmann's partner in the conversation reproduced below is Werner Gräff (1901–78), one of the founders of the Berlin review *G* and a member of the German Werkbund. Gräff was the author of the book *Es kommt der neue Fotograf!* (Here comes the new photographer!), published in 1929, which attempted to persuade amateur photographers to adopt the techniques of the new vision. Gräff's real contribution to this dialogue is difficult to assess, since many of the remarks attributed to him appear to be drawn from Hausmann's previous writings.

Original publication: Raoul Hausmann and Werner Gräff, "Wie sieht der Fotograf?" *Das Deutsche Lichtbild* (1933), pp. 11–18.

H: Dear G., experience teaches us that almost no photographer has the slightest inkling of the most important artistic questions. Framing an image, guiding the viewer's eye, the relationship between space and form—these are, for most photographers, nothing but empty concepts.

G: Yes, dear H., a lot can be said about that, and these are questions that have not been publicly discussed with sufficient clarity.

H: Although some years ago, in your book *Here Comes the New Photographer!* you gave quite a few examples of the liberation of photography from the antiquated rules of aesthetics!

G: But I took care not to set up new rules.

H: Others have done that in the meantime.

G: And in your opinion they have done it in a way that would seem to require some correction?

H: Yes, indeed. I think it desirable to arrange all the relevant questions systematically and then try to answer them as simply as possible. Let's try that.

G: I'm all for it! So our first observation is this: that the pictures lack visual organization because the photographers don't know what seeing is, and how to make practical use of this photographic and visual knowledge. Our conversation, therefore, will be structured as follows: first an explanation of human seeing in general, and then of the resultant knowledge concerning the relationship between guiding the eye and simple volumes, the opposition between space and form, the framing of an image, and the correcting influence of consciousness on what is seen.

H: But these are difficult questions that have to be answered with some thoroughness. Incidentally, I believe we first have to say something about photography as an intermediate stage between art and technology, and about the fact that, like technology, photography is playing a historical role in the education of human consciousness.

G: How do you mean that? Are you sure you're not claiming too much?

H: Well, yes. But I think it's important to do so, to avoid giving the impression that we're trying to set up arbitrary, pseudo-original rules instead of providing as scientific an investigation of photographic seeing as possible. And also because most people hardly know anything about the interrelationship between art and technology, and are at best always talking about how "interesting" and "beautiful" it all is—which isn't worth very much.

G: So what do you want to say about art and technology?

H: That both are means, closely related, for clarifying the position of man in the world of things. Technology and art help clarify the possibilities held out by nature for expanding our physical capacities and our senses. Just as prehistoric man needed a very precise knowledge of the animals he hunted and therefore drew them in the most exact and characteristic detail on the walls of caves, in the same way, human seeing has at all times been influenced by pictures, the purpose being to gain a better grasp of environmental conditions. In the fifteenth century, perspective was introduced into painting, technology began with printing and gun powder, and the world expanded for the new

bourgeoisie; in the nineteenth century, the golden age of the bourgeoisie and the development of the locomotive were paralleled by color theory and Impressionist painting. In our time, photography and film have a tremendous effect on their viewers. One can say that photography, photomontage, and film sharpen and develop the senses of the stirring masses. To see—and to know what you are seeing and what is the purpose of your seeing—is one of the most important matters, particularly in our time; that is why the development of photography as an art is beginning just now.

G: When you speak of photography as an art, many people will get angry with you.

H: Nevertheless it has to be said: the root meaning of "art" is "skill": so art involves technique. And it makes no difference whether the medium is paint or the camera. In both cases, the essential thing is: Who sees What?

G: We can aim at an artistic whole by bringing out contrasts of forms, of tones, of points of view, regardless of whether or not some technical means is employed. But how few photographers know how to make practical use of today's photographic-visual knowledge! For the rules one finds even in the more high-toned manuals are usually quite arbitrary; their creators are at a loss to justify them conclusively. Let's look more closely at some of these rules. For example: "The plane must be organized in such a way as to create a triangular structure, with special emphasis on the open field." Or: "A picture is poorly structured if it does not include a diagonal." Or: "The principal motif is whatever object takes up the most space and most strongly attracts the eye by its tone values." These rules are obviously weak, but once they're established, they should at least be scientifically supported by visual experience!

H: And that would imply that the only possible instruction is instruction in seeing—but not in some papery concepts of abstract beauty. For example, what is the basis of the idea of the importance of the diagonal? That is the question; and to what degree is a diagonal useful, and what are its limits!

G: Right! Let's take the following as the point of departure for these investigations. Certain exact experiments have proved that when a plane—a poster, say, or the page of a book, or a photograph—suddenly enters a field of vision, our gaze inadvertently falls, at first, on a spot at the left on the upper third of the plane; apparently our habits of

reading have conditioned us to do that. Therefore people who are not eidetically (visually) developed find it hard to "read" photographs whose focal point is not in that place. Even when orienting himself in open space, a person's first glance will always proceed in the most organically natural direction, which in a case of active left-eye or right-eye vision will show a slight shift toward one of these two sides. This is important in making a general description of the way people see, for it is well known that right-handed people (that is, the majority) have more acute vision on the left side, and will therefore begin to orient themselves on the left.

H: What follows, then, is this: if a certain part of the pictorial space— somewhere in the left of the upper third of the picture—is privileged by the fact that the eye always falls on that spot first, the photographer will have to pay very special attention to that place.

G: The logical inference, therefore, would be to put the main object there . . .

H: . . . Which is easily done by pointing the camera accordingly.

G: Indeed. But it only makes sense to put the main object at the primary point of vision if the rest of the picture space is particularly easy to scan. For example, if the entire plane except for the main object has a clear and generally known structure: let's say the surface of a body of water, sand, a plowed field; or the top of a table, floorboards, asphalt. If the surrounding plane is more complicated, if its structure is not immediately recognizable, the eye must be guided more effectively. But the glance must always begin on the left in the top third of the picture, and be directed from there (possibly via some secondary objects) to the main object. It could, for example, be a diagonal leading from the upper left to the lower right.

H: In which case it would make sense to put the main object at the end of that movement, that is on the lower right.

G: Yes. and that is the secret, that is the origin of the famous demand for diagonals in a picture. It permits the swiftest and most emphatic orientation, the fastest overview, and at the same time it leads most directly to the main object.

H: So you agree with the demand for a diagonal in the picture?

G: Only to a degree; the diagonal is the simplest but not the only possible device for guiding the eye. Besides, the proponents of the diagonal theory make the mistake of equating the diagonal leading from the upper left to the lower right with the one leading from the

upper right to the lower left. Experiments have shown that they have completely different functions. A diagonal beginning in the upper left, at the primary point of vision, is actually able to direct the gaze across the picture; but the counter-diagonal is capable of only one effect: it restrains the gaze! Its point of origin is too far removed from the primary point of vision, and that alone renders it inadequate to the task of guiding the eye.

H: This should be obvious to anyone who has given thorough attention to what happens in the act of seeing. And I would like to present the following for consideration, regarding the general process of seeing: the space we see does not proceed in a straight line toward a vanishing point, diminishing at a rate equal to the square of the increasing distance; what we see, due to the construction of our visual organs, is a combination of two confluent hemispheres which together, depending on the position of the eyes in the head, tend more or less toward an ellipsoid. All lines within this system merely appear to run straight; actually, we see in curved lines. These curves, however, are so minimal that they appear to be straight; but for the live experience of seeing, which involves a perpetual sliding from side to side, a peeling out or suppression of volumes, directions, brightness, and darkness, they are very important. The well-corrected vision of a camera lacks this essential element, for the slight displacement of the focal points (corresponding to the aberration of our eye) is not registered by the camera lens. So we must take special measures to create effects with the anastigmatic lens[1] that analogically reproduce our natural way of seeing (though "looking" would be the better word).

G: Could you give an example?

H: Yes! Imagine a panoramic view from a high position onto a large surface: say, from a lighthouse onto the sea surrounding an island. The actual appearance is that of a circular plane. Even though individual segments of the horizon are apparently straight as if drawn with a ruler, they cannot actually be straight. Now if you look closely at segments of the visual field, you will notice an apparent bulging of the surface of the water in approximately the lower two thirds of the visual field; only in the upper third does the area appear flatter to the eye. This is because within the hemispheres of our vision we actually put the center of gravity, which lends direction to our seeing, in the middle of the upper third. So the most important thing is learning to recognize the elements that most affect our impression of nature. The simple

recipe, "One must learn to see lines in nature," is completely inadequate. Drawing lines isn't the issue at all, what is important is the aliveness of our seeing, a perception of the formal contrast between the volumes to be depicted and the visual focus. The most advantageous choice then determines the way we frame the image.

G: In my opinion, there's another reason why lines aren't always a decisive factor in a picture: the gaze can be just as easily guided by planes. Also, in framing, it strikes me as significant that every viewer feels an unconscious impulse to imagine a form extended and continuing beyond an edge by which it has been cut off. One is tempted to fill out what is missing. If, for example, at the edge of a picture, the otherwise level horizon lifts just a little bit, the viewer's imagination will extend this small rise into a mountain; similarly, a small dip of the horizon at the opposite edge of the picture makes you imagine a precipice just beyond that edge. Now cut the picture a little differently, eliminating the minor rise and the minor fall, and any viewer will think of the landscape as flat. But you spoke of volumes. Would you please explain how you want that term to be understood?

H: What I mean by volumes are the most basic, fundamental forms of bodies—cylinder, cone, sphere, polyhedron, hollow sphere; and also "directional" planes like the square, the triangle, etc., with the directions: straight-parallel, straight-diagonal, around a center, variously scattered around a center, a point within its surroundings—all these basic forms in their disguises, since the pure prototypes rarely appear in a photograph. Let's say, for example: on the top of a table, glasses (cylinders), cups (hollow hemispheres), teapots (ellipsoids). Now picture a fixed source of light. At the place where the strongest light (arched) contrasts with a deep shadow (indented), the eye is most easily captured; therefore that is the best place to start leading the viewer's gaze. Having established this point of focus, we must bring it into harmony or contrast with the principal corresponding axes of the cylinders, hollow spheres, or ellipsoids. The visual analysis of the basic elements must be brought to a synthesis by the layering of light-dark gradations in the picture space. That's what has to be done. It's not the literary notion of "tea" that's decisive, but the form. I'm not trying to say that literary notions aren't capable of formal expression! The poster (commercial or political) is a literary idea, but it can only be effective after the corresponding formal idea has been found. Mastery of form is more important for a photographer than literary ideas.

G: For without a clear formal language even an excellent literary idea cannot be effectively expressed. A picture that is good formally, on the other hand, is effective without any literary content. This seems obvious, and yet some manuals perpetuate the idea that photographic depiction must primarily and under all circumstances have a narrative meaning. Thus, the author of a recent booklet about the artistic problems of photography rejects a certain photograph, not because it does not correspond to the aesthetic rules set up by the author, but because the picture contains, simultaneously, a radish, a mug of beer, and a piece of cake. He claims that it leads the viewer to imagine the devastating effects of consuming these things all at once. And it's no help that the same author, without any explanation, prescribes the following: "Foreground and background must differ by a ratio of 2:1; they should never meet in the middle." Naturally he fulminates against lines running parallel to the edge of the picture—but as for the questions that have real practical significance, like: the way the content of a picture is affected by the way it is framed (as I showed earlier by the example of the rising and falling motion of the horizon near the edge of the picture), or: ease of visual orientation due to effective guidance of the eye, or: how to create a clear impression of space—strangely, those books don't tell you anything about that!

H: The last thing you mentioned does not seem surprising if you consider how little our education of the past few decades has done to develop a sense of three-dimensional space, how exclusively our attention has been limited to the plane.

G: True enough. And that is the reason one finds so few pictures that give a good representation of space: one rarely meets photographers who have a good sense of spatial values. But you can't effectively show something you yourself can't see.

H: Right! But what are the elements conducive to spatial perception in photography, in your opinion?

G: First of all: You can tell that in half the pictures that exist, the photographer has not done anything to bring out the third dimension in some simple way. The pictures are conceived in purely planar terms: the main object of the picture—let's say a group of people—is built up on a plane, and the background is also planar, without any suggestion of depth, even though that could be given so easily and with such simple means. There is no question, moreover, that a clear, unambiguous perspectival arrangement of the main elements of the picture would

stimulate the spatial imagination. But atmospheric perspective is also very poorly understood. By the use of stronger or less strong filters, the effect of spatial depth can, in many cases, be adjusted in any way the photographer pleases. It's the same with depth of focus, which creates a similarly variable gradation of depth. But these, of course, are just the means for creating depth. The challenge is clearly to perceive the uniqueness of an interior or a landscape, be it a natural or artificial landscape (an industrial city, a street); and to express its particular spatial character with the help of these methods, always bearing in mind that a simple, easy orientation is appropriate in any circumstance. Now, if the picture gives a strong impression of three-dimensional space, then this easy orientation should be in terms of that space, and the clear, unambiguous completion of parts of the picture cut off at the edge must be possible in terms of space as well.
H: Here I would like to say something about the focal point and depth of field. The scientific and aesthetic students of optics claim, over and over again, that the human eye perceives all objects with the same depth of focus regardless of their relative position in space, while the camera lens can only focus within a limited zone. In reality, the human eye focuses on a series of points, leaving everything around them out of focus; the apparent sharpness of all parts of the field of vision is "ideo-plastic," a product of consciousness and imagination. There are instances, for example, where the space surrounding the observed object is virtually "erased" by a "corrective" operation of consciousness, as if the object existed in isolation, without any environment; but the camera lens reproduces with varying sharpness of focus all objects and spatial elements within the visual angle. The idea that "sharp focus in the foreground" most closely corresponds to natural vision is also a mistake. A picture's depth of focus should be distributed in such a way as to support and elicit perception so that only those directions, volumes, and gradations of light that are essential to the photographer become structural elements of the picture. The proper focal point is chosen based on the volumes under consideration, the spatial positions, and the preferred depth of field. This effectively cancels the "law" according to which one must eschew plunging lines or excessive foreshortenings, for only in our minds is a vertical line always vertical. We just don't notice, when we look down from a high window, that the verticals are no longer vertical in relation to our axis of vision; our "knowledge" corrects the impression that external space

is leaning in toward us. The same thing happens when we look almost straight on at a person who is lying down; the mind, using our "knowledge" of the body's position, alters the actual visual perception, while the camera reproduces it accurately. The two are interdependent: in the first case, consciousness has to correct the appearances registered by the eye, while in the second, the visual facts must take precedence over our unconscious bias.

G: To sum up, one could say that wherever circumstances allow the photographer to work without hurrying, chance should be left out of the picture. Exact guidance of the viewer's gaze, careful selection of the pairs of opposites (form and form detail, light and dark, large and small): this is the only way to turn photography from an imitative, at best documentary technique, into a medium of creative expression. The most important factor in any work of visual art is to create a balance of all the contrasting directions, volumes, points of focus, and gradations of light and dark; that is, to aim at an equilibrium among all the contending elements in the picture.

H: So we have arrived at the conclusion that balancing the contrasts removes the picture from the realm of chance. In addition to the points we have already discussed, we should add what I would like to call the dialectic of form: distinguishing details of the large volumes by their characteristic designs. The simplest contrasts of this kind are structures, types of surface like rough or smooth, leaves vs. sand, etc. But even for a face, formal contrasts will be necessary. The face, as the most individual form of expression, has to be constructed out of the shapes of the sense organs, of which the most eloquently expressive are the eye, the nose, the mouth, and the ear. Foreheads, cheeks, and chins are more supra-individual: they are indicators of cranial volumes that are more pertinent to the characteristics of a class or a race than of a single person, and are therefore not always significant in a "portrait." The straightness or crookedness of a nose will not be the only form expressing a person's character. Ear, mouth, or eyes cannot establish the nature of the individual, except by their mutual interplay or contrast. Large planes of bright and dark can be used for characterization by presenting, say, a brightly lit profile and an ear shining out from the darkness of the cheek and the back of the head; or perhaps an out-of-focus background and an equally out-of-focus portion of the head in the foreground, and between these barely distinguishable planes a clearly delineated profile within the focus zone, thus overall a balance

between contrasting details and volumes. With the use of light, heads can also be vertically divided into a light and a dark side; but in that case the face must offer a very simple, clear outline in front view, or else the line of the nose and mouth can be emphatically contrasted with the line of the ear and neck in four-fifths profile. In the balance and "weight distribution" of contrasting volumes and the specific arrangement and shaping of characteristic sense organs, the way a head is "cut" and placed in the picture space is of decisive importance. For seeing is not just glancing. To look at something implies a directedness of all the senses of the body, and it is from this directedness that the artist draws his creative power. And insofar as this is possible with technical, mechanical means, the photographer does the same thing.

G: The recent spate of photographs showing details and structures of, say, a crystal, sand, stones, plants, all sorts of minerals, is interesting and helps develop visual ability; but this path will soon offer as little opportunity as any other path that is taken purely for the sake of originality.

H: But what will be new again and again is the meaning of a piece of earth, its harmony with wind, clouds, water, plants, and sun. The important thing is the ability to see the real essence of a face, a landscape, a flower, an animal—and when we experience this essence, it reveals itself at all times and in all circumstances without any need for artifice! As for the type of diaphragm or negative that is used, shutter speed, fidelity of color reproduction—there is no rule for any of these, only a choice dictated by the more or less strong feeling of the person behind the camera for the characteristic qualities of the given circumstances.

Translated by Joel Agee

1. See p. 139, n. 2.

DURUS (ALFRED KEMÉNY)

PHOTOMONTAGE AS A WEAPON IN CLASS STRUGGLE

By the early 1930s photomontage was being increasingly used as a vehicle for political statements by German parties of both the left and the right. In an essay which reveals a striking turnabout from his "Photomontage, Photogram" (see page 182) of the preceding year, Kemény here embraces the use of photomontage for political graphics. His change of mind was due to the effectiveness of John Heartfield's biting photomontages for the weekly *Arbeiter Illustrierte Zeitung* (Workers' illustrated). Praising Heartfield's talent and determination, Kemény offers encouragement to the graphic artists of the League of Revolutionary Artists who have followed in his footsteps.

Original publication: Durus, "Fotomontage als Waffe im Klassenkampf," *Der Arbeiter-Fotograf* 6, no. 3 (1932), pp. 55–57.

The bourgeois conception of photomontage can be summed up in the following remark made by a well-known bourgeois art critic: "Montage, i.e., the artist and the craftsman are replaced by the engineer. Pieces of photographs are pasted together the way parts of machines are joined together with screws." Is this the actual state of affairs? Has the engineer actually taken the place of the artist? Are pieces of photographs installed like parts of machines? Not at all. The photo "monteur" is an artist—not an engineer. And the photo "montage" is a work of art—not just a machine. A work of art that offers completely new opportunities—with regard to content, not just form—for uncovering *relationships, oppositions, transitions, and intersections of social reality.* Only when the photomonteur makes use of these opportunites does his photomontage become a truly revolutionary weapon in the class struggle.

We must emphasize: *In a class society there can be no "classless-revolutionary" photomontage.* Like all art forms before the classless society, photomontage is *determined by social class.* The "non-representational" stance of formalist photomontage—playing with light effects, superimpositions, overexposures, strange angles "without content"—merely *veils* the bourgeois contents, the dead-end perspec-

tive of rootless bourgeois artists. *In this as in any other field, the revolutionary working class does not separate theory from practice—it sets a high value on photomontage as an extraordinarily effective propagandistic and organizational weapon in the class struggle.*

It is becoming more and more obvious that the cognitive value of photomontage is inseparable from its role in the class struggle. Could the development of photomontage take place outside the context of class struggle? Certainly not. Why did formalist photomontage grind to a halt after a few superficially interesting experiments? Because it operated in a vacuum, divorced from the decisive social conflicts of our era; because it could not carry out its essential purpose: *to reveal the truth. Why did proletarian-revolutionary photomontage attain such a high level in the Soviet Union and Germany?* Because it not only did not oppose the revolutionary development of humanity, *but developed in close conjunction with the revolutionary workers' movement.*

And we can see that while in response to the intensified economic crisis, the bourgeois advertising industry is dispensing with more and more of its most artistically and technically expert photomonteurs, our publishing houses and our magazines require an ever greater number of qualified photomonteurs. *One need only look at the display windows of our bookstores: invariably, one's eye is caught by interesting, original, and thought-provoking photomontages on the covers of books and brochures.*

The very first *dadaist* works using paste and photographs (by *Heartfield, George Grosz, Hausmann,* and *Baader*) set the course for the development of a *consciously political* proletarian photomontage—despite the anarchist-individualist philosophy of their creators. *But the rising line of German proletarian-revolutionary photomontage is most intimately associated with the epoch-making work of the brilliant "monteur" John Heartfield.*

His works can already be considered "classic." He pioneered the use of photomontage for book jackets and in the design of political picture books. *He always focused the aesthetically effective elements of photography's "gray-scale structures," of planar division, of combinations of script and photography, on maximizing the political content.* All traces of "beautiful, self-contained form" have been ruthlessly swept away. In place of a bourgeois aesthetic we have the sharpest, strongest, most penetrating political militancy of a no longer "neutral" art. Faced with the powers of inertia and habitual rigidity, Heartfield

never took the path of least resistance. *After years of stubborn and consistent work, he won the adoption of the line which he considered the most appropriate for the proletarian liberation struggle.*

As a creator of satirical photomontages, he is unsurpassed. His satirical contributions to the *AIZ*—the "Tiger," the "Cabbage Head," "Solar Eclipse on the 'Liberated' Rhine," "6 Million Nazi Voters: Fodder for a Big Mouth," to mention just a few—are among the *most significant satirical creations of our time.*

Today the ranks of revolutionary photomonteurs are increasing considerably in Germany. The best photomontages by the members of the *League of Revolutionary Artists*,[1] who use this artform as a weapon in the daily practice of class struggle, are by no means simple imitations of Heartfield. The high artistic and political quality of the works of Gü, Pewas, and Eggert[2] proves that among photomonteurs, Heartfield no longer stands alone and unrivaled. The last exhibition of proletarian photographers (at the decennial IAH show in Berlin)[3] was of high quality not only photographically, but in the use of montage. We know, however, that such quality has not yet been achieved by more than a minority of the German worker-photographers. Naturally, as with many other problems awaiting our solution, proletarian photomontage experiences occasional setbacks. Sometimes the work being turned out is politically shallow, and the products are frequently slipshod, particularly the designs for magazine covers.

Translated by Joel Agee

1. The Bund Revolutionär bildender Künstler Deutschlands was founded in 1928; Kemény was one of its leading members.

2. Gü and Pewas were members of the League of Revolutionary German Artists who exhibited in the 1931 "Photomontage" exhibition in Berlin. Werner Eggert (1909–ca. 1960s) was a typographer for the *Arbeiter Illustrierte Zeitung* and the designer of photomontage book jackets for the popular "red novels" of the Internationalen Arbeiter Verlag (International workers' publishing house).

3. The Internationale Arbeiter Hilfe (International workers' relief) was founded in 1921 to aid famine victims in the Soviet Union. Under the direction of Willi Münzenberg it became an influential, worldwide organization with headquarters in Berlin. The IAH was instrumental in founding the *Arbeiter Illustrierte Zeitung* and the worker-photographer movement.

ERNST JÜNGER

PHOTOGRAPHY

AND THE "SECOND CONSCIOUSNESS"

An excerpt from ON PAIN

The ideas of the writer Ernst Jünger (b. 1895) grew out of his experiences in World War I, in which he was a much-decorated front-line soldier. His published war journal, *In Stahlgewittern* (The storm of steel, 1920), helped galvanize the "front generation" of ex-soldiers, whose battle experience became the central emotional event of their lives. During the 1920s Jünger was a tireless right-wing opponent of German democracy, preaching a doctrine of technocratic "total mobilization." In his book *Der Arbeiter* (The worker), published in 1932, he described the idealized worker-soldiers whom he envisioned as the standard-bearers of this new social order. Too much an individualist to join the Nazi party, Jünger was nonetheless one of the major writers who remained active in Hitler's Germany.

Jünger was unusual among German right-wing intellectuals of this period because of his enthusiasm for technology. In his view the technological world was bringing forth a "second nature," and in the same way he saw photography as a sign of the emergence of a colder, instrumental "second consciousness." He praised the camera as a new eye devoid of feeling and thus able to contemplate the horrors of the modern world with an almost aesthetic detachment. The following essay excerpt makes it clear that Jünger regarded photography both as a shield for the sentiments and as an aggressive visual weapon.

Original publication: Ernst Jünger, "Über den Schmerz," in *Blätter und Steine* (Leaves and stones) (Hamburg: Hanseatische Verlagsanstalt, 1934), pp. 200–203.

If one were to characterize with a single word the human type that is evolving in our time, one might say that among his most obvious characteristics is his possession of a "second" consciousness. This second, colder consciousness shows itself in the ever more sharply developed ability to see oneself as an *object*. It should not be confused with the self-reflective stance of traditional psychology. Psychology differs from

the second consciousness in that the subject of its investigations is a feeling human being, while the second consciousness is focused on a person who stands outside the sphere of pain. Naturally there are overlapping areas; like every disintegrating process, psychology, too, has its well-ordered side, especially in those branches where the science has developed into a pure system of measurement.

But there is much more to be learned from the symbols which the second consciousness seeks to produce. Not only are we the first living creatures to operate with artificial limbs, but we are also in the process of creating strange realms in which the use of artificial organs of perception facilitates a high degree of typical[1] accord. But this fact is closely connected with the objectification[2] of our worldview and thereby with our attitude toward pain.

A first case in point is the revolutionary fact of photography. Statements made in photographs are accorded documentary status. The World War was the first great event experienced in this manner, and since then no significant event occurs that is not captured by the artificial eye. Our endeavor is to go further and peer into spaces that are inaccessible to the human eye. The artificial eye penetrates barriers of fog, haze, darkness, and even the resistance of matter itself; optic cells are at work in the depths of the ocean, and high above with the meteorological balloons.

The photograph stands outside the realm of sensibility. It has something of a telescopic quality: one can tell that the object photographed was seen by an insensitive and invulnerable eye. That eye registers just as well a bullet in midair or the moment in which a man is torn apart by an explosion. This is our characteristic way of seeing, and photography is nothing other than an instrument of this new propensity in human nature. It is remarkable that this propensity is still as invisible as it is in other fields, such as literature; but no doubt, if we can expect anything from writing as well as painting, the description of the most minute psychic events will be replaced by a new kind of precise and objective depiction.

We already pointed out in *The Worker* that photography is a weapon which the new type of person makes use of. For him, seeing is an act of aggression. And correspondingly, the desire grows to make oneself invisible, as with the use of camouflage during the World War. A military position became untenable at the moment when it could be de-

tected in an aerial photograph. These conditions push us inexorably toward a greater flexibility and objectification. Already there are guns equipped with optic cells, and even aerial and aquatic war machines with optic steering mechanisms.

In politics, too, the photograph is a weapon that is being used with increasing mastery. It seems to offer our new type a particularly effective means of tracking down his enemy's individual (and hence no longer adequately defended) character; the private sphere is no match for the photograph. Furthermore, it is easier to change one's views than one's face. The use of poster-sized photographs of people murdered in political struggle is a particularly malevolent practice.

Photography, then, is an expression of our characteristically cruel way of seeing. Ultimately it is a new version of the evil eye, a form of magical possession. One feels this acutely in places where a different cultic substance is still alive. At the moment when a city like Mecca can be photographed, it moves into the colonial sphere.

There is in us a strange and not easily describable urge to endow the living process with the character of a slide prepared for the microscope. Today, any event worthy of notice is surrounded by a circle of lenses and microphones and lit up by the flaming explosions of flashbulbs. In many cases the event itself is completely subordinated to its "transmission"; to a great degree, it has been turned into an object. Thus we have already experienced political trials, parliamentary meetings, and contests whose whole purpose is to be the object of a planetary broadcast. The event is bound neither to its particular space nor to its particular time, since it can be mirrored anywhere and repeated any number of times. These are signs that point to a great detachment; and the question arises whether this second consciousness, which is so tirelessly active in us and around us, has been given a center from which the growing petrification of life could, in a deeper sense, be justified.

The fact that there is a distancing is even more evident in the case of projections—the mirroring of photographs into a second space that is even less accessible to feeling. This becomes most apparent when we confront our own reflection: whether by observing our movements on film, or by hearing our own voice strike our ear as if it were the voice of a stranger.

As the process of objectification progresses, the amount of pain

that can be endured grows as well. It almost seems as if man had an urge to create a space where, in a sense quite different from the one we are accustomed to, pain can be regarded as an illusion. . . .

Translated by Joel Agee

1. Jünger's idiosyncratic use of "typical" refers to the term *Typus* by which he designated the new worker-soldier who would serve the total state.

2. The German word *Vergegenständlichung*, as Jünger uses it, connotes the conscious perception of the living world as no more than a series of inert objects; a more metaphysical notion than the English word "objectification."

[GUSTAV KLUCIS?]

PHOTOMONTAGE

Photography and photomontage awakened considerable enthusiasm among the Soviet avant-garde in the 1920s. Constructivist artists in particular felt that painting was an antiquated visual medium; that in the modern age the artist must move, in the words of constructivist theorist Nikolai Tarabukin, "from the easel to the machine." Image-making machines like photography and cinema were not primarily regarded as instruments of individual expression, but as means to shape a radically new, collective vision. The question of precisely how photography might serve a revolutionary culture was central to the Soviet debates around photography in the late 1920s, and was answered in a variety of ways.

Although this short text, one of the earliest to address photomontage, was initially published unsigned, it is widely thought to be the work of Gustav Gustavovich Klucis (1895–1944), the collagist, photomontagist, and graphic artist. Klucis formulated his views on photomontage in a number of later articles, including a major essay, "Photomontage as a New Kind of Agitational Art" (1931).

The essay presented here first appeared in 1924 in the Moscow avant-garde review *Lef*, whose name is an abbreviation of *Levyi front iskusstv* (Left front of the arts). Founded by Vladimir Mayakovsky in 1923, *Lef* offered strong critical support for Russian constructivism. The magazine closed in 1925 but was revived in 1927–28 as *Novyi lef* (New lef). Through his association with *Lef* Klucis was in direct communication with Alexander Rodchenko, Sergei Senkin, Anton Lavinsky, and other experimental artists and designers, with whom he shared the belief that a rapprochement between art and politics was a necessity.

Original publication: Anonymous, "Foto-Montazh," *Lef* (Moscow), no. 4 (1924), pp. 43–44.

"Photomontage" we understand to mean the utilization of the photographic shot as a visual medium. A combination of snapshots takes the place of the composition in a graphic depiction.

What this replacement means is that the *photographic snapshot is not the sketching of a visual fact, but its precise record.* This precision

and documentary character of the snapshot have an impact on the viewer that a graphic depiction can never attain.

A poster on the subject of famine composed of snapshots of starving people makes a much stronger impression than one presenting sketches of the same.

An advertisement with a photograph of the object being advertised is more effective than a drawing on the same theme.

Photographs of cities, landscapes, faces, give the viewer a thousand times more than can paintings of these subjects.

Until now, professional, that is artistic, photography endeavored to imitate painting and drawing; consequently, photographic production was weak and did not reveal the potential inherent in it. Photographers presumed that the more a snapshot resembled a painting, the more artistic it was. In actual fact, the reverse was true: *the more artistic, the worse it was.* The photograph possesses its own possibilities for montage—which have nothing to do with a painting's composition. These must be revealed.

Here in Russia we can point to the works of *Rodchenko* as models of photomontage—in his covers, posters, advertisements, and illustrations (Mayakovsky's *Pro eto*).[1]

In the West the works of *George Grosz*[2] and other dadaists are representative of photomontage.

Translated by John E. Bowlt

1. Mayakovsky's poem *Pro eto* [About it] was published in Moscow in 1923, illustrated with seven photomontages by Rodchenko. The poem's central theme was Mayakovsky's love affair with Lili Brik, the wife of the writer and critic Ossip Brik.

2. After his visit to Berlin in late 1922 Mayakovsky brought back to Moscow examples of photomontage work by German artists like George Grosz and John Heartfield. These were seen by Rodchenko and very likely by other members of the *Lef* group, including Klucis.

THE PHOTOGRAPH VERSUS THE PAINTING

Ossip Maximovich Brik (1888–1945) was a leading member of INKHUK (Institute of Artistic Culture) and IZO NKP (Visual Arts Section of the People's Commissariat for Enlightenment), and a frequent contributor to *Lef*. Brik wrote mainly on questions of literature, contributing, for example, to the critical anthology *Literatura fakta* (The literature of fact) in 1929. But he maintained an active interest in many aspects of the visual arts, including photography, cinema, and textile design. Brik was especially close to Alexander Rodchenko, and did much to make his photographic work known.

This article is one of several early essays that Brik devoted to the question of photography; they culminated in 1928 in his comprehensive "From the Painting to the Photograph." In the essay that follows Brik assumes—as did many avant-gardists of the period—the imminent replacement of representational painting by an image-making machine, the camera. He argues that photographers should no longer attempt to imitate the pictorial forms developed by painting, but like Rodchenko should search out new ways of picture-making suited to photography itself.

Original publication: Ossip Brik, "Foto-kadr protiv kartiny," *Sovetskoe foto* (Soviet photo) (Moscow), no. 2 (1926), pp. 40–42.

Photography is supplanting painting. Painting resists and does not wish to surrender. Hence the struggle that began a hundred years ago when the camera was invented, and that will end when photography dislodges painting from its last positions in everyday life.

Photographers declared: "Precise, fast, cheap." In this lay their advantage. They were able to combat their competitors, the painters. Above all in portraiture.

Not a single painter, even the most talented, can transmit as close a resemblance as the camera can. Even the speediest of artists cannot prepare a portrait within a few seconds. The cheapest painting is still more expensive than an expensive camera.

Photographers moved on from the portrait to landscapes, repro-

ductions, and genre scenes. And always with the same announcement: "Precise, fast, cheap."

Painters realized the danger. Photography was enjoying colossal success. Urgent measures had to be taken. An intensive propaganda counter-campaign had to be mounted.

It was difficult to argue against cheapness and speed. The camera operates more cheaply and more quickly. But a case could be made against "precision." That's where they aimed the blow.

The photograph is uncolored. But the painting has many colors. Consequently, the painting expresses the subject more accurately, and in this respect it is beyond competition.

That's how the painters reasoned. And they tried to convince the consumer of this. But the painters were mistaken, and many of them still are.

In life we certainly do see things in color. And in a painting things do have color. But the two sets of colors are not the same, they differ. Painting cannot *transmit* actual colors. It can merely *imitate* with greater or less approximation the coloring that we see in nature. It's not a question of the painter's talent, but of the very essentials of the painter's craft. The material colors (oil, watercolor, gum paint) with which the painter works affect our vision differently from the light rays that color objects in various shades. However much he tries, the painter cannot break out of the narrow confines of his palette. He is unable to provide that richness of color (both qualitatively and quantitatively) that we observe in actual nature.

Therefore, color in a painting does not define nature more precisely, but on the contrary distorts it, because nature is depicted falsely, with the wrong coloring—not the colors it has in reality.

At the moment the photograph gives no color at all, but at least it does not distort the subject by giving it a *false* color. That's a big plus.

The leading, more sensitive painters have long understood that transmitting color "accuracy" is not an easy matter, and that the principles of color in painting do not coincide with those of color in nature—so they declare: "It's not a question of precision."

The painter's task is certainly not to depict the object as it really is, but to recreate the object in the painting in accordance with purely painterly laws. What concern is it of ours (they ask) how the object

looks in reality? Let simple spectators and photographers worry themselves about that: we painters make paintings in which nature is not the objective but the pretext. The painter not only *has the right* to modify reality—he is *obliged* to do so. Otherwise he is not a painter but a bad copyist, a *photographer.*

It is impossible to *express* life in a painting and it is absurd to *imitate* it. So we should rebuild it on the canvas, in our own way, in a painterly fashion. Herein lies the real meaning of the art theories and schools that emerged from the mid-nineteenth century onward, under the titles Impressionism, cubism, suprematism, etc., etc.

Painting's refusal to depict nature caused a distinct line to be drawn between photography and painting. The two proved to have different goals. Incommensurable ones. They each did their own work. The photographer documents life, the painter makes paintings. The photograph transmits no color at all, the painting—*consciously*—invests objects with a different and unreal color.

That position, it would seem, was clear enough. But here in Soviet Russia a curious artistic phenomenon can now be observed: painters are trying to win back the positions they ceded, and, along with the photographers, to be transmitters of reality. Witness to which is the activity of AKhRR.[1]

The social derivation of this phenomenon is quite clear: first, there is an enormous demand for documentation of the new life; second, there are an awful lot of painters around who have nothing to do because there's no one to sell paintings to; third, the level of the consumer's artistic taste has dropped, and he is unable to distinguish between an accurate depiction of nature and a very approximate one.

AKhRR's attempt to resurrect so-called realist painting is in vain. At one debate a defender of AKhRR said: "So long as our photography is inadequately developed, realist painting will be needed."

In this "so long as" lies the whole sense of the AKhRR endeavor. Until we have enough cars, we'll still have to ride in carts. But sooner or later we'll all be riding around in cars.

The photographer records life and events more cheaply, more quickly, and more accurately than the painter. In this lies his strength, his great significance for society. No relapse into primitive painting methods frightens him.

Still, the photographers themselves do not understand their own social significance. They know that they are engaged in a worthwhile and necessary enterprise, but they imagine that they are merely craftsmen, modest toilers who of course are far beneath artists and painters, the creators.

The fact that a painter does not work on commission but "for himself"; the fact that paintings are displayed at big exhibitions with *vernissages*, catalogues, music, food and drinks and speeches; the fact that long articles are written about each painting and each painter, that detailed analyses of composition, texture, brushstroke, and "color scale" are undertaken; the fact that such exhibitions are valued as cultural events—all these things make a tremendous impression on photographers and reinforce their notion that painting is real art, whereas photography is an unprepossessing handicraft.

Hence the dream of every photographer: to attain a "painterly effect" in his photographs. Hence his attempts to take and process a photograph "artistically"—"so it will look like a reproduction of a painting."

The photographer fails to understand that in his pursuit of artistic effect, in his servile imitation of painting, he is degrading his own métier and depriving it of the strength that ensures its social significance. His departure point is the documentation of nature, but he falls into the clutches of aesthetic laws—laws that distort nature.

The photographer wishes to gain the same social recognition that the painter enjoys. Which is an entirely legitimate desire. Although it can be fulfilled, not by the photographer's trying to keep up with the painter, but by his opposing his art to that of the painter.

Building on the fundamental principle of his own occupation, i.e., the precise documentation of nature, the photographer must create objects—photographs—which in the intensity of their effect on the viewer are every match for any painted picture. The photographer must demonstrate that what is being recorded is not just life transformed according to aesthetic laws, but life itself, life recorded in the technical perfection of the photograph.

In struggling against the aesthetic deformation of nature, the photographer will gain his right to social recognition. But he will not attain it by fruitless attempts to imitate painterly models, so foreign to photography.

This is not an easy path, but it is the only true one. It is not easy because neither we nor the West have even the rudiments of a theory of the photographic art, the art of making highly professional photographs.

Everything that is said and written on this issue can be reduced either to technical advice and formulas or to a variety of instructions on how to attain "painterly effects"—how to prevent the photograph from looking like a photograph.

But as a matter of fact, there are some individuals among the photographers, cultural organizers, and artists who have left painting for photography—who realize that photography has its own tasks, its own aims, its own paths of development. By working in this area they have already achieved results.

It is essential that such people somehow share their experiences, reach some kind of agreement, and combine their efforts for the common good—for the common struggle against "artistic" domination in photography—and for the creation of their own theory of photographic art, independent of the laws of painting.

Of particular interest in this respect are the experiences of ex-painters.

The best opponents of religion are ex-priests and monks. Nobody knows the "mysteries" of the church and the monastery better than they.

The best fighters against painterly aestheticism are ex-painters. Nobody knows the "secrets" of artistic creation better than they. Nobody can expose the falsity of the "artistic reflection of reality" better than they. They rejected painting by a conscious choice, and they will fight for the photograph just as consciously. One such person is A. M. Rodchenko. Once a brilliant painter, he is now an ardent photographer.

The general public is not well acquainted with his photographic work because it is predominantly of an experimental type. One should appear in public only when one has the finished result. Still, professional photographers and those photographers interested in the development of the photographic art must definitely get to see Rodchenko's experiments.

His objective is to reject the principles of painterly, "pictorial" construction for the photograph, and to discover other, specifically photographic laws for taking and composing the shot.

Surely this should interest anyone who regards photography not

as a "pitiful" handicraft but as a subject of great social significance, one that is summoned to replace the painter's primitive methods of "artistically reflecting life."

Translated by John E. Bowlt

1. AKhRR, the Association of Artists of Revolutionary Russia (Assotsiatsiia khudozhnikov revoliutsionnoi Rossii), was founded in 1922 in Moscow by a group of artists who favored a return to a figurative, narrative style of painting; its members included Alexander Grigoriev and Evgenii Katsman. AKhRR members attracted a large following throughout the 1920s, aided by numerous exhibitions, declarations, and official sponsorship. In 1928 the AKhRR changed its name to AKhR, the Association of Artists of the Revolution (Assotsiatsiia khudozhnikov revoliutsii). The group was disbanded in 1932.

WHAT THE EYE DOES NOT SEE

As early as 1923 the Soviet filmmaker Dziga Vertov (1896–1954) had introduced the idea of an expanded "camera-eye" no longer bounded by the limitations of human vision. In his experimental documentaries like *Kino-Eye* (1924) and *The Man with the Movie Camera* (1929) Vertov made extensive use of unusual camera placements and viewing angles, as well as fast-motion, slow-motion, and rapid montage sequences. Vertov and Alexander Rodchenko were well acquainted in the early 1920s, thanks to their association in 1922–23 with Alexei Gan's cinema review *Kino-Fot*.

In this short essay Ossip Brik points out the similarity between Vertov's and Rodchenko's attitudes regarding the use of the camera, and proposes that henceforth the camera be used as a device for extending and transforming human vision. Brik's text was illustrated with four of Rodchenko's steep-angled photographs of Moscow architecture.

Original publication: Ossip Brik, "Chego ne vidit glaz," *Sovetskoe kino* (Soviet cinema) (Moscow), no. 2 (1926).

Vertov is right. The task of the cinema and of the camera is not to imitate the human eye, but to see and record what the human eye normally does not see.

The cinema and the photo-eye can show us things from unexpected viewpoints and in unusual configurations, and we should exploit this possibility.

There was a time when we thought it was enough just to photograph objects at eye level, standing with both feet firmly on the ground. But then we began to move around, to climb mountains, to travel on trains, steamships, and automobiles, to soar in airplanes and drop to the bottom of the sea. And we took our camera with us everywhere, recording whatever we saw.

So we began to shoot from more complex angles which became increasingly diverse, even though the link with the human eye and its usual optical radius remained unbroken.

However, that link is not really needed. Beyond that, it actually

limits and impoverishes the possibilities of the camera. The camera can function independently, can see in ways that man is not accustomed to—can suggest new points of view and demonstrate how to look at things differently.

This is the kind of experiment that Comrade Rodchenko undertook when he photographed a Moscow house from an unusual viewpoint.

The results proved extremely interesting: that familiar object (the house) suddenly turned into a never-before-seen structure, a fire escape became a monstrous object, balconies were transformed into a tower of exotic architecture.

When you look at these photos it is easy to imagine how a cinematic sequence could be developed here, what great visual potential it could have—much more effective than the usual shots on location.

The monotony of form in the cinematic landscape has inspired some people to seek an answer in movie decorations, props, and displacements, or to prevail upon the artist to "invent an interesting slice of life," to build "fantasy houses" and construct a "nonexistent nature."

A hopeless task. The camera does not tolerate props, and mercilessly exposes any cardboard theatricality offered instead of the real thing.

That's not the answer, and there's only one way out of the dilemma: we must break out beyond the customary radius of the normal human eye, we must learn to photograph objects with the camera outside the bounds of that radius, in order to obtain a result other than the usual monotony. Then we will see our concrete reality rather than some kind of theater prop, and we will see it as it has never been seen before.

The cinema and the photo-eye must create their own point of view, and use it. They must expand—not imitate—the ordinary optical radius of the human eye.

Translated by John E. Bowlt

EL LISSITZKY

THE ARCHITECT'S EYE

The Russian painter, architect, typographer, and graphic designer El Lissitzky (1890–1941) was one of the most important members of the constructivist movement of the 1920s. During the early part of the decade he lived and traveled extensively in Europe, where he came into contact with the leading figures of the Western avant-gardes. He closely followed developments in European art and architecture even after he returned to Moscow in 1925 and resumed teaching, graphic design, and exhibition design.

This text is a review of Erich Mendelsohn's *America: An Architect's Picturebook*, published in Berlin in 1926. Mendelsohn (1895–1953), whom Lissitzky had met in Germany, was one of that country's leading modern architects. Mendelsohn had visited the United States in the fall of 1924 to gather material for a series of articles on American architecture. In *America* he brought together a striking collection of photographs, some his own and some taken by other architects. With its dizzying images of American cities and skyscrapers, *America* made an influential contribution to the mid-1920s "America cult" in Germany, and at the same time stimulated the photographic and cinematic use of extreme perspectives.

Lissitzky's review, which appeared in a Moscow architectural journal, reveals his keen interest not only in the architecture of contemporary America, but also in what he called the "architecture of the book." During the mid-1920s Lissitzky was engaged in developing new forms of book design that could create a more dynamic relation between the reader and the printed page. He was evidently fascinated not just by the architectural subject matter of *America*, but also by the visual imagination that informs the structure of a book and its photographic images.

Original publication: El Lissitzky, "Glaz Arkhitektora," *Stroitelnaya promyshlennost* (Construction industry) 2 (1926).

This "Architect's Album" which has just come out in Berlin is of course immeasurably more interesting than those photographs and postcards by which we have known America up to now. A first leafing through its pages thrills us like a dramatic film. Before our eyes move pictures that are absolutely unique. In order to understand some of the photographs you must lift the book over your head and rotate it.

The architect shows us America not from a distance but from within, as he leads us into the canyon of its streets.

The album bears the emphatic title *America*, but don't expect to see the continent of both Americas, from Alaska across Panama to Tierra del Fuego and from the Atlantic to the Pacific Ocean. Naturally one could not expect such scope from the architect's ten-week visit. His America is only New York, Chicago, Detroit, and the grain elevators of Buffalo. But it is this American excerpt that now holds sway over Europe. From it Mendelsohn has extracted an architectural excerpt: his album shows the architecture that has been created by American finance capital. It is a great pity that he neglected what its industrial capital has created.

The architect's mind is visible in the very arrangement of the album's material. Following a preface, there begin individual sections bearing pointed headings:

1) Typically American; 2) Exaggerated Civilization; 3) Center of Money—Center of the World; 4) The Gigantic; 5) The Grotesque; 6) The New—The Coming.

In the preface Mendelsohn defines, in short sentences, his attitude towards America. This man with European nerves confesses that although he is an objective observer capable of understanding the masses of people, the powerful sweep of vital energy, the extraordinary scale of spatial relations, and the tempo of street traffic—all the same his first impression there was like a blow to the head. But after recovering from the initial shock, the European starts to weigh America on the scales of his own culture; he looks for its "soul," and then disillusionment sets in. "America, the richest country in the world, has only recently amassed her gold. For this she has tortured her wide fields, has strapped her people on the flywheel of an exploitation machine, and has created an absolutely cultureless existence—a truth that cannot be hidden by either the horizontals of the underground railway or the verticals of skyscrapers."

What then does the architect see, whose sight is clearer than his understanding? This eye is not blinded by the eccentricity of the sensations of the city that surround it; it sees and ascertains that real progress—really profound change in the very principles and forms of spatial division—is still very rare. On the other hand one finds much energy and very large dimensions. Everything grows elementally, like a tropical forest, depriving itself of light and air, consuming itself.

Typically American. Sailing in to New York, the world's harbor —the island of skyscrapers and the Brooklyn Bridge—one is disappointed (at least by the photograph). Actually, after a week of the ocean's flat horizon, these skyscrapers, verticals without scale, probably produce a different impression. But when we reach Broadway, the fourteen-mile-long avenue in New York, and stand next to such a giant, in order to see the whole thing we must tilt our head way back. And that will have to be done very often in this America. Herein lies Mendelsohn's basic service: he records this point of view with his camera (see the photographs of the skyscraper in *Stroitelnaya promyshlennost* 1).

Next: Chicago, grain elevators. Special trains bring grain from the country's heartland, steamers carry it across the Great Lakes, all this grain is poured into underground mills and, as flour, fills up the battery of silos.

The next contrast: a Gothic church, founded by the first sea pirates, against a background of skyscraper banks, the churches of the latest land pirates.

And suddenly a street at night, the flash of headlights, illuminated signs, unbroken rows of lit-up windows. And on the next page, Fifth Avenue—a conglomeration of all the styles borrowed from every historic square in Europe, luxurious and rich. And then the skyscraper of a bank, with a classical temple for public entrance and a cheerless row of standardized floors of offices over its pediment.

Exaggerated Civilization. Chicago. Twelve-mile-long Michigan Avenue. Built up on one side, with an open view of the embankment. New York. Madison Avenue. A continuous row of skyscraper hotels. All according to the same plan. They vary only in price and comfort. All directly connected underground to Grand Central Station. Straight from a Pullman car to a palm lobby. Chicago again. The elevated railway. The street is covered over, darkened by iron girders; overhead is the station, with moving staircases leading up to it. Everything thunders and roars. The European is blinded by the din, the American hears nothing unusual.

Detroit. A city that lives by the automobile. It calls itself "dynamic." In the last four years it has quadrupled in size. Commercial buildings, garages, factories, and skyscrapers. There is an architectural bureau where some three hundred architects, engineers, business managers, and mechanics work, one hundred for Ford alone.

Center of Money—Center of the World. New York. Wall Street. A street of banks, the gold sack of the world. A narrow street, like in old Frankfurt, only ten, thirty times taller. Chicago. Calmer. Simpler. But in these growing steel terra-cotta masses you can already see a hunger for billions of dollars. A street at third-floor level, especially for automobiles. A hotel where you can rent a room for ten or twenty thousand dollars a year.

The Gigantic. Approaching the huge streets. From a distance they still glitter in the light. Up close they are canyons, dark below and with alpine contrasts of light and shadow above. The maximum concentration on the minimum amount of land. Five to fifteen thousand people in each house. Six hundred thousand people to 150,000 square feet. Another page, and suddenly something incredible and unbelievable. It is a steep photograph looking up the fifty-three-story facade of the highest skyscraper (Woolworth). All the ornamentation is of embossed copper, for which the upkeep comes to 200,000 dollars a year. This is the first phase of skyscraper design. In the second comes liberation from excessive ornamentation, the height speaks for itself. The third is seen in the Shelton Hotel, a bachelors' hotel, with masses that decrease as it goes higher (a new building code) and spatial intersections. The thirty-five-story tower of the Chicago newspaper. Not yet finished, although it has been under construction for eight months: such are America's demands.

Buffalo. Grain elevators. One-hundred-cylinder verticals, clumsy, thrown up in haste. These are childish forms, full of natural strength, but not yet put into a system. Still primitive in their elemental function of sucking in and spitting back out. Wherever an organizing will appears, giddiness turns into boldness and confusion into harmony. The impression of such rows of hundred-foot-high cylinders, glazed reddish brown, connected to the black iron towers of the elevators and distributor bridges, must be splendid out in the open! A number of superb shots of individual details are shown us here.

The Grotesque. New York. Broadway at night. Illuminated signs turn the street into an eerie theatre. Flashing and streaking lights. And now by day. Total confusion. The last leafless sapling in this stone canyon. Near the center—streets that still preserve their old provincialism, with two-story houses and laundry hung out along the streets to dry. And behind them the tops of skyscrapers that tomorrow will swallow them up.

Narrow streets five yards wide between hundred-yard-high walls. The back sides of the splendid facades facing the avenue. The dark, gray ditches of the narrow streets—that's where all the fire escapes lead.

Detroit. A police tower built like a dovecote, from which the traffic of five million cars and four million residents is regulated. There is a church whose walls are leased for advertisements, and in the time off from hours of worship it is rented out as a cinema.

The New—The Coming. The steel skeletons of unfinished skyscrapers, powerful in their simplicity and honesty, but merely bare skeletons awaiting an equivalent formation of their flesh.

Several works by one of America's best artists, the architect Frank Lloyd Wright. New graduated skyscrapers, where it is no longer ornamentation or the flatness of walls that stands out, but the movement of masses. And something most characteristic in the new buildings: facades that face a courtyard. Display is out of place here, and thus there are no superfluous gestures. There are windows only where necessary; fire escapes, elevator shafts, ventilation pipes. Strikingly simple and monumental in their expressiveness. Below are fences with a modern fresco—a poster and a car, which at once gives everything dimension and life. This is architecture of labor, in contrast to the architecture of a parasite, who creates on someone else's account. The building is in control of both its front facade and the street. When individual houses such as these are joined into complexes or groups, a type starts to be established. This is something that not just America, but we too, must create.

We have leafed through the album. We recall the travel albums of other architects that we have seen. Usually they set out armed with pencils, brushes, and watercolors; and handling this material required so much energy from them that only fragments of the actual objects they sketched were recorded. The modern architect has armed himself with a more modern instrument—a small camera. He merely has to take a good look, and be able to see—for therein consists all of art. And then he must be in control of the camera, and not the camera of him: he finds the point of view and releases the shutter. He has an excellent sense of light and shadow, although the method, it is true, is rather monotonous: the foreground in deep shadow, the background in bright light. The camera's view of tall buildings from below is very striking in its foreshortening, but it is a shame that the opposite possi-

bility is not used at all, especially as the roofs of skyscrapers are flat and easy to get to—usually there is a restaurant there.

One thing about the album is surprising: there are no people. The streets are almost empty, the crowds have disappeared. It is as if the architect tries to stay eye to eye with the architecture itself, they both move around each other; and this transforms vital, pulsating life into a museum. The old cities of the old world are represented that way, but this is the new world which hasn't yet gone down in history. The movement of human masses among these architectural masses is not revealed: for instance, we do not see the tide of many hundreds of thousands flowing to work and back again over the Brooklyn Bridge, against a background of skyscrapers. An isolated building and especially a street, a whole city—these are dead without man. And yet, as a whole, this book should be welcomed, along with the architect's eye which shows us familiar things in a way that forces us to ponder them more deeply.

Translated by Alan Upchurch

OSSIP BRIK

FROM THE PAINTING TO THE PHOTOGRAPH

In the late 1920s, a time when the resurgence of Soviet realist painting was increasingly apparent, Ossip Brik (see p. 213) and other members of the avant-garde *Novyi lef* group remained convinced that photography was the image-making medium best suited to a modern society. In this essay Brik attempts to distinguish between the visual means available to painting and to photography. While painting must operate at a temporal remove from the pictured moment, he argues, photography is able to render fleeting events at the very instant they occur. For this reason, photography is better equipped to explore the new relations between the individual and the social environment in a revolutionary country like the USSR.

One idea frequently advanced in the pages of *Novyi lef* was that radically new visual and literary forms were needed to portray a society utterly transformed by revolution and technology. Shaping his argument around an example that recurred frequently in the Russian debates on photography, Brik here contends that the new leaders of Soviet society should not be portrayed as isolated, heroic individuals, as is traditional in western painting; instead they should be presented in ways that visually emphasize their connections to a revolutionary, collective society.

Original publication: Ossip Brik, "Ot kartiny k foto," *Novyi lef* (Moscow), no. 3 (1928), pp. 29–33.

1

Until the invention of the camera, drawing and painting were the only media for recording visual facts. As they evolved, graphics and painting elaborated distinctive methods of representing visual facts. These methods and forms changed depending on the social commission and the particular development of the technique of representation, and also changed whenever the craft in question was enriched with new materials.

In people's minds, the age-old practices of painting and the graphic arts created specific clichés which now appear to be indispensable to the representation or recording of any visual fact.

Schools have changed, styles and tastes have changed, but they always have had something in common that has remained constant for the visual arts as a whole.

But now, photography has provided mankind with a completely new means of recording visual facts. Instead of relying on the hand-crafted sketch, we have the opportunity to obtain representations of outer phenomena by mechanical means. Naturally, from the moment it appeared, painters and draftsmen used photography merely as a new technical medium. Delacroix even said that the photograph, in the hands of the skillful artist, is a great help to his work.

Of course, when independent photographers came on the scene—that is, people who worked with the craft of photography independently of, and apart from, artists—they tried to follow the norms and rules which had previously been established for all kinds of representation.

They felt that the highest achievement of the photograph would be to scale the very heights occuppied by the visual arts.

Owing to their still-clumsy handling of technical matters, the first photographers simply could not attain these painterly heights; only gradually and closer to our time did photographers reach the trium-phant decision that now they, no less than artists, could create pictures.

But it became patently obvious that, all this time, photography had been aspiring to something that was foreign to it. The fact was, those same photographic experiments and snapshots that had nothing in common with painting, and that enlightened photographers regarded as failures, actually possessed the greatest photographic value.

It turned out that photography has its own potentials and forms which have nothing in common with the potentials and forms of the visual arts, and that the task of photography is to comprehend its own specific forms and methods and, in developing them, to develop the photographic art.

The invention of the movie camera provided man with yet another medium for recording visual facts, enabling him to record the object not only in still shots but also in motion.

The movie camera appeared shortly after the photographic camera. That was the time when photography had not yet evolved its own ideol-ogy and still depended wholly upon painterly stereotypes; and natu-rally, the movie camera succumbed to the same influence.

As a result, we now have three different media for the recording of outward phenomena: painting, photography, and the cinema. But

not only has the range of their possibilities not been assessed: it is still under that same influence of the age-old, traditional visual clichés. Curiously enough—and not illogically—modern painting has been unable to avoid the influence of photography and the cinema, and in its latest achievements is now trying to snatch something from these new forms of visual art.

As a result, we have an eclectic, artistic-cum-photographic culture that has mixed up all the old painterly clichés and the new experiments in photo-cinematographic creativity.

2

The basic difference between the handcrafted sketch and the photographic snapshot is not that one is made by hand and the other by a mechanical apparatus. What is significant is that the sketcher is dealing with an object that has to be as motionless as possible. Even in so-called quick sketches the sketcher can catch only one particular feature of the subject, and if the subject then disappears from his field of vision he is obliged to construct the drawing not on the basis of nature, but relying on whatever pictorial knack he may happen to have.

Photography has the capacity to take the object in all its details and in an extraordinarily short period of time. For the photographer, therefore, the motion of the object does not present a particular problem, whereas for the artist the object must be stationary if he is to produce a successful work.

But since in reality all objects are in constant movement and in constant contact with other adjacent objects, any attempt to set up nature so as to record it by painting is bound to be spurious.

Inevitably, any painting by any artist is structured around a central object isolated from its environment. So in the picture objects are presented not in their continuity, but in isolation.

The artist is unable to catch the object changing in time and space, and in order to paint his picture he is obliged to remove time and space: he is forced to construct the object not in real time and space, but according to the conditions of graphic and painterly correlations—something engendered not by this or that style, not by this or that treatment of nature, but by the very essence of the craft of painting.

The photographer—and in this lies the radical difference—can

snap the phenomenon in its continuity. He does not have to set the scene up in order to take it. He can use real-life nature, regardless of whether it exists outside, before, or after the photographic shot.

In concrete terms: if a painter wanted to sketch Holy Square[1] he would have to rebuild the houses, regroup the people, and invent some kind of connection between them besides the one that exists in reality. Only then would he be able to achieve a painterly effect —something dictated by the fact that Holy Square is not a finished, self-enclosed totality, but merely a point for the intersection of various temporal and spatial phenomena. The painter is unable to present the dynamics of this point of intersection. He has to arrest its movement, for otherwise he cannot record it; but movement brought to a stop does not possess the interrelationship of parts essential to the static object. Consequently the artist is forced to reorganize these arrested objects by himself.

The photographer does not have to halt the movement but can record it in motion, and if he is unable to convey this sensation, at least he can imply it.

3

Differentiating individual objects so as to make a pictorial record of them is not only a technical, but also an ideological phenomenon. In the pre-Revolutionary (feudal and bourgeois) period, both painting and literature set themselves the aim of differentiating individual people and events from their general context and concentrating attention on them.

This is not the place to dwell on that phenomenon. But it is important, at least, to indicate that the methods of both literary and scholarly investigation find parallels in painting.

Whatever the historical event, it was important for the historian, writer, or painter to find the principal and central *dramatis personae*, and to concentrate on them his attention and that of his public.

In the Napoleonic campaigns it was Napoleon who was such a persona; everything that surrounded him was merely historical, literary, or pictorial background.

We know that in reality Napoleon was not the central figure of the Napoleonic campaigns, and that had Napoleon not existed, the Napoleonic campaigns would have taken place all the same.

To the contemporary consciousness, an individual person can be understood and assessed only in connection with all the other people —with those who used to be regarded by the pre-Revolutionary consciousness as background.

That is why we pay attention not to the individual characters as such, but to the social movements and connections that define their particular positions.

That is why historical monographs, literary biographies, and pictorial iconographies are so inadequate.

We need a method whereby we can represent this individual persona not in isolation, but in connection with all the other people. In the visual arts it is the photograph that offers this technical possibility.

To take a snapshot, a photographer does not have to differentiate the individual. Photography can capture him together with the total environment and in such a manner that his dependence on the environment is clear and obvious. The photographer, then, can resolve this problem—something that the painter cannot do.

However, the photographer still feels beholden to the external clichés of painting. He still cannot understand his contemporary assignment, and still uses his camera merely to imitate the painted picture.

The portrait photographer always places his model so as to isolate him from the surrounding ambience. He'll take him into his special studio and create an artificial photographic environment. All this in order to produce a portrait in maximum isolation, and create the maximum resemblance to a painted picture.

Moreover, when he processes the photograph the portrait photographer carefully covers up all so-called fortuitous or uncharacteristic features of the piece. He abstracts it, algebraicizes it, and thereby makes it even more like a work of painting.

Taking photographs in their studios, these portrait photographers have the opportunity to "process" the results long and carefully. They are the envy of press photographers who, because of external conditions, are unable to take such pains with their work and are obliged to photograph their subjects in a hurry.

They feel that the people's commissar who is photographed with his visitors during a conversation, or as he's coming out of the meeting-room—photographed casually in an "unartistic" pose—is not as good as the people's commissar photographed in a special armchair, with a

special expression on his face, and specially isolated from people irrelevant to that setting.

The press photographer does not realize that the people included next to the people's commissar in his candid photograph are not extraneous, and that the latter can be understood only in connection with them.

Whenever the people's commissar is isolated from his environment, the result is an iconography: he's being regarded as a heroic figure, just like Napoleon, who might seem to be the central figure in the Napoleonic campaigns.

The press photographer does not realize that—ideologically—the so-called fortuitous conditions of his work are in fact indispensable for presenting the subject so that we can understand it. He does not realize that whenever he records his subject by old-fashioned methods he also returns us to the ideology of the ancien régime.

If we can follow this, we can also comprehend that the task of the contemporary photographer is not to make his snapshots more like painted pictures, but to understand the new method of his work and to develop it as fully as possible.

The task of the contemporary photographer is not to photograph the people's commissar when he is alone or in a photogenic pose, but the reverse: to take his picture when he is in maximum contact with his environment, operating in real life and not just for the photographer.

What I have said about the photographic portrait is equally true of the other photographic genres. When taking an urban or rural landscape, the photographer should aspire—as far as he can—to present it as interconnected with the rest of the world.

You can't just show a single house or tree in isolation. That might look nice, but it will be a work of painting, a branch of aesthetics, the aesthetic enjoyment of the individual at the expense of its links with the other phenomena of nature or with human labor.

It should be clear from the photograph that this house is interesting not in itself, but as part of the overall structure of the street and the city; and that its value lies not in its visual outlines, but in the function it fulfills within the given social ambience.

We should not have to wait for those nearby to pass the house, to go in or come out; on the contrary, we should photograph it just when the pedestrian traffic is at its most intense. Only then will the full meaning and significance of the subject become clear.

Our photographers and cinematographers are still so charmed by pictorial painting that they value precisely those frames that from the photographic standpoint are the least interesting—a fact which is made clear by just a look at the exhibitions that photographers organize or the photographs that cinematographers send to movie magazines for reproduction.

They all share the same dream: to do things as well as a painter might do. Herein lies the failing—not the virtue—of the art of photography.

Translated by John E. Bowlt

1. Holy Square (Strastnaia ploshchad) in Moscow is now called Pushkin Square.

VARVARA STEPANOVA

PHOTOMONTAGE

Varvara Fedorovna Stepanova (1894–1958), who was married to Alexander Rodchenko (see p. 238), was in her own right an important artist and achieved recognition for her collages, visual poetry, textile designs, and stage designs. This essay was written in 1928 and circulated in typescript form. It was published only in 1973, in the Czech journal *Fotografie*.

Stepanova's short history of Russian photomontage divides it into two broad phases which, not surprisingly, closely parallel Rodchenko's own development. The first stage, beginning in the early 1920s, was marked by the combination within a single picture of diverse photographic fragments of different sizes—as in Rodchenko's illustrations for *Pro eto*. During the second phase the emphasis shifted to the artist's direct use of the camera to produce series of pictures that record an immediate reality. Both approaches, Stepanova argues, seek to convey an expanded, documentary sense of the contemporary world. Similarly, she proposes, both find their ultimate application within the "polygraphic" media of printed posters, books, and magazines aimed at a mass audience.

Original publication: Varvara Stepanova, "Foto-montazh. Aleksandr M. Rodchenko," *Fotografie* (Prague), no. 3 (1973), pp. 18–19.

A group of artists on the left artistic front have given their attention to the problems of production art.[1] This shift of interest has dictated a change in the basic method of work, that is, in the use of technique and artistic media to express documentary truth. Now we are using photography as a viable method of communicating realities.

In polygraphy[2]—more than in other forms of communication—images must transmit the phenomena of the external world. And this places considerable responsibility upon the artist. Periodicals, newspapers, book illustrations, posters, and all other types of advertising confront the artist with the urgent problem of how to record the subject in documentary terms. An approximate artistic design cannot meet this challenge, this need to provide documentary truth. The mechanical complexity of the external forms of objects and of our whole industrial culture is forcing the artist concerned with production—the

constructivist artist—to move from the imperfect method of drawing to the utilization of photography.

And so photomontage was born. Photomontage: the assemblage and combination of the expressive elements from individual photographs. In our country the first photomontages were created by the constructivist A. M. Rodchenko in 1922 as illustrations to I. A. Aksenov's book *Gerkulesovy stolby* (The pillars of Hercules). . . .[3]

The need for documentary truth is characteristic of our era, but it is not confined to mere advertising, as some people suppose. We now know that even artistic literature requires it. The first great work in photomontage (i.e., the one that played a definite and necessary role in the development of our book illustrations, book covers, and posters) was V. V. Mayakovsky's book with photomontages by A. M. Rodchenko.[4] From that time on, photomontage—as a new art form replacing drawing—has expanded greatly and has permeated the periodical press, propagandistic literature, and advertising. Because of its great potential this method is becoming very popular and much relied upon. It is quickly catching on in workers' clubs and in schools, where photomontage on wall notices can present a ready response to any topic of urgency. Photomontage is being used extensively in political campaigns, and from anniversary celebrations and parties right down to the decoration of offices and corners of rooms.

All our Soviet publishing houses . . . have accepted photomontage, and it is one of the commonest methods of typographical layout for book covers and posters. Photomontage is found even in movie posters. The years 1924–26 witnessed a general upsurge of interest in photomontage on the part of the Soviet press.

During its short life photomontage has passed through many phases of development. Its first stage was characterized by the integration of large numbers of photographs into a single composition, which helped bring into relief individual photo-images. Contrasts between photographs of various sizes, and to a lesser extent, the graphic surface itself, formed the connective medium. One might say that this kind of montage possessed the character of a planar composition superimposed on a white paper ground.

The subsequent development of photomontage has made clear the possibilities of using photography itself, as such. The photographic snapshot is becoming increasingly self-sufficient. (Of the distinguished works of this period one should single out *Istoriya VKP (b)* [History of

the All-Union Communist Party], published by the Communist Academy in 1926. It utilizes a poster format with Rodchenko's photomontages, but the individual snapshots are not fragmented and have all the characteristics of a real document.) The artist himself must take up photography. He searches for the particular shot that will satisfy his objective—but montaging someone else's photographs will not fulfill his needs. Hence, the artist moves from an artistic montage of photographic fragments to his own distinctive shooting of reality.

This was the path taken by A. M. Rodchenko, the first photomontagist. From 1924 onward Rodchenko worked with his camera. Instead of the conglomerate photomontage, he used a montage of individual photographs or a series of individual photographs. The value of the photograph itself came to assume primary importance; the photograph is no longer raw material for montage or for some kind of illustrated composition, but has now become an independent and complete totality. This increases the documentary value of photography and provides precise information on time and place in the created work. But it poses another problem—the need for a technique to express reality in characteristic and explicit terms.

In the final stage of photomontage we note that virtually every artist who has some connection with the polygraphic industry has equipped himself with a camera. Photography is the only medium that can provide him with the traditional method of drawing while allowing him to fix and record the reality around us.

Translated by John E. Bowlt

1. The term "production art" was used frequently in the early 1920s among the Soviet avant-garde. It signified the merging of artistic and technical skills in the hands of an "artist-constructor" whose goal was to create functional, utilitarian products. The terms "production art" and "constructivist art" were often employed interchangeably.

2. The word "polygraphy," as employed in the Soviet Union during the 1920s, refers to the use of typographic and photographic elements for the design of printed works such as posters, illustrated books and magazines, and advertisements.

3. Ivan Alexandrovich Aksenov (1884–1955) was a critic of literature and art who was especially close to the avant-garde painter Alexandra Exter and the artists of the pre-revolutionary "Jack of Diamonds" group. The book cited was never published.

It should be noted that other Russian artists besides Rodchenko, notably Gustav Klucis, also worked extensively with photomontage in the early 1920s.

4. The book referred to is Mayakovsky's poem *Pro eto* (1923); see p. 212, n. 1.

ALEXANDER RODCHENKO

AGAINST THE SYNTHETIC PORTRAIT,

FOR THE SNAPSHOT

A painter, sculptor, and photographer, Alexander Rodchenko (1891–1956) was one of the central figures of the Russian constructivist movement. After abandoning the traditional fine arts in the early 1920s, Rodchenko began active work in photomontage, graphic design, and photography. In 1927–28 he was associated with the avant-garde review *Novyi lef*, to which he contributed cover designs, photographs, and photomontages. A series of controversies grew out of Rodchenko's insistence on the pursuit of formal innovation in photography as a means to transform perception. The selections that follow trace the development of the Soviet debate on the subject of photography "à la Rodchenko."

In this essay Rodchenko draws a sharp line between painting and photography, using as his point of reference the suitability of each for contemporary portraiture. He finds little contemporary value in the usual single-image, or (as he calls it) "synthetic" portrait; in its place he proposes not one but a series of objective photographic portraits revealing the sitter in different aspects and at different moments. Rodchenko's arguments for the serial portrait were also voiced by his *Novyi lef* associate Ossip Brik (see "From the Painting to the Photograph," p. 227).

While in this essay Rodchenko uses the example of Lenin—who, at the time, was rapidly being enshrined in the official iconography of the Revolution—his own most striking application of these ideas was his 1924 series of six related portraits of his friend, the poet Vladimir Mayakovsky.

Original publication: Alexander Rodchenko, "Protiv summirovannogo portreta za momentalnyi," *Novyi lef*, no. 4 (1928), pp. 14–16.

I was once obliged to dispute with an artist the fact that photography cannot replace painting in a portrait. He spoke very soundly about the fact that a photograph is a chance moment, whereas a painted portrait is the sum total of moments observed, which, moreover, are the most characteristic of the man being portrayed. The artist has never added an objective synthesis of a given man to the factual world, but has

always individualized and idealized him, and has presented what he himself imagined about him—as it were, a personal summary. But I am not going to dispute this; let us assume that he presented a sum total, while the photograph does not.

The photograph presents a precise moment documentarily.

It is essential to clarify the question of the synthetic portrait; otherwise the present confusion will continue. Some say that a portrait should only be painted; others, in searching for the possibility of rendering this synthesis by photography, follow a very false path: they imitate painting and make faces hazy by generalizing and slurring over details, which results in a portrait having no outward resemblance to any particular person—as in pictures of Rembrandt and Carrière.

Any intelligent man will tell you about the photograph's shortcomings in comparison to the painted portrait; everyone will tell you about the character of the Mona Lisa, and everyone forgets that portraits were painted when there was no photography and that they were painted not of all the intelligent people but of the rich and powerful. Even men of science were not painted.

You need not wait around, intelligentsia; even now AKhRR[1] artists will not paint you. True—they can't even depict the sum total, let alone .001 of a moment.

Now compare eternity in science and technology. In olden times a savant would discover a truth, and this truth would remain law for about twenty years. And this was learned and learned as something indisputable and immutable.

Encyclopedias were compiled that supplied whole generations with their eternal truths.

Does anything of the kind exist now? . . . No.

Now people do not live by encyclopedias but by newspapers, magazines, card catalogues, prospectuses, and directories.

Modern science and technology are not searching for truths but are opening up new areas of work, and with every day change what has been attained.

Now they do not reveal common truths—"the earth revolves"—but are working on the problem of this revolution.

Let's take: aviation
 radio
 rejuvenation,[2] etc.

These are not mere platitudes, but constitute areas that thou-

sands of workers are expanding in depth and breadth, thanks to their experiments.

And it is not just one scientist, but thousands of scientists and tens of thousands of collaborators.

And hence there will never be eternal airplanes, wireless sets, and a single system of rejuvenation.

There will be thousands of airplanes, motorcars, and thousands of methods for rejuvenation.

The same goes for the snapshot.

Here is an example of the first big collision between art and photography, a battle between eternity and the moment. Moreover, in this instance photographs were taken casually, but painting attacked photography with all its heavy and light artillery—and failed miserably. . . .

I mean Lenin.

Chance photographers took his picture. Often when it was necessary, often when it was not. He had no time; there was a revolution on, and he was its leader—so he did not like people getting in his way.

Nevertheless, we possess a large file of photographs of Lenin.[3]

Now for the last ten years artists of all types and talents, inspired and rewarded in all sorts of ways and virtually throughout the world and not just in the USSR, have made up artistic depictions of him; in quantity they have paid for the file of photographs a thousand times, and have often used it to the utmost.

And show me where and when and of which artistically synthetic work one could say: this is the real V. I. Lenin.

There is no one. And there will not be.

Why not? Not because, as many think, "We have not yet been able to, we haven't had a genius yet, but certain people have at least done something."

No, there will not be—because there is a file of photographs, and this file of snapshots allows no one to idealize or falsify Lenin. Everyone has seen this file of photographs, and as a matter of course, no one would allow artistic nonsense to be taken for the eternal Lenin.

True, many say that there is no single snapshot that bears an absolute resemblance, but each one in its own way resembles him a bit.

I maintain that there is no synthesis of Lenin, and there cannot be one and the same synthesis of Lenin for each and every one. . . .

But there is a synthesis of him. This is a representation based on photographs, books, and notes.

It should be stated firmly that with the appearance of photographs, there can be no question of a single, immutable portrait. Moreover, a man is not just one sum total; he is many, and sometimes they are quite opposed.

By means of a photograph or other documents, we can debunk any artistic synthesis produced by one man of another.

So we refuse to let Lenin be falsified by art.

Art has failed miserably in its struggle against photography for Lenin.

There is nothing left for it but to enlarge photographs and make them worse.

The less authentic the facts about a man, the more romantic and interesting he becomes.

So that is why modern artists are often so fond of depicting events long past and not of today. That is why artists have enjoyed less popularity when they have depicted contemporaneity—they are criticized, it is difficult to lie to their faces . . . and they are acknowledged afterward when their contemporaries have died off.

Tell me frankly, what ought to remain of Lenin:

an art bronze,
oil portraits,
etchings,
watercolors,
his secretary's diary, his friends' memoirs—

or

a file of photographs taken of him at work and rest,
archives of his books, writing pads, notebooks,
shorthand reports, films, phonograph records?

I don't think there's any choice.

Art has no place in modern life. It will continue to exist as long as there is a mania for the romantic and as long as there are people who love beautiful lies and deception.

Every modern cultured man must wage war against art, as against opium.

Photograph and be photographed!

Crystallize man not by a single "synthetic" portrait, but by a whole lot of snapshots taken at different times and in different conditions.

Paint the truth.

Value all that is real and contemporary.

And we will be real people, not actors.

Translated by John E. Bowlt

1. The Association of Artists of Revolutionary Russia (see p. 218, n. 1).

2. The term refers to the Soviet emphasis on mass gymnastics and health exercises, which were particularly stressed during the 1920s and 1930s. Rodchenko himself was an avid sportsman and photographed many scenes of sports activity, including calisthenics, diving, and parachuting.

3. Lenin was a favorite subject for Soviet photographers. The file that Rodchenko refers to is probably the *Albom Lenina. Sto fotograficheskikh snimkov* (Lenin album: a hundred snapshots), compiled by Viktor Goltsev and published by the State Press in 1927. Rodchenko himself also photographed Lenin; one of his portraits served as the cover of *Novyi lef*, no. 8/9 (1927).

"A PHOTOGRAPHER"

AN ILLUSTRATED LETTER TO THE EDITOR:

AT HOME AND ABROAD

By 1928 the publication of Rodchenko's photographs taken from dizzying perspectives had begun to attract wide comment in Moscow. To photographers convinced that their primary task was to document the emerging Soviet society as accurately as possible, Rodchenko's photographs seemed unnecessarily preoccupied with formal questions. This anonymous letter was published in the pages of *Sovetskoe foto* with three pairs of photographs in which Rodchenko's images were set against earlier, non-Soviet works. The letter sought to cast suspicion on Rodchenko's motives by implying that he was merely imitating the mannerisms of Western avant-garde photographers. *Sovetskoe foto*'s editors chose not to print Rodchenko's reply; he published it instead in *Novyi lef* (see the following selection). An extended dispute was launched which pitted Rodchenko against critics both within and without the *Novyi lef* group. The key exchanges are presented in this and the seven following selections.

Original publication: "Illiustrirovannoe pismo v redaktsiiu: nashi i za granitsa," *Sovetskoe foto*, no. 4 (April 1928).

Materials: 6 photographs

Top left: Photo by D. Martin (USA), 1925[1]
Top right: Photo by A. Rodchenko (Moscow), 1926

Center left: Photo by A. Renger-Patzsch (Germany), 1924
Center right: Photo by A. Rodchenko (Moscow), 1927

Lower left: Photo by Prof. Moholy-Nagy (Germany)
Lower right: Photo by A. Rodchenko (Moscow), 1926.

Note: A. Rodchenko is no run-of-the-mill photographer. He is an artist and professor at Vkhutemas[2] in Moscow, is exploring new paths in the art of photography, and is famous for his ability to see things in his own way, in a new way, from his own point of view. This talent is now

so widespread that if a photographer takes a photograph from above down, or from below up, people say: "He's photographing in the Rodchenko style, he's imitating Rodchenko."

Preliminary conclusion: Foreign photographers should be ashamed of themselves for using the achievements of Soviet photography for their imperialist goals—and they are passing them off as their own, too.

Ultimate conclusion: Let the reader draw his own inferences from the materials presented here.

A Photographer

Editor's note: Unfortunately, the above is no April Fool's joke. The Editor's office received all six photographs from the correspondent in the form of clippings from local and foreign newspapers. From these it is clear that the photographs really were taken by the photographers named in the letter. The dates have also been checked carefully.

Translated by John E. Bowlt

1. The photograph reproduced with this letter, an image of boats in a lake, was the work of the New York photographer Ira W. Martin (1886–1960), a leading member of the Pictorial Photographers of America.

2. Vkhutemas was the acronym for the Higher State Art-Technical Studios (Vysshie gosudarstvennye khudozhestvenno-tekhnicheskie masterskie), the restructured art schools in Moscow, Leningrad, and other cities. The Moscow Vkhutemas attracted many of the avant-garde to its faculty, among them Rodchenko, who taught there, primarily in the metalwork section, from 1920 to 1930.

ALEXANDER RODCHENKO

DOWNRIGHT IGNORANCE OR A MEAN TRICK?

This is Rodchenko's angry response to the anonymous attack on him which had been published in *Sovetskoe foto* (see previous selection). In his reply he defends the use of unusual photographic viewpoints, insisting that his aim is to produce an entirely new impression of ordinary, everyday objects. He challenges *Sovetskoe foto* to move forward out of the "mire" of conventional photography and embrace the cause of modern photography.

Original publication: Alexander Rodchenko, "Krupnaia bezgramotnost ili melkaia gadost?" *Novyi lef*, no. 6 (1928), pp. 42–44.

(The fourth issue of the journal *Sovetskoe foto* published a "letter" which, in thinly disguised terms, accused A. Rodchenko of plagiarizing works by foreign photographers, in particular by Moholy-Nagy.

That's point no. 1.

But when A. Rodchenko sent a letter to the editors of *Sovetskoe foto* in order to expose the disgusting innuendo in this remark, they did not publish it.

That's point no. 2.

That's why A. Rodchenko is forced to publish his letter to the editors of *Sovetskoe foto* in the pages of *Novyi lef*.)

April 6, 1928

To the Editors of *Sovetskoe foto*:

I am an "explorer of new paths in photography" (goes the "letter" that you published).

Quite correct.

Isn't that why your letter was printed?

". . . known for his ability to see things in his own way, in a new way, *from his own point of view.*"

I did not know that I was known for my ability to see things "*in my own way and from my own point of view.*"

Only an ignoramus can think of owning points of view.

It's one thing to "seek paths" and quite another to "have one's own viewpoints."

Photography possesses old points of view, those of man standing on earth and looking straight ahead. What I call "shooting from the belly button"—with the camera hanging on one's stomach.

I am fighting against this standpoint and shall continue to do so, as will my comrades, the new photographers.

Photograph from all viewpoints except "from the belly button," until they all become acceptable.

The most interesting viewpoints today are "from above down" and "from below up," and we should work at them. I've no idea who invented them, but they've been around a long time. I want to affirm these vantage points, expand them, get people used to them.

To me—as to any cultured individual—it's unimportant who said "A" first. What is important is to expand this "A" and make full use of it, so that somebody can then say "B."

If people say that "from above down" and "from below up" photographs are in the Rodchenko style, then we ought to explain the ignorance in that assertion; we should acquaint them with modern photography, and show them photographs by the best masters from different countries.

The photographs you have juxtaposed to my own demonstrate the downright illiteracy of the person who made the comparison, or rather, his unscrupulous attempt at sabotage. You can juxtapose and make selections as much as you want. But to draw a conclusion about plagiarizing is, to say the least, garbage.

How is culture to evolve if not by the exchange and assimilation of experiences and achievements?

Herewith I attach an example to show how easy it is to make such a selection. I didn't rummage around in foreign journals. I simply took two Soviet journals—*Sovetskoe foto* and *Sovetskoe kino*.

If we may use the language of *Sovetskoe foto*, then the plagiarism by S. Fridliand and Shaikhet is more revealing than mine.[1] But that's no concern of mine. I have great respect for Shaikhet's photographs and Fridliand's experiments and for their desire to climb out of the mire of old photography. The best photographs from the West cannot help but influence them—they're alive, after all.

Does the journal *Sovetskoe foto* publish the best photographs of foreign photographers?

I hope it's not because these photographs don't have to be paid for.

Let's get down to the "illustrations" in your letter:

D. Martin's *Boats* is much weaker in composition than mine, and I think one could easily compile a whole album of such boats.

A. Renger-Patzsch's *Chimney* and my *Tree*, both taken from below, are very similar, but don't the "Photographer" and the publishers see that I made them similar on purpose?

For hundreds of years painters kept on doing the same old tree "from the belly button." Then photographers followed them. When I present a tree taken from below, like an industrial object—such as a chimney—this creates a revolution in the eyes of the philistine and the old-style connoisseur of landscapes.

In this way I am expanding our conception of the ordinary, every-day object.

Do I have to give you a whole lecture about this?

Photographs like Renger-Patzsch's *Chimney* are, to me, authentic, modern photography (don't assume that this is Renger-Patzsch's "own" viewpoint—it's *ours*). I myself published such photographs, and specifically this one, in the photo and cinema section of the journal *Sovetskoe kino* (which I'm in charge of).

The author of the illustrated letter ended by juggling the facts.

Moholy-Nagy's photograph called *The Balcony* and my *Balcony* are "remarkably similar," so he placed them next to each other. But the dates of these pieces speak in my favor; that's why he left out the date on the Moholy-Nagy. I can rectify that. My *Balcony* and several other photographs of a balcony were published in *Sovetskoe kino* (1926), and Moholy-Nagy's in the journal *UHU* (February 1928).[2]

What will the publishers of *Sovetskoe foto* (who "verified" the letter and its illustrations) say to that?

I would point out that there is another *Balcony* by Moholy-Nagy, very similar to mine, that appeared in *Das Illustrierte Blatt* 15 (1928).

But none of this should serve to disparage the excellent work of such an extraordinary master as Moholy-Nagy, a man whom I value very highly.

Moholy-Nagy, once a leftist, non-figurative painter, has asked me several times to send him my photographs. He knows them very well and he values my work. When we were both painting I exerted a considerable influence on him, and he has often written about this.[3]

If straightforward honesty is not required of items published in

the journal *Sovetskoe foto*, then perhaps at least we might be permitted to ask for some elementary literacy.

The new, contemporary photography has a job to do.

I don't think that my photographs are any worse than those to which they are compared. Therein lies their value.

In addition to those, I have photographs that cannot easily be compared.

If there are one or two photographs resembling mine—well, one could find thousands comparable to the endless landscapes and heads published in your journal.

You ought to publish a few more of *our* imitations, instead of Rembrandt imitations, in *Sovetskoe foto*!

Don't be the grave diggers of modern photography. Be its friends!

Translated by John E. Bowlt

1. Semen Osipovich Fridliand (1905–64) and Arkadii Samlilovich Shaikhet (1898–1959) were well-known Soviet press photographers whose work was often published in magazines like *Sovetskoe foto* and *Sovetskoe kino*. (As selections following this one make clear, the photographs that Rodchenko alludes to were credited in *Novyi lef* to Fridliand and M. A. Kaufman, not to Shaiket.) The photographs reproduced here showed abstract patterns formed by the lattice structure of Moscow's celebrated radio tower.

2. UHU was a popular German monthly magazine published in Berlin by Ullstein Press.

3. Moholy-Nagy's paintings of the early 1920s display an awareness of the non-figurative work of several Russian artists, not least among them El Lissitzky and Rodchenko. Nevertheless it is by no means certain that Moholy regarded Rodchenko, whom he never met, as having influenced his own work.

BORIS KUSHNER

OPEN LETTER TO RODCHENKO

Rodchenko's main opponent in the 1928 photography debate which unfolded in the pages of *Novyi lef* was Boris Kushner, who voiced strong opposition to Rodchenko's call for a "revolution in vision." Kushner (1888–1937) was a literary critic and theorist as well as a poet; like Ossip Brik's, however, his interests extended well beyond the domain of literature into questions concerning the role of the artist in industrial society. A lecturer at the Vkhutemas, Kushner was, like Rodchenko, a member of the editorial board of *Novyi lef*.

In his "open letter" Kushner questions the value of experimental photography from a utilitarian point of view. Do photographs taken from unusual vantage points, such as Rodchenko's, actually teach us anything new or useful about their subjects? His challenge to Rodchenko to provide a more precise account of his own thinking set the stage for Rodchenko's lengthy response in "The Paths of Modern Photography."

Original publication: Boris Kushner, "Otkrytoe pismo," *Novyi lef*, no. 8 (1928), pp. 38–40.

Dear Rodchenko,

Obviously there is no need for me to mention that I wholeheartedly agree with the principles you have elucidated in your letter to the publishers of *Sovetskoe foto* and published in *Novyi lef* under the title, "Downright Ignorance or a Mean Trick?" My agreement is obvious from the very beginning.

But I do find one sentence in your letter perplexing and it makes me skeptical. It concerns, not the absurd attacks against you by the author of the letter to *Sovetskoe foto*, but the principles of modern photography.

You assert that the "most interesting viewpoints today are 'from above down' and 'from below up.'" Perhaps in matters of photography I myself am not very literate, but I don't find your arguments in favor of always locating the point of view at a 90° angle and in a vertical position very convincing. The necessity of waging an active campaign against the conservative principle of "shooting from the belly button"

just cannot explain your decisive, categorical preference for the vertical shooting direction as opposed to all other possible perspectives.

The weakness of the principle you set forth is emphasized particularly clearly by the photographs appended to your letter. Of course, this is fortuitous. You included the photographs for a completely different purpose. But the fact that they testify so strikingly against your principle does not make them any less convincing.

Of the eight photographs you selected, only two make full use of your principle of the "most interesting viewpoint": the shots of the Shukhov radio tower. And in my opinion these are the weakest ones of all; to put it bluntly, they're really bad photographs. To depict a 150-meter-high radio tower as a wire bread basket is to fail to respect reality and to scoff at the facts. It is more desirable to take the tower "from the belly button" than to turn our finest example of high-rise technology into a kitchen utensil. Such photographic sleight of hand is of no use to anyone. I should emphasize in particular that both photographs (the Kaufman and the Fridliand) in actual fact have nothing in common with what is seen by the living eye of the spectator standing inside the tower and looking up. In this case, turning the viewpoint away from the "belly button" by 90° has not only not contributed to a fuller photographic exposition of the fact, but, on the contrary, has distorted it quite inadmissibly.

There is no doubt that the best photograph of all the ones you included is the railroad bridge by H. Flach.[1] Its merits are as follows: 1) It reveals the symmetrical curves of the bridge's arc in a new and idiosyncratic way. Normally these curves operate within the field of vision of anyone crossing the bridge, but then they appear in more intricate combinations than the forms presented in the photograph. The complete symmetry of the curves and their dominating role in the structure are fully revealed by a single vertical ordinate—one of an infinite number of possibilities. H. Flach managed to position the lens of his camera precisely on this ordinate. 2) The photograph renders the algebraic proportions of individual parts of the structure accessible and intelligible to the eye—the supporting girder, the span of the bridge, the width of the railroad track, etc. 3) It gradually fragments the connecting girder into a series of thrusts, and thereby establishes an indissoluble link between the visible object and the piece of functioning engineering.

Rarely does a photograph give so much simultaneously. There

can be no doubt that this is a first-class piece of photography. It is an intensive lesson in photography, in bridge construction, in railroad engineering, and in how to see. This kind of photograph is worth a whole book of description.

And what about the "most interesting viewpoint for contemporaneity" in this photograph?

The angle at which the bridge was taken is approximately 30° up from the "belly button" line. So, it's closer to that than to the "from above down" position.

Anyone who looks carefully at the photographs you appended to your letter is bound to conclude that "from below up" is no good, but 30° up from the "belly button" is great.

Of course, this is not enough to make us assert that the most interesting viewpoint is a vertical perspective at 30°, but it is quite enough to enable us to refute your statement about "above" and "below."

In your letter you presented this theoretical formulation that I'm now disputing in a rather hurried, incidental manner. You probably did not define it closely enough.

However, I have ventured to quarrel with you deliberately because I have long been troubled by doubts about the merits and advantages of using a vertical or nearly vertical shooting line in photography. I would be very grateful if you would respond to my letter and include arguments to support the correctness of your thesis.

Comradely greetings,

Boris Kushner

Novosibirsk, August 8, 1928

Translated by John E. Bowlt

1. A photograph of a lattice-girdered bridge by Hannes Maria Flach (1901–36), an architectural photographer in Cologne, had been reproduced in Rodchenko's "Downright Ignorance or a Mean Trick?"

SERGEI TRETYAKOV

PHOTO-NOTES

Sergei Tretyakov (1892–1939), who took over from Vladimir Mayakovsky the editorship of *Novyi lef* for its last five issues in 1928, was himself a photographer as well a highly regarded playwright, poet, journalist, translator, film scenarist, and literary critic. He maintained a keen interest in the critical issues surrounding film and photography, and in 1936 was coauthor, with Solomon Telingater, of the first monograph on John Heartfield.

In his "Photo-Notes" Tretyakov addresses, through a series of anecdotes, a number of important questions which occupied *Novyi lef*'s collaborators. He argues against the idea that there exists any fixed "modern" or *Lef* style in the arts, and spells out the constructivist position that the artist's real task is always one of imaginatively fitting available means to ideological ends. Tretyakov champions what might be called a functional concept of photography—one less concerned with the establishment of any single "modern" style than with encouraging a wide range of visual approaches suited to many different themes and audiences. Tretyakov thus set himself apart from both Kushner and Rodchenko, as became apparent in his subsequent editorial remarks in *Novyi lef*.

Original publication: Sergei Tretyakov, "Fotozametki," *Novyi lef*, no. 8 (1928), pp. 40–43.

When I was in Kislovodsk, a photographist came up to me (I won't say "photographer" because that usually suggests a professional practitioner) who wanted to work in the *Lef* style.

He told me that a local photographer had begun to take portraits "from way below" and that, consequently, this fellow now thought he was making leftist art.

So I explained that this kind of "ersatz *Lef*" does not make us especially happy (we immediately punned on the theme of "*pod Lef*" [ersatz *Lef*] and "*opodlev*" [having become mean]). It's the application of our constructive principles to aesthetic ends.

There is no such thing as *Lef* photography. What matters most is how you go about setting it up, the aim (purpose) of the photograph and why you have to take it, and then finding the most rational means

for the actual photographing and the points of view—that's the *Lef* approach.

We started to talk about portraiture. The photographist said:

"*Lef* once wrote that a man's portrait should be composed of an entire range of snapshots taken of him in his normal environment."

We came to the conclusion that there are portraits and portraits, i.e., there are different goals. If we want to form an impression of a fellow in his everyday reality, well, there's no better approach. People generally conceal their real, ordinary selves and have themselves photographed looking unusual, very special, heroic. Naturally, heroes need Rembrandt shadows, a clean-shaven face, a youthful air, a special twinkle in the eye, and smart clothes. So all warts, pimples, and wrinkles are carefully removed. But there's also the kind of portrait where it's important to record these very same details, I mean the I.D. No Rembrandt shadows, no snapshots of the ordinary environment either—just an exact description of the face. Those are the kind of portraits used by the Department of Criminal Investigation.

The ability to pinpoint a necessary feature of detail assumes particular importance when the portrait is a scientific commission. Medicine has no interest in likeness, but on the other hand will demand the exact rendering of an eczemateous texture; anthropology will demand the close-up of a cranial construction; eugenics needs to see the elements that resemble ancestral portraits; while a reporter will reproduce a face against the background of the sensational event which he is describing in his telegram.

In struggling against the professional photographer we are fighting against the habit people have of lying about themselves. We are struggling against the widespread opinion that individualistic and false self-promotion is the synthetic (aggregate) truth about this or that person.

The Kislovodsk fellow is photographing geological sections in precipices. But he forgets to put a human being or tree next to the precipice. So the result is a precipice devoid of scale—it could be either a piece of geology or a slice of layer cake.

As we analyze these geological photographs, let us take into account the possible mistakes. We might enthuse over the play of light and shadow and enjoy an effect like that of a nice landscape photograph; but the shadows traversing the strata or cast next to them confuse the viewer, creating the impression of varieties of rock strata which actually are not there.

Could there ever be a reason to set up a landscape and photograph it so that it looks nice?

Yes, there could, if the purpose was to attract the kind of idle tourists who exclaim "Marvelous!" at a particular sight. But *Lef* is for the re-education of the tourist, and feels that this kind of purely picturesque delight is characteristic of the bourgeois—not the Soviet—tourist.

Delight in nature "untouched by the blasphemous hand of man," in "virgin" forest, in "chaos," in the great masses of tree trunks rotting irresponsibly and unmethodically, is just a belch of reactionary Romanticism. Would it not be more correct to express interest in nature organized to human advantage? In the fields plowed and sown, in the forests cleared and cultivated, in the rivers locked in the casemates of dams turning the hydroelectric turbines?

The poster. The book cover. The postcard. The atlas. The guidebook. The textbook. All these are different kinds of useful objects that dictate to the photographer different methods of photographing. The photographer's worth lies not in his inventing his own particular "style" of working, but in the fact that he executes every commission with maximum expedience and ingeniousness, making it accessible to the consumer.

I took a lot of photographs in an agricultural commune, and I had to conduct one of the photography sessions in the repair workshop. This involved a good deal of self-control; the workers were forced to pose against their will. They crowded around a disassembled tractor engine, and one of them grabbed a ruler in one hand and calipers in the other so as to measure the thickness of the shaft. But the calipers appeared at the very edge of the foreshortening focus and would have looked in the photograph like a piece of cotton thread. So I asked the worker to point the calipers at another shaft, so it would appear bigger.

The reply was exhaustive:

"You want to make a fool of me? That shaft can never be measured with a pair of calipers."

For this man it's the opinion of his fellow technicians that is important. He wants to be photographed as an engineer, not as a hero.

When I was photographing a work scene at a brick factory, I pointed the camera at a woman who was turning some bricks. When she saw

this she immediately took off her kerchief, and to my question why she had done that, she replied:

"Why should I come out looking like an old woman?"

This reluctance to be photographed during working hours is characteristic (especially of women): "This is an old dress." "My hands are dirty." "I have to look at what I'm doing, you won't see my face."

The method I used in order to bring people out of their stiff posing was to turn their attention to some defect in their work, and while they were straightening it out, to photograph them—before they had a chance to adopt a pose. They were usually full of regrets:

"What? You've already taken me? And I had my hand on my hip."

On Sunday one of the commune men dropped by to have himself and his family photographed. His wife was in her Sunday best and held a kerchief in her hand. The youngest son was holding a toy horse. They explained that this was precisely how a photographer from the town had photographed them before.

I let them make themselves comfortable as they thought fit.

Basically it was the typical pose: one sitting, another standing alongside with a hand on the other's shoulder and looking straight ahead. The children were arranged around them.

The mother instructed the little boy with the toy horse to look straight into the lens and insisted that he not screw up his eyes from the sun. Another boy wearing a jacket and long trousers held a puppy (people don't like being photographed empty-handed, they just have to be holding something—an apple, a pigeon, a chicken, any old object, an instrument, a branch, and if worse comes to worst, even a handkerchief). When the family members had already grouped, the mother suddenly shouted to the boy with the dog:

"Take off your shirt and roll up your trousers!"

All the family helped him to roll up his trousers and then pronounced with great satisfaction:

"Now you're wearing shorts. You'll look like an athlete. In any case, the dog will come out better against the white body."

Translated by John E. Bowlt

ALEXANDER RODCHENKO

THE PATHS OF MODERN PHOTOGRAPHY

This essay, a reply to Boris Kushner's "Open Letter" (see p. 249), is Rodchenko's most fully elaborated statement of his convictions about the need to "revolutionize" visual thinking through photography. Because our vision of the world is inevitably deadened by habits of perception and the conventions of pictorial form, he contends, we require visual shocks to jolt us into a new awareness. Moreover, the visual traditions which photography has inherited from painting are no longer adequate to portray an urban, techno-logical world, a world in which, Rodchenko maintains, "it would seem that only the camera is capable of reflecting contemporary life." His aim is not to develop a personal art of photography, Rodchenko emphasizes, but to spur the transformation of Soviet press photography, and in that way to introduce new visual and perceptual habits to a vast audience.

Original publication: Alexander Rodchenko, "Puti sovremennoi fotografii," *Novyi lef,* no. 9 (1928), pp. 31–39.

Dear Kushner,

You touched upon an interesting question concerning "from below up and from above down," and I feel obliged to respond, inasmuch as these photographic viewpoints have been "foisted upon" me (if I may use the "literate" language of the journal *Sovetskoe foto*).

I do, indeed, support the use of these viewpoints above all oth-ers. Here's why:

Look at the history of art or the history of painting of all coun-tries, and you'll see that all paintings, with some very minor excep-tions, have been painted either from the belly button level or from eye level.

Don't take the impression apparently created in icons and primi-tive paintings to be a bird's-eye view. The horizon has simply been raised so that a lot of figures can be put in, but each of these figures is presented at eye level. The whole thing taken together corresponds neither to reality nor to the bird's-eye view.

Although the figures seem to be looking upward, each one has a

correctly drawn front view and profile. Except—they are placed *one above the other, and not one behind the other* as in realist pictures.

The same with Chinese artists. True, they have one advantage —all the possible declivities of an object are recorded in their moments of movement (foreshortenings)—but the point of observation is always at mid-level.

Take a look at old journals carrying photographs—you'll see the same thing. It's only over recent years that you'll sometimes come across different vantage points. I underline the word *sometimes*, since these new viewpoints are few and far between.

I buy a lot of foreign journals and I collect photographs, but I have managed to put together only about three dozen pieces of this kind.

Behind this dangerous stereotype lies the biased, conventional routine that educates man's visual perception, the one-sided approach that distorts the process of visual reason.

How did the history of pictorial invention evolve? At first there was the desire to make something look "like life," as in Vereshchagin's pictures[1] or Denner's portraits[2]—which were about to crawl out of their frames and in which the very pores of the skin were painted. But instead of being praised, these painters were censured for being "photographers."

The second path of pictorial invention followed an individualistic and psychological conception of the world. Variations on exactly the same type are depicted in the paintings of Leonardo da Vinci, Rubens, etc. Leonardo da Vinci uses the Mona Lisa, Rubens his wife.

The third path was stylization, painting for painting's sake: van Gogh, Cézanne, Matisse, Picasso, Braque.

And the last path was abstraction, non-objectivity: when virtually the only interest the object held was scientific. Composition, texture, space, weight, etc.

But the paths exploring new viewpoints, perspectives, and methods of foreshortening remained quite untrodden.

It seemed that painting was finished. But if in the opinion of AKhRR[3] it was not yet finished, still no one paid any attention to the question of viewpoint.

Photography—the new, rapid, concrete reflector of the world —should surely undertake to show the world from all vantage points, and to develop people's capacity to see from all sides. It has the ca-

pacity to do this. But it's at this juncture that the psychology of the "pictorial belly button," with its authority of the ages, comes down on the modern photographer; it instructs him through countless articles in photographic journals, such as "The Paths of Photo-Culture" in *Sovetskoe foto*, providing him with such models as oil paintings of madonnas and countesses.

What kind of Soviet photographer or reporter will we have if his visual reason is clogged with the examples set by world authorities on the compositions of archangels, Christs, and lords?

When I began photography, after I had rejected painting, I did not then realize that painting had laid its heavy hand upon photography.

Do you understand now that the most interesting viewpoints for modern photography are from above down and from below up, and any others rather than the belly-button level? In this way the photographer has moved a bit farther away from painting.

I have difficulty writing; my thought process is visual, only separate fragments of ideas come to me. Still, no one has written about this matter, there are no articles on photography, its tasks and successes. Even leftist photographers such as Moholy-Nagy write personal articles such as "How I Work," "My Path," etc. Editors of photographic journals invite painters to write about developments in photography, and maintain an inert, bureaucratic attitude when dealing with amateur photographers and press photographers.

As a result, press photographers give up sending their photographs to photographic journals, and the photographic journal itself is turning into some kind of *Mir iskusstva* [World of art].[4]

The letter about me in *Sovetskoe foto* is not just a piece of ridiculous slander. It is also a kind of bomb dropped on the new photography. While discrediting me, it aims as well to frighten off any photographers who are using new viewpoints.

Sovetskoe foto, in the person of Mikulin, informs young photographers that they are working "à la Rodchenko," and therefore that their photographs cannot be accepted.

But in order to show how cultured they themselves are, the journals publish one or two photographs by modern, foreign photographers —although without the artist's signature and with no indication as to the source.

But let us return to the main question.

The modern city with its multi-story buildings, the specially de-

signed factories and plants, the two- and three-story store windows, the streetcars, automobiles, illuminated signs and billboards, the ocean liners and airplanes—all those things that you described so wonderfully in your *One Hundred and Three Days in the West*[5]—have redirected (only a little, it's true) the normal psychology of visual perceptions.

It would seem that only the camera is capable of reflecting contemporary life.

But. . . .

The antediluvian laws of visual rationality recognize the photograph as merely some kind of low-grade painting, etching, or engraving, possessing their same reactionary perspective. From the force of this tradition, a sixty-eight-story building in America is photographed from the belly button. But this belly button is on the thirty-fourth floor. So they climb up inside an adjacent building, and from the thirty-fourth story they photograph the sixty-eight-story giant.

And if there is no adjacent building they still get the same head-on, sectional view.

When you walk along the street you see buildings from below up. From their upper stories you look down at the automobiles and pedestrians scurrying along the street.

Everything you glimpse from the streetcar window or the automobile, the view you get from above down when you sit in the theater auditorium—all are transformed and straightened into the classical "belly button" view.

As he watches *Uncle Vanya* from the gallery, i.e., from above down, the spectator transforms what he sees. From his mental mid-view *Uncle Vanya* progresses as if in real life.

I remember when I was in Paris and saw the Eiffel Tower for the first time from afar, I didn't like it at all.[6] But once I passed very close to it in a bus, and through the window I saw those lines of iron receding upward right and left; this viewpoint gave me an impression of its massiveness and constructiveness. The belly-button view gives you just the sweet kind of blob that you see reproduced on all the postcards ad nauseam.

Why bother to look at a factory if you only observe it from afar and from the middle viewpoint, instead of examining everything in detail —from inside, from above down, and from below up?

The camera itself is equipped so that it will not distort perspective, even when perspective is distorted in reality.

If a street is narrow and gives you no room to step off to the side, then, according to the "rules," you are supposed to raise the front of the camera with its lens and incline the back, etc., etc.

All this is to ensure the "correct" projectional perspective.

Only recently, and in so-called amateur cameras, have short-focus lenses been employed.

Millions of stereotyped photographs are floating around. The only difference between them is that one might be more successful than the other, or that some might imitate an etching, others a Japanese engraving, and still others a "Rembrandt."

Landscapes, heads, and naked women are called artistic photography, while photographs of current events are called press photography.

Press photography is considered to be something of a lower order.

But this applied photography, this lower order, has brought about a revolution in photography—by the competition among journals and newspapers, by its vital and much-needed endeavors, and by performing when it is essential to photograph at all costs, in every kind of lighting and from every viewpoint.

There is now a new struggle: between pure and applied photography, artistic photography and press photography.

All is not well in photo-reporting. Here too, in this very genuine activity, stereotype and false realism have divided the workers. At a picnic I once saw reporters staging dances and arranging picturesque groups of people on a hillock.

It's interesting how the girls who hastened to join the "picturesque" group first hid in the car to do their hair and makeup.

"Let's go and get photographed!"

It's not the photographer who takes his camera to his subject, but the subject who comes to the camera; and the photographer gives him the right pose in accordance with the canons of painting.

Here are some photographs from the journal *Die Koralle*:[7] they constitute a chronicle, a piece of ethnography, a document. But everyone's posing. Yet the minute before the photographer came along these people were doing their own work and were in their own places.

Imagine the scenes the photographer would have captured if he had taken them unexpectedly, unawares.

But you see, it's difficult to photograph unawares, whereas it's quick and easy to use a system of posing. And no misunderstandings with your customer.

In journals you can see photographs of small animals and insects taken close up, bigger than life size. But it's not the photographer who takes his camera close to them, it's they who are brought up to the camera.

New photographic subjects are being sought, but they're being photographed according to bygone traditions.

Mosquitoes will be photographed from the belly button and according to the pictorial canon of Repin's *Zaporozhtsy*.[8]

But it is possible to show an object according to the point of view from which we look at it rather than the one from which we see it.

I am not speaking of those everyday objects which can be shown in quite an unusual way.

You write about Flach's bridge. Yes, it's great. But it is so because it's taken from the ground, not from the belly button.

You write that Kaufman's and Fridliand's photographs of the Shukhov radio tower are bad, that they resemble a bread basket more than a really remarkable structure. I quite agree, but . . . any viewpoint can violate the real appearance of an object if the object is new and is not fully revealed to you.

Only Fridliand is guilty of error here, not Kaufman. Kaufman's photograph is just one of several frames he took of the tower from various viewpoints. And in the movie these views are in motion: the camera revolves and clouds fly above the tower.

Sovetskoe foto speaks of the "photo-picture" as if it were something exclusive and eternal.

On the contrary. One should shoot the subject from several different points and in varying positions in different photographs, as if encompassing it—not peer through one keyhole. Don't make photo-pictures, make photo-moments of documentary (not artistic) value.

To sum up: in order to accustom people to seeing from new viewpoints it is essential to take photographs of everyday, familiar subjects from completely unexpected vantage points and in completely unexpected positions. New subjects should also be photographed from various points, so as to present a complete impression of the subject.

In conclusion I include a few photographs to illustrate my assertions.

I have deliberately chosen photographs of the same building.

The first ones come from the American album *America*. These photographs have been taken in the most stereotyped manner. They

were difficult to take, because the adjacent buildings got in the way; that's why they were touched up.

That's the way it is. Both Americans and Europeans brought up on the laws of correct perspective see America this way.

It's what, in reality, cannot possibly be seen.

The second set of photographs of the same building are by the German leftist architect Mendelsohn.[9] He photographed them in an honest way, just as the man in the street could see them.

Here's a fireman. A very real viewpoint. That's how you might see him if you looked out the window. How striking it is. It's quite possible that we often look at things like this, but don't see them.

We don't see what we look at.

We don't see the extraordinary perspectives, the foreshortenings and positions of objects.

We who are accustomed to seeing the usual, the accepted, must reveal the world of sight. We must revolutionize our visual reasoning.

"Photograph from all viewpoints except 'from the belly button,' until they all become acceptable."

"And the most interesting viewpoints today are those from above down and from below up and their diagonals."

August 18, 1928

Translated by John E. Bowlt

1. Vasilii Vasilievich Vereshchagin (1842–1904), a realist painter, was famous for his battle scenes and ethnographic compositions rendered with great accuracy of detail.

2. Balthasar Denner (1685–1749) was a portraitist and miniature painter known for his precision. He used a special varnish to render flesh tones in his portraits, and for this reason was nicknamed "Porendenner."

3. AKhRR: The Association of Artists of Revolutionary Russia. See p. 218, n. 1.

4. World of Art was the name given in the 1890s to a group of artists, aesthetes, and writers led by Sergei Diaghilev and Alexandre Benois in St. Petersburg. They sought to renew old traditions of Russian art, devoting particular attention to the decorative arts. The circle published a journal (1898–1904) and organized a series of exhibitions (1899–1906) under the name *The World of Art*. After a break that began in 1906, a group bearing the same name resumed exhibition activity during 1910–24.

5. Boris Kushner published this book of descriptions and episodes, *Sto tri dnia na Zapade*, in Moscow in 1928.

6. Rodchenko's visit to Paris of March 19–June 10, 1925 coincided with the *Exposition internationale des arts décoratifs*; he designed a workers' reading room for the Soviet pavilion. His letters from Paris were published in *Novyi lef*, no. 2 (1927).

7. *Die Koralle* was a popular illustrated scientific magazine published in Berlin 1925–41.

8. *The Zaporozhtsy* (1878–91), an exuberant painting by the realist Ilia Efimovich Repin (1844–1930), illustrates an episode in which the Zaporzhe Cossacks refused the Turkish Ottoman's invitation to join his empire.

9. On Mendelsohn, see above, pp. 221.

ALEXANDER RODCHENKO

A CAUTION

In "A Caution" Rodchenko responds to those in the *Novyi lef* group who proclaimed the documentary "fixing of facts" to be the sole basis of the contemporary literary and visual arts. Rodchenko advances his own argument that in a post-revolutionary society, new social "facts" can only be portrayed by means of equally new aesthetic forms. Hence, he concludes, "we are obliged to experiment."

Original publication: Alexander Rodchenko, "Predosterezhenie," *Novyi lef*, no. 11 (1928), pp. 36–37.

(In publishing Rodchenko's remarks, the editors [of *Novyi lef*] maintain their disagreement with the author's basic idea: to substitute a campaign for a "new aesthetics" in place of those utilitarian and productional functions of modern photography that interest *Lef* above all. The editors will provide a detailed response to "A Caution" in the twelfth number of *Novyi lef*).

By regarding "what" is photographed rather than "how" it is photographed as the most important aspect of photography, certain comrades in *Lef* are issuing a caution against turning photography into an easel art, against experimentation, and against formalism. In so doing they themselves succumb to the aesthetics of asceticism and philistinism.

It should be pointed out to our comrades that the fetishism of fact[1] is not only not needed, it's also pernicious for photography.

We are fighting against easel painting not because it is aesthetic, but because it is out of step with modern times, weak in its reproductive technique, unwieldy, introverted, and cannot serve the masses.

Strictly speaking we are fighting not against painting (it's dying anyway) but against photography "à la painting," "inspired by painting," "à la etching," "à la engraving," "à la drawing," "à la sepia," "à la watercolor."

There's absolutely no point in fighting over "what" to depict; one only need indicate it. Which is what everyone is doing.

A fact badly or simply recorded is not a cultural event or a thing of value in painting.

There's no revolution if, instead of making a general's portrait, photographers have started to photograph proletarian leaders—but are still using the same photographic approach that was employed under the old regime or under the influence of Western art.

A revolution in photography takes place when a factual photograph acts so strongly and so unexpectedly with its photographic elements (because of its quality, because of "how" it was taken) that it not only can compete with painting, but can make clear to any viewer that this is a new and complete means of revealing the world of science, technology, and the everyday life of modern man.

As the avant-garde of Communist culture, *Lef* is obliged to show what must be photographed, and how.

Any photo-circle[2] knows what to take, but very few know how.

When a worker is photographed looking like Christ or a lord, when a woman worker is photographed looking like a madonna, these images indicate what is valued, what is regarded as important.

Stated simply, we must find—we are seeking and we will find—a new (don't be afraid) aesthetic, a new impulse, and a pathos for expressing our new socialist facts through photography.

A photograph of a newly built factory is, for us, not simply the snapshot of a building. The new factory in the photograph is not simply a fact, it is the embodiment of the pride and joy felt in the industrialization of the country by the Soviets. And we have to find "how to take it."

We are obliged to experiment.

Photographing mere facts, like just describing them, is not a very novel affair. But the trouble is that painting can obscure a fact that has merely been photographed, a novel can obscure a fact that is merely described. You who love actuality—you don't find it so easy to write down the facts either.

If you don't look out, comrades, you'll soon lose your sense of right and left.

Not the *Lef* member who photographs facts, but the one who can fight against "à la art" with high-quality examples of photography—

this is the person who needs to experiment, even to the point of turning the craft of photography into an easel art.

What is easel photography? Actually, there is no such term, but we might understand it to mean experimental photography.

Don't teach only theoretically, without consulting those who have practical experience; and don't be friends who are worse than enemies.

Abstract theories dictating to those who practice their profession, theories invented for the sake of an aesthetics of asceticism—they constitute a very great danger.

Translated by John E. Bowlt

1. The "fetishism of fact" alludes to the demand of some *Novyi lef* members for an entirely fact-based art and literature, or "factography."

2. By 1928 around three thousand amateur photography organizations or "photo-circles" organized in schools, factories, and army units had sprung up in the USSR, with a total membership of nearly fifty thousand. In the late 1920s these groups were encouraged by the Soviet government to provide reportage photographs to the growing illustrated press, and to concentrate on themes that glorified the achievements of the first Five Year Plan. Rodchenko led one Moscow photo-circle and took part in its exhibitions.

BORIS KUSHNER

FULFILLING A REQUEST

As this reply by Boris Kushner to the previous selection demonstrates, Rodchenko's description of experimental photography as "easel photography" only provided fresh ammunition to critics who saw him as obsessively concerned with formal issues.

Original publication: Boris Kushner, "Ispolnenie prosby," *Novyi lef*, no. 11 (1928), pp. 40–41.

My comrades in *Novyi lef* have asked me to respond to A. Rodchenko's "A Caution," published in the eleventh issue.

Comrade Rodchenko's mistakes are very elementary and quite obvious. Their appearance here can only be explained by their having been written under the influence of his stupefying theory about fighting against the aesthetics of painting with the methods of easel photography.

I can't understand a thing in Rodchenko's complicated aesthetic philosophy, and I must thus restrain myself from passing judgment on it. I have never had the opportunity to see easel photography, and I am inclined to think that it does not exist anywhere in the whole wide world. However, maybe I'm mistaken as a result of my extreme ignorance.

Still, I feel that Rodchenko is obviously in error when he asserts that "There's no revolution if, instead of making a general's portrait, photographers have started to photograph proletarian leaders." But this is what the revolution's all about. A. Rodchenko thinks that it's only "how" our leaders are photographed that is revolutionary. He quite forgets that for him to formulate the question like that, a revolution first had to take place. Before the Revolution, proletarian leaders were impossible. There were only supposed to be generals. After the Revolution the generals are impossible, but the leaders are needed, and they exist. How can anyone assert that there's no revolution in this change? Therein lies the essence of the revolution that, from the standpoint of any revolutionary proletarian photographer, has taken place.

This is what determines the subsequent development of the photo-graphic art or technique (I'm not sure how Rodchenko prefers to de-scribe his profession).

The author of "A Caution" repeats exactly the same mistake in his arguments about photographing a new factory. Here too he imagines that the crux of the matter is "how" to take the factory. Once again, he overlooks the revolution in the very fact that the factory was built, that its constuction was possible and necessary, and that it was constructed within the system of a socialist planned economy. Therein lies its revolutionary quality and the remarkable feature that distinguishes it from all other factories being built beyond the frontiers of our country. The questions of "how to build" and "how to photograph" are second-ary. In this respect we have not yet managed to produce anything that has not already been seen and talked about in the bourgeois, capitalist countries. We have simply set ourselves the aim of catching up with the technology of the capitalist countries and of overtaking it, but we still have a long way to go in this. In the matter of "how" we are still very much behind Western Europe and America. On this basis would Rodchenko assert that we did not make a revolution?

In accordance with the meaning and character of our epoch, the revolution is precisely a revolution of facts—not of how we perceive them, or how we depict, transmit, render, or pinpoint them.

In such a simple affair as a revolution, facts play not only a persistent role, but also a decisive one.

Rodchenko's statement that "we must find, we are seeking and we will find a new aesthetic, a new impulse and pathos for expressing our new socialist facts through photography" is all very fine and merits praise.

Still, why all this pathos about facts if they themselves are devoid of meaning?

An obvious "misunderstanding."

One must certainly agree with Rodchenko: abstract theories con-stitute a very great danger.

A clear example is Rodchenko's theory of facts which leads him to a quite undialectical statement: the revolution is to be found not in the fact that the proletariat seized power, but in what occurred *after* this.

A second example is the theory about fighting the aesthetics of painting with the medium of easel photography.

Translated by John E. Bowlt

[SERGEI TRETYAKOV]

FROM THE EDITOR

The concluding remarks in this cycle of polemical exchanges were contributed by Sergei Tretyakov, who was at this time editor of *Novyi Lef*. In this short, trenchant essay, Tretyakov faults both Kushner and Rodchenko for falling into predictable arguments based on the false opposition of visual form and content. Tretyakov reminds Kushner that photography is not just an imitative "mirror" that automatically reflects the "facts" of reality; inevitably it acts, too, as a filter and interpreter of that reality. At the same time he argues that Rodchenko's repeated pleas for a new photographic aesthetic lose sight of the immediate social goals to which photography should be directed. In the course of the critique Tretyakov once again advances his own conception of a functional, innovative, politically committed photography aimed at a mass public.

Original publication: [Sergei Tretyakov], "Ot redaktsii," *Novyi lef*, no. 11 (1928), pp. 41–42.

The Editor believes that both Rodchenko's "A Caution" and Kushner's response contain a radical mistake, one that comes from disregarding the functional approach to photography.

For the functionalists, apart from the links of "what" and "how" (the notorious "form" and "content"), there is an even more important link—"why." This is the link that transforms a "work" into an "object," i.e., into an instrument of expedient effect.

From the functional standpoint both the choice of subjects (the what) and the choice of media for the design (the how) must be subordinate to a definite purpose. If this is overlooked you can argue a great deal, but your arguments won't lead anywhere.

Instead of exploring the whole range of utilitarian goals confronting photography, Rodchenko is only interested in its aesthetic function. He reduces its activity to simply a reeducation of taste based on certain new principles—"we are seeking a new aesthetic," "the capacity to see the world in a new way."

By limiting photography's aims to those that once belonged to

painting—"reflection," "manifestation of emotional attitudes to the object"—Rodchenko narrows the scope of the problem and succumbs to stylistic subjectivism.

The fight against aestheticism is an *incidental* function of modern photography, and it is impossible to begin with this. One has to begin with utilitarian goals—photo-information, photo-illustration, scientific photography, technological photography, photo-posters. Actually Rodchenko understands this very well, or he would not have written: We are rebelling against painting "because it is weak in its reproductive technique and cannot serve the masses."

Rodchenko imagines that some of us are against experiment. He forgets one thing—it is necessary to experiment as far as opportunity allows, in order to resolve concrete problems. Ehrlich experimented with arsenic to find a cure for syphilis;[1] he didn't just fool around with chemical experiments presuming that something or other would emerge. An experiment divorced from a goal can easily degenerate into "art," into an "aesthetic element." Aesthetic perception is, in fact, the perception of form removed as far as possible from immediate utilitarian effect.

Kushner's mistake is vice versa. For him the whole problem is simply the actual presentation of the facts. How these facts are presented is immaterial to him.

Rodchenko says that photographing the leaders of the Revolution by using the same devices employed for photographing the generals does not constitute a revolution. What revolution? Obviously, a revolution in photography.

Kushner objects: the whole essence of the revolution is to be found in the fact that in the old days there were generals and now there are leaders.

But photography is not just a stenographer, it also explains. To fulfill a stenographic function, the photograph has merely to record the image of the proletarian leader. But the essential, social role of the leader will be distorted if he's photographed like some kind of Red general. This either will automatically transfer the old authoritarian, fetishistic psychology to the new leader, or will appear as a mockery and parody; in either case it will fulfill an anti-revolutionary role.

The question cannot be resolved by cheap recourse to the "primacy of content," by asserting that "what" is more important than "how."

When a demonstration is being photographed, any of several different aims may be operating:

If you want to show the crowds of people, it's best to take the photograph from above, vertically.

If you want to show the crowd's social composition, you should shoot point-blank, selecting points where a person's clothes indicate his profession, and people in the foreground should be taken close up.

If you want to show the demonstration's impetuous forward rush, feet might prove to be the most effective element; and an angle of gradient might create the illusion of human lava pouring forth (a purely aesthetic assignment).

If you want to show the demonstration's demands you should photograph the posters in as large a scale as is possible, and make sure that the captions come out distinctly.

If you want to show the human mass crystallizing around a central driving force, you can make a double exposure: to a photo of the demonstration taken from above you can add a shot of an analogous construction (an anthill, bees in their honeycombs, the growth rings in a tree trunk, metal filings around a magnet).

When a machine is photographed its essential detail is singled out, while its other less important parts are obscured and made lighter. A photographer from the Criminal Investigation Department will record the image of a face, but ignore the tie. An advertiser for a tie firm will standardize the face but single out the tie. Specific elements can be emphasized by unusual foreshortening, by lighting, by coloring. Doesn't the technique involved in the polygraphical[2] reproduction of photographs require a change in the methods of photography?

To assert the primacy of the raw, unworked, unorganized fact is to threaten the practical, professional skill of the photographer.

Translated by John E. Bowlt

1. Paul Ehrlich (1854–1915), a German bacteriologist and biochemist, was known for his work on disease immunity, especially in the area of venereal disease.

2. For "polygraphy," see p. 236, n. 2.

ALEXEI FEDOROV-DAVYDOV

INTRODUCTION to MOHOLY-NAGY'S
PAINTING PHOTOGRAPHY FILM

Lázsló Moholy-Nagy's book *Painting Photography Film*, first published in Germany in 1925 and reissued in an expanded version in 1928, was brought out in the USSR in 1929 as part of a series published by the magazine *Sovetskoe foto*. The book's publication reflected a widespread interest among Soviet photographers in the questions that Rodchenko had raised in the preceding years. While the editors of *Sovetskoe foto* were generally opposed to the experimental photography that Moholy advocated, undoubtedly they were intrigued by his argument that photography would inevitably assume painting's traditional functions. The editors inserted their own note before the introductory essay; both note and introduction are reproduced below.

Alexei Fedorov-Davydov (1900–1969) was a prominent Soviet art historian, and at the time this essay was written was the director of the Tretyakov Gallery in Moscow. In his introductory essay for the Russian edition, Fedorov-Davydov stresses Moholy's ideas about photography overtaking painting, but is by no means uncritical of them. Moholy is characterized as a utopian, formalist artist; his main flaw as a theorist, according to Fedorov-Davydov, is his inability to comprehend the development of photography in terms of social and historical processes. Another objection raised is that in advocating wide-ranging photographic experiment for its own sake, Moholy ignores the question of photography's practical application.

Original publication: Alexei Fedorov-Davydov, Introduction to László Moholy-Nagy, *Zivopis' ili fotografia* (Moscow, 1929).

From the editorial board of Sovetskoe foto

The little booklets published in the series of the Library of *Sovetskoe foto* are written and prepared for beginners and advanced intermediate amateur photographers, most of them members of photo clubs.

This book by Moholy-Nagy, a German leftist artist, is different from the books the library has hitherto published, and—one should be forewarned—only a narrow circle of amateur photographers will be

able to understand it. Nevertheless, *Sovetskoe foto* deemed it useful, for several reasons, to publish this book too, especially in a form that follows the original German edition in its artistic typography and layout.

The function of photographic representation in technology, information, public education, individual and collective life, is becoming more and more significant. The specific features of photography as a tool of cognition and of expression emerge increasingly sharply, and this definitely makes photography an autonomous territory with its own technical and aesthetic laws. Individual students of the problem, starting out from different directions, have all come to the common conclusion that photography is the art of the present, as opposed to painting which is the art of the past. This problem is still waiting for its final solution, which will be reached only by the employment of the science of our age, dialectical materialism. Such works as Moholy-Nagy's book, which we are now handing over to the reader, should be used as one step towards facilitating the solution of this problem.

In the international technical literature of photography such a work as this occurs only rarely. There are but few writers in the capitalist West who are able to step onto the road which leads to the analysis of photography as a socially and economically determined art; but since their thinking lacks the equipment of the tools of Marxism-Leninism, their thinking is bound to lead in false directions and to faulty experimental little jerks; moreover, they are enmeshed in a tangle of overestimated values of vulgar utilitarianism, of the remnants of idealism, and of "biological-ontological causes."

All these failings are present in Moholy-Nagy's work too. Nevertheless its publication for the use of the Soviet reader is justified, since, first, Moholy-Nagy tries to discover and define photography's own language as the language of an art; second, he does this in the context of the state of modern technology and its impact on the psychological constitution of modern man. This is far from being materialism, but it nonetheless deserves our attention.

At the same time the reader will be able to familiarize himself with the newest trends in the field of photography in the West. Although the book is laconic and complex, if its expositions, made more intelligible by the copious illustrations, encourage the reader toward further search and investigation, the publication of this book could be regarded as well justified.

Introduction by the editor of the translation [Alexei Fedorov-Davydov]

Photography is spreading in an ever-widening circle among the workers, and is becoming one of the most important forms of spontaneous artistic activity for the masses. The number of workers' photo clubs is on the increase and as they become stronger photography is beginning to gain an important position in the movement aimed at informing the worker. This development creates a substantial interest in its possibilities and in the achievements of Western photography. On the one hand, the practice of photography could owe its development to being close to life, to the fact that it is easy to understand even by a wide public, to never having severed its ties with artistic representation and practical (scientific, journalistic) documentation. On the other hand, its great possibilities spur us on to try to learn its essential features and to compare its artistic possibilities with those of other branches of art. Moreover, today the problem of photography as an art form is further sharpened and activated by the present crisis of painting.

The Soviet photographer has practically no place to go for answers to the questions he is interested in. In his conscious search for new forms of expression and new approaches to the objects of the outside world, the Soviet photographer cannot be satisfied with those traditional concepts according to which "the artistic" is equivalent to the imitation of painterly methods. The special literature dealing with photography is basically of a technical nature, textbookish in character, and it does not shed light on the aesthetic problems of photography.

Moholy-Nagy's book, in this sense, could make very profitable reading. It has several flaws, ideological—we will speak of those later—as well as presentational in nature. The fact that its mode of expression is relatively difficult to understand belongs to the latter. The translator and the editor of the book have tried to make the author's language a bit easier to understand, but the text of the book, even in this form, requires very attentive reading. However, work invested in its understanding will definitely bring a fair return.

Moholy-Nagy is a German leftist artist who, like our Rodchenko, came to photography from his experimentation with "cubo-futurism," and transferred its achievements and main problems to the field of photography. Moholy-Nagy, this restless and witty innovator, tries to make a break from the mechanical operation of the camera, to make it

more lively, and to convert the camera into an obedient tool of the creative conceptions of the photographer. His propositions and experiences, which he discusses in relation to a wide range of problems, and his examination of the polygraphical[1] achievements and possibilities of photography outside the context of the film, will undoubtedly widen the horizons of our readers and encourage them to be fruitfully inventive. A rich body of illustrations, made up of Moholy-Nagy's photographs, makes the experiences and proposals here more easily accessible.

Besides these so-called practical, "applied" problems, the book also discusses such ideological-theoretical issues as the relationship between photography and painting and the meaning of photography as an art. The basic thesis of Moholy-Nagy's proposition is that the representational possibilities of painting are no longer capable of satisfying those newly arisen needs which were created through the development of technology, by the quickening pace of life and by the tremendous spatial and material expansion of the culture. "Man's interest, striving to know the world in its totality, aroused a new need in him, a new need of connecting himself—at every moment, in every situation—to its current." The newspaper, with its own technology (the telegraph, the radio, the rotary press), the illustrated magazines which use the same technology, the cinema, all satisfy these aims. But the painted picture, which is inherently static, subjective, and individualistic, cannot. "It is a surprising fact that today's painter of 'genius' possesses very little scientific knowledge in comparison with the 'unimaginative' technician, and this is the painting which claims to be the sole representative of fine art, and which holds photography to be inert, mechanical. This is entirely false, since the basis of painting is not to be found in its representational character (in certain periods it could have been and was nonrepresentational), and being representational does not exhaust the meaning of painting. On the contrary, the precise mechanical processes of photography and of the film are incomparably better-functioning tools of *representation* than the manual procedures of representational painting hitherto known." Moholy-Nagy's other idea, according to which the mechanical character of photography does not exclude it from being a form of fine art, is absolutely correct too. "Alongside the creative intellectual process of the genesis of the work, the problem of its materialization is important only insofar as its technical procedures should be totally mastered. However, it does not

matter at all in what manner—whether personally, or by substituted work, manually or mechanically—the work was executed." We must add to this that the requirement that a work of art be manually produced is predetermined by a certain class aesthetics; that it came about because of the break between the artist on the one hand, and technology and the general process of production of material goods on the other; and that this is a characteristic of bourgeois society. This break is the product of the commodity and monetary economy, and with the death of capitalist society it too will cease to exist. It is characteristic that at the dawn of the bourgeois society, such views of art were not held. For example, Leonardo kept dreaming of producing painting by mechanical means. This is, of course, utopia, which, conversely, Moholy-Nagy tries vainly to resurrect in his chapter entitled "The Domestic Pinacotheca." The painting is always an individual phenomenon, a manually crafted product, and it can only exist as such.

But as the concept of art is wider than the concept of painting, so the characteristic methods (manual work) of the production of painting do not necessarily apply to the other branches of fine art. In particular, the purely mechanical production of art, the fact that works of art could be mass-produced and reproduced, might make an art viable for the coming socialist society, which will be based on a well-developed industry.

Moholy-Nagy's demonstration of how photography and film widen and enrich the functions of our organs, the system of our reactions, our own empirical-physical cognition of the world and our practical self-orientation in it, is one of the valuable parts of his book. He is absolutely right in stating that, generally, every kind of art creates new relationships between known and hitherto unknown optical, acoustical, and other functional phenomena, and forces the human sensory organs to perceive and register them, thereby enriching them. Naturally, the role art plays in human society cannot be reduced to merely biological significance; moreover, art performs even its biological function through its social function—at least, it does in developed societies. Nevertheless, the social-biological significance of art is determined, and to a certain degree, this is where the aesthetic meaning of its formal structure lies—and this holds for the structure of photography and film, too.

The attentive reader most probably will recognize the major flaws

in the methodology of Moholy-Nagy's book, namely that he has failed to discuss the issues from a sociological point of view and has ignored the issues from a class-conscious point of view. The lack of class-oriented analysis is a specific ideology in itself. Moholy-Nagy is a representative of bourgeois thinking and this unavoidably puts on him a stamp of limited thinking. Although he is asking the right questions in the right way, he is unable to come to their correct solutions, because without the help of sociological analysis that cannot be achieved, and because these solutions would lead him to revolutionary conclusions.

Moholy-Nagy correctly states that although technique is a very important factor in the evolution of art, it is not the only and most important one; but then he thinks that he has discovered this factor in biology, which leads him to erroneous deductions, especially as applied to the future of easel painting.

Moholy-Nagy tries to delineate the two spheres of photography and of painting, respectively, by giving the representational function to the former while reducing the latter to mere color constructions. He is absolutely correct in interpreting the essential features of the evolution of painting—that its aspects of form were born out of its actual representational tasks and characteristics—and its survival and transformation from the prime mover of the evolution of the color construction into its main hindrance. But then he cannot work up his courage to make the logical deduction: that easel painting is doomed to die out.

This is because he artificially selects color construction, only one element of the complex conglomerate of painting, as important, and traces it back to a biological-ontological first cause. And since man's biological constitution has remained more or less unchanged from his beginnings, he reasons that the foundation of painting has remained the same. However, he does not realize that he is committing the same logical error as those who refuse to accept the artistic significance of photography. They too identify one possible kind of color construction (painting) with color construction in general. The perception of and need for color construction is indeed one of the properties of man's biological nature, and therefore color construction is eternal. However, the various forms of satisfying this need could freely replace each other, since this process is sociologically and not biologically determined. "It is inherent in the nature of man that he has aesthetic taste and ideas. And his environment will determine the

materialization of his possibilities" (Plekhanov).[2] Characteristically, when Moholy-Nagy poses the problem on a practical-production level and not on an abstract-biological level, he comes to the conclusion that painting will be replaced by photography and the representation of color combinations will be replaced by a veritable play of materials of various colors: the functional application of a wide variety of building materials—concrete, steel, nickel, artificial materials, etc.—can equivocally define the color scheme of the room and of the whole architecture. Of course, painting a room is not identical with painting a picture.

I have already mentioned how utopian are those concepts of Moholy-Nagy which state that "With the aid of machine production, with the aid of exact mechanical and technical instruments and processes (spray guns, enameled metal, stenciling), we can today free ourselves from the domination of the individual handmade piece and its market value. Such a picture will obviously not be used, as it is today, as a piece of lifeless room decoration, but will probably be kept in a compartment on a shelf or a 'domestic picture gallery' and brought out only when it is really needed." These "paintings" will not really be paintings, because the meaning of a painting is that it hangs on a wall and decorates the room. Moholy-Nagy's reference to Japan does not stand up to criticism, since the Japanese "kakemono" and "makimono" have nothing to do with European painting. Moreover, with Japan becoming a capitalist state, the traditional Japanese forms are being pushed out by European bourgeois painting. Moholy-Nagy does not take into account that easel painting is a product not only of determined conditions of artistic production but of determined conditions of artistic consumption too. Painting is produced mostly for the individual bourgeois and petit bourgeois apartment. Its "chamber" character, its closed structure, its relative immobility, its uniqueness, and its individuality stem from this fact. This is why painting is still here to stay as a dominant form of art, since the bourgeois individualism of "existence" and of "consciousness" is still dominant, and because "men still club each other to death and they still haven't realized why and how they are living, and the politicians are still unable to see that the earth is one unified entity." At best, Moholy-Nagy is nothing but a member of the petit bourgeois radical intelligentsia. He has no clear notion of the relationship between the inevitable demise of capitalist society and the complete revaluation of its culture in the framework of the conditions of building a socialist society. However, he has already under-

stood what a unifying role progressive technology and its artistic equivalent, progressive "technological" art, play in destroying the basis of the bourgeois society.

From this abstract biologism dominant in his evaluation of social phenomena stems Moholy-Nagy's other fault, his formalism. His effort to preserve painting—which lost its social function when it lost its representational character—leads him to the proclamation of non-objective painting as the pure, "absolute" form of painting. "The real content of color creation was always embedded in these interrelation-ships [i.e., pure forms—F. D.] . . . The divergences in the paintings of various ages could only be grasped as a temporary form-metamorphosis of the same phenomenon." By drawing a faulty analogy with music (which is, according to him, "pure" and contains only emotions), he is reducing the function of painting to the satisfaction of pure emotions, as if human emotions could exist independently from a man's social attitudes and intellectual capacities. We find this same formalism, based on his concept of the so-called immutable biological laws of taste, in his experimental constructions, too. This can be especially detected in his chapter called "Typophoto."[3] Moholy-Nagy set up some very interesting goals: "that those possibilities of the subjective char-acter of the existence of typography which are capable of generating new effects should be brought in to participate in the work, and it should not be used just as an objective tool, fashionably, as it has been until now." However, he has no chance whatsoever of solving this problem in a practical way. The reason for his failure here, just as in his chapter dealing with his experimentations with new film projec-tion, is that he has no definite practical-functional goals in front of him. This is nothing but experimentation for experimentation's sake, searching for a new form for the sake of the form itself; at most this is a search for a new emotional expressive power, but not for the satisfac-tion of some real social need.

Of course, this does not mean that experimentation could not be utilized to achieve practical goals, or that experimentation would not be determined by those social needs which influence the artist but of which the artist remains unaware. The heart of the matter is the fact that his petit bourgeois ideology prevents the artist from attending to these social needs.

And yet even Moholy-Nagy himself indicates that technology and the new forms of art brought forth by technology are themselves the

products of these new needs. After all, he notes that photography was a prisoner of painting until now, and that it has just started to liberate itself from the influence of painting. The question is: what determined this imprisonment and what caused its present liberation?

Moholy-Nagy is unable to give an answer to these questions. In order to do so, he should have conducted a social-economic analysis of the phenomena of art. If he had done that he would have understood that every new form is born out of the realization of the most economical artistic execution of a given social or social-ideological task in life (in the context of the current state of technology and of the existing conditions). And if this were so, then experimentations being currently conducted in the fields of photography, film, and typophoto should be channeled to the requirements of our immediate future tasks. This kind of asking the right question could only be made possible on the basis of our Marxist world view, and its realization, too, could be made possible only under our own conditions. For the time being, Western photography is superior to ours in many respects; however, the real conditions for its development, which will revolutionize its own representational methods as well as the representational methods of art in general, exist only in our own photography. If the problem of the new form is not just a problem of the new technology but of its serving new needs, then its utilization by the working class is of paramount importance. That is why the problems of mass amateur photography and of the worker-reporter's photography and, similarly, the phenomena stemming from the cultural organization of the dictatorship of the proletariat, are so important; and why we must interpret the route for the development of photography—which is one of the seedbeds of the fine arts of the present as well as of the future—in the correct way. However, even though all these questions have emerged during the course of our discussion of Moholy-Nagy's book, their solution will be the task of another work.

Translated by Judith Szollosy

1. For "polygraphy," see p. 236, n. 2.

2. Georgi Valentinovitch Plekhanov (1856–1918) was a leading exponent of the

philosophy of Marxism and one of the founders of the Russian Marxist movement, although he later split with the Bolsheviks. Plekhanov's book *Art and Social Life* (1912) drew a sharp distinction between art for art's sake and utilitarian art. This idea underlay much of the debate over art in the USSR during the 1920s.

3. Moholy-Nagy's term "typophoto," like the term "polygraphy" used in the Soviet Union, refers to the combining of photography and typography on the printed page, as for example in magazines, posters, and illustrated books.

ANONYMOUS

PROGRAM OF THE OCTOBER PHOTO SECTION

This text appeared in a collection of articles published in 1931 called *Izofront* (Visual Arts Front), under the subtitle "Documents of October," and dated 1930. Although it is unsigned and presented as a collective statement of the October group, the tone and principles bring to mind similar writings by Gustav Klucis.

The October group was established in 1928 and included Klucis, Alexei Gan, El Lissitzky, Alexander Rodchenko, Sergei Eisenstein, Varvara Stepanova, Sergei Senkin, and Solomon Telingater among its associates. It was one of the last havens of the avant-garde before the doctrine of socialist realism was imposed in the early 1930s. October's members were especially interested in the applied arts, graphic design, photography, and cinema, and the group's work won wide attention with exhibits in both Moscow and Berlin.

The 1930 program of October's Photo Section reflects the debates which continued to swirl around the subject of photography in the USSR. Especially evident here is the attempt of the Photo Section to leave behind the politically charged arguments over photographic formalism. While the clichés of official "heroic" Soviet photography are dismissed, the brand of experimental "new photography" associated with Moholy-Nagy and Man Ray is explicitly rejected as well. The Photo Section's program also demonstrates October's affirmation of the cultural goals set by the Party. Its members state their intent to encourage both photographic literacy and political literacy, by organizing documentary and propaganda projects with amateur photographers drawn from factories and collective farms.

Original publication: "Programma fotosektsii obedineniia OCTIABR," *Izofront*. *Klassovaia borbana fronte prostranstvennykh iskusstv* (Moscow/Leningrad, 1931), pp. 149–51.

1. A perfect medium for affecting the broad masses, photography is an especially important weapon on the front of the cultural revolution. By recording facts that are socially oriented and are not staged, we can both stimulate and reveal the struggle for socialist culture.

2. We are categorically against any fake setups that obstruct the meaning of photography and cheapen reality. These stagings make the masses distrust the documentary value of the photograph and discredit

our immediate and decisive struggle on the cultural front. We are against the AKhRR kind of art[1] and the interminable sickly sweetness of smiling heads, jingoism in the form of smokestacks, tedious workers with hammers and sickles, and Red Army helmets (hurrah—let's toss our hats in the air!). We are against pictorial photography and false pathos based on old bourgeois stereotypes.

We are also against the aesthetic slogans "Photography for photography's sake," "Photography is pure art," and, consequently, "Photograph what and how you want."

We are against the notion—imported from the bourgeois West—of the "new photography" or "leftist photography."

We are against the aesthetics of abstract, "leftist" photography like Man Ray's, Moholy-Nagy's, etc.

3. We are for a revolutionary photography aesthetically unconnected with either the traditions of autonomous painting or the non-objectivity of "leftist photography." We are for a revolutionary photography, materialist, socially grounded, and technically well equipped, one that sets itself the aim of propagating and agitating for a socialist way of life and a communist culture.

Photography will play an enormous role in the formation of a proletarian art by displacing the dead techniques of the old spatial arts and serving the ideological requirements of the proletariat.

4. The topicality of the ideological effect of photography on the viewer, its unswerving communication of the fact of socialist construction and its discrediting of capitalist society, its application of the most advanced techniques and most expressive means of presenting the material—all these should be acknowledged as the "artistic" criteria of photography.

5. Anyone who joins the October Photo Section must be linked to production, i.e., should work in printing or be involved in newspapers, magazines, etc. Further, every member of the Photo Section should be linked with a factory or collective farm circle and supervise it.[2] If he's not, his photographic work will acquire the form of studio photography or will degenerate into a nice little technical-aesthetic school interested only in formal goals. For the photo-worker, only concrete participation in industrial production guarantees the social significance of his work.

6. In the Photo Section we are for a collective method of studying the tasks set by the Party and the special photographic methods essential for the best resolution of these tasks.

7. This is what our work methods should be: political literacy, class and proletarian determination, sophisticated photo-technical literacy.

In the very near future October has the primary aim of organizing and instructing groups of proletarian photo-workers who will then be able to record the growth of the Five Year Plan and collective farm construction—and who will also be able to attract the best photo-workers from rank and file workers' photo clubs.

8. Proceeding from all the above, we who work in the field of photography consciously subordinate all our activity to the tasks of the proletariat's class struggle for the new communist culture.

Translated by John E. Bowlt

1. The Association of Artists of Revolutionary Russia; see p. 218, n. 1.

2. That is, an amateur photo circle; see p. 266, n. 2.

chronophotography, this is only by virtue of the fact that, like them, it has its origins in the wide field of photographic science, the technical means forming common ground. All are based on the physical properties of the camera.

We are certainly not concerned with the aims and characteristics of cinematography and chronophotography. We are not interested in the precise reconstruction of movement, which has already been broken up and analyzed. We are involved only in the area of movement which produces sensation, the memory of which still palpitates in our awareness.

We despise the precise, mechanical, glacial reproduction of reality, and take the utmost care to avoid it. For us this is a harmful and negative element, whereas for cinematography and chronophotography it is the very essence. They in turn overlook the trajectory, which for us is the essential value.

The question of cinematography in relation to us is absolutely idiotic, and can only be raised by a superficial and imbecilic mentality motivated by the most crass ignorance of our argument.

Cinematography does not trace the shape of movement. It subdivides it, without rules, with mechanical arbitrariness, disintegrating and shattering it without any kind of aesthetic concern for rhythm. It is not within its coldly mechanical power to satisfy such concerns.

Besides which, cinematography never analyzes movement. It shatters it in the frames of the filmstrip, quite unlike the action of Photodynamism, which analyzes movement precisely in its details. And cinematography never synthesizes movement, either. It merely reconstructs fragments of reality, already coldly broken up, in the same way as the hand of a chronometer deals with time even though this flows in a continuous and constant stream.

Photography too is a quite distinct area; useful in the perfect anatomical reproduction of reality; necessary and precious therefore for aims that are absolutely contrary to ours, which are artistic *in themselves*, scientific in their researches, but nevertheless always directed towards art.

And so both photography and Photodynamism possess their own singular qualities, clearly divided, and are very different in their importance, their usefulness, and their aims.

Marey's chronophotography, too, being a form of cinematography carried out on a single plate or on a continuous strip of film, even if it

ANTON GIULIO BRAGAGLIA

Excerpts from *FUTURIST PHOTODYNAMISM*

The first attempt to understand photography within the framework of ideas elaborated by the European avant-gardes took place in Italy. In 1911, Anton Giulio Bragaglia (1890–1960) and his brother Arturo Bragaglia (1893–1962) began to photograph rapid human movements using extended exposure times. The resulting images captured the vivid yet apparently dematerialized traces of these physical gestures. By early 1913 the Bragaglias began to describe their method as "futurist photodynamism," hoping, no doubt, to establish a link between their work and that of futurist painters like Boccioni, Balla, and Severini. In June 1913 Anton Giulio Bragaglia published *Futurist Photo-dynamism*. This book-length essay not only demonstrated his assimilation of the ideas of F. T. Marinetti, the leader of the futurist movement, and his adoption of Marinetti's hyperbolic rhetoric; it showed, too, Bragaglia's famil-iarity with a wide range of modern writers who had addressed the philosophi-cal aspects of time and movement. In the fall of 1913, however, the Bragaglias were officially excluded from the futurist movement; the futurist painters were unwilling to admit photography within the circle of the arts. Only in the mid-1920s, when photography began to capture the attention of avant-garde artists in France, Germany, and the Soviet Union, did the medium win the approval of Italian futurists.

In the following excerpt from *Futurist Photodynamism* Bragaglia sets out to distinguish photodynamism from motion pictures (cinematography), on the one hand, and from the stop-action sequential photography of the French scientist E. J. Marey (chronophotography), on the other. Photodynamist pho-tographs, asserts Bragaglia, use blur and visual flux to suggest the experienced emotion of dynamic, continuous movement. It is for this reason that photo-dynamism, according to the author, stands utterly apart from all previous photography, whether documentary or pictorial.

Original publication: Anton Giulio Bragaglia, *Fotodinamismo futurista* (Rome: Natala Editore, 1913), sections 18–26, 28–31.

To begin with, Photodynamism cannot be interpreted as an innovation applicable to photography in the way that chronophotography[1] was. Photodynamism is a creation that aims to achieve ideals that are quite contrary to the objectives of *all* the representational means of today. If it can be associated at all with photography, cinematography and

does not use frames to divide movement which is already scanned and broken up into instantaneous shots, still shatters the action. The instantaneous images are even further apart, fewer and more autonomous than those of cinematography, so that this too cannot be called analysis.

In actual fact, Marey's system is used, for example, in the teaching of gymnastics. And out of the hundred images that trace a man's jump, the few that are registered are just sufficient to describe and to teach to the young the principal stages of a jump.

But although this may be all very well for the old Marey system, for gymnastics and other such applications, it is not enough for us. With about five extremely rigid instantaneous shots we cannot obtain even the *reconstruction* of movement, let alone the *sensation*. Given that chronophotography certainly does not reconstruct movement, or give the sensation of it, any further discussion of the subject would be idle, except that the point is worth stressing, as there are those who, with a certain degree of elegant malice, would identify Photodynamism with chronophotography, just as others insisted on confusing it with cinematography.

Marey's system, then, seizes and freezes the action in its principal stages, those which best serve its purpose. It thus describes a theory that could be equally deduced from a series of instantaneous photographs. They could similarly be said to belong to different subjects, since, if a fraction of a stage is removed, no link unites and unifies the various images. They are *photographic, contemporaneous*, and appear to belong to *more* than one subject. To put it crudely, chronophotography could be compared with a clock on the face of which only the quarter hours are marked, cinematography to one on which the minutes too are indicated, and Photodynamism to a third on which are marked not only the seconds, but also the *intermovemental* fractions existing in the passages between seconds. This becomes an almost infinitesimal calculation of movement.

In fact it is only through our researches that it is possible to obtain a vision that is proportionate, in terms of the strength of the images, to the very tempo of their existence, and to the speed with which they have lived in a space and in us.

The greater the speed of an action, the less intense and broad will be its trace when registered with Photodynamism. It follows that the slower it moves, the less it will be dematerialized and distorted.

The more the image is distorted, the less real it will be. It will be more ideal and lyrical, further extracted from its personality and closer to *type*, with the same evolutionary effect of distortion as was followed by the Greeks in their search for their type of beauty.

There is an obvious difference between the photographic mechanicality of chronophotography—embryonic and rudimentary cinematography—and the tendency of Photodynamism to move away from that mechanicality, following its own ideal, and completely opposed to the aims of all that went before (although we do propose to undertake our own scientific researches into movement).

Photodynamism, then, analyzes and synthesizes movement at will, and to great effect. This is because it does not have to resort to disintegration for observation, but possesses the power to record the continuity of an action in space, to trace in a face, for instance, not only the expression of passing states of mind, as photography and cinematography have never been able to, but also the immediate shifting of volumes that results in the immediate transformation of expression.

A shout, a tragical pause, a gesture of terror, the entire scene, the complete external unfolding of the intimate drama, can be expressed in one single work. And this applies not only to the point of departure or that of arrival—nor merely to the intermediary stage, as in chronophotography—but continuously, from beginning to end, because in this way, as we have already said, the *intermovemental* stages of a movement can also be invoked.

In fact, where scientific research into the evolution and modeling of movement are concerned, we declare Photodynamism to be exhaustive and essential, given that no precise means of analyzing a movement exists (we have already partly examined the rudimentary work of chronophotography).

And so—just as the study of anatomy has always been essential for an artist—now a knowledge of the paths traced by bodies in action and of their transformation in motion will be indispensable for the painter of movement.

In the composition of a painting, the optical effects observed by the artist are not enough. A precise analytical knowledge of the essential properties of the effect, and of its causes, is essential. The artist may know how to synthesize such analyses, but within such a synthesis the skeleton, the precise and almost invisible analytical elements,

must exist. These can only be rendered visible by the scientific aspect of Photodynamism.

In fact, every vibration is the rhythm of infinite minor vibrations, since every rhythm is built up of an infinite quantity of vibrations. Insofar as human knowledge has hitherto conceived and considered movement in its *general rhythm*, it has fabricated, so to speak, an algebra of movement. This has been considered *simple* and *finite* (cf. Spencer: *First Principles—The Rhythm of Motion*).[2] But Photodynamism has revealed and represented it as *complex*, raising it to the level of an *infinitesimal calculation of movement* (see our latest works, e.g., *The Carpenter, The Bow, Changing Positions*).

Indeed, we represent the movement of a pendulum, for example, by relating its speed and its tempo to two orthogonal axes.

We will obtain a continuous and infinite sinusoidal curve.

But this applies to a theoretical pendulum, an immaterial one. The representation we will obtain from a material pendulum will differ from the theoretical one in that, after a longer or shorter (but always *finite*) period, it will stop.

It should be clear that in both cases the lines representing such movement are continuous, and do not portray the reality of the phenomenon. In reality, these lines should be composed of an infinite number of minor vibrations, introduced by the resistance of the point of union. This does not move with smooth continuity, but in a jerky way caused by infinite coefficients. Now, a *synthetic* representation is more effective, even when its essence envelops an *analytically divisionist* value, than a synthetic impressionist one (meaning divisionism and impressionism in the philosophical sense). In the same way the representation of realistic movement will be much more effective in synthesis—containing in its essence an analytical divisionist value (e.g., *The Carpenter, The Bow*, etc.), than in analysis of a superficial nature, that is, when it is not minutely interstatic but expresses itself only in successive static states (e.g., *The Typist*).

Therefore, just as in Seurat's[3] painting the essential question of chromatic divisionism (synthesis of effect and analysis of means) had been suggested by the scientific inquiries of Rood,[4] so today the need for movemental divisionism, that is, synthesis of effect and analysis of means in the painting of movement, is indicated by Photodynamism. But—and this should be carefully noted—this analysis is infinite,

profound, and very sensitive, rather than immediately perceptible.

This question has already been raised by demonstrating that, just as anatomy is essential in static reproduction, so the anatomy of an action—intimate analysis—is indispensable in the representation of movement. This will not resort to thirty images of the same object to represent an object in movement, but will render it *infinitely multiplied and extended*, while the figure *present* will appear *diminished*.

Photodynamism, then, can establish results from positive data in the construction of moving reality, just as photography obtains its own positive results in the sphere of static reality.

The artist, in search of the forms and combinations that characterize whatever state of reality interests him, can, by means of Photodynamism, establish a foundation of experience that will facilitate his researches and his intuition when it comes to the dynamic representation of reality. After all, the steady and essential relationships which link the development of any real action with artistic conception are indisputable, and are affirmed independently of formal analogies with reality.

Once this essential affinity has been established, not only between artistic conception and the representation of reality, but also between artistic conception and application, it is easy to realize how much information dynamic representation can offer to the artist who is engaged in a profound search for it.

In this way light and movement in general, light acting as movement, and hence the movement of light, are revealed in Photodynamism. Given the transcendental nature of the phenomenon of movement, it is only by means of Photodynamism that the painter can know what happens in the intermovemental states, and become acquainted with the *volumes of individual motions*. He will be able to analyze these in minute detail, and will come to know the *increase in aesthetic value of a flying figure*, or its *diminution*, relative to light and to the dematerialization consequent upon motion. Only with Photodynamism can the artist be in possession of the elements necessary for the construction of a work of art embodying the desired synthesis.

With reference to this the sculptor Roberto Melli[5] wrote to me explaining that, in his opinion, Photodynamism "must, in the course of these new researches into movement which are beginning to make a lively impression on the artist's consciousness, take the place which has until now been occupied by drawing, a physical and mechanical phenomenon very different from the physical transcendentalism of

Photodynamism. Photodynamism is to drawing what the new aesthetic currents are to the art of the past."...

Now, with cinematography and Marey's equivalent system the viewer moves abruptly from one state to another, and thus is limited to the states that compose the movement, without concern for the intermovemental states of the action; and with photography he sees only one state. But with Photodynamism, remembering what took place between one stage and another, a work is presented that transcends the human condition, becoming a *transcendental photograph of movement*. For this end we have also envisaged a machine which will render actions visible, more effectively than is now today possible with actions traced from one point, but at the same time keeping them related to the time in which they were made. They will remain idealized by the distortion and by the destruction imposed by the motion and light which translate themselves into trajectories.

So it follows that when you tell us that the images contained in our Photodynamic works are unsure and difficult to distinguish, you are merely noting a pure characteristic of Photodynamism. For Photodynamism, it is desirable and correct to record the images in a distorted state, since images themselves are inevitably transformed in movement. Besides this, our aim is to make a determined move away from reality, since cinematography, photography, and chronophotography already exist to deal with mechanically precise and cold reproduction.

We seek the interior essence of things: pure movement; and we prefer to see everything in motion, since as things are dematerialized in motion they become idealized, while still retaining, deep down, a strong skeleton of truth.

This is our aim, and it is by these means that we are attempting to raise photography to the heights which today it strives impotently to attain, being deprived of the elements essential for such an elevation because of the criteria of order that make it conform with the precise reproduction of reality. And then, of course, it is also dominated by that ridiculous and brutal negative element, the instantaneous exposure, which has been presented as a great scientific strength when in fact it is a laughable absurdity.

But where the scientific analysis of movement is concerned—that is, in the multiplication of reality for the study of its deformation in motion—we possess not merely one but a whole scale of values applied to an action. We repeat the idea, we insist, we impose and return to it

without hesitation and untiringly, until we can affirm it absolutely with the obsessive demonstration of exterior and internal quality which is essential for us.

And it is beyond doubt that by way of such *multiplication of entities* we will achieve a *multiplication of values* capable of enriching any fact with a more *imposing personality*.

In this way, if we repeat the principal states of the action, the figure of a dancer—moving a foot, in midair, pirouetting—will, even when not possessing its own trajectory or offering a dynamic sensation, be much more like a dancer, and much more like dancing, than would a single figure frozen in just one of the states that build up a movement.

The picture therefore can be invaded and pervaded by the essence of the subject. It can be *obsessed by the subject to the extent that it energetically invades and obsesses the public with its own values*. It will not exist as a passive object over which an unconcerned public can take control for its own enjoyment. It will be an active thing that imposes its own extremely free essence on the public, though this will not be graspable with the insipid facility common to all images that are too faithful to ordinary reality.

To further this study of reality multiplied in its volumes, and the multiplication of the lyrical plastic sensation of these, we have conceived a method of research, highly original in its mechanical means, which we have already made known to some of our friends.

But in any case, at the moment we are studying the trajectory, the synthesis of action, that which exerts a fascination over our senses, the vertiginous lyrical expression of life, the lively invoker of the magnificent dynamic feeling with which the universe incessantly vibrates.

We will endeavor to extract not only the aesthetic expression of the motives, but also the inner, sensorial, cerebral and psychic emotions that we feel when an action leaves its superb, unbroken trace.

This is in order to offer to others the necessary factors for the reproduction of the desired feeling.

And it is on our current researches into the *interior* of an action that all the emotive artistic values existing in Photodynamism are based.

To those who believe that there is no need for such researches to be conducted with photographic means, given that painting exists, we would point out that, although avoiding competing with painting, and working in totally different fields, the means of photographic science

are so swift, so fertile, and so powerful in asserting themselves as much more forward looking and much more in sympathy with the evolution of life than all other old means of representation.

Translated by Caroline Tisdall

1. Chronophotography was a technique developed in the 1880s by the French physiologist Etienne Jules Marey (1830–1904). Using a camera designed to make instantaneous, repeating exposures, he captured on a single photographic plate the sequential stages of human and animal movement. Marey's chronophotographs were well known to French painters and to the Italian futurist painters.

2. Herbert Spencer (1820–1903), a British philosopher and sociologist, was the author of *First Principles of a New System of Philosophy* (1862). A chapter of the book, "The Rhythm of Motion," examined the importance of movement in every field of life phenomena.

3. Georges Seurat (1859–91), the French painter associated with the Impressionists who was known for his pointillist painting, devoted considerable attention to the scientific theories of color.

4. Ogden Rood (1831–1902) was the American author of influential studies on color theory.

5. Roberto Melli (1885–1958) was an Italian sculptor later admired by the Valori Plastici group which formed around Giorgio De Chirico and Carlo Carrà in 1918.

PHOTOMONTAGE

A self-taught painter and graphic designer, Vinicio Paladini (1902–71) was closely connected to the futurist movement in the early 1920s. However, he soon became a critic of the pro-fascist stance taken by the futurist leader, F. T. Marinetti, and separated himself from the futurists. Paladini was well versed in the art of various movements, including dada, Russian constructivism, and surrealism, and his own work reflected a wide range of sources. During the late 1920s he conceived several ambitious film projects; although these were never realized, Paladini prepared a number of photomontages to suggest his cinematic ideas.

In the following essay Paladini demonstrates his awareness of the unusual situation of photomontage within the visual arts: rooted in the documentary objectivity of the individual photographs, it is at the same time an imaginative product of the artist's recombination of picture fragments.

Original publication: Vinicio Paladini, "Fotomontage," *La Fiera letteraria* (Rome) 5, no. 45 (November 10, 1929).

New materials of art have always given rise to new forms of art, and the discovery of those new means has been stimulated by expressive needs—whose numerous determining factors have always been the despair of aesthetic criticism. This is what happened with the Romans' brickwork arch, with the introduction of oil paints in the fifteenth century, with the Gothic rampant arch, and, in modern times, with ironwork structures and reinforced concrete, and with photography, the cinema, and the sound film. Thus, the discovery of new worlds which, even if not yet clearly delimited in our spiritual geographical atlas, have nonetheless given rise to formal constructions fundamental for the history of the human spirit.

Here we run into the obsessive question of the egg and the chicken. Was it the new means of expression that determined the new aesthetic values? Or was the need to manifest such new aesthetic values—values

that took shape in us through social, ethical, critical, or some other sort of influences—responsible for the discovery of those new means? A difficult dilemma indeed. Free will or determinism? We image makers have made known our ideas on that subject. "Art is the disruption and recomposition of a harmony," and therefore resides in the process itself, not in anyone's intentions!

To turn now to our particular interest: the importance of photomontage and its creative value now appear quite clear, because we find in its characteristics all the significant elements of true artistic phenomena. Photography responds in full to our contemporary need to fix instantaneously the outward, eternally changeable aspects of the world as it appears to us, from the tiniest to the greatest, from the most remote to the nearest. Photomontage, in its turn, has given us the means to approach those aspects on an artistic basis, and in such a way as not to lose that feeling of amazement and marvel which objective reality awakens in our spirit. Photographic objectivity offers us the possibility of profiting to the utmost from the powerful aesthetic factor of documentation, and to do so for our own, more specifically spiritual purposes.

Photomontage was born in Germany at a time when the emphasis on objectivity had created the appropriate climate—which would then give rise to all the neorealist tendencies in the various arts. At the exact same time in France, thanks to Man Ray, and in Germany thanks to Schwerdtfeger,[1] the objective approach was utilized to create abstractly formal photograms in response to necessities entirely contrary to each other, yet equally urgent, which once again demonstrates that art resides in the process and not in the intentions.

True photomontage, however, was realized by Moholy-Nagy and Hannah Höch.[2] It then found a particularly fertile field for development in the USSR—where the necessity for propaganda led to the discovery that this extremely modern technique offers the most effective means to exert on the popular imagination the kind of pressure that state art requires. As for photomontages in movement, we have all seen them applied in no end of films.

In Italy, so far as I know, Ivo Pannaggi[3] and Vinicio Paladini have been the only ones to sense the value of this new art, the former using procedures in keeping with the constructivist aesthetic, the latter with methods that could be called Proustian. Photomontages by Pannaggi

and Paladini have been published in the review *Cinematografo* with introductory articles by Solaroli.

Translated by Robert Erich Wolf

1. Kurt Schwerdtfeger (1897–1966) was a German sculptor and painter who studied at the Bauhaus in the years 1920–24.

2. For Hannah Höch, see p. 103, n. 5.

3. Ivo Pannaggi (1901–81), an Italian painter and photomonteur, was a close friend of Paladini during the 1920s.

F. T. MARINETTI and TATO

FUTURIST PHOTOGRAPHY

If in 1913 the futurist painters denied any kinship between photography and art, by the end of the 1920s photography had come to play an important role in the futurist movement. This manifesto—which was written in 1930 by the founder of futurism, Filippo Tommaso Marinetti (1876–1944), and the photographer Tato (the pseudonym of Guglielmo Sansoni, 1896–1974)—attests to the futurists' belated recognition of photography as a medium for visual experiment.

The section of the manifesto in which the different paths open to photographic experiment are enumerated was no doubt the work of Tato. A self-taught photographer, he joined the futurist movement in 1920, at the time organizing his own funeral procession in the streets of Bologna to signal his rebirth as the futurist Tato. Although he began to photograph and make photomontages in the mid-1920s, it was only after 1929 that he developed an organized, coherent approach to the medium. This systematic quality, which Tato probably acquired from a familiarity with Moholy-Nagy's writings on photography, is clearly evident in the following text.

Original publication: F. T. Marinetti and Tato, "La fotografia futurista," published manifesto, April 11, 1930; this translation is based on the revised text which appeared in *Il Futurismo* (Rome), January 11, 1931.

The photograph of a landscape, a person, or a group of persons arranged with the sort of harmony, precision of details, and truth to type that make people say "it looks just like a picture" is for us something absolutely over and done with.

After Photodynamism, or the photography of movement—created by Anton Giulio Bragaglia in collaboration with his brother Arturo, presented by me in 1912[1] in the Sala Pichetti in Rome, and thereafter imitated by all the avant-garde photographers of the world—these other new photographic possibilities need to be realized: 1) the drama of objects both stationary and in motion, and the dramatic intermixture of mobile and immobile objects; 2) the drama of the shadows cast by objects, contrasting with and isolated from those objects themselves; 3) the drama of objects humanized, petrified, crystallized, or

vegetalized by means of camouflaging[2] and special lighting; 4) the spectralization of certain parts of the human or animal body isolated or joined together in defiance of logic; 5) the fusion of aerial, marine, and terrestrial perspectives; 6) the fusion of views taken from below with views from above; 7) objects or human and animal bodies, unmoving or moving, photographed obliquely; 8) moving or immobile objects shown in suspension and maintained in equilibrium; 9) mobile and immobile objects shown in dramatic disproportion; 10) the tender or violent interpenetrations of moving or stationary objects; 11) the transparent and semitransparent superimposition of persons and concrete objects, and of their semiabstract phantasms, with the simultaneity of memory or dream; 12) the overpoweringly enormous enlargement of something minuscule and almost invisible in a landscape; 13) a tragic or satirical interpretation of life by means of a symbolism employing camouflaged objects; 14) the composition of landscapes that are entirely extraterrestrial, astral, or spiritualistic by means of unclear thicknesses, elasticities, and depths, of limpid transparencies, of algebraic or geometrical values having nothing human, vegetable, or geological about them; 15) the organic presentation of a person's various states of mind by means of intensified rendering of the most typical parts of his body; 16) the photographic art of camouflaged objects, with the aim of developing military camouflage designed to deceive aerial observers.

All these investigations have the aim of making the science of photography cross over the border more and more into pure art, and of automatically encouraging its development in the field of physics, chemistry, and war.

Translated by Robert Erich Wolf

1. It seems probable that Marinetti first saw the Bragaglias' photographs in early 1913.

2. "The camouflage of objects" was Tato's preferred term for the introduction of surreal effects into photographs of everyday objects.

ARTURO BRAGAGLIA

FUTURIST PHOTOGRAPHY

Arturo Bragaglia (1893–1962) was the younger brother of Anton Giulio Bragaglia (see p. 287), and his partner in the first experiments in futurist photodynamism. After the Bragaglias were rejected by the official futurist movement in 1913, Arturo became a professional portrait photographer in Rome. In the late 1920s, when the futurists began to display a keen interest in photography, he resumed the making of experimental photographs and photodynamist portraits.

In this essay Arturo Bragaglia looks back, from two decades later, on the first photodynamist achievements. While never explicitly repudiating photodynamist photography, he suggests that the central issue facing modern photographers is photographic objectivity, and how to employ it to attain expressive results.

Original publication: Arturo Bragaglia, "La fotografia futurista," *Il Futurismo* 1, no. 7 (October 23, 1932).

Now, twenty years after its first eventful appearance, photodynamism can be understood and justified more easily if it is considered on the same plane as other artistic manifestations of the time.

The new, exuberant, irrepressible sensibility that gave rise in Italy to splendid artistic movements imbued with a high pictorial and musical feeling (sometimes disordered and fragmentary), expressed itself in the art of photography with an analogous exploration of states of mind and fleeting impressions, drawn from current life in all its vital immediacy.

In the elementary approach of the first attempts at photodynamism one still finds Impressionism, and thus a vagueness of sensory interpretations that were perhaps overly acute, almost convulsive, and unwholesome. Those attempts paralleled the dynamic or motion-inspired constructions of the futurist painters, notably the magnificent and energetic approach opened up by Boccioni and, perhaps more, that of a great poet of the vibrations of the fleeting instant like Giacomo Balla.[1]

Anton Giulio Bragaglia, with his alert originality and his shrewd,

quick intuition, had some quite elegant things to say on the subject, beginning with his short book of 1913 titled *Fotodinamismo*. But I shall not repeat here what he said.

Consistent with my point of view, which is concrete and in line with the current critical approach and its emphasis on the technical side, I limit myself to proposing a reevaluation of those efforts that were based on photographic sensitization, efforts moreover not lacking a compositional syntax of their own, nor their own quite noble intentions.

What I contrive to do every day in the great art of the portrait photograph with framing, posing, lighting, expression—in short, everything having to do with life, innovation, and beauty—is still closely related to those early explorations, which, if we think about it, were more practical than theoretical.

With eyes open to what has been done in the figurative arts from that time to today, I too work to achieve—photographically—subjects and atmospheres that are from time to time metaphysical and surreal, chimerical and dreamlike, architectural and scenographic, with theatrical and cinematic effects suggested by my familiarity and fraternity with the goals of the artistic life that surrounds us in Rome, capital of the fine arts.

The photographer, who is here, there, and everywhere, and is not only the *documenting* eye but also, and perhaps above all, the lyrical and fantasizing eye, who sees everything modern and of our time, and who can construct however he wishes images that bear the mark of the immediate instant, and at the same time abstract them away from merely contingent reality with his own arbitrary schematic arrangement; the good photographer, who is alert and open-minded and without cultural biases, deals with the most varied and dissimilar themes to be found in the vast outward world, and transfigures them at will—in his truly new art—without any prejudice in favor of realism.

If it were not for this blessed profession, and if everything were permitted to one's passion for portraying things as they are or as they ought to be—with no limitations whatever—who would bring to a halt the wonders of a truly vital photography? Who would prevent the unfurling of the free song of lights and shadows in motion, in competition with the screen and with every other art involving lines, rhythms, and colors?!

Technological rhetoric does not choke off those of us who delight

in technique. The dynamized documentary does not limit us, if our wings can soar freely in it!

A photographer of profoundly modern conviction, today I strive for a penetrating and conclusive psychological rendering of the inward motivations—more than the outward ones—of every person I portray. And this, it seems to me, can succeed in overcoming a hollow rhythmic formalism which has no place in photography, although it is certainly conceivable. Vice versa, the naturalness of the scenes invalidates all the clever contrivances of the human draftsman, and wins out over the machine. The notorious mechanical eye is sensitive above all to concrete optical appearances, which it can deform or synthesize even into an Olympically classical ideal. However, it refuses excessively geometrizing or decoratizing superpositions. (Barring the abstract or antirealist taste of the intellectual client, which after all does count for something!)

Landscape and the figure, the out-of-doors and the closed space of inhabited rooms, can be viewed and rendered *spiritually*, with passion, with personality, with true artistic expression.

Toward that end, the photodynamic experiment has proved its value.

Translated by Robert Erich Wolf

1. Paintings by the Italian futurist Umberto Boccioni (1882–1916) investigated the visual effects of violent, rapid movement. Giacomo Balla (1871–1958), also a futurist, explored the theme of sequential movement in a number of paintings made around 1913.

CESAR DOMELA NIEUWENHUIS

PHOTOMONTAGE

The son of a prominent Dutch socialist leader, Cesar Domela (b. 1900) became a member of the De Stijl group in 1924; his geometric abstract paintings attracted attention in the mid-1920s. During the latter part of the decade he turned increasingly to graphic design, and after moving to Berlin in 1927 he began to work in photomontage. In 1931 Domela organized and designed the catalogue for an important exhibition of photomontage held in Berlin.

Like Jan Tschichold, Piet Zwart, and Kurt Schwitters, his fellow members of the Circle of New Advertising Designers, Domela belonged to that section of the avant-garde that did not regard it as contradictory for an artist to work in commercial graphic design. Such commissions, Domela believed, provided a way to introduce the visual language of modern art to the public at large, through advertising and public display. In a statement made in 1930 Domela cited, among the principal factors influencing him, the work of Mondrian, and asserted that he hoped "to realize the fundamental ideas of neoplasticism[1] in life, in the sphere of interior design and in advertising." In the essay that follows Domela addresses the question of photomontage in modern graphic design.

Original publication: Cesar Domela Nieuwenhuis, "Fotomontage," *De Reclame* (Amsterdam), May 1931, pp. 211–15.

Nowadays no one will question the important, even primordial role that photography plays in advertising. There are two possible ways to use photography in advertising. First, one can combine the picture, as it is, with typography. Everyone interested in advertising knows about this method; its advantage is that usually a good typographer can carry it out, thus saving the expense of an artist. As it is very schematic it becomes boring after a while, which is a disadvantage. I wish to consider in greater detail the second possibility, photomontage. The pros and cons of photomontage are currently much discussed, mainly for this reason: people have not yet learned to distinguish between photographs put together in an absurd way, and a photomontage in which design and content are skillfully combined. It cannot be held against photomontage that the former is more often encountered than the latter.

Photography has almost completely superseded the artist-illustrator. With the development of newspapers, which need many contemporary pictures, photography has struck root and expanded more and more. In addition, the production of negatives has dramatically increased. Thus photography has more and more become an international means of communication, and a particularly powerful one since, owing to language barriers, an image is more easily comprehended everywhere than a text. The tendency of newspapers to utilize more pictures and to reduce the text to slogans results, in my opinion, from the fact that modern man wants to assimilate the content of a newspaper as quickly as possible. In the silent movies too, the attempt was made to use as little text as possible: the image had to speak for itself. Here also, understanding was to be visual. A very successful example in which the text was entirely left out was the Russian movie by Kaufman, *The Man with the Movie Camera*.[2]

The cubists in Paris—I mention for example Picasso—and the futurists in Milan under the leadership of Marinetti (*Futurist Manifestos*) were the first ones who tried consciously to utilize type as a plastic element. The origin of photomontage can also be found in eighteenth-century quodlibets (these whimsies were extremely realistic imitations, in oil or watercolor, of a pack of paper or printed matter with some other objects lying on top); nevertheless it is to the dadaists that credit goes for combining photography and type for the first time within one composition. Slowly the artist grew familiar with this new material, so that the results he achieved improved in content and form. I must also emphasize here that it is the artist, not the photographer, who recognized the montage possibilities of photography. After this brief consideration of its origin, I wish to go back to photomontage itself and try to define it.

Photomontage—I'd personally prefer to say photo-composition—is a composition consisting of a harmoniously combined unity of many completely or partially cut out photographs. Color or text can be added to this composition, provided that this does not interfere with the unity of the whole. This consciously, harmoniously structured composition falls theoretically under the rubric of fine art. I quote here from Jan Tschichold's excellent book *The New Typography*: "The initially accidental form of the individual photo (gray tones, structural effect, line movements) acquires artistic meaning through the composition of the whole. . . . The 'logic' of such a creation is the irrational logic of art.

But a quite supernatural effect is created when a photomontage consciously exploits the contrast between the plasticity of the photograph and the inanimate white or colored surface. This extraordinary impression is beyond the reach of drawing or painting. The possibilities of strongly contrasting sizes and shapes, of contrasts between near and distant objects, of planar or more nearly three-dimensional forms, combine to make this an extremely variable art form."[3] The essence of photomontage is to express an idea.

Photomontage can be either free or applied. By free photomontage I mean a harmonious composition of photographs which expresses an idea without the use of print. This type of photomontage is an intermediate stage between photography and film. Let us take for instance the notion of war; one photograph of the front is not quite enough to communicate the concept of war. Thus I take a number of war pictures: fighting on land, on sea and under the sea, in the air, etc.; I combine them, and if the combination is skillful, the onlooker will experience the idea of war. Of course the effect can be better achieved in film, but a moving image cannot be fixed on a plane; that is what photomontage is for.

By applied photomontage I mean a composition of photographic elements linked to print. This type of photomontage is very suitable for advertising purposes. Naturally it is only possible to realize a work of art in this area now and then, because the compositional element is constrained by requirements of logic and coherence as well as by the given text. However, the task of the advertising designer is not to make art, but to create efficient advertisements. Although the two may go hand in hand, this is not a requirement.

The fact that currently many people think they can make photomontages without having the slightest notion of the matter does a great deal of harm to photomontage. In most cases they paste happily away and call their product a photomontage. Many illustrated magazines publish these products of amateurs which give a bad name to photomontage, while excluding the really good ones which take much more time, work, and money to produce. It would be a very good thing if these photo-combiners exercised more self-criticism. Even photographers, except for a few, design bad photomontages, although their material is often good. Also, they give the name "photomontage" to prints of superimposed negatives, which in my opinion is an error, since the result is mostly fortuitous and not a consciously planned

composition. And one can only print a very limited number of super-imposed images. In the movies it is easily done, however, proof being the Russian films.

I want to say a few words about inserting letters into photomon-tages, although this is really a personal matter of the artist's. The main appeal of photomontage consists in contrasts, such as large-small, black-white, etc.; therefore, to contrast with a more or less subjective composition, I would choose the most neutral, impersonal typeface possible. Thus I limit myself to the wide sans serif typeface, narrow "accidens" sans serif, and for negative type the lucina. The advantage of these types is their legibility. It also seems preferable to me to run the type from left to right rather than from top to bottom. One often sees handwritten text on photomontage: I am opposed to this. Have we worked for so long to improve typefaces, only to return at this point to the handwritten text? I also refuse to use the so-called *kunstgewerbliche* [handcrafted] types. Many artists design their own letters without real-izing that this is extremely difficult and that it constitutes a specialty in itself. The best solution is to find a good typeface among the many existing ones. The *kunstgewerbliche* types are all too often used to mask weak areas within the composition.

I hope that in this brief exposition I have clarified the nature and the importance of photomontage. This kind of use of photographs in the fields of illustration and advertising is something I would very much like to see in Holland.

Translated by Michael Amy

1. In the early 1920s Mondrian published a series of essays on the application of his system of rigorously geometric composition to art, architecture, and design. Trans-lated into German in 1925 as *Neoplastizmus* and published as one of the Bauhaus Books, these essays proved extraordinarily influential in the late 1920s.

2. The Soviet filmmaker Denis Arkadyevich Kaufman (1894–1954) was better known by the pseudonym Dziga Vertov. His film *The Man with the Movie Camera*, which demonstrated the new visual possibilities of the camera, appeared in 1929.

3. This quotation from Tschichold's book *The New Typography* (1928) is drawn from the chapter entitled "Photography and Typography," which is reproduced in this volume (see pp. 121–27).

VILÉM SANTHOLZER

THE TRIUMPHANT BEAUTY OF PHOTOGRAPHY

During the 1920s and 1930s Czechoslovakia enjoyed extensive cultural con-
tacts with Germany, France, and the Soviet Union; for this reason Czech
writers and artists were in an excellent position to observe the directions
taken by the various branches of the international avant-garde. By 1922 the
members of the Czech *Devĕtsil* group had already begun to show an interest
in film and photography, thanks in large part to the writings of Karel Teige
(see next selection). Teige's provocative argument in favor of the aesthetic
power of functional photography—that photography is beautiful precisely
when it does not strive to be artistic—was echoed in this short essay by
Vilém Santholzer (b. 1903). The essay was to be part of a book, planned
but never published, which Santholzer called *The Beauty of Mathematics and
Machines*. The enthusiasm it exudes for the new visual sensations offered by
aerial photography, scientific photography, and X-rays was shared by virtu-
ally every avant-garde movement.

Original publication: Vilém Santholzer, "Vitĕzná krása fotografie," *Disk* (Prague
and Brno), no. 2 (1925), p. 10.

The triumphant beauty of photography results from the contemporary
perfection of photographic cameras, film technique, photochemical
and reproduction processes. For the majority of present-day humanity,
the picture almanac offering photographs of the latest events fulfills
the need for pictures that can provide visual enjoyment—a category
which until recently has been unjustly monopolized by painting. The
precision and conscientiousness of the photographic camera contrasts
sharply with the lesser precision achievable by the human hand. And
what else? Humanity does not need any kitschy "moods," and gladly
leaves them to the garret walls of the kitsch-makers—and the same
goes for sentimental, so-called artistic photography. The photogenic[1]
character of modern film is being heightened through the optical pos-
sibilities of photography. Its capacity for unlimited multiplication is
a miraculous blessing.

 The beauty of photography from an airplane often has a com-
pletely unprecedented effect on the human imagination, and as re-

gards sensationalism,[2] it is a great feast. New spatial combinations are revealed in photographs of craters, sea inlets, and high mountain ranges.

The beauties of scientific photography through a microscope, and of astronomical photography, which uses a telescope, are often a sensation in the grandest style, since they are absolutely authentic. A brief fact: an old photographic plate was found, on reexamination, to reveal a newly discovered star.—The photographs of traces of flying atoms and electrons made by C. T. R. Wilson.[3] The smallest particles of matter in a photograph! The schemata of crystal structures on Laue's[4] X-ray photographs—photographic proof of the existence of primary geometric pictograms in the internal composition of matter! The planet Saturn in the simple blackness of the telescopic image. Man's heartbeats on an X-ray-cinematographic filmstrip! All this competes, in the sphere of pure optical impression, with the subjectless compositions of Man Ray. At the same time it is

a beauty that can be infinitely multiplied.

While nothing new can be expected in the future from painted pictures, one need not be cautious when speaking about the possibilities of photography. Wireless transmission of images into the distance, together with optophonetics,[5] are among the fruit ripening in the unknown sphere of aesthetic pleasures of the future. Although it is still a long way from talking films to optophonetics—since the basis is the idea that it is possible to change "images of sounds" into sound, why should it be impossible to change any photograph into sound? The telephones capable of changing photography into sound shall create for future humanity something still imaginary for us,

including music through photographs!

Translated by Jitka M. Salaquarda

1. For *photogénie*, a term widely used in French film criticism in the early 1920s, see p. 36, n. 1.

2. Santholzer's use of "sensationalism" reflects the term's employment in German critical discussion, and refers to the startling photographic images that began appearing in the illustrated press with increasing frequency in the early 1920s.

3. Charles Thomson Rees Wilson (1869–1959) was a British scientist specializing in electrical phenomena.

4. Max Theodor Felix von Laue (1879–1960), a German physicist, introduced the X-ray analysis of crystal structures.

5. For optophonetics, see p. 93, n. 3.

THE TASKS OF MODERN PHOTOGRAPHY

Karel Teige (1900–1951) was a leading figure in the Czech avant-garde. One of the founders of the *Devětsil* group in 1920, he was a painter, graphic artist, typographer, and photomonteur, and the author of books on modern architecture, literature, Russian art, surrealism, film, and photography. Teige was an early Czech advocate of avant-garde film and photography; in his 1922 book *Foto-Kino-Film* he enthusiastically examined the new visual possibilities of photography and reproduced some of Man Ray's first rayographs.

Yet by the early 1930s, Teige, like many others who had formerly applauded the new world of technology and industry, was considerably less optimistic, as is evident from this essay, a "balance sheet" on avant-garde photography. Teige expresses a fear that avant-garde photography has fallen victim to a new aestheticism, and offers a criticism of faddish "photo-inflation" that picks up the theme introduced earlier by Ernö Kallai (see p. 140). Like other members of the Czech Film-Photo Group of the Left Front, formed in the late 1920s, Teige recommends a return to the tradition of pure documentary and reportage photography, and to the practical use of scientific photography. He places his hopes in what later came to be known as "social photography"— the kind of functional photo-reportage previously called for by the Soviet critic Sergei Tretyakov. Teige's essay provides a vivid sense of the moment in the early 1930s when documentary and reportage photography began to seem better attuned to the times than avant-garde photography.

Original publication: Karel Teige, "Úkoly moderní fotografie," in *Moderná tvorba úžitková* (Modern applied creative work) (Bratislava: Svaz čs. diela, 1931), pp. 77–78.

If you follow the stupendous rise and triumphant progress of modern photography, lately so evident—the large and important photographic exhibitions such as the traveling "Fifo" (*Film und Foto*) exhibit of the German Werkbund, first mounted in 1929 in Stuttgart, or even the more extensive and also more eclectic 1930 exhibit *Das Lichtbild*, in Munich; or the splendid portfolios and publications devoted to modern efforts in the area of photography, photomontage, and photogram, e.g., Tschichold-Roh, *Photo-Eye*; W. Gräff, *Here Comes the New Photogra-*

pher!; Renger-Patzsch, *The World Is Beautiful*; G. Krull, *Métal*; Helmar Lerski, *Faces from Everyday Life*; the collection of photographs from *Arts et métiers graphiques* and the *Fotothek* edited by F. Roh;[1] or the monographs of the outstanding representatives of the black-and-white modern movement: Man Ray, Moholy-Nagy, and others, and others—in short, if you observe how in the last few years photography has invaded the world of art with all its genres, has fought for and gained its place and its honors there next to painting, and often against painting, since photographic exhibitions and publications today often enjoy a far greater popularity than do expositions and publications of painting; then you will probably agree with the statement that "photography, invented a century ago, is being truly discovered only today" (L. Moholy-Nagy).

Well then, the aim of this article is to be a silent protest against the present photographic inflation at exhibitions and in publications, a protest that is perhaps a little inappropriate in our country, where modern photography (completely domesticated not only in Germany and France but also in a somewhat different way in the Soviet Union) is still a Cinderella, and, with a few exceptions, is practically nonexistent. No one here wants modern photography and nobody suffers from the lack of it. Our picture magazines and illustrated weeklies are probably quite content with the below-average journalistic shots at their disposal. Our publicity and advertising are on the whole still so immature and provincial that they have not begun to realize what advantages a perfect, high-quality modern photograph could offer them. Those numerous exhibitions and publications in other countries have served as a kind of school, an excellent school that educated experts as well as the public. The Czechoslovakian public has not yet been offered such a school. (The only exceptions have been the exhibitions of modern photography in *Aventinská mansarda* [Aventine garret] in Prague, which are, alas, too poor in content.) To accomplish that here, there would have to be created a number of better-organized modern photographic exhibitions, some portfolios of excellent images, and a critical monograph on international modern photography.

However, even if we do not take special account of Czechoslovakian conditions, rather underdeveloped in this area, we must still voice strong opposition: on the one hand, to the fact that modern photography has become a great fashion of the art world abroad, which means that once again we will have to look at artistic photography in

some renewed and modernized form; and on the other, to the above-cited Moholy-Nagy statement that only today has photography been truly discovered. This assertion encourages us to underestimate the older and even the oldest documentary and reportage pictures, and to overestimate the present many-sided tricks of the photographic camera that pretend to give us a new view of the world by depicting it—following the already conventional recipes—from up above, down below, in tilted angles, or as a gigantic close-up.

We want, above all, for no photography, even the most up-to-date and perfect, to present itself as art, because by doing so it again exposes itself to the dangerous plague of aestheticism and academicism,

—we want the so-called "artistic photo" to be extirpated as a hybrid phenomenon which is neither photography nor painting, even in the case when this photography adopts a modernistic guise—since it makes utterly no difference whether the photographers borrow from Rembrandt and the Impressionists, or from Picasso, Léger, abstract and surrealist painters.

—we want ultimately to destroy the already widespread idea of the "avant-garde photo," as well as of the "avant-garde film"; that is to say, "avant-garde" superficiality and commercial salability, with no misgivings about the vitriol of snobbism, artism, and aestheticism, as long as success and profits are achieved, exploiting the fact that "avant-garde" is in vogue.

Modern photography dates further back than is usually thought. As a matter of fact, the first photographs were considerably more modern than all the later artistic photography. We can perhaps discern two culminating periods in the development of photographic work up until now, that is, one at its beginning, in the age of Daguerre, and the other today. After the first chapter of development, we note, the photographic work of the several decades following fell victim to failure and banality. The value and importance of current photographic work—undoubtedly representing great progress compared to the preceding years of decadent salon photography—consist mainly in the fact that photographers are abandoning bad old painter's-studio habits, that they are rejecting the lifelessness of pseudo-Impressionist murkiness; without, however, always being able to keep photography independent of the influence of more modern painterly methods and directions.

The history of photographic work contains more riches than are

usually perceived. We can date the beginnings of photography back some hundred years before Daguerre's invention. And at that beginning we find precisely the images revitalized by Man Ray: photograms, i.e., images made without a camera, direct recordings of light on a sensitive surface. Long before Daguerre, long before the Englishmen Davy and Wedgwood,[2] it was a German physician in Halle, Johann Heinrich Schulze, who, in 1727, conducted the first photogram experiments. These photograms—copies of objects on a sensitive surface —naturally were not permanent, because it was not yet possible to fix the image on the illuminated surface. Only a hundred years later, in 1829, J. Nicéphore Niepce and a painter, Louis Jacques Mandé Daguerre, concluded a contract establishing a firm where they chemically fixed the optical images produced by the camera obscura. Daguerre announced his invention to the public only in 1839. He photographed on a smooth, silver-coated copper plate which was exposed to the effect of iodine vapors, whereby a light-sensitive silver iodide layer was deposited on the silver-coated surface. The exposed image was developed in mercury vapors and then stabilized in special baths. The image was positive, however, and thus unique. It could not be multiplied or copied.

The early daguerreotypes are clearly modeled images, clean and precise drawings. Despite their firm matter-of-fact quality, the old daguerreotypes contain something phantasmal, pathetic, and poetic. By their truthfulness and precision of drawing the daguerreotypes very decisively drove out the types of pictures which can be designated as the forerunners of photography, such as silhouettes, miniature portraits, lithographic portraits, etc. Daguerreotypes were not polluted by "art," they owed absolutely nothing to painting and the graphic arts. They were a clean piece of work. Daguerre's invention was at the time too revolutionary to allow anyone to imagine that this new form of picturing could learn anything from the painters. Quite the contrary: the first epoch of photography lived in the proud awareness that it had surpassed painting and triumphed over it. Jules Janin (Paris, 1838) wrote about Daguerre's work: "Not even the best masters of drawings managed anything similar to this. Imagine, it is sunlight itself, the almighty agent of an entirely new art, that produces these momentous works: the miracle takes place just as quickly as a sudden flash of the sun."

The advances of photography which followed were in the first

place almost always of a technical nature. In 1839 an Englishman, W. H. F. Talbot, invented the so-called "talbotype," i.e., photography on paper, and with it the possibility of making copies and the discovery of the printing process. In 1851 appeared the first images on glass: negatives supported by a black surface, thus giving the semblance of positives. The public tends to confuse this rather imperfect system with the first daguerreotypes. The first to introduce photography in today's sense of the word were David O. Hill in England and Nadar in France.[3] With these names ends the first photographic era. The works from this period, works of high standards untainted by artistic infections, are in effect the incunabula of photography: if you wish, they establish the genuine and honest "tradition" of pure photographic work.

This line of honest work devoid of artistic tricks was followed principally by reportage and documentary photography. In the old picture magazines, an outstanding and expressive photograph is, on the whole, a rare exception, but it is nevertheless here that it may be found, not in the studios of portrait and "artistic" photographers. Although reportage photography in the illustrated magazines tended, and in general still tends today, to be quite static, lifeless, and soulless, in the spirit of a family album—it is possible, here and there within the avalanche of often comical shots, to find perfect scientific photography (astronomical, geographical, or microscopic images) and thrilling aerial shots. For example, some twenty years ago L'Illustration published the cycle "Paris Photographed from a Balloon": the shot of the Eiffel Tower[4] (reproduced in Stavba [Construction] and in ReD 2, no. 7, and then reprinted in numerous avant-garde publications) can compete with the most outstanding contemporary images.

In addition to the anonymous scientific and reportage photos, there is one name that should be mentioned: that of a nearly unknown and unimportant painter, Eugène Atget (d. 1927), who undemandingly spent his days and indeed his entire life photographing the streets and corners of Paris, its byways, oases, and store windows—in short, the motifs which he wanted to paint. His paintings are forgotten, but his photographs belong among the most beautiful works of the black-and-white chemistry of light: today he is ranked, with Nadar, among the greatest photographers of the early era.

It is characteristic of the images of this early era that they are artistically undemanding, truthful in relation to the depicted object,

and have a relatively high degree of technical perfection: honest work which is not glancing surreptitiously at painting and does not fear its competition. To some extent the photographer becomes not a parasite of the painter, but a helper. Manet's historical picture *The Execution of the Emperor Maximilian* very closely follows a journalistic photograph. Utrillo painted pictures closely modeled after ordinary Parisian postcards. Straightforward reportage snapshots exercised a strong influence on Degas, showing him the optical abbreviations and deformations of the foreground that occur through the camera lens, and the tilting of the lines from a bird's-eye perspective. Degas even composed his pictures to create the impression that they were uncomposed snapshots of everyday events and real life (*Place de la Concorde, Pedicure,* etc.).

With Nadar, we find already not only masterly portraits but also photographic kitsch. It is of course necessary to note that in the last two or three decades of the nineteenth century the human figure attired in contemporary dress, in keeping with contemporary fashion, had become virtually a parody of all concepts of human dignity. Images from that period should therefore be termed monstrosities rather than photographic kitsch. In those photographs, the period of our fathers' youth appears as something totally repugnant to present physical culture and hygiene: we see a carnival of the most grotesque costumes in rooms overflowing with heavy-footed pseudostylish furniture; the smell of dust pervades everything and thick curtains bar the rays of the sun. Ladies nipped in like wasps by firm corsets and the armor of the stays, with bows below their skirts; comic poses, the affectation of grimaces as the portrayed person flirts with some unknown spectator; the portraits of famous singers, actresses, and honorable patricians—that is the perfectly repugnant, hallucinatory face of the grand and petite bourgeoisie of that time. Mr. Raoul Korty in Vienna has a collection of such monstrous photographs, and the periodical *Documents* (1929, no. 4) printed a series of Nadar's portraits from the bourgeois and theatrical world. René Clair ridiculed this world in his film *The Straw Hat,* simply by veristically setting it before the eyes of the contemporary spectator.

In the end, it is a style of monstrosity, but still a style; or, to put it differently: however ugly, perverse, and false the models of these images, the photographic work itself remains clean, precise, solid, and pure. The real fall of photography took place in the first quarter of the twentieth

century, in the fields of commercial portrait photography and of so-
called "artistic photography," a parasite of painting, particularly of
Impressionism. Such photography is practiced to this day by commercial
studios, or by eager amateur photographers searching to satisfy their
painterly aspirations in the oil print medium, that bastard of photography
with pigment and brush technique.

In the time of this utter decay of the photographic work, the
photographic avant-garde comes as a sign of rebirth. Setting itself
against hybrid "artistic" photography and commercial portraiture, it
follows principally the early pure work of the age of daguerreotypes,
the photograms preceding Daguerre, and unspoiled scientific, reportage,
and aviation shots. Photographic technique is being perfected and its
possibilities enriched. It uses multiple exposure, photomontage, negative
copies, enlargements, etc. Old aesthetic recipes, erroneously derived
from painting, are rejected. This great renaissance which tore
photography loose from the grip of the petty business machinations of
the studios, and from artistic dilettantism, came about thanks to a
number of modern, mainly French and German, artists, often former
painters: Man Ray, Kertész, Abbott, Germaine Krull, Eli Lotar, Florence
Henri, Tabard, or W. Peterhans, Moholy-Nagy, H. Bayer, Lucia Moholy,
Umbo, and others.[5] These are the most often listed names.

This avant-garde of photographers and photomonteurs comes
face to face with painting, which offers up its demise. Oil paints and
canvas cannot compete any longer with the richness of optical effects
provided by photo-optics and silver bromide paper. The photographers,
frequently former painters, believe that it is their mission to replace
the dying art of painting. Aside from utilitarian photography (document,
reportage, portrait, advertising, science, etc.) there now appears
Fotografie als zweckfreies Gebilde, free photography, pictorial photography,
which does not wish to be more than a play of shapes, lights, and
shadows, a photogenic[6] poem. This photography does not care about
the subject, it is concerned only with the photochemical qualities.
The importance of these photographs is twofold: one, they form quite
an important school of photographic technique and method; and two,
the new images of quite commonplace realities, which we usually do
not notice, have considerably enriched our cognizance of reality, of
matter and its structure—in short, they have enriched our visual
experience and sharpened our ability to look and see.

However, this avant-garde photography was soon threatened by a

serious danger. The proximity of art (and that is where modern photography found itself) is always a temptation, because, sadly enough, the mechanical process of photographic work does not exclude toying with moods and coincidences. It was Renger-Patzsch in particular who, with his *The World Is Beautiful*, set photography once more on the track of renewed and modernized "artistic photography": he realized that the world is beautiful, proceeded to photograph it in a very beautiful manner, and offered very appealing and sentimental models for the well-to-do young ladies who want to kill the time on their hands with Kodaks and Leicas.

The new modernistic art photography is born from the unemployment of photomaniacs. W. Peterhans photographed, with masterly technique and miraculous perfection, cigarette butts, leftovers, fragments of objects, pieces of string: to show people facets of reality which they are unable to notice or unable to see? Why not? But enough is enough: to offer the thousand and first variation is not desirable. To demonstrate and study all the possibilities of photography, through manifold view angles, lens systems, negative prints, multiple printing, double exposure, etc.? Of course, that is very important. However: have we acquired all these techniques just for the sake of using them, or to achieve a higher purpose and goal?

Avant-garde photography, celebrating its successes by exhibitions and books, is slowly withering into a sick *l'art-pour-l'artisme*. Modernistic art photography will end just as ingloriously as did the older art photography. In this case the photographic camera is devalued to a machine with grandiose possibilities, but without any clear goal.

Therefore with this article we wish to draw attention to another—modern—photography that incorporates itself within social life, as opposed to the one that has excluded itself from social life as "art."

Photography did not triumph over painting in order to take its place. It has taken over from painting the functions of depicting and documenting, and it cannot betray them precisely because photography is better able to exercise these functions than any kind of painting. But let us not forget the most important thing:

Photography (unlike painting) forcefully demolishes artistic professionalism. Laymen can practice it: the technical apparatus is of such simplicity that basically anyone can acquire its command. In photography, as in other fields, the most important things have frequently

been created not by experts, who had ossified in conventional attitudes or in academicism, but by laymen and amateurs. The decisive impulses often came from circles at a considerable distance from the experts. Franz Roh, as a modern art historian interested principally in the *allgemeine Laienproduktivität* [general lay productivity], emphasizes the lay character of photography. "Raphaels without hands can create today, because the technical means of photography are so simple that it is easy to learn how to work with them: they can thus be the keyboards of expression for everyone."

It has been pointed out several times that in the near future people ignorant of photography will be considered illiterate. It is necessary for the teaching of photography to be included in the syllabus of general and secondary schools, e.g., as part of drawing.

Emphasis on the lay character of photography should not be understood as praise for the amateur activity of the bourgeoisie and petite bourgeoisie. The sad, anemic, touristy weekend snapshots, born ten-thousandfold each week, are truly repugnant: tired businessmen and office workers in Europe and America, or young ladies who have given up embroidery to play with their cameras, believe in art and sin against it in their spare moments. For that, of course, one does not even have to be too perfectly in command of the technique.

There is something at stake here other than an unimportant sport for the bored petite bourgeoisie:

Three thousand photo-circles,[7] one hundred thousand worker-photographers in the USSR: from the icy sea to the Turkmenistan steppes the camera is recording through its lens the theme of life, not a pose. It collects documents from geographic and cinematographic expeditions for historians and ethnographers, and the results of socialist construction projects for the reporters. The *rabkors* (worker correspondents) and *selkors* (peasant correspondents) with cameras in their hands are sensitive seismographs and tachometers of the rhythm of construction and the grandiose epic of the new world, depicting work, factories, state farms, children's homes, the reconstruction of work methods, mountains, rivers, cities, and the Five Year Plan! The contemporary Soviet avant-garde managed to steer clear of the Scylla of aestheticism and the Charybdis of *l'art-pour-l'artisme* on which the West European avant-garde wrecked itself. We have said that this art for art's sake is the result of the photographer's unemployment. In the Soviet Union,

social commissions call photographers to work swiftly on concrete tasks. The revolution and the worker's movement first increased the demand for documentary shots and for propaganda photomontages that exhort. For the Soviet modern movement, a photo-reportage is practically a slogan and a manifesto against painting, an iconoclastic credo: "We do not want painting that falsifies and prettifies, we want to see and get to know things as they are!" The theoretical problems of photo-reportage and photomontage have been thoroughly elaborated by the Soviet intellectual left group *Lef*,[8] owing mostly to the efforts of Rodchenko, a former suprematist, who exchanged his painter's palette for a camera.

Soviet photographers have not engaged in any very detailed experiments with free, abstract photography. They are very clearly aware of the tasks that photography has to accomplish: that is, documentary, reportorial, scientific, pedagogical, propaganda, and agitational tasks. For Soviet artists, photomontage is not a new kind of abstract graphics but a successful tool of political, cultural or industrial propaganda, of visual journalism.

Here photography is on the right path, fulfilling its true mission. It disdains aestheticism and "art," it wishes to be unpretentious documentation, a pictorial record. It knows that this is a great task and a great responsibility: most of the picture magazines are still very bad, although their consumption by the public is enormous. In reporting, the indirect, written form of communication is giving way to the direct one, the image.

In essence, photography is a service, a helper to science, journalism, industry, civilization, and culture. In the hands of, say, Lissitzky, Rodchenko, Klucis, or of John Heartfield or the American social genre author Tina Modotti,[9] it simultaneously turns into a means and a weapon of revolutionary struggle.

We demand that such reportage offer not only precision and truthfulness, but also freshness, daring and novelty of view, sharpness and clarity, living dynamics. Service is the future of modern photography and its tasks will be utilitarian: to serve science, ideas, and social progress. As with contemporary architecture, also exclusively utilitarian, such utilitarian photography promises—if it reaches perfection—a far superior cultural and social value than mere "art." To be sure, such photography is today only in its beginning; nevertheless, we can already (although sporadically) encounter in some illustrated newspapers (e.g.,

AIZ)[10] and scientific publications dazzling, monumental, emotive images; next to them the charms of the pretty "artistic photographs" of the so-called avant-garde pale considerably.

Translated by Jitka M. Salaquarda

1. In 1930 the French magazine *Arts et métiers graphiques* published a special photography issue, which was continued as the annual *Photographie*. Also in 1930 the German art historian Franz Roh announced a series of photography monographs called *Fotothek*; only two books appeared, on the photographers László Moholy-Nagy and Aenne Biermann.

2. Sir Humphrey Davy (1778–1829) and Thomas Wedgwood (1771–1805) in 1802 published a scientific paper in which they detailed their experiments with the image-forming capacity of silver salts. Their findings were important to the later development of photography in Great Britain.

3. David Octavius Hill (1802–70), a Scottish painter, in the 1840s carried out, with his partner Robert Adamson, a series of notable photographic portraits. Felix Nadar (see p. 3, n. 4) was the best-known French portrait photographer of the nineteenth century.

4. Teige is undoubtedly referring to the dramatic overhead view of the Eiffel Tower which appeared in the June 5, 1909 issue of *L'Illustration*. The photograph, one of a series by the balloonists André Schelzer and Albert Omer-Decugis, later served as a model for one of Robert Delaunay's paintings of the tower.

5. All of the photographers mentioned by Teige took part in the 1929 *Film und Foto* exhibition in Stuttgart. Eli Lotar (1905–69) and Florence Henri (1895–1982) were photographers working in Paris in the 1920s and 1930s. Maurice Tabard (1897–1984) was a French photographer who in that period carried out a number of experiments in photomontage, multiple exposure, and solarization. Lucia Moholy (b. 1908), a photographer, was the wife of László Moholy-Nagy. Umbo was the pseudonym of Otto Umbehr (1902–80), a German photographer working in Berlin in the 1920s and 1930s.

6. For *photogénie*, see p. 36, n. 1.

7. On the circles of amateur photographers in the Soviet Union, see p. 266, n. 2.

8. For *Lef*, see p. 211.

9. Tina Modotti (1896–1942) was an Italian-born photographer active in Mexico and Germany in the 1920s. She lived briefly in Berlin in 1930, at which time her photographs were published in the review *Der Arbeiter-Fotograf*.

10. The *Arbeiter Illustrierte Zeitung* was the radical German illustrated weekly in which John Heartfield's photomontages regularly appeared.

JAROMÍR FUNKE

FROM THE PHOTOGRAM TO EMOTION

A professional photographer working in Prague, Jaromír Funke (1896–1945) was among the founders of the Czech Photographic Society in 1924. During the 1920s he explored a wide range of photographic themes and techniques, from geometric light/shadow abstractions to portraiture and social reportage. In this essay, written over a decade later at a time when the earlier debates over avant-garde photography were beginning to recede into history, Funke offers an assessment of the formal legacy of modern photography. Searching next for a new photography of imagination and emotion that will embrace all of the previous stylistic directions of the avant-garde movements from abstraction to documentation to surrealism, Funke anticipates the similarly inclined Subjective Photography movement that arose after World War II in Germany and other European countries.

Original publication: Jaromír Funke, "Od fotogramu k emoci," *Fotografický obzor* (Prague) 48, no. 11 (1940), pp. 121–23.

If we look back at the development of photography since about 1922, we are pleased to observe that this developmental growth was influenced by search, experimentation, and a struggle to master content and photographic expression. Photography traveled a variety of paths before it came to this tumultuous period which achieved a liberation from prejudice, a liberation from the asthmatic artiness of imitative graphic works, and a freedom from dependencies. Photography then justifiably established its own strong, independent foundations; it is now proclaimed without hesitation that photography is an independent means of expression with its own order, its own rhythm, and its own image, that is, representational capacity. It is certainly true that some earlier individual creators had perceived photographically, and did not entangle photographic expression with graphic and artistic expression. But these rare individualists were largely an exception, and to a certain degree were also a peculiarity which was neither welcomed nor recognized by others. These individualists, misunderstood in their day, have left behind significant works which are today outstanding

expressions of their time: the works have temporal character, they have photographic veracity. They convince through their open, pure, uncontaminated photographic truth, something one cannot wholeheartedly say about the work that was carried out with complicated pigment processes. And if a gracious gum print fascinates us by its technical virtuosity and the patina of age, then it is a wonder which is very close to a bibelot, or, if you like, a curiosity, which—in its own peculiar way—is also a testament to its time. For it is indisputable that the photographer and his photograph are inseparable components. This is actually the fate of photographic expression in every era, even today; the person makes the photograph and in it also discloses his working methods, his comprehension of photography, and his views about it. Photography, like every other representational activity, is based on the life rhythm of the surrounding world, and is expression, tightly bound to the human being; it fixes his thoughts.

The liberation of photography from cumbersome graphic processes meant a great deal for its further development. Photography was thereby relieved of its dependence on earlier pictorial conventions, and began to grow conscious of its own mission and potential. Regarding mission and purpose, today there is basically no longer any controversy. A photograph is a document, and that is how one should regard it. Photography is dependent upon its spatial conventions—that is why it should assimilate the subject matter in its approach to the problem. However, photography is black-and-white. This means that, although it is the most truthful of all methods of representation, it is also not absolutely truthful and cannot be. One cannot press a three-dimensional space onto a two-dimensional surface. As for the whole, photography can only present a part of surrounding space—photography must choose. This selection is a task of utmost importance and responsibility. Through selection one can impart value to the subject matter or take it away. The selection is subject only to the free decision of the photographer, who—through composition, lighting, technical finesse, exposure, the awaiting of favorable conditions, knowledge, and experience—can imbue even an unpretentious, inconspicuous subject with unusual, even dazzling form, so that it becomes something very interesting and new. A new photographic reality is thus formed which makes use of the subject only as pretext for photographic expression.

The purity of the photographic design, free of those elements which disturb the inner discipline of the photographic composition;

the photographic concept; and the desire to take full advantage of all the possibilities of the black-white scale, led the inquisitive and independent-minded creator to experiment. Indirectly, there also came to the aid of photography the fine artist, who, after the turbulent epoch of Impressionism, looked more closely at form, which through the Impressionists' treatment had become more flexible. The artists of this time were searching for a solid form which, through the construction of shape and color in the formation of the image, would take back its representational function. This search for form and Gestalt found its analogy in photography.

Photography searches; in its search it experiments. This is the origin of the photogram. The effort to discover new possibilities thus led toward the long-forgotten idea of projecting objects onto a sensitive emulsion. It suddenly became apparent that straightforward copying contained in itself a surprise and a new beauty. Opaque form is recorded through contour, a rich lace pattern presents itself in black and white like an exotic beauty, glass has pleasant nuances, trifling objects combined in various ways evoke new impressions and enigmatic, apocalyptic forms of quotidian life. The photogram became an instructor in beauty made magical in black-and-white raiment, and a base for the transfiguration of form which—through partial disavowal of the real appearance, through combination, copying, and distancing of different objects—awakens all at once a new and newly discovered shadow play. It is a photographic poetry which discovers form, a form freed of all appendages of the everyday, and which somehow transfers magic from this commonplace world into the world of black-and-white so that the original form loses its mundane character and becomes simply a pretext to evoke new impressions. The mixture of shapes within the subtle tonal play of the photogram only increases the sensation, which in the best work often transforms itself within a mysterious aura whose exclusive power is, to a broad circle of viewers, often incomprehensible. The photogram, enhanced and autonomous, reaches the limits of its own potential and dies of exhaustion. It dies of beauty and naiveté; it has fulfilled its mission, has demonstrated what one can conjure out of light play, the interference with nets, threads, paper clips, a human hand, a finger, variously formed stuffs, glass in differing shapes, etc. etc.

There remained, however, a legacy. For the experiment was a daring one which had no fear of a montage with an X-ray, no fear of

combining with real photography. And if its beauty lay only in en-
chantment and pure black-and-white poetry, sheerly pragmatic adver-
tising photography came to make use of this legacy; it gladly exploited
projected shadow play, especially that of glass, for its purposes. In an
advertising montage, a photogram is well suited for startling and de-
lighting the viewer, who rarely even notices which tricks are utilized
for his pleasure and enticement.

This period of photography, when works were being made without
camera and often also without lens, sciopticon, or enlarger, was not
exclusively the era of the photogram. At the same time, in the years
from 1922 to 1930, several stages of photographic expression flourished.
After romantic pictorialism came New Objectivity, which presents the
magic of the commonplace, and in the same years advertising
photography progressed towards its own successes and demonstrated,
by its choice of subject matter, new possibilities for content. This
photographic realism, created with an intentional emphasis on the
advertising content, was actually the reaction of a practically conceived
applied photography against the autonomy of the photogram. However,
the conflict over the possibilities of photography did not end. The
photogram continued to exist in full splendor during this time of New
Objectivity and advertising photography, although for some creators it
was already long exhausted. For that reason, around 1926 this black-
and-white photographic poetry received a new strengthening in the
form of abstract photography. The characterization "abstract" is not
fully justified, but the term established itself because it at least partially
suggested the program. [1]

That is a matter not of simple reality, but of a truth which
through the act of photographing is suspended as physical truth and
begins to live a new life, its own, only in the finished photograph. By
this means a new photographic reality is generated; the constructed
subject matter is only a pretext for a photograph. As opposed to the
photogram, this is a pure photographic technique, eliminating neither
the camera nor the lens, but seeking through photographic technique
a real, photographic justification. It is, then, not the photographic
primitivism of the photogram, detached from technique, but rather
straight photography which, on its own photographic path, seeks and
also finds the furthest boundaries of the black-and-white scale.

To the extent that it regards *both* negative and positive techniques
as indispensable, this abstract photography is an absolute novelty. It

did not achieve greater dissemination, because of the mysteriousness of its formation; but it did bring rich variations to the black-white theme. It is also an absolutely independent photography which seeks magic in the purity of balanced and calibrated composition, and which absorbs itself, with delight, in the transformation of shapes, light, surfaces, and values. . . .

From this visual interpenetration black-white patterns are produced whose enchantment derives from their formal promiscuity, which provokes fantasy and imagination. Variations within a narrowly limited space—penetrations of light and shadow in which, by suggestion, the phantoms of the play of light on projected objects are observed—are the subjects of these photographs. There remains for the viewer only a poem, exempt from reality in that the object is fully nullified and only pure form remains. And to encourage this black-white poetry to reach the outermost limits of its potential, one can blend elements of reality into this space or surface, of course joining them seamlessly. The exotic strangeness of the hummingbird or starfish or clam is a bonus for us, as a somewhat unusual component of daily life which successfully expands this light play. In these abstract photographs it is clearly demonstrated that simple reality contains much that is mysterious—a quality which makes photography fantastic—and also a novel and evocative poetic value. From this photographic standpoint it is only a small step to a search for fantastic elements in nature herself. All kinds of shadows on various broken surfaces form wonderful curves and patterns, which in the photographic composition become an autonomous image, independent of the original subject matter. Obviously, reality is a necessity for photography, but the photographically produced image in abstract photographs actually has no connection to reality. The form on the water's surface creates a wonderful arabesque and ceases thus to be a mere document; it becomes a cultivated photograph with an unusual viewpoint when it is both seen and taken in this way. It is here that the experimental combination [of abstract seeing with real objects] also finds its justification, the play of chance on the sensitive emulsion. Structures appear whose mottled colors call forth wonderful mysteries and fantasies of fairy-tale phantoms.

Certainly, the search for sensations is not the only source for this fantastical reality. With structural layering of different constructions, spirals, shapes, and simple realities, one can also conjure up startling configurations which, illuminated and evoked by a rich play of shadows,

bring a real photographic magic to the commonplace. This is not New Objectivity, for it does not want to operate through commonplace subject matter. It operates much more intensely, through a simple contrast or harmonious unity, as a complete entity whose real purpose is the awakening of the powers of imagination and sense of plastic beauty. A great number of events and situations can be made use of. This unconditional mission requires only personal fantasy, a strictly defined view of the object, a personal program, a knowledge of one's own spiritual characteristics, a knowledge of photographic technique, and a feeling for expressive form. This kind of photography is not only a matter of photography, but to a far greater extent a matter of personal culture. One can create new impressions in this manner—through interlayering photos and old needlework, for instance, or by making use of old pictures of our grandfathers and grandmothers; one can combine different color prints, artificial roses, plaster models; one can montage all sorts of photos and then confront them with any kind of real objects so that the whole contains within itself the power to evoke. The starting point and the objective is emotion, an emotion something like a dream, where human fantasy is laid open and fairy-tale-like rifts are mended.

Fairy tales indeed, but created out of a photographic reality. A human dream, photographed in order to relate it to others. The means are likewise inexhaustible. A simultaneous joining of two exposures on one emulsion can contain spaces which complement each other and form a new totality; silhouette-like traces of acrobats in a net create a suggestive abbreviated form through the underplay of detail and negative printing; the combination of the woven texture of the net with the sharp outlines of the head has an inner rhythm and is striking, unusual; an imaginary space drawn through outspread hands, the formal confrontation of gloves with a naked body and all of this then skillfully manipulated in an expressive utilization of shadow effects; a well-defined and plastically sculpted statue photographed together with a living hand. Amusement fair attractions, folk art, posters—the primitivism of our time—carry within them also this enchantment, this magic, next to whose photographic cradle a man with a camera stands with wide and covetous eyes directing his photographic vision.

One cannot record with a pen all the other possibilities in the field of photography that are also magically endowed. For this is a matter of photographic practice. One can give no advice for this kind

of photography. Where no personal imaginative powers exist, no fantasy or concept, there can only remain plagiarism, which dilutes and kills a valuable subject. And this is absolutely not the objective, for life itself continuously offers new situations and possibilities, and it is up to the photographer to find himself and to do exclusively what he can do. For even a simple doll under the open sky, with outspread arms and a pathetic tendril instead of a head, calls out with its own expression, which photography with its truthfulness only accentuates grotesquely.

Obviously, life itself offers the most varying situations, and it is the responsibility of the photographer to become conscious of the possibilities reality brings to him, be it through selection and expressive isolation, or through mutual confrontation. Space and object have their own rhythm and order. It is up to the photographer to subordinate both, according to his purpose. Vaclav Navratil[2] defined it so: "Every reality has its melody. The art of the photographer is to listen closely for the most penetrating and essential melody, and to present this melody again on an unreal, imaginary, two-dimensional surface. Photography is not only a matter of technical proficiency, but also and especially of a poetical sensitivity for a poetical effect." This is the real core of emotional photography, where its whole development until now reaches its climax. Common reality, released from simple description, is transformed by photographic intensification into an apparition: an eighteenth-century moss-covered statue, in all seriousness, crowns a modern factory smokestack; the passerby on the street encounters a cemetery; our art-nouveau childhood is brought back to life in front of a villa where an arrogant sphinx is carved with a modest inscription, "Vlasta";[3] the hour creeps toward twelve, where the totality of time originates and where for always and everywhere time persists from *anno domini* to eternity!

And photography continues to develop—we know where it is, but do we know where it is going? We can only guess.

Through the cyclical progression of styles, the proper mission of photography is strengthened and intensified. Photography is able to meet this challenge. It has those who press forward and continuously demand from it new possibilities. There is no necessity for everyone to be so compelled. For photography contains many areas where it needs encouragement, and everyone should not, and cannot, work in all its areas. Although photography is universal, and every photographer can work successfully in several of its areas at once, they need not all work

exclusively in this specialty. For it involves not only photography, but also sensitivity and an understanding of the purpose, as well as the potential, of an emotional photography.

Translated by Suzanne Pastor

1. Funke was the only writer to use the term "abstract photography" in this way. From 1927 to 1929 he produced his own brand of "abstract" photographs by photographing objects set amid the play of patterned lights and shadows in the studio.

2. Vaclav Navratil was a Czech philosopher.

3. Vlasta: a Czechoslovakian cigarette brand.

SELECTED BIBLIOGRAPHY

BOOKS AND CATALOGUES, 1910–1939

Aenne Biermann: 60 Fotos. Edited and with an introduction by Franz Roh. Berlin: Klinkhardt und Biermann, 1930.

Aragon, Louis. *Paysan de Paris*. Paris: Gallimard, 1926. Translated as *Paris Peasant*. London: Cape, 1971.

Atget: Photographe de Paris. Essay by Pierre Mac Orlan. Paris: Henri Jonquières; New York: Weyhe; Leipzig: Verlag Henri Jonquières, 1930.

Bellmer, Hans. *Die Puppe*. Karlsruhe: Privately printed, 1934.

Binding, Georg Rudolph. *Menschen auf der Straße: 42 Variationen über ein einfaches Thema*. Photographs by Moholy-Nagy, A. Biermann, S. Stone, et al. Stuttgart: Engelhorn, 1931.

Blossfeldt, Karl. *Urformen der Kunst*. Introduction by Karl Nierendorf. Berlin: Ernst Wasmuth, 1928. Translated as *Art Forms in Nature*. New York: Weyhe; London: A. Zwemmer, 1929.

Bragaglia, Anton Giulio. *Fotodinamismo futurista*. Rome: Natala Editore, 1913.

Brandt, Bill. *The English at Home*. London: B. T. Batsford, 1936.

_____. *A Night in London*. London: Country Life, 1938.

Brassaï. *Paris de nuit*. Essay by Paul Morand. Paris: Arts et Métiers Graphiques, 1933.

Breton, André. *L'Amour fou*. Paris: Gallimard, 1937.

_____. *Nadja*. Paris: Gallimard, 1928.

Brooklyn Museum. *International Photographers*. Exhibition catalogue, 1932.

Bucholtz, Ferdinand. *Der gefährliche Augenblick*. Essay by Ernst Jünger. Berlin: Junker und Dunnhaupt, 1931.

Cahun, Claude. *Aveux non avenus*. Photomontage illustrations by "Moore." Paris: Éditions du Carrefour, 1930.

Deutsches Werkbund. *Film und Foto: Internationale Ausstellung des deutschen Werkbund*. Exhibition catalogue. Stuttgart, 1929.

Diesel, Eugen. *Das Land der Deutschen*. Illustrated with numerous aerial photographs by Robert Petschow. Leipzig: Bibliographischer Institut AG, 1931.

_____. *Das Werk: Technische Lichtbildstudien*. Photographs by Renger-Patzsch, Gutschow, Paul Wolff, et al. Leipzig: Karl Robert Langwiesche, 1931.

Drtikol, František. *Les Nus de Drtikol*. Introduction by Claude de Santeul, Paris: Librairie des Arts Décoratifs, 1929.

Erste Internationale Dada Messe. Exhibition catalogue. Berlin: Malik Verlag, Dada Abteilung, 1920.

Fargue, Léon-Paul. *Banalités*. Illustrations by Roger Parry. Paris: Gallimard, 1930.

Formes nues. Photographs by Man Ray, Moholy-Nagy, Henri, Kertész, Hausmann, Brassaï. Paris: Forme, 1935.

Führmann, Ernst. *Die Pflanze als Lebewesen: Eine Biographie in 200 Aufnahmen.* Frankfurt: Societäts-Verlag, 1930.

Gräff, Werner. *Es kommt der neue Fotograf!* Berlin: Hermann Reckendorf, 1929.

Grosz, George. *Mit Pinsel und Schere: 7 Materialisationen.* Berlin: Malik Verlag, 1922.

Gutschow, Arvid. *See–Sand–Sonne.* Hamburg: Enoch, 1930.

Hugnet, Georges. *La Septième face du dé.* Paris: Éditions Jeanne Bucher, 1936.

Internationale Presse-Ausstellung, Cologne. *Die Pressa: Katalog des Sowjets Pavillon auf der Internationale Presse-Ausstellung.* Exhibition and catalogue designed by El Lissitzky. Exhibition catalogue. Cologne: Dumont Verlag, 1928.

Die Kamera: Ausstellung für Fotografie, Druck, und Reproduktion. Exhibition catalogue. Berlin: Gemeinnützige Berliner Ausstellungs-, messe- und fremdenverkehrs- gesellschaft, 1933.

Kassak, Lajos, and László Moholy-Nagy. *Buch neuer Künstler.* Vienna: Buch- und Steindruckerei Lebemühl, 1922.

Kertész, André. *Paris vu par André Kertész.* Essay by Pierre Mac Orlan. Paris: Librairie Plon, 1934.

Kollman, Franz. *Schönheit der Technik.* Photographs by Renger-Patzsch, et al. Munich: Albert Langen Verlag, 1928.

Krull, Germaine. *100 x Paris.* Berlin: Verlag der Reihe, 1929.

———. *Métal.* Introduction by Florent Fels. Paris: Librairie des Arts Décoratifs, 1927.

Lerski, Helmer. *Köpfe des Alltags.* Berlin: Hermann Reckendorf, 1931.

Levy, Julien. *Surrealism.* New York: Black Sun Press, 1936; reprinted New York: Arno/Worldwide, 1968.

Lindner, Paul. *Die Photographie ohne Kamera.* Berlin: Union Deutsche Verlagsgesellschaft, 1920.

Lissitzky, El, and Hans Arp. *Die Kunstismen.* Erlenbach-Zurich: Eugen Rentsch, 1925.

Mac Orlan, Pierre. *Photographes nouveaux: Germaine Krull.* Paris: Gallimard, 1931.

Man Ray. *Les Champs délicieux.* Essay by Tristan Tzara. Paris: Société Générale d'Imprimerie et d'Éditions, 1922.

———. *La Photographie n'est pas l'art.* Introduction by André Breton. Paris: GLM, 1937.

Man Ray: 104 Photographs, 1920–1934. Texts by Man Ray, André Breton, Paul Éluard, Rrose Sélavy, and Tristan Tzara. Hartford, Conn.: James Thrall Soby, 1934.

Mayakovsky, Vladimir. *Pro eto.* Photomontage illustrations by Rodchenko. Moscow: Lef Editions, 1923.

Mendelsohn, Erich. *Amerika: Bilderbuch eines Architekten.* Berlin: Rudolf Mosse, 1926.

_____. *Russland, Europa, Amerika: Eine architektonischer Querschnitt*. Berlin: Rudolf Mosse, 1928.

Moholy-Nagy, László. *Malerei Photographie Film*. Bauhausbücher 8. Munich: Albert Langen Verlag, 1925; second expanded edition 1927. Translated as *Painting, Photography, Film*. Cambridge, Mass.: MIT Press, 1969.

_____. *Von Material zu Architektur*. Bauhausbücher 14. Munich: Albert Langen Verlag, 1929. Translated as *The New Vision: From Material to Architecture*. New York: Brewer, Warren and Putnam, 1930.

Moholy-Nagy: 60 Fotos. Edited and with an introduction by Franz Roh. Berlin: Klinkhardt und Biermann, 1930.

Musée des Arts Décoratifs, Paris. *Exposition internationale de la photographie contemporaine*. Exhibition catalogue, 1936.

Nus: La Beauté de la femme. Photographs by Man Ray, Drtikol, Moholy-Nagy, Lynes, et al. Paris: Masclet, 1933.

Partito Nazionale Fascista, Rome. *Mostra della rivoluzione fascista*. Photomurals designed by Nizzoli, Prampolini, Terragni, et al. Exhibition catalogue, 1933.

Rasch, Heinz, and Bodo Rasch. *Gefesselter Blick*. Stuttgart: Wissenschaftlicher Verlag Dr. Zaugg und Co., 1930.

Renger-Patzsch, Albert. *Eisen und Stahl*. Introduction by Dr. Albert Vögler. Berlin: Hermann Reckendorf Verlag, 1931.

_____. *Die Welt ist schön*. Introduction by Carl Georg Heise. Munich: Kurt Wolff Verlag, 1928.

Renner, Paul. *Mechanisierte Grafik; Schrift, Typo, Foto, Film, Farbe*. Berlin: Hermann Reckendorf Verlag, 1930.

Richter, Hans. *Filmgegner von Heute—Filmfreunde von Morgen*. Berlin: Hermann Reckendorf Verlag, 1929.

Riefenstahl, Leni. *Schönheit im olympischen Kampf*. Berlin: Im Deutschen Verlag, 1937.

Roh, Franz. *Nachexpressionismus*. Leipzig: Klinkhardt und Biermann, 1925.

Roh, Franz, and Jan Tschichold, eds. *Foto-Auge*. Stuttgart: Akademischer Verlag Dr. Fritz Wedekind, 1929.

Salomon, Erich. *Berühmte Zeitgenossen in unbewachten Augenblicken*. Stuttgart: J. Engelhorn Nachf., 1931.

Sander, August. *Antlitz der Zeit*. Introduction by Alfred Döblin. Munich: Kurt Wolff, 1929.

Schall, Roger. *Paris de jour*. Paris: Arts et métiers graphiques, 1937.

Schöppe, Wilhelm. *Meister der Kamera erzählen*. Halle-Saale: Wilhelm Knapp, 1937.

Staatliche Museen, Berlin. *Fotomontage*. Texts by Cesar Domela Nieuwenhuis and Gustav Klucis. Exhibition catalogue, 1930.

Sutnar, Ladislav, and Jaromír Funke. *Fotografie vidi povrch* (Photography sees the surface). Prague: Druzstevni prace, 1935.

Tretyakov, Sergei, and Solomon Telingater. *John Heartfield* (in Russian). Moscow: Ogis, 1936.

Tschichold, Jan. *Die neue Typographie.* Berlin: Bildungsverband der Deutscher Buchdrucker, 1928.

Tucholsky, Kurt. *Deutschland, Deutschland über Alles.* Illustrations by John Heartfield. Berlin: Neuer Deutscher Verlag, 1929.

ESSAYS, 1910–1939

Abbott, Berenice. "Eugène Atget." *Creative Art,* September 1929, pp. 651–56.

Abbott, Jere. "Notes from a Russian Diary." *Hound and Horn,* April–June 1929, pp. 257–66.

Agha, Dr. M. F. "A Word on European Photography." *Pictorial Photography in America* 5 (1929).

Aragon, Louis. "John Heartfield et la beauté révolutionnaire." *Commune,* no. 20 (1935), pp. 985–91. Translated as "John Heartfield and Revolutionary Beauty." *Praxis,* no. 4 (1978), pp. 3–7.

————. "Un 'Salon' photographique." *Commune,* no. 22 (1935), pp. 1189–92.

————. Untitled contribution to *La Querelle du réalisme: Deux Débats par l'Association des Peintres et Sculpteurs de la Maison de la Culture,* pp. 55–68. Paris: Collection Commune, Éditions Social International, 1936. Translated as "Painting and Reality." *Transition,* no. 25 (Fall 1936), pp. 53–103.

Barr, Alfred H., Jr. "The LEF and Soviet Art." *Transition,* no. 14 (1928), pp. 267–70.

Bellmer, Hans. "Poupée: Variations sur une mineur articulée." *Minotaure,* no. 3/4 (1933), pp. 6–7.

Benjamin, Walter. "L'Oeuvre d'art à l'époque de sa reproduction mécanisée." *Zeitschrift für Sozialforschung* (Paris), May 1936. Second, revised version translated as "The Work of Art in the Age of Mechanical Reproduction." In Benjamin, *Illuminations,* pp. 217–52. New York: Schocken Books, 1969.

————. "Kleine Geschichte der Photographie." *Literarische Welt,* September 18 and 25, October 2, 1931. Translated as "A Short History of Photography." In Alan Trachtenberg, ed., *Classic Essays in Photography,* pp. 199–216. New Haven: Leete's Island Books, 1980.

————. "Pariser Brief (II): Malerie und Photographie" (1936). In Benjamin, *Gesammelte Schriften,* vol. 3, pp. 495–507. Frankfurt am Main: Suhrkamp, 1972.

Bofa, Gus. "Magie noire." *Jazz,* no. 3 (February 15, 1929), pp. 107–8.

Bonnard, Abel. "Remarques sur l'art photographique." *Gazette des Beaux-Arts,* November 1933, pp. 300–313.

Born, Wolfgang. "Photographischen Weltanschauung." *Photographische Rundschau,* 1929, pp. 141–42.

————. "Zum Stilproblem de modernen Photographie." *Photographische Rundschau,* 1929, pp. 212–14, 241–43, 287–88.

Bragaglia, Anton Giulio. "La fotografia del movimento." *Noi e il mondo* (Rome), April 1, 1913.

Brandt, Bill. "The Perfect Parlourmaid." *Picture Post*, July 29, 1939, pp. 43–46.

Brassaï. "Du mur des cavernes au mur d'usine." *Minotaure*, no. 1 (1933), pp. 41–44.

––––––. "Technique de la photographie de nuit." *Arts et métiers graphiques*, no. 33 (January 1933), pp. 24–27.

Brik, Ossip. "Chego ne vidit glaz" (What the eye does not see). *Sovetskoe kino*, no. 2 (1926), pp. 22–23.

––––––. "Ot kartiny k foto." *Novyi lef*, no. 3 (1928), pp. 29–33. Translated as "From Painting to Photography." In David Elliott, *Rodchenko and the Arts of Revolutionary Russia*, pp. 90–91. New York: Pantheon, 1979.

Burchartz, Max. "Handschrift-type: Zeichnung-foto." *Gebrauchsgrafik* 3, no. 8 (August 1926), pp. 37–44.

Cheronnet, Louis. "Un Livre illustré par la photographie" (review of *Banalités*). *Art et décoration* 55 (1929), pp. 26–33.

––––––. "L'Objet mis à lumière." *Art et décoration* 62 (1933), pp. 11–20.

Cocteau, Jean. "Lettre ouverte à M. Man Ray, photographe américain." *Les Feuilles libres*, no. 26 (April–May 1922), pp. 134–35.

Crevel, René. "Le Miroir aux objets." *L'Art vivant*, no. 14 (August 1925), pp. 23–24.

Dali, Salvador. "Photographic Testimony." *La gaceta literaria* (Barcelona), no. 6 (February 1929), pp. 40–42; French translation in Dali, *OUI 1: La Révolution paranoïaque-critique*, pp. 97–99. Paris: Denoël-Gonthier, 1971.

––––––. "Photography, Pure Creation of the Mind." First published in *L'Amie de les arts* (Sitgès), no. 18 (September 30, 1927), pp. 90–91. Translated as "La Photographie: Pure création de l'esprit." In Dali, *OUI 1: La Révolution paranoïaque-critique*, pp. 24–26. Paris: Denoël-Gonthier, 1971.

Desnos, Robert. "Man Ray." *Le Journal*, December 14, 1923. Translated as "The Work of Man Ray." *Transition*, February 1929, pp. 264–66.

––––––. "Les Spectacles de la rue—Eugène Atget." *Le Soir*, September 11, 1928, p. 5.

Domela Nieuwenhuis, Cesar. "Fotomontage." *De Reclame*, May 1931, pp. 211–15.

Durus [Alfred Kemény]. "Fotogramm, Fotomontage." *Der Arbeiter Fotograf*, no. 7 (1931), pp. 166–68.

Éluard, Paul. "Les Plus belles cartes postales." *Minotaure*, no. 3/4 (1933), pp. 85–100.

Federov-Davydov, Alexei. Introduction to László Moholy-Nagy, *Zivopis' ili fotografia* (Painting photography film). Moscow, 1929. Translated in Krisztina Passuth, *Moholy-Nagy*, pp. 418–22. New York: Thames and Hudson, 1985.

Fels, Florent. "L'Art photographique—Adjet [*sic*]." *L'Art vivant*, February 1931, p. 28.

––––––. "Bibliographie photographique." *L'Art vivant*, March 1931, p. 85.

──────. "Le Premier Salon indépendent de la photographie." *L'Art vivant*, June 1, 1928, p. 445.

Frenzel, H. K. "John Heartfield und seine photographischen Arbeiten." *Gebrauchsgraphik* 4, no. 7 (1927), pp. 17–32.

Funke, Jaromír. "Man Ray." *Fotograficky obzor*, no. 1 (1927).

Gallotti, Jean. "La Photographie est-elle un art?: Kertész." *L'Art vivant*, March 1, 1929.

George, Waldemar. "Photographie vision du monde—Adget [*sic*] photographe de Paris." *Arts et métiers graphiques*, no. 16 (March 15, 1930), pp. 5–20, 131–61.

Hartlaub, G. F. "Rückblick auf den Konstruktivismus." *Das Kunstblatt*, 1927, pp. 253–63.

Hausmann, Raoul. "Fotomontage." *a bis z* 2, no. 16 (May 1931), pp. 61–62.

Hausmann, Raoul, and Werner Gräff. "Wie sieht der Fotograf." *Das Deutsche Lichtbild*, 1933, pp. 11–18.

Kallai, Ernst. "Malerei und Fotografie." *i10*, 1, no. 4 (1927), pp. 148–57.

Klucis, Gustav. "Fotomontaz, kak novaja problema agitacionnogo iskusstva" (Photomontage as a problem of agitational art). *Literatura i iskusstvo*, no. 9 (1931), pp. 86–95.

Kracauer, Siegfried. "Die Photographie." *Frankfurter Zeitung*, October 28, 1927. Reprinted in Kracauer, *Das Ornament der Masse*, pp. 21–39. Frankfurt am Main: Suhrkamp, 1977; English ed., *The Mass Ornament*. Translated by Thomas Y. Levin. Cambridge, Mass.: Harvard University Press, forthcoming.

Lotz, Wilhelm. "Architektur fotos." *Die Form* 4, no. 3 (1929), pp. 69–70.

──────. "Fotografie und Object. Zu den Fotos von Renger Patzsch." *Die Form* 4, no. 7 (1929), pp. 162–67.

Mac Orlan, Pierre. "Éléments de fantastique social." *Le Crapouillet*, January 1929, pp. 3–5.

──────. "Photographie." *Le Crapouillet*, March 1929, p. 33.

──────. "La Photographie." *Nouvelles littéraires*, September 22, 1928, p. 1.

──────. "La Photographie et le fantastique social." *Les Annales politiques et littéraires*, November 1, 1928, pp. 413–14.

"Martin Munkacsi." *Gebrauchsgraphik* 9, no. 7 (1932), pp. 36–51.

Moholy-Nagy, László. "Die beispiellose Fotografie." *i10*, 1, no. 1 (1927), pp. 114–17.

──────. "Die Fotografie in der Reklame." *Photographische Korrespondenz*, no. 9 (September 1927).

──────. "Fotogramm und Grenzgebiete." *i10*, 2, no. 21/22 (1929), pp. 190–92.

──────. "Fotoplastiche Reklame." *offset*, no. 7 (1926), pp. 386–91.

──────. "Light: A Medium of Plastic Expression." *Broom* 4, no. 4 (March 1923), pp. 283–84.

──────. "Noch einmal die Elemente." *Film Technik*, no. 25 (May 1929).

──────. "La Photo, ce qu'elle était, ce qu'elle devra être." *Cahiers d'art*, no. 1 (1929), pp. 29–32.

──────. "Scharf oder unscharf?" *i10*, 2, no. 20 (1929), pp. 163–67.

_____. "Zu den Fotografien von Florence Henri." *i10*, 2, no. 17/18 (1928), p. 117.

Nezval, Viteszlav. "Surrealism and Photography" (in Czech). *Ceske Slovo*, January 30, 1935.

Prampolini, Enrico. "Conquiste e strategie della camera oscura." *Natura 9*, no. 3 (March 1936).

Raynal, Maurice. "Variétés du corps humain." *Minotaure*, no. 1 (1933), pp. 41–44.

Renger-Patzsch, Albert. "Die Freude am Gegenstand." *Das Kunstblatt*, no. 12 (1928), p. 19.

_____. "Hochkonjunktur." *bauhaus*, no. 4 (October–December 1929), p. 20.

_____. "Photographie und Kunst." *Photographische Korrespondenz*, no. 3 (1927), pp. 80–82.

_____. "Ziele." *Das Deustche Lichtbild*, 1927.

Renner, Paul. "Das Lichtbild." *Die Form* 5, no. 14 (1930), pp. 377–78.

Rim, Carlo. "Curiosités photographiques: De l'instantané." *L'Art vivant*, no. 137 (September 1, 1930).

_____. "Défense et illustration de la photographie." *Vu*, April 20, 1932, p. 587.

Rodchenko, Alexander. "Protiv summirovannogo portreta za momentalnyi snimok." *Novyi lef*, no. 4 (1928), pp. 14–16. Translated as "Against the Synthetic Portrait, for the Snapshot." In John Bowlt, ed., *Russian Art of the Avant-garde*, pp. 250–54. New York: Viking, 1976.

_____. "Puti soverennoj fotografi" (Paths of contemporary photography). *Novyi lef*, no. 8 (1928), pp. 31–39.

Roh, Franz. "Der Wert der Fotografie." *Hand und Maschine* 1 (February 1930), pp. 219–20. Trans. in *Franz Roh*. Düsseldorf: Editions Marzona, 1981.

Sambuy, Eduardo di. "La fotodinamica futurista di Anton Giulio e di Arturo Bragaglia." *La fotografia artistica* 10, no. 5 (May 1913), pp. 71–75.

Sander, August. "Erläuterung zu meiner Ausstellung im Kölnischen Kunstverein," 1927. Reprinted in *Vom Dadamax bis zum Grüngürtel: Köln in den zwanziger Jahren*, p. 148. Cologne: Kölnisch Kunstverein, 1975.

_____. "Photography as a Universal Language." Typescript (in German) of a 1931 radio lecture. Translated in *Massachusetts Review* 19, no. 4 (Winter 1978), pp. 674–79.

Schalcher, Traugott. "El Lissitzky." *Gebrauchsgraphik* 5, no. 12 (1928), pp. 49–64.

Sidorow, Dr. Alexys A. "Wege der Lichtbildkunst in Sowjet-Russland." *Das Deutsche Lichtbild*, 1928/1929, unpaged.

Sieker, Hugo. "Absolut Realistik: Zu Photographien von Albert Renger-Patzsch." *Der Kreis* 3 (March 1928), pp. 144–48.

Soupault, Philippe. "État de la photographie." *Photographie*, 1931, unpaged.

Sterne, Katherine Grant. "American versus European Photography." *Parnassus*, March 1932, pp. 16–20.

Strand, Paul. Letter in response to Aragon's "Painting and Reality." *Art Front* 17 (February 1937), p. 18.

Styrsky, Jindrich. "Picture" (in Czech). *Disk* (Prague), no. 1 (December 1923). Translated in Stephen Bann, *The Tradition of Constructivism*, pp. 97–102. New York: Viking, 1974.

Teige, Karel. "Modern Photography" (in Czech). *Rozpravy Aventina*, 1930.

———. "Painting and Poetry" (in Czech). *Disk*, no. 1 (December 1923).

———. Review of *Film und Foto* exhibition (in Czech). *ReD* 3, no. 10 (1929), pp. 320–22.

———. "Úkoly moderni fotografie" (The tasks of modern photography). In *Moderna tvorba usitkova*. Bratislava, 1931.

Tretyakov, Sergei. "Ot fotoserii—k olitel'nomu fotonabljudeniju" (From the photo-series to extended photo-observation). *Proletarskoe foto*, no. 4 (1931), pp. 20ff.

Tucholsky, Kurt. Review of August Sander, *Antlitz der Zeit* (1930). In Tucholsky, *Gesammelte Werke*, vol. 3, pp. 393–94. Reinbeck: Rowohlt, 1960.

Valentin, Albert. "Eugène Atget." *Variétés*, December 15, 1928, pp. 403–7.

Van Hecke, P. G. Review of Pierre Bost, *Photographies modernes*. In *Variétés* 2, no. 12 (April 1930), pp. 873–75.

Warstatt, Willi. "Die 'entfesselte Kamera' und die 'produktive Photographie': Zu den Ideen Professor Moholy-Nagy." *Deutsche Kamera Almanach*, 1929, pp. 43ff.

Westheim, Paul. "Bezeichnet oder geknipst?: Zu Kunstblatt-Ausstellung Porträt-Zeichnungen, -Grafik, und -Fotos." *Das Kunstblatt*, 1930, pp. 33–47.

———. "Maschinenromantik." *Das Kunstblatt*, 1923, pp. 33–40.

Windisch, Hans. "Sehen." *Das Kunstblatt*, 1930, pp. 129–34.

SPECIAL ISSUES OF PERIODICALS, 1910–1939

Campo grafico (Milan), March 1934. "Fotografia e Tipografia."

Die Form 4, no. 10 (1929). *Film und Foto* issue.

Das neue Frankfurt 3, no. 3 (1929). "Experimentelle Fotografie."

Novyi lef, no. 9 (1928). Photography issue.

ReD 2, no. 8 (1929). Film, photography, and typography issue.

Social Kunst (Copenhagen), no. 9 (1932). Photomontage issue; includes work by Lissitzky, Moholy-Nagy, Rodchenko.

Telehor 1, no. 1/2 (1936). Moholy-Nagy issue.

Typografische Mitteilungen (Leipzig), October 1925. "Elementary Typography," Jan Tschichold, ed.

USSR in Construction, December 1933. "The Great White Sea Canal," featuring photographs by Rodchenko; designed by Rodchenko and Stepanova.

Wendigen 5, no. 8/9 (1923). X-ray and microscopic imagery issue.

Das Werk (Zurich) 13, no. 7 (1926). "The New World," Hannes Meyer, ed.

BOOKS AND CATALOGUES, 1940–1989

Ades, Dawn. *Photomontage*. New York: Thames and Hudson, 1983.

Adriani, Götz. *Hannah Höch: Fotomontagen, Gemälde, Aquarelle*. Cologne: Dumont, 1980.

Akademie der Künste, Berlin. *Hannah Höch: Collagen aus den Jahren 1916–1971*. Exhibition catalogue, 1971.

American Federation of Arts, New York. *The Photographs of Josef Albers: A Selection from the Collection of the Josef Albers Foundation*. Essay by John Szarkowski. Exhibition catalogue, 1987.

André Kertész. Essays by Harold Riley et al. Manchester: Manchester Collection, 1984.

Arco Center for Visual Art, Los Angeles. *Herbert Bayer: Photographic Works*. Essay by Leland Rice. Exhibition catalogue, 1977.

Art Institute of Chicago. *André Kertész: Of Paris and New York*. Essays by Sandra Phillips, David Travis, and Weston Naef. Exhibition catalogue. Chicago: Art Institute of Chicago; New York, Metropolitan Museum of Art, 1985.

———. *Photographs from the Julien Levy Collection: Starting with Atget*. Text by David Travis. Exhibition catalogue, 1976.

Arts Council of Great Britain, London. *Dada and Surrealism Reviewed*. Text by Dawn Ades. Exhibition catalogue, 1978.

Barents, Els, and W. H. Roobol. *Dr. Erich Salomon, 1886–1944: Aus dem Leben eines Fotografen*. Munich: Schirmer/Mosel, 1981.

Bellmer, Hans. *Petite Anatomie de l'inconscient physique ou l'anatomie de l'image*. Paris: Le Terrain Vague, 1957.

Benson, Timothy O. *Raoul Hausmann and Berlin Dada*. Ann Arbor: UMI, 1987.

Bertonati, Emilio. *Das experimentelle Photo in Deutschland, 1918–1940*. Exhibition catalogue. Munich: Galleria del Levante, 1978.

Bill Brandt: Behind the Camera. Essays by Colin Osman and David Mellor. New York: Aperture, 1985.

Bory, J. F. *Prolégomènes à une monographie de Raoul Hausmann*. Paris: L'Herne, 1972.

Brancusi: Photographer. New York: Agrinde Publications, 1979.

Brancusi: The Sculptor as Photographer. Essay by Hilton Kramer. New York: David Grob Editions/Callaway Editions, 1979.

Brassaï [Gyula Halász]. *Graffiti*. Stuttgart: Chr. Belser, 1960. Translated as *Graffiti de Brassaï*. Paris: Éditions du Temps, 1961.

Breton, André. *Surrealism and Painting*. New York: Harper and Row, 1972.

Bronx Museum of Art. *Moholy-Nagy; Fotoplastiks: The Bauhaus Years*. Essay by Julie Saul. Exhibition catalogue, 1983.

Busch-Reisinger Museum, Cambridge, Mass. *El Lissitzky, 1890–1941*. Essay and catalogue entries by Peter Nisbet. Exhibition catalogue, 1987.

Büthe, Joachim, et al. *Der Arbeiter Fotograf: Dokumente und Beiträge zur Arbeiterfotografie, 1926–1932*. Cologne: Prometh Verlag, 1977.

Cartier-Bresson, Henri. *Images à la sauvette*. Paris: Éditions Verve, 1952. Translated as *The Decisive Moment*. New York: Simon and Schuster, 1952.

Centre Georges Pompidou, Paris. *Hans Bellmer, photographe*. Exhibition catalogue, 1983.

———. *La Photographie polonaise, 1900–1981*. Essays by William A. Ewing, Adam Sobata, Urszula Czartoryska, and Stanislaw Kopf. Exhibition catalogue, 1981.

———. *Photographies tchèques, 1920–1950*. Essays by Zdenek Kirschener and Antonin Dufek. Exhibition catalogue, 1983.

Clair, Jean. *Duchamp et la photographie*. Paris: Chêne, 1977.

Claremont College, Claremont, Calif. Leland D. Rice and David W. Steadman, eds. *Photographs of Moholy-Nagy from the Collection of William Larson*. Exhibition catalogue, 1975.

Cohen, Arthur A. *Herbert Bayer: The Complete Work*. Cambridge, Mass.: MIT Press, 1984.

Coke, Van Deren, and Diana Dupont. *Photography; A Facet of Modernism: Photographs from the San Francisco Museum of Modern Art Collection*. Exhibition catalogue. New York: Hudson Hills Press, in association with the San Francisco Museum of Modern Art, 1986.

Dech, Gertrud Jula. *"Schnitt mit dem Küchenmesser Dada durch die letzte weimarer Bierbauchkulturepoch Deutschlands": Untersuchungen zur Fotomontage bei Hannah Höch*. Munster: Lit-Verlag, 1981.

Elderfield, John. *Kurt Schwitters*. Exhibition catalogue. New York: Museum of Modern Art, 1985.

Elliott, David, ed. *Rodchenko and the Arts of Revolutionary Russia*. New York: Pantheon, 1979.

Erlhoff, Michael. *Raoul Hausmann: Dadasophe*. Hanover: Verlag Zweitschrift, 1982.

Eskildsen, Ute, and Christopher Horak, eds. *Film und Foto der zwanziger Jahre*. Stuttgart: Hatje, 1979.

Faglio, Maurizio. *Florence Henri: Una riflessione sulla fotografia*. Turin: Martano Editore, 1975.

Fárová, Anna. *František Drtikol: Photograph des Art Deco*. Munich: Schirmer/ Mosel, 1986.

Fondation Nationale de la Photographie, Lyons. *Maurice Tabard: L'Alchimiste des formes*. Exhibition catalogue, 1985.

Franz Roh. Essay by Juliane Roh. Düsseldorf: Edition Marzona, 1981.

Galeria Wspolczesna, Warsaw. *Fotomontaze, 1924–1934*. Exhibition catalogue, 1970.

Galerie Adrien Maeght, Paris. *Raoul Ubac: Photographies des années trente*. Exhibition catalogue, 1983.

Galerie Altes Theater, Ravenberg, W. Ger. *Marta Hoepffner: Das photographische und lichtkinetische Werke.* Exhibition catalogue, 1982.

Galerie Gmwrzynska, Cologne. *From Painting to Design: Russian Constructivist Art of the Twenties.* Exhibition catalogue, 1981.

Galerie Kunze, Berlin. *Heinz Hajek-Halke: Fotografie, Foto-Grafik, Licht-Grafik.* Exhibition catalogue, 1978.

Galleria Schwarz, Milan. *Dada Schad.* Exhibition catalogue, 1970.

Gassner, Hubertus. *Rodchenko Photographien.* Munich: Schirmer/Mosel, 1972.

Germaine Krull: Fotografien, 1922–1966. Cologne: Rheinland-Verlag, 1977.

Giroud, Michel, ed. *Raoul Hausmann: "Je ne suis pas un photographe."* Paris: Chêne, 1975.

Hambourg, Maria Morris, and Christopher Phillips. *The New Vision: Photography Between the World Wars, Ford Motor Company Collection at The Metropolitan Museum of Art.* New York: The Metropolitan Museum of Art, 1989.

Haus, Andreas. *Moholy-Nagy: Photographs and Photograms.* New York: Pantheon, 1980.

———. *Raoul Hausmann: Kamerafotografien, 1927–1957.* Munich: Schirmer/Mosel, 1979.

Hausmann, Raoul. *Courrier Dada.* Paris: Le Terrain Vague, 1958.

———. *Im Anfang war Dada.* Giessen, W. Ger.: Anabas Verlag, 1972.

———. *Texte bis 1933.* Michael Erlhoff, ed. Munich: Text & Kritik, 1982.

Herbert List: Photographs, 1930–1970. Essay by Günter Metken. New York: Rizzoli, 1981.

Herzfelde, Wieland. *John Heartfield: Leben und Werke.* Berlin: DEB, 1986.

Hight, Eleanor M. *Moholy-Nagy: Photography and Film in Weimar Germany.* Exhibition catalogue. Wellesley, Mass.: Wellesley College Museum, 1985.

Houston Museum of Fine Arts. *Czech Modernism, 1900–1945.* Essays by Jaroslav Andel and Willis Hartschorn. Exhibition catalogue, 1989.

Hugnet, Georges. *Dictionnaire du Dadaisme, 1916–1922.* Paris: Jean-Claude Simoen, 1976.

Jaguer, Eduard. *Les Mystères de la chambre noire.* Paris: Flammarion, 1982.

Janus, ed. *Man Ray: The Photographic Image.* Woodbury, N.Y.: Barron's, 1980.

Jürgens-Kirchoff, Annegret. *Technik und Tendenz der Montage in der bildenden Kunst des 20. Jahrhunderts.* Giessen, W. Ger.: Anabas Verlag, 1978.

Kemp, Wolfgang. *Foto-Essays.* Munich: Schirmer/Mosel, 1979.

———. ed. *Theorie der Fotografie, Vol. 2, 1912–1945.* Munich: Schirmer/Mosel, 1979.

Kepes, Gyorgy. *Lightgraphics.* Exhibition catalogue. New York: International Center of Photography, 1984.

Kertész, André. *Day of Paris.* New York: J. J. Augustin, 1945.

Kestner-Gesellschaft, Hanover. *Dada Photographie und Photocollagen.* Essays by Richard Hiepe, Eberhard Roters, Arturo Schwarz, Werner Spies, Carl-Albrecht Haenlein. Exhibition catalogue, 1979.

Khan-Magomedov, Selim O. *Rodchenko: The Complete Work*. Cambridge, Mass.:
MIT Press, 1987.

Kostelanetz, Richard. *Moholy-Nagy*. New York: Praeger, 1970.

Krauss, Rosalind, and Dawn Ades. *L'Amour fou: Photography and Surreal-
ism*. New York: Abbeville, 1985. Published in conjunction with an ex-
hibition at the Corcoran Gallery of Art, Washington, D.C.

Kunstverein, Ingolstadt, W. Ger. *Die Fotomontage: Geschichte und Wesen einer
Kunstform*. Essay by Richard Hiepe. Exhibition catalogue, 1969.

Leclanche-Boulé, Claude. *Typographies et photomontages constructivistes en
URSS*. Paris: Papyrus, 1984.

Linhart, Lubomir. *Alexandr Rodčenko*. Prague: Státní nakladatelství krasne
literatury a umění, 1964.

Lissitzky-Küppers, Sophie. *El Lissitzky: Life, Letters, Texts*. Greenwich, Conn.:
New York Graphic Society, 1968.

Lista, Giovanni. *Futurismo e fotografia*. Milan: Edizioni Multhipla, 1979.

———. *I futuristi e la fotografia: Creazione fotografica e immagine quotidiana*.
Modena: Edizioni Panini, 1986.

———. *Photographie futuriste*. Exhibition catalogue. Paris: Musée d'Art
Moderne de la Ville de Paris, 1982.

Lodder, Christina. *Russian Constructivism*. New Haven: Yale University Press,
1983.

Long Island University School of Art, Greenvale, N.Y. *Futurism and Photog-
raphy*. Exhibition catalogue, 1984.

Lusk, Charlotte Irene. *Montagen in Blaue: László Moholy-Nagy; Fotomontagen
und Collagen, 1922–1943*. Giessen, W. Ger.: Anabas Verlag, 1980.

Man Ray. *Self-Portrait*. Boston: Little, Brown, 1963; reprint 1988.

Man Ray Photographs. Essays by Janus, Herbert Molderings, and Philippe
Sers. New York: Thames and Hudson, 1982.

Margolin, Victor. *The Transformation of Vision: Art and Ideology in the Graphic
Design of Alexander Rodchenko, El Lissitzky, and László Moholy-Nagy*.
Ann Arbor: UMI Research Press, 1986.

Martini and Ronchetti Galleria, Rome. *Florence Henri*. Exhibition catalog, 1974.

März, Roland. *John Heartfield: Der Schnitt entlang die Zeit*. Dresden: Verlag
der Künste, 1981.

Mattenklott, Gert. *Karl Blossfeldt, 1865–1932: Das fotografische Werk*. Mu-
nich: Schirmer/Mosel, 1981.

Mellor, David, ed. *Germany: The New Photography, 1927–33*. London: Arts
Council of Great Britain, 1978.

Moholy, Lucia. *Moholy-Nagy: Marginal Notes*. Krefeld: Scherpe Verlag, 1972.

Moholy-Nagy, Sibyl. *Moholy-Nagy: Experiment in Totality*. New York: Harper
and Brothers, 1950.

Musée Carnavalet, Paris. *Brassaï: Paris le jour; Paris la nuit*. Essay by Kim
Sichel. Exhibition catalogue, 1988.

Musée d'Art Moderne de la Ville de Paris. *Florence Henri: Photographies*.
Essay by Herbert Molderings. Exhibition catalogue, 1978.

Musée Sainte Croix, Poitiers. *La Nouvelle Photographie en France, 1919–1939.* Essay by Christian Bouqueret. Exhibition catalogue, 1986.

Musées d'Arles. *Krull: Photographie, 1924–1936.* Text by Christian Bouqueret. Exhibition catalogue, 1988.

Museum Ludwig, Cologne. *Werner Mantz: Architekturphotographie in Köln, 1926–1932.* Essays by Christoph Brockhaus, Wolfram Hagspiel, and Reinhold Misselbeck. Exhibition catalogue, 1982.

Museum of Modern Art, New York. *Dada, Surrealism, and Their Heritage.* Essay by William Rubin. Exhibition catalogue, 1968.

_____. *Henri Cartier-Bresson: The Early Work.* Essay by Peter Galassi. Exhibition catalogue, 1987.

_____. *The Photographs of Henri Cartier-Bresson.* Essays by Beaumont Newhall and Lincoln Kirstein. Exhibition catalogue, 1947.

National Museum of American Art, Washington, D.C. *Perpetual Motive: The Art of Man Ray.* Essays by Merry Foresta, Sandra Phillips, et al. Exhibition catalogue. New York: Abbeville, 1988.

Neue Galerie, Kassel, W. Ger. *Wechselwirkungen: Ungarische Avantgarde in der Weimarer Republik.* Essays by Hubertus Gassner, Andreas Haus, et al. Exhibition catalogue. Marburg: Jonas Verlag, 1986.

New Gallery of Contemporary Art, Cleveland. *Photographic Surrealism.* Essay by Nancy Hall-Duncan. Exhibition catalogue, 1979.

The New Vision: Forty Years of Photography at the Institute of Design. Essays by John Grimes and Charles Traub. Millerton, N.Y.: Aperture, 1982.

Palazzo Reale, Milan. *Christian Schad; Mostra retrospettiva: Dipinti, rilievi, schadografie, acquerelli, disegni, incisioni.* Exhibition catalogue. Milan: Arti Grafiche Fiorin, 1972.

Photographers Gallery, London. *Czechoslovakian Photography: Jaromír Funke/Jaroslav Rössler.* Exhibition catalogue, 1985.

Rudolf Kicken Galerie, Cologne. *Jaromír Funke.* Exhibition catalogue, 1984.

Sachsse, Rolf. *Lucia Moholy.* Düsseldorf: Edition Marzona, 1985.

San Francisco Museum of Modern Art. *Avant-garde Photography in Germany, 1918–1933.* Text by Van Deren Coke; essays by Ute Eskildsen and Bernd Lohse. Exhibition catalogue, 1980.

Sander, Gunther, ed. *August Sander: Citizens of the Twentieth Century.* Essay by Ulrich Keller. Cambridge, Mass.: MIT Press, 1984.

Sartorti, Rosalinde, and Henning Rogge. *Sowjetische Fotografie, 1928–1932.* Munich: Carl Hanser Verlag, 1975.

Scharf, Aaron. *Art and Photography.* Baltimore: Pelican Press, 1969.

Schwarz, Arturo. *Katalog Berman.* Exhibition catalogue. Milan: Galleria Schwarz, 1973.

_____. *Man Ray: The Rigour of Imagination.* New York: Rizzoli, 1977.

Siepmann, Eckhard. *Montage: John Heartfield. Vom Club Dada zur Arbeiter-Illustrierten Zeitung.* Berlin: Elefanten Press, 1977.

Spectrum Photogalerie/Kunstmuseum Hannover. *Umbo: Photographien, 1925–1933.* Essay by Georg Reinhardt. Exhibition catalogue, 1979.

Sprengel Museum Hannover. *El Lissitzky, 1890–1941: Retrospektive.* Essays by Peter Nisbet, Kai-Uwe Hemken, Walter Kambartel, Beatrix Nobis, and Christian Grohn. Exhibition catalogue, 1988.

Staatliche Kunsthalle, Berlin. *Christian Schad.* Exhibition catalogue, 1980.

Steinorth, Karl. *Photographen der 20er Jahren.* Munich: Laterna Magica, 1979.

Szarkowski, John, and Maria Morris Hambourg. *The Work of Atget.* 4 vols. Exhibition catalogue. New York: Museum of Modern Art, 1981–85.

Von der Heydt-Museum, Wuppertal, W. Ger., *Schadografien, 1918–1975.* Exhibition catalogue, 1975.

Weiss, Evelyn, ed. *Rodchenko Fotographien, 1920–1938.* Cologne: Wienand Verlag, 1980.

Wescher, Herta. *Collage.* New York: Abrams, 1968.

Westfälischer Kunstverein, Münster, W. Ger. *Florence Henri: Aspekte der Photographie der 20er Jahre.* Essay by Herbert Molderings. Exhibition catalogue, 1976.

Whelen, Richard. *Robert Capa: A Biography.* New York: Knopf, 1985.

Willett, John. *Art and Politics in the Weimar Period: The New Sobriety, 1917–1933.* New York: Pantheon, 1978.

Willmann, Heinz. *Geschichte der Arbeiter-Illustrierte-Zeitung.* Berlin: Dietz Verlag, 1975.

ESSAYS, 1940–1989

Adcock, Craig. "Marcel Duchamp's 'Instantanés': Photography and the Event Structure of the Ready-Mades." In Stephen C. Foster, ed., *"Event" Arts and Art Events,* pp. 203–38. Ann Arbor: UMI Research Press, 1988.

Allner, H. "Surrealism in Photography—Raoul Ubac." *Graphis,* no. 9/10 (July–September 1945), pp. 258–63.

Amaya, Mario. "My Man Ray: An Interview with Lee Miller Penrose." *Art in America,* May–June 1975, pp. 54–60.

Andel, Jaroslav. "Construction et 'poétisme' dans la photographie tchèque." *Photographies,* no. 7 (May 1985), pp. 21–25.

Barr, Alfred H., Jr. "Russian Diary, 1927–1928." *October,* no. 7 (Winter 1978), pp. 7–50.

Brockhaus, Christoph. "Flach, Rodtschenko, Moholy-Nagy, und die Diskussion um die neuen Perspektiven in der Photographie." In Museum Ludwig, Cologne, *Hannes Maria Flach: Photographien der zwanziger Jahre.* Exhibition catalogue, 1983.

Buchloh, Benjamin. "From Faktura to Factography." *October,* no. 30 (Fall 1984), pp. 82–119.

Clifford, James. "On Ethnographic Surrealism." *Comparative Studies in Society and History* 23, no. 4 (1981), pp. 539–64.

Cohen, Ronny. "Alexander Rodchenko." *Print Collector's Newsletter,* July–August 1977, pp. 68–70.

"Collages 1935 par Eluard." *Labyrinthe*, no. 21 (July–August 1946), p. 10.

Colomina, Beatriz. "Le Corbusier and Photography." *Assemblage*, no. 4 (October 1987), pp. 7–23.

Compton, Susan. "Art and Photography." *Print Collector's Newsletter*, March–April 1976, pp. 12–15.

Demarais, Charles. "Julien Levy: Surrealist Author, Dealer, and Collector." *Afterimage*, January 1977, pp. 729–32.

Denoyelle, Françoise. "Éléments de bibliographie, 1919–1939." *La Recherche photographique*, no. 2 (May 1987), pp. 63–69.

Eskildsen, Ute. "Photography and the Neue Sachlichkeit Movement." In Hayward Gallery, London, *Neue Sachlichkeit and German Realism of the Twenties*, pp. 85–97. Exhibition catalogue, 1979.

Fawkes, Caroline. "Photography and Moholy-Nagy's Do-It-Yourself Aesthetic." *Studio International*, July–August 1975, pp. 17–21.

Foster, Hal. "L'Amour Faux." *Art in America*, January 1985, pp. 117–28.

Gassner, Hubertus. "Analytical Sequences." In Oxford Museum of Modern Art, *Rodchenko and the Arts of Revolutionary Russia*, pp. 108–11. Exhibition catalogue, 1979.

_____. "La Construction de l'utopie: Photomontages en Union Soviétique, 1919–1942." In Centre Georges Pompidou, Paris, *Utopies et réalités en URSS, 1917–1934: Agit-Prop Design Architecture*, pp. 51–57. Exhibition catalogue, 1980.

_____. "Von der Utopie zur Wissenschaft und zurück: Zur Geschichte des Konstruktivismus in der Sowjetunion." In Neue Galerie für Bildende Kunst, Berlin, *"Kunst in die Produktion": Sowjetische Kunst während der Phase der Kollektivierung und Industrialisierung, 1927–1933*, pp. 51–101. Exhibition catalogue, 1977.

Graeve, Inka. "Internationale Ausstellung des Deutschen Werkbunds Film und Foto." In *Stationen der Moderne. Die bedeutenden Kunstausstellungen des 20. Jahrhunderts in Deutschland*, pp. 237–43. Exhibition catalogue. Berlin: Berlinische Galerie, 1988.

Gussow, Ingeborg. "Die neusachliche Photographie." In Helmut Friedel, ed., *Kunst und Technik in den 20en Jahren*, pp. 94–107. Exhibition catalogue. Munich: Stadtische Galerie in Lenbachhaus, 1980.

Halley, Anne. "August Sander." *Massachusetts Review* 19, no. 4 (Winter 1978), pp. 663–73.

Haus, Andreas. "Dokumentarismus, Neue Sachlichkeit, und Neues Sehen—Zur Entwicklung des Mediums Fotografie in den USA und Europa." *Amerika Studien* 26, no. 3/4 (1981), pp. 315–39.

Hayes, K. Michael. "Photomontage and Its Audience, Berlin, circa 1922." *Harvard Architectural Review*, no. 6 (1987), pp. 19–31.

Hermand, Jost. "Unity within Diversity?: The History of the Concept 'Neue Sachlichkeit.'" In Keith Bullivant, ed., *Culture and Society in the Weimar Republic*, pp. 166–82. Manchester, Eng.: Manchester University Press, 1977.

Horak, Jan-Christopher. "The Films of Moholy-Nagy." *Afterimage*, Summer 1985, pp. 20–23.

Jagels, Kah. "Frühe Fotografien Christian Schads." *Fotogeschichte*, no. 18 (1985), pp. 23–28.

Keller, Ulrich. "Die deutsche Portraitfotografie von 1918 bis 1933." *Kritische Berichte* 5, no. 2–3 (1977), pp. 37–66.

Kovacs, Steven. "Man Ray as Film Maker." *Artforum*, December 1972, pp. 62–66.

Krauss, Rosalind. "Corpus Delicti." *October*, no. 33 (Summer 1985), pp. 31–72.

———. "Jump over the Bauhaus." *October*, no. 15 (Spring 1980), pp. 103–10.

———. "Nightwalkers." *Art Journal* 41, no. 1 (Spring 1981), pp. 33–38.

———. "The Photographic Conditions of Surrealism." *October*, no. 19 (Winter 1981), pp. 3–34.

———. Preface to *Poetic Injury: The Surrealist Legacy in Postmodern Photography*, pp. 3–7. Exhibition catalogue. New York: Alternative Museum, 1987.

———. "When Words Fail." *October*, no. 22 (Fall 1982), pp. 91–102.

Kuspit, Donald B. "The Dynamics of Revelation: German Avant-garde Photography (1919–1939)." *Vanguard* 11, no. 7 (September 1982), pp. 22–25.

Lavin, Maud. "Androgyny, Spectatorship, and the Weimar Photomontages of Hannah Höch." *New German Critique*, Summer 1989.

———. "Heartfield in Context." *Art in America*, February 1985, pp. 84–93.

———. "Ringl + Pit: The Representation of Women in German Advertising, 1929–33." *Print Collector's Newsletter*, July–August 1985, pp. 89–93.

Lista, Giovanni. "Futurist Photography." *Art Journal* 41, no. 4 (1981), pp. 358–64.

Miller, Sandra. "Constantin Brancusi Photographs." *Artforum*, March 1981, pp. 38–44.

Model, Lisette. "Why France Fell." *PM*, January 1941, pp. 33–39.

Molderings, Herbert. "La Seconde découverte de la photographie." In Centre Georges Pompidou, Paris, *Paris/Berlin*, pp. 250–60. Exhibition catalogue, 1978.

———. "Man Rays 'Die Photographie ist nicht Kunst.'" *Fotogeschichte*, no. 19 (1986), pp. 29–40.

Mousseigne, Alain. "Rôle et place de la photographie dans les revues d'avant-garde artistique en France." In *Le Retour à l'ordre dans les arts plastiques et l'architecture, 1919–1925*, pp. 317–29. Saint-Étienne: CIEREC/Université de Saint Étienne, 1975.

———. "Surréalisme et photographie: Rôle et place de la photographie dans les revues du mouvement surréaliste, 1929–1939." In *L'Art face à la crise, 1929–1939*, pp. 153–81. Saint-Étienne: CIEREC/Université de Saint-Étienne, 1980.

Nesbit, Molly. "Photography, Art, and Modernity." In Jean-Claude Lemagny and André Rouillé, eds., *The History of Photography*, pp. 103–23. New York: Cambridge University Press, 1987.

Newhall, Beaumont. "Photo Eye of the Twenties: The Deutsche Werkbund Exhibition of 1929." *New Mexico Studies in the Fine Arts* 2 (1977); re-

printed in David Mellor, ed., *Germany: The New Photography, 1927–33*, pp. 77–86. London: Arts Council of Great Britain, 1978.

————. "The Photography of Moholy-Nagy." *Kenyon Review* 3 (1941), pp. 344–51.

Osman, Colin, ed. "Alexander Michailovitch Rodchenko, 1891–1956: Aesthetic, Autobiographical, and Ideological Writings." *Creative Camera International Year Book*, 1978, pp. 189–233.

Pincus-Witten, Robert. "May Ray: The Homonymic Pun." *Artforum*, April 1975, pp. 54–59.

Pohlmann, Ulrich. "Nur die Sieger zahlen: Die Funktion der Schönheit bei Leni Riefenstahl." *Tendenzen*, no. 154 (April–June 1986), pp. 69–76.

Roditi, Edouard. "Interview with Hannah Höch." In Lucy Lippard, ed., *Dadas on Art*, pp. 68–77. Englewood Cliffs, N.J.: Prentice-Hall, 1971.

Roters, Eberhard. "Collage und Montage." In *Tendenzen der Zwanziger Jahre*, part 3, pp. 30–41. Exhibition catalogue. Berlin: Dietrich Reimer Verlag, 1977.

Sachsse, Rolf. "Germany: The Third Reich." In Jean-Claude Lemagny and André Rouillé, eds., *The History of Photography*, pp. 150–57. New York: Cambridge University Press, 1987.

Schmidt-Linsenhoff, Viktoria. " 'Körperseele,' Freilichkeit, und Neue Sinnlichkeit: Kulturgeschichtliche Aspekte der Akt-Fotografie in der Weimarer Republik." *Fotogeschichte* 1, no. 1 (1981), pp. 46–59.

Schwarz, Angelo. "Fascist Italy." In Jean-Claude Lemagny and André Rouillé, eds., *The History of Photography*, pp. 136–40. New York: Cambridge University Press, 1987.

Sekula, Allan. "On the Invention of Photographic Meaning." *Artforum*, January 1975, pp. 37–45.

Sobieszek, Robert. "Erotic Photomontages: Georges Hugnet's *La Septième face du dé*." *Dada/Surrealism*, no. 9 (1980), pp. 66–82.

Solomon-Godeau, Abigail. "The Armed Vision Disarmed: Radical Formalism from Weapon to Style." *Afterimage*, January 1983, pp. 9–14.

Stein, Sally. "The Composite Photographic Image and the Composition of Consumer Ideology." *Art Journal* 41, no. 1 (Spring 1981), pp. 39–45.

Tausk, Petr. "The Roots of Modern Photography in Czechoslovakia." *History of Photography* 3, no. 3 (July 1979), pp. 253–71.

Tisdall, Caroline, and Angelo Bozzolla. "Bragaglia's Futurist Photodynamism." *Studio International*, July–August 1975, pp. 12–16.

Vilodie, Nicolas. "Christian Schad, période Dada." *Photographies*, no. 7 (May 1985), pp. 26–28.

Watney, Simon. "Making Strange: The Shattered Mirror." In Victor Burgin, ed., *Thinking Photography*, pp. 154–76. London: Macmillan, 1982.

Weimarer, Peter. "Von der Kunstfotografie zur Neuen Sachlichkeit." In *Geschichte der Fotografie in Österreich*, pp. 187–203. Bad Ischl: Verein für Erarbeitung der Geschichte, 1983.

Zannier, Italo. "Illusion et réalité dans la photographie italienne entre les deux guerres." In Centre Georges Pompidou, Paris, *Les Réalismes, 1919–1939*, pp. 301–6. Exhibition catalogue, 1981.

ACKNOWLEDGMENTS

Every effort has been made to locate the owners of copyrighted material and to make full acknowledgment of its use. Errors or omissions will be corrected in subsequent editions if notification in writing is received by the publisher. Grateful acknowledgment is made for permission to include the following essays and translations:

Louis Aragon, contribution to *The Quarrel over Realism*. English translation published in *Transition*, no. 24 (June 1936). Reprinted by permission of Betsy and Tina Jolas.

Rudolph Arnheim, excerpt from *Film as Art*. English edition published by the University of California Press, 1966. Reprinted by permission of the author.

Anton Giulio Bragaglia, excerpts from *Futurist Photodynamism*. From *Futurist Manifestos*, edited by Umbro Apollonio. Copyright © 1970 by Verlag M. DuMont Schauberg, Cologne, and Gabriele Mazzotta Editore, Milan. English language translation copyright © 1973 by Thames and Hudson Ltd. Reprinted by permission of Viking Penguin, a division of Penguin Books USA, Inc., and Thames and Hudson Ltd.

Jean Cocteau, "An Open Letter to M. Man Ray, American Photographer." Reprinted by permission of Dodd, Mead & Co.

Salvador Dali, "Photographic Testimony," excerpt from Salvador Dali, *Oui*. Copyright © 1971 by Denoël-Gonthier. Reprinted by permission of Denoël-Gonthier.

Robert Desnos, "Spectacles of the Street—Eugène Atget." Reprinted by permission of Dr. Michel Fraenkel. English translation reprinted by permission of Commerce Graphics Ltd., Inc.

Robert Desnos, "The Work of Man Ray." Reprinted by permission of Dr. Michel Fraenkel. English translation reprinted by permission of Betsy and Tina Jolas.

Cesar Domela Nieuwenhuis, "Photomontage." Reprinted by permission of the author.

Alexander Dorner, "Original and Facsimile." Reprinted by permission of Niedersächsisches Hauptstaatsarchiv. Catalogue information: Hauptstaatsarchiv Hannover, VVP 21 Nr. 8.

Alexei Fedorov-Davydov, Introduction to the Russian edition of László Moholy-Nagy's *Malerei Fotografie Film*. English translation by Judith Szollosy, from *Moholy-Nagy* by Krisztina Passuth. New York: Thames and Hudson; Budapest: Corvina Press, 1985. Reprinted by permission.

Jaromír Funke, "From the Photogram to Emotion." Reprinted by permission of Milena Rupešová. English translation from *Funke*, exhibition catalogue. Cologne: Galerie Kicken-Pauseback, 1984. Reprinted by permission of Galerie Kicken-Pauseback.

Raoul Hausmann and Werner Gräff, "How Does the Photographer See?" Raoul Hausmann, "Photomontage." Reprinted by permission of Marthe Prévot.

Ernst Jünger, "Photography and the 'Second Consciousness,'" excerpt from "Über den Schmerz," in *Sämtliche Werke*, Band 7. Stuttgart: Klett-Cotta, 1980. Copyright © 1980 Ernst Klett Verlage GmbH & Co. KG. Reprinted by permission.

Ernö Kallai, "Painting and Photography." English translation by Harvey L. Mendelsohn from *Bauhaus Photography*. Cambridge, Mass.: The MIT Press, 1985. © 1985 by The Massachusetts Institute of Technology. Originally published in West Germany under the title *Bauhaus Fotografie*, copyright © 1982 by Edition Marzona, Düsseldorf. Reprinted by permission of The MIT Press.

Pierre Mac Orlan, "Elements of a Social Fantastic," "The Literary Art of Imagination and Photography," Preface to *Atget Photographe de Paris*. Reprinted by permission of the Comité Pierre Mac Orlan.

Man Ray, "The Age of Light," "Deceiving Appearances," "On Photographic Realism." Copyright 1989 ARS N.Y./ADAGP. Reprinted by permission. English translation of "Deceiving Appearances" from *Man Ray: The Photographic Image*, edited by Janus. Woodbury, N.Y.: Barron's, 1980.

László Moholy-Nagy, "Photography in Advertising," "Production-Reproduction," "Sharp or Unsharp?," "Unprecedented Photography." Reprinted by permission of Hattula Moholy-Nagy. English translation of "Production-Reproduction" from *Studio International*, August 1975. Reprinted by permission. English translation of "Sharp or Unsharp?" by Matyas Esterhazy, from *Moholy-Nagy* by Krisztina Passuth. New York: Thames and Hudson; Budapest: Corvina Press, 1985. Reprinted by permission.

Walter Peterhans, "On the Present State of Photography." English translation by Harvey L. Mendelsohn from *Bauhaus Photography*. Cambridge, Mass.: The MIT Press, 1985. © 1985 by The Massachusetts Institute of Technology. Originally published in West Germany under the title *Bauhaus Fotographie*, copyright © 1982 by Edition Marzona, Düsseldorf. Reprinted by permission of The MIT Press.

Albert Renger-Patzsch, "Photography and Art." English translation reprinted from *Germany—The New Photography 1927–33*, edited by David Mellor. London: Arts Council of Great Britain, 1978. Reprinted by permission.

Carlo Rim, "On the Snapshot." Reprinted by permission of the author.

Alexander Rodchenko, "Against the Synthetic Portrait, for the Snapshot." English translation from *Russian Art of the Avant-Garde: Theory and Criticism 1902–1934*, edited and translated by John E. Bowlt. Copyright © 1976 by John E. Bowlt. Reprinted by permission of Viking Penguin, a division of Penguin Books USA, Inc.

August Sander, "Remarks on My Exhibition at the Cologne Art Union." Copyright © by The August Sander Archive. Reprinted by permission.

Philippe Soupault, "The Present State of Photography." Copyright by Lachenal & Ritter. Reprinted by permission. Publication forthcoming in France by Lachenal & Ritter in *Littérature et le reste*, an anthology of writings by Philippe Soupault.

Varvara Stepanova, "Photomontage." English translation from *Rodchenko and the Arts of Revolutionary Russia*, edited by David Elliott. Copyright © 1979 by Museum of Modern Art, Oxford. Reprinted by permission of Pantheon Books, a division of Random House, Inc., and A. Zwemmer Ltd.

Jan Tschichold, "Photography and Typography." Reprinted by permission of David R. Godine, Publisher, Inc.

Tristan Tzara, "Photography Upside Down," "When Objects Dream." Reprinted by permission of the estate of Tristan Tzara. English translation of "Photography Upside Down" reprinted from *Aperture*, no. 85 (1981), by permission of the Aperture Foundation.

Photographs:

JACKET/COVER FRONT:
László Moholy-Nagy (American, born in Hungary, 1895–1946) or Lucia Moholy (British, born in Czechoslovakia, 1899), *László Moholy-Nagy*, 1925–26. Gelatin silver print, 10⅛ × 7⅞ in. The Metropolitan Museum of Art, Ford Motor Company Collection, Gift of Ford Motor Company and John C. Waddell, 1987 (1987.1100.69)

JACKET/COVER BACK:
André Kertész (American, born in Hungary, 1894–1985), *Fork*, 1928. Gelatin silver print, 2¹⁵⁄₁₆ × 3⅜ in. The Metropolitan Museum of Art, Ford Motor Company Collection, Gift of Ford Motor Company and John C. Waddell, 1987 (1987.1100.46)

FRONTISPIECE:
Man Ray (American, 1890–1976), Rayograph, 1922. Gelatin silver print, 9¾ × 7 in. The Metropolitan Museum of Art, Ford Motor Company Collection, Gift of Ford Motor Company and John C. Waddell, 1987 (1987.1100.42)